A new home!

THE DESERT

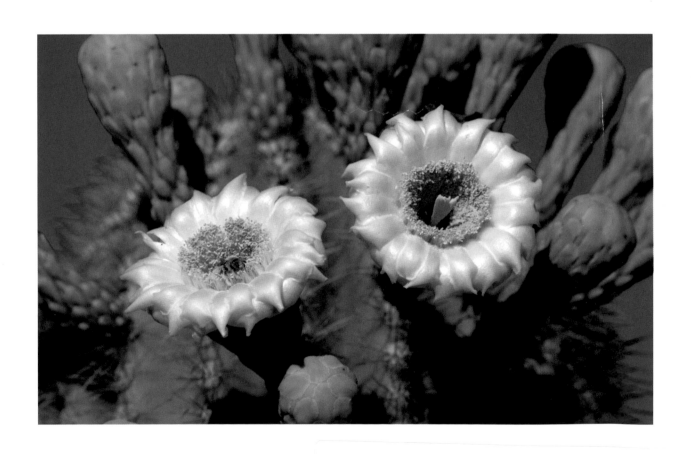

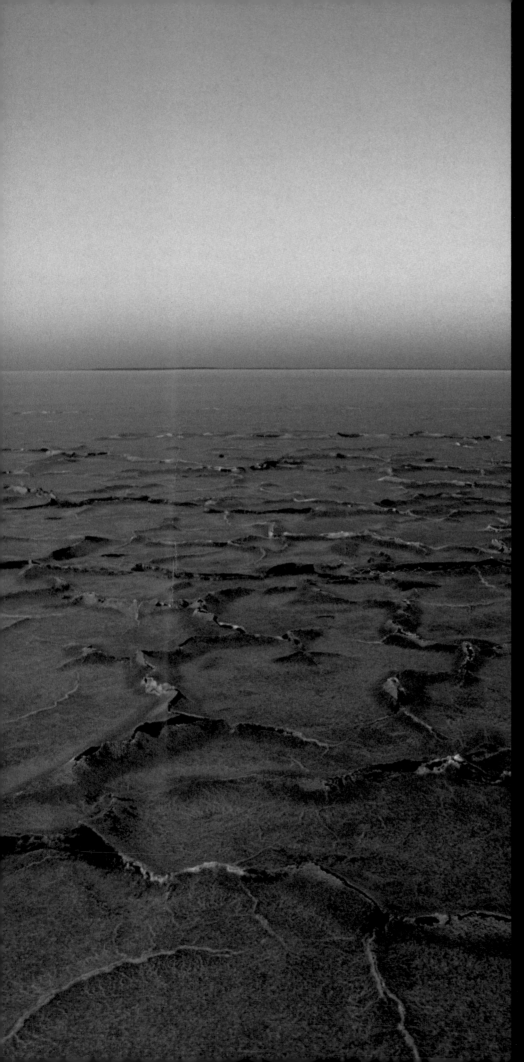

THIS IS A CARLTON BOOK

Design and text copyright © Carlton Books Limited 2011

This edition published in 2011
by Carlton Books Limited
20 Mortimer Street
London W1T 3JW

10 9 8 7 6 5 4 3 2 1

A CIP catalogue record for this book is available from the British Library.

ISBN 978 1 84732 298 2

Printed and bound in Dubai

Senior Executive Editor: Lisa Dyer
Managing Art Director: Lucy Coley
Designer: Anna Pow
Copy Editor: Liz Dittner
Picture Research: Jenny Meredith
Production: Kate Pimm

PREVIOUS Saguaro flowers provide a rich source of pollen for a wide range of wildlife, some of which time their reproductive cycles to coincide with the flower's flowering season.

LEFT The forbidding salt flats of Lake Eyre seem an unlikely place for wildlife but are the surprising home of the Lake Eyre Dragon.

OPPOSITE Widespread but rarely seen, the Fennec Fox spends most of its day underground in its den, emerging at night to track down prey by sound using its large ears.

OVERLEAF Cold offshore currents help bring a lifeline to the arid Namibian coast via the regular mists that form here.

THE
DESERT

JAMES PARRY

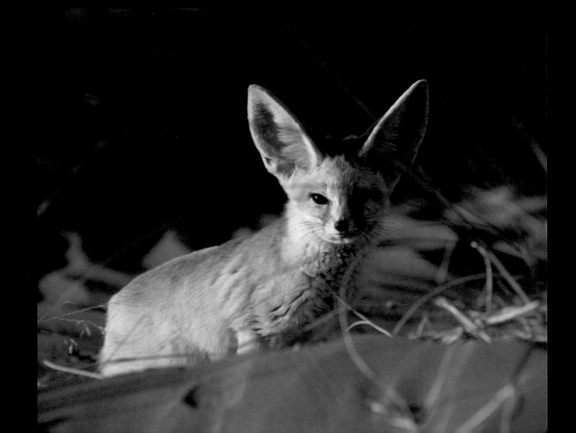

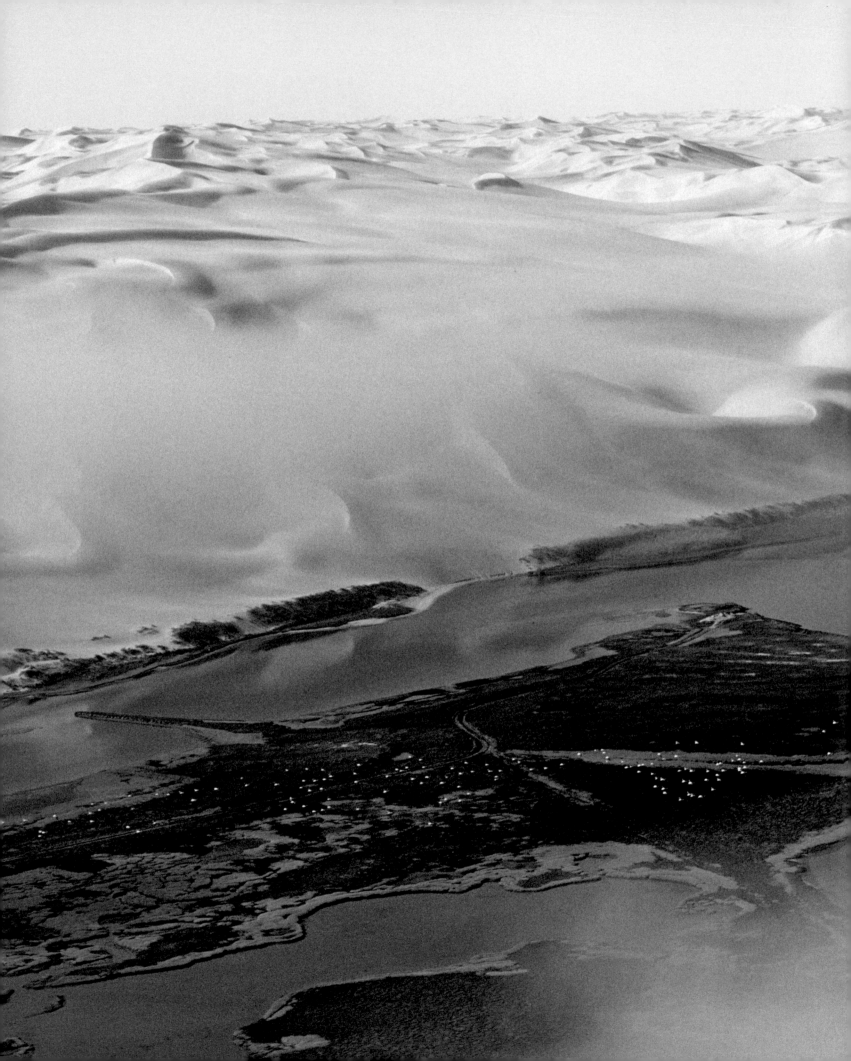

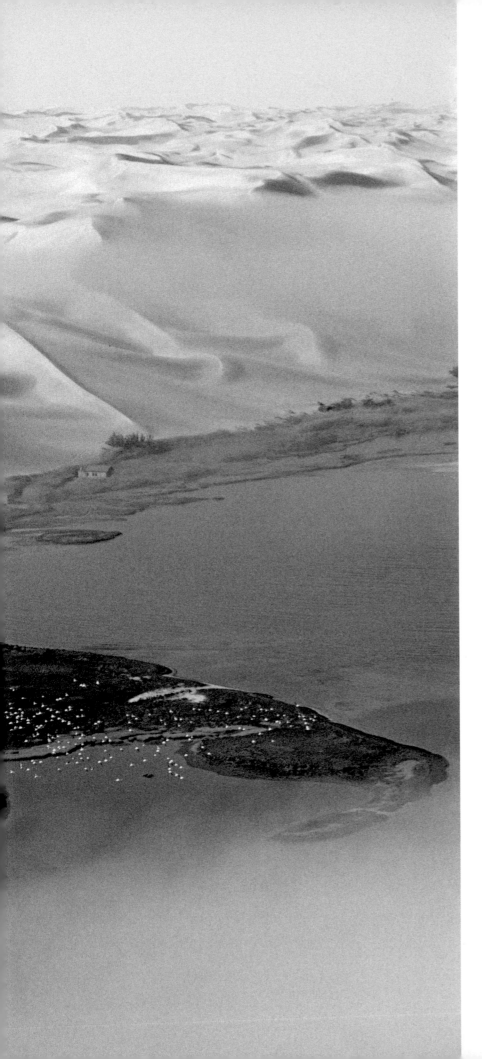

CONTENTS

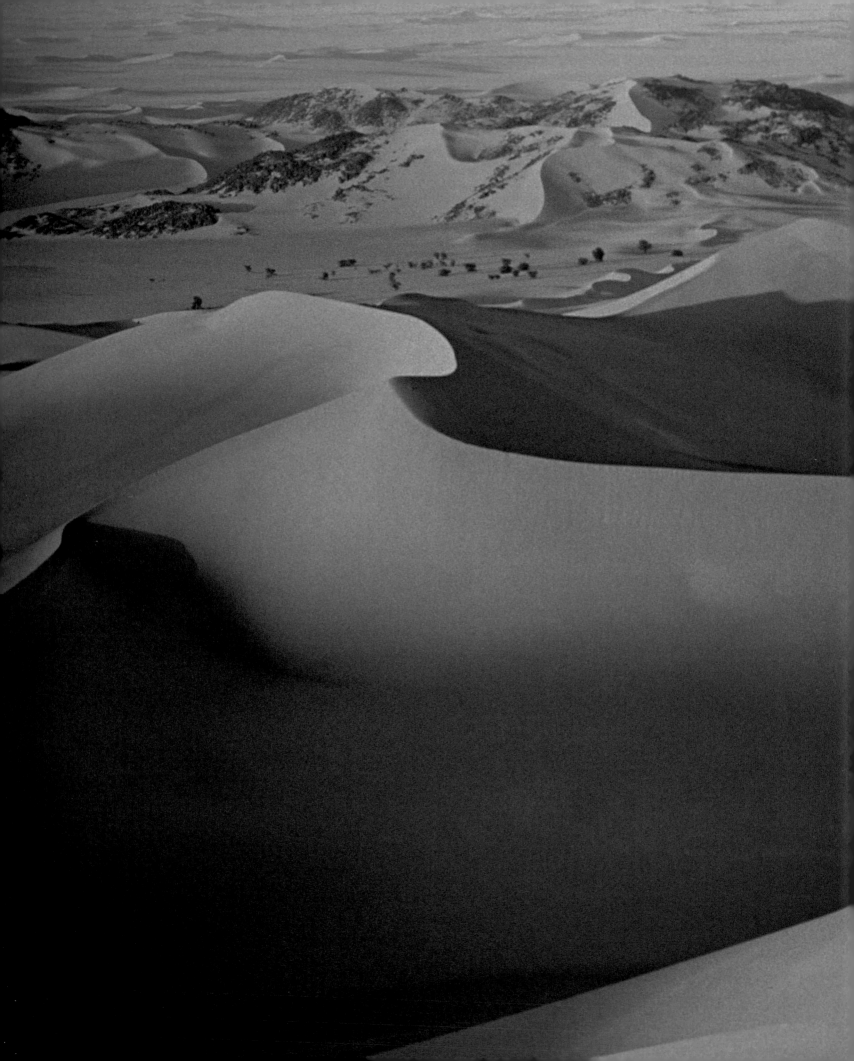

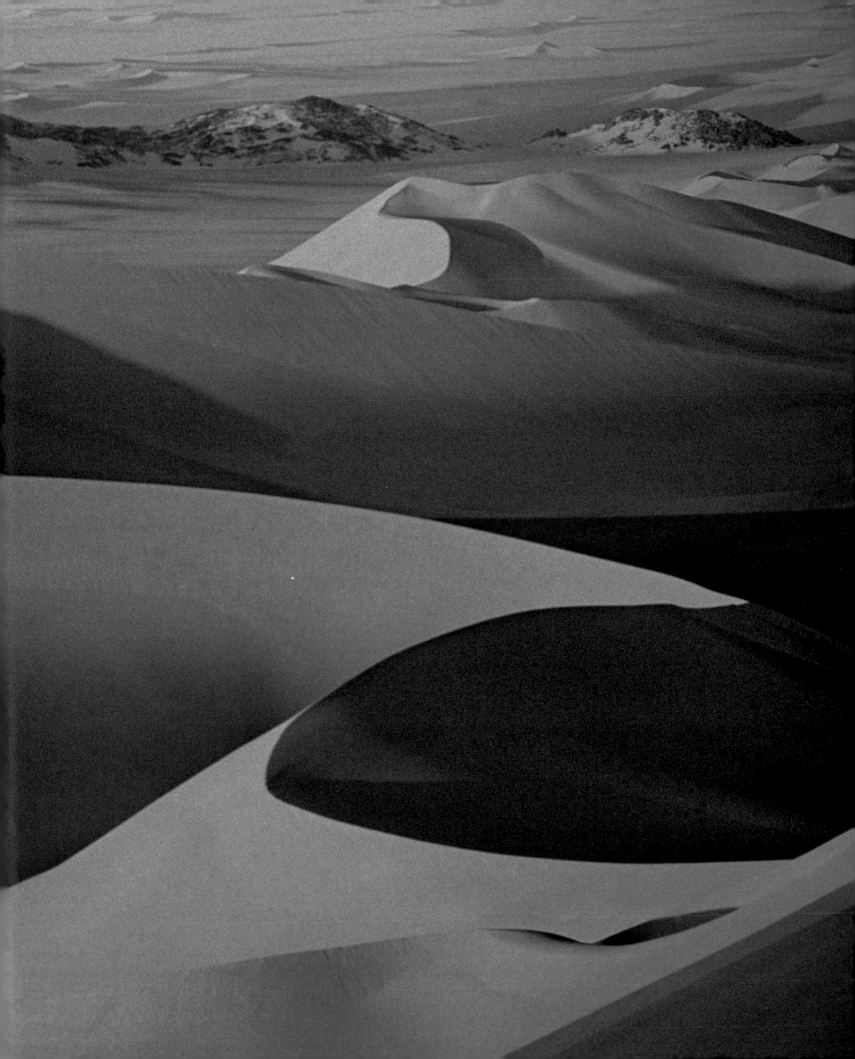

INTRODUCTION

On a recent visit to Dubai I was struck by how subordinate the desert there has become to the shiny brash city which now dominates that corner of Arabia. Fifty years ago the desert would have been all around, dominant and seemingly an everlasting constant. At that time the local people lived and breathed the desert, it was home to many of them; indeed, it was the only home that the true Bedouin knew. They were as familiar with the desert as we might be with our home street or town, constantly attuned to its rhythms and its ways and intimately familiar with its wildlife, knowing where was a good place to find springtime flowers, Houbara Bustard and herds of gazelle. Such knowledge was passed on from father to son, as part of the desert traditions which these people and their ancestors had preserved for thousands of years.

Today all that has changed. The desert near Dubai has been vanquished by a sea of glass, concrete, metal and cement, and the only gazelle you are likely to see there now will be a fibreglass effigy adorning a lavishly landscaped roundabout. I saw no real desert wildlife in the Dubai area; worse than that, the desert was little more than a scruffy "gap" between places, something you peer at through the window of your fiercely air-conditioned vehicle as you drive at high speed between new developments or from Dubai to Abu Dhabi and back. Fragmented and marginalized, the desert has become a nowhere place.

Yet it need not be like that. Although one does not have to look far to find other examples of deserts under pressure, there are happily many places where this most magical of landscapes still weaves its spell. All of the sites in this book have something of that quality, and in each there are examples of the problems and opportunities that are part of desert life in the twenty-first century. In particular, these deserts are notable for the wildlife they support. Some of the best wildlife viewing I have ever enjoyed has been in the desert, where the enigmatic qualities of the landscape lend a particular dimension to watching wildlife. The unforgiving nature of the terrain somehow adds to the experience, the blinding sun and intense heat serving to underline the great resilience and highly specialized characters of desert-dwelling plants and animals. It is a privilege to spend time observing desert creatures in their natural environment, and a humbling experience indeed to study their ingenuity in coping with some of the harshest conditions found anywhere in the world.

James Parry

PREVIOUS PAGE **Some of the world's greatest expanses of sand dune are in the Sahara. The Réserve Naturelle de l'Aïr et du Ténéré is one of the largest protected areas in the world and home to a range of endangered wildlife whose survival has been helped by its isolation.**

RIGHT **Formerly widespread across the Middle East, the Arabian Oryx was hunted to extinction in the wild in the 1970s. Thanks to reintroduction schemes, hundreds of oryx now roam freely in the region and the species has become a defining symbol of desert wildlife.**

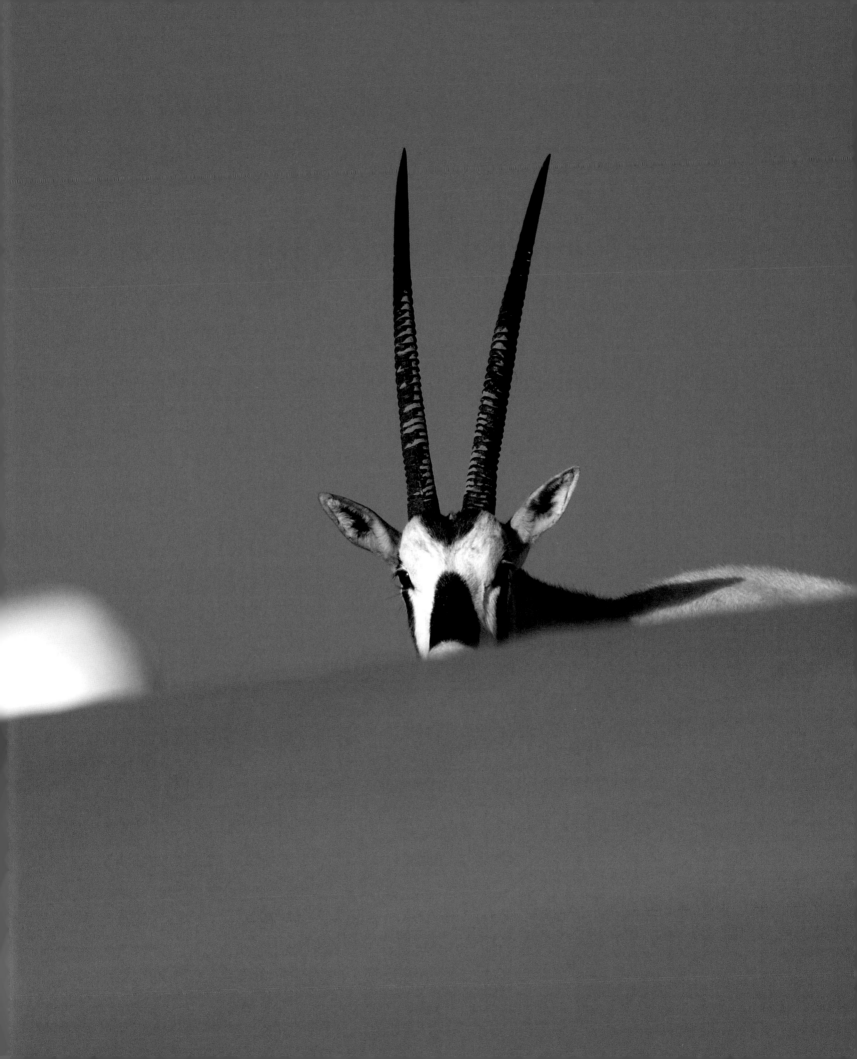

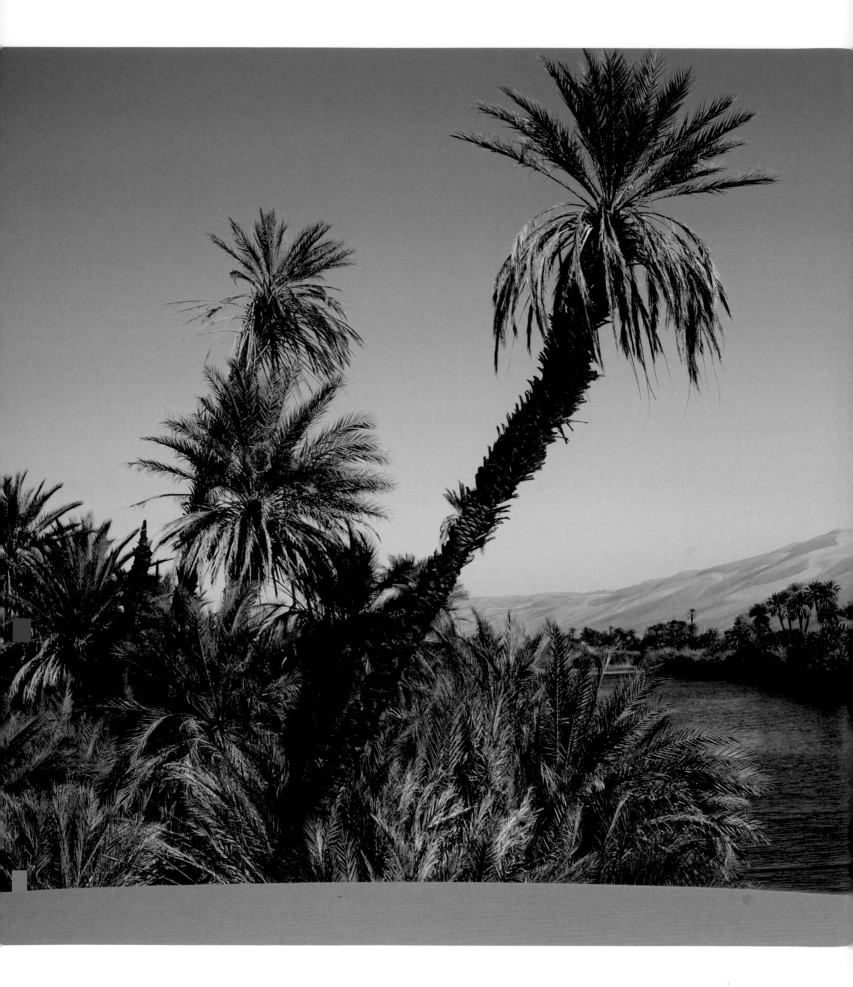

DESERTS: CONTEXT AND CHARACTERISTICS

Few landscapes occupy so prominent a niche in our imagination as the desert. The unique qualities of this most challenging of environments, where nature and the elements combine in such a raw and seemingly primitive state, have retained the power to beguile over many thousands of years. Inhabited by a range of highly specialized wildlife and only the most resilient of human communities, deserts have traditionally been regarded as a world apart, the inhospitable nature of their terrain serving to inhibit contact and understanding by those living outside their boundaries. It was well into the twentieth century before some of the world's greatest deserts were scientifically surveyed and mapped. Indeed, even as the second decade of the twenty-first century gets into its stride, there remain tracts of desert in Asia and Africa that are still a relatively unknown quantity in terms of the wildlife they support.

Estimated to cover a fifth or so of the world's land surface, deserts remain one of the least understood of natural environments. Definitions vary, but a true desert is generally interpreted as somewhere receiving less than 250 millimetres (10 inches) of rain annually. However, it is perhaps more useful to think in terms of "drylands", areas where annual rainfall is less than 600 millimetres per annum. Such landscapes cover as much as 40 per cent of the globe's land area and their conditions vary widely. However, rainfall totals alone are not the most useful defining quality for deserts or arid areas. The regularity – or not – of rainfall patterns is also important, as is the character of the precipitation. In many cases it is fitful and erratic, often falling in sudden downpours that can be positively violent, causing flash flooding and the destruction of life and property. An entire year's rainfall can fall in a few minutes on such occasions. In other places, such as Madagascar's Spiny Desert, the rainfall is as limited in terms of overall totals but usually more predictable, arriving as part of the wider monsoon patterns that affect tropical parts of the world. Yet some deserts – notably the Atacama and some areas of the Arabian Peninsula – receive hardly any rain as such. Instead, regular fogs deposit adequate moisture to sustain forms of plant life and, in turn, various species of wildlife, in what would otherwise be impossible conditions. Meanwhile, in high altitude deserts such as the Tibetan Plateau, much of the annual precipitation falls in the form of snow.

LEFT **Permanent lakes and watercourses in the Sahara are few and far between, but when they do occur they support a range of habitats that would otherwise be impossible in such an arid climate. These are especially valuable to many millions of migrating birds.**

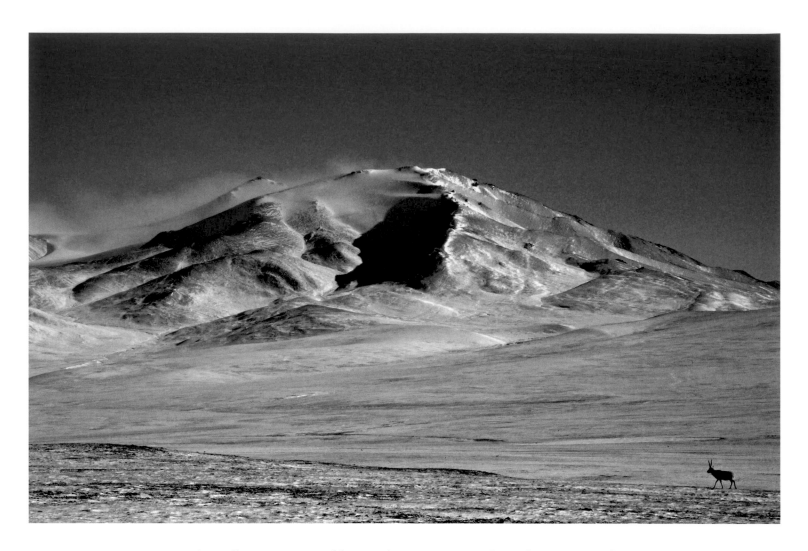

An equally important aspect of desert conditions is temperature. Deserts have a reputation for being hot and many desert locations regularly record temperatures approaching, or even exceeding, 50°C (122°F) during their hotter months. At these times the daily maximum temperature can rise to over 40°C (104°F) for weeks on end. Yet at night it can become surprisingly cool very quickly, and a large diurnal temperature range is characteristic of many deserts. In some locations in the Sahara, for example, the temperature can rise by as much as 25°C (45°F) between 5am and 3pm and fall equally quickly after sunset. In winter, frosts are quite commonplace in deserts and very low temperatures have been recorded in elevated deserts, such as the Gobi and the Great Basin Desert. Here the thermometer may drop to as low as -30°C (-22°F) which, combined with a high wind chill factor, makes for exceptionally harsh conditions. Generally speaking, humidity levels in deserts are low, except where affected by proximity to coastal areas.

In the popular imagination deserts famously look alike, endless swathes of featureless dunes studded by the occasional oasis of date palms. Whilst such desert scenery can indeed be found – a sizeable percentage of the world's deserts are indeed made up of dune systems – the real point about deserts is their sheer diversity. They contain an astonishing range of different types of scenery, from salt pans and gravel "seas" through scrub-studded plains and isolated thickets of vegetation fed by springs to exposed lava flows and rocky plateaux incised by surprisingly verdant canyons and gullies, finally reaching up to bare mountains as much as several thousand metres high. Deserts occur at all altitudes, from the Dead Sea, the world's lowest point at 422 metres (1,385 feet) below sea level, and the virtually lifeless and brutal Danakil Desert in Ethiopia and Djibouti, where the Afar Depression sinks to 155 metres (509 feet) below sea level, to the rarefied atmosphere of the Tibetan Plateau, which has an average elevation of over 4,500 metres (14,764 feet).

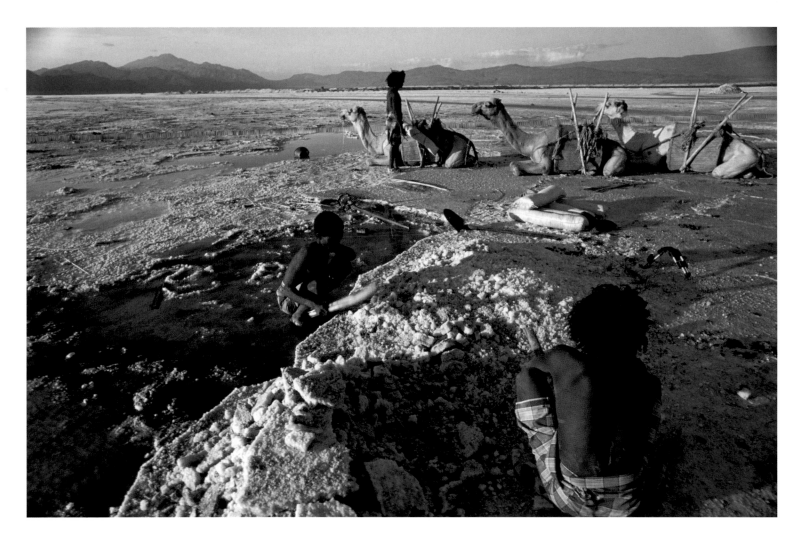

Eking out a living in the desert is never easy. These men are mining salt at Lake Assal in Djibouti, the second lowest point on the planet. This is an activity that has been taking place for hundreds if not thousands of years, and little has changed.

Continual processes of erosion and deposition have helped form and shape much of the desert scenery we see today and what all deserts have in common is a plethora of striking natural features, fashioned by the action of sun, wind and water. Nowhere is this more apparent than with regard to sand dunes, which are formed by the deposition of wind-blown material that has been eroded from rock by the effects of wind, rain and also chemical processes. This material accumulates in the depressions between mountain ranges, sometimes forming vast sand seas. Many of these were traditionally unstable, shifting, expanding and contracting as conditions varied. The largest of these systems, in Arabia's Rub al Khali for example, are now essentially static, but smaller complexes of dunes remain "on the move" in many parts of the world. Meanwhile, the dunes in the Namib Desert are the highest anywhere, reaching heights of 300 metres (980 feet) or more.

Such features are made all the more dramatic and obvious by the general lack of vegetation, although it is important to bear in mind that this was not always so with deserts. The extent of global climatic change has been such that all the world's deserts have, at some point in their history, been considerably more vegetated than they are today. In some cases the character of the plant cover amounted to lush rainforest; parts of the Sahara, for example, were covered by tracts of woodland as recently as 10,000 years ago, since when declining rainfall patterns have transformed the landscape out of all recognition.

Given all these factors, it is perhaps extraordinary that deserts sustain much life at all. Yet they are surprisingly rich biologically, and even in the most unlikely of circumstances a wide range of plants and creatures can be found. Even so, much desert wildlife is modest in size and in number. Generally speaking, there are few large mammals living in deserts as they are neither capable of storing the large amounts of water they require nor of withstanding intense heat. There are notable exceptions to this general rule – the camel being the most obvious – and the largest land mammal of all, the African Elephant *Loxidonta africana*, which can still be found on the fringes of the great Sahara in Mali. Otherwise, the largest true desert-dwelling mammals are species of wild ass *Equus* sp., antelopes such as oryx *Oryx* sp. and gazelles *Gazella* sp., and the carnivores that prey on them, notably Leopard *Panthera pardus* and Wolf *Canis lupus*. Sadly, however, all these mammals only survive in numbers greatly reduced from even a century ago. Many are locally extinct, hanging on only in protected areas or in captive breeding programmes, victims in the wild of unsustainable levels of human persecution and disturbance. The advent of motorized transport transformed human access to deserts – for the first time it was possible for people to reach areas in a matter of hours that had hitherto taken days to get to. This factor, coupled with the increasing ease of availability of modern firearms, placed much desert wildlife under a sustained onslaught from which it has never recovered.

However, most deserts remain rich in wildlife and any trip of reasonable duration into a desert environment will reveal a range of interesting flora and fauna. Conditions being what they are, almost all desert plants and creatures have evolved specific adaptations that enable them to survive incredibly high temperatures and intense aridity. The leaves of desert plants are typically small (which reduces the surface area through which moisture can be evaporated) and waxy (which helps reduce the impact of the desiccating sun), nowhere more so than with cacti, where the leaves are reduced to spines. Meanwhile, root systems can be vast, enabling the plant to extract water from as wide an area as possible.

ABOVE **Desert wildlife needs to be able to withstand great extremes of temperature . This Sandfish** *Scincus scincu*s, **a type of lizard found in North Africa and the Middle East, is able to "swim" through the sand and bury itself in the cooler layers below.**

BELOW **Cacti such as this Cottontop Cactus** *Echinocactus polycephalus* **in Arizona are iconic desert plants, protected from grazing animals by a barrage of effective spines. They also have an impressive water-storage capacity within their fleshy trunks.**

Most desert wildlife does not need to drink regularly, deriving adequate moisture from its food, be that plant matter or other animals. Heightened senses make it possible for ungulates, for example, to detect the presence of grazing opportunities at several kilometres' range. Even so, most desert creatures are adapted to withstand long periods of drought and lack of food, and many have inbuilt water and fat storage systems designed to help them survive in lean times.

Meanwhile, the ability to deal with high temperatures is essential for warm-blooded creatures such as mammals and birds, which would otherwise overheat. Pale hide, skin or plumage coloration helps reflect the sun's heat and evaporative cooling through sweating and panting helps keep body temperatures at appropriate levels. One way of keeping cool is to increase the surface area of the body through which internally generated heat can be radiated out into the environment, an evolutionary trait that can be seen in physical features such as enlarged ears and extended necks and limbs. Even so, many desert animals are mainly active during the more benign conditions between sunset and sunrise.

For land-based wildlife the ability to move with ease across desert terrain, ranging from sand to gravel and rock, is equally essential. Larger mammals have wide hooves or paws to help obtain purchase on loose substrates. Some species of snake and lizard have evolved particular modes of locomotion to avoid contact with burning hot sand, while others will bury themselves underground for months on end, remaining dormant until conditions are right for them to emerge again. Life cycles, both for plants and animals, are often accelerated, so that the entire reproductive process – which can comprise courtship, mating, gestation, birth and rearing of young – is condensed into the brief interlude offered by cooler or wetter conditions.

Yet such miraculous aspects of the natural history of deserts can be hard to observe and study in any detail. The hostile environment means that much of the wildlife is shy, unobtrusive and, in some cases, inaccessible for much of the year. Its ecology therefore remains imperfectly understood, and the challenge for us now is to ensure that we establish the true biodiversity levels of the world's arid lands before yet more become compromised and whole systems are lost forever. Far from being sterile wastelands, our deserts are full of life and deserve to be acknowledged and celebrated for their beauty and diversity.

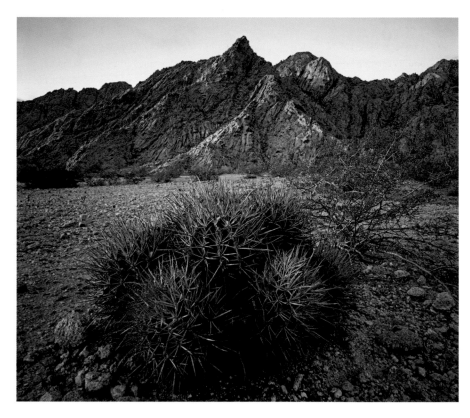

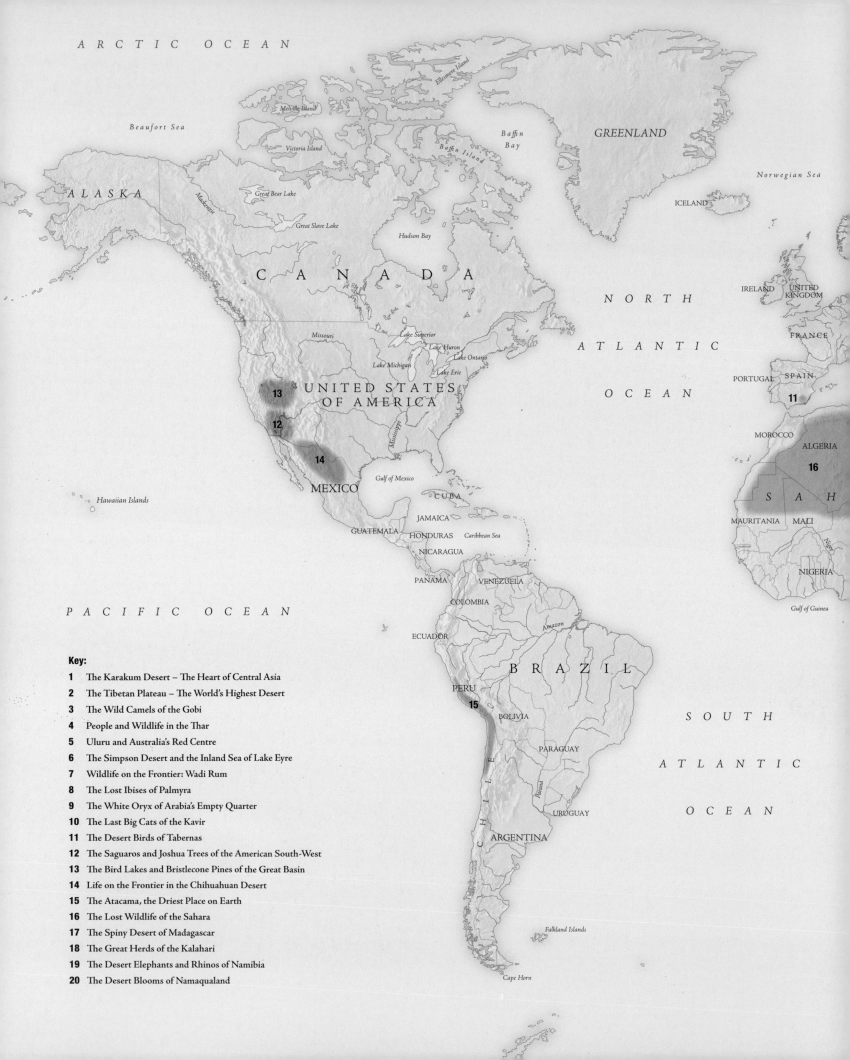

ARCTIC OCEAN

Beaufort Sea

ALASKA

Victoria Island

Melville Island

Great Bear Lake

Great Slave Lake

Mackenzie

C A N A D A

Baffin Island

Ellesmere Island

Baffin Bay

GREENLAND

Norwegian Sea

ICELAND

Hudson Bay

Missouri

Lake Superior
Lake Huron
Lake Michigan
Lake Ontario
Lake Erie

UNITED STATES
OF AMERICA

13

12

14

MEXICO

Mississippi

Gulf of Mexico

CUBA

JAMAICA

GUATEMALA
HONDURAS
NICARAGUA

Caribbean Sea

N O R T H

A T L A N T I C

O C E A N

IRELAND UNITED
KINGDOM

FRANCE

PORTUGAL SPAIN

11

MOROCCO

ALGERIA

16

S A H

MAURITANIA MALI

NIGERIA

Gulf of Guinea

Hawaiian Islands

P A C I F I C O C E A N

PANAMA
COLOMBIA

VENEZUELA

ECUADOR

Amazon

B R A Z I L

PERU

15

BOLIVIA

PARAGUAY

Paraná

URUGUAY

ARGENTINA

Falkland Islands

Cape Horn

S O U T H

A T L A N T I C

O C E A N

Key:

1 The Karakum Desert – The Heart of Central Asia

2 The Tibetan Plateau – The World's Highest Desert

3 The Wild Camels of the Gobi

4 People and Wildlife in the Thar

5 Uluru and Australia's Red Centre

6 The Simpson Desert and the Inland Sea of Lake Eyre

7 Wildlife on the Frontier: Wadi Rum

8 The Lost Ibises of Palmyra

9 The White Oryx of Arabia's Empty Quarter

10 The Last Big Cats of the Kavir

11 The Desert Birds of Tabernas

12 The Saguaros and Joshua Trees of the American South-West

13 The Bird Lakes and Bristlecone Pines of the Great Basin

14 Life on the Frontier in the Chihuahuan Desert

15 The Atacama, the Driest Place on Earth

16 The Lost Wildlife of the Sahara

17 The Spiny Desert of Madagascar

18 The Great Herds of the Kalahari

19 The Desert Elephants and Rhinos of Namibia

20 The Desert Blooms of Namaqualand

ARCTIC OCEAN

Svalbard

Franz Joseph Land

Severnaya Zemlya

New Siberia Islands

Barents Sea

Novaya Zemlya

East Siberian Sea

Wrangel Island

S I B E R I A

Ob

Yenisey

Lena

RUSSIAN FEDERATION

Bering Sea

Sea of
Okhotsk

Lake Baykal

Aleutian Islands

NORWAY
SWEDEN
FINLAND

Baltic
Sea

Volga

POLAND
RMANY

UKRAINE

KAZAKHSTAN

Aral Sea

Lake Balkhash

MONGOLIA

3

Sea of
Japan

JAPAN

ROMANIA

Black Sea

Caspian
Sea

Volga

1

C H I N A

ITALY
GREECE
TURKEY

TURKMENISTAN

IRAN

10

2

Tibet

Yellow
Sea

SYRIA
8
JORDAN
7
IRAQ

Mediterranean Sea

Yangtze

Indus

NEPAL
Ganges

PACIFIC OCEAN

RA

LIBYA

EGYPT

Red Sea

SAUDI
ARABIA

OMAN
9

4

INDIA

BURMA

Hainan

ER
CHAD

Nile

SUDAN

YEMEN

THAILAND

South
China
Sea

PHILIPPINES

ETHIOPIA

SOMALIA

SRI
LANKA

AMEROON

Congo

KENYA

MALAYSIA

Sumatra

Borneo

Sulawesi

New Guinea

Lake Victoria

ZAIRE

Lake Tanganyika

TANZANIA

Lake Nyasa

I N D O N E S I A

Java

Timor

PAPUA
NEW
GUINEA

ANGOLA

ZAMBIA

MOZAMBIQUE

I N D I A N O C E A N

19

MADAGASCAR

18
AMIBIA BOTSWANA

17

AUSTRALIA

5

6

20 SOUTH
AFRICA

Cape of Good Hope

NEW
ZEALAND

Tasmania

S O U T H E R N O C E A N

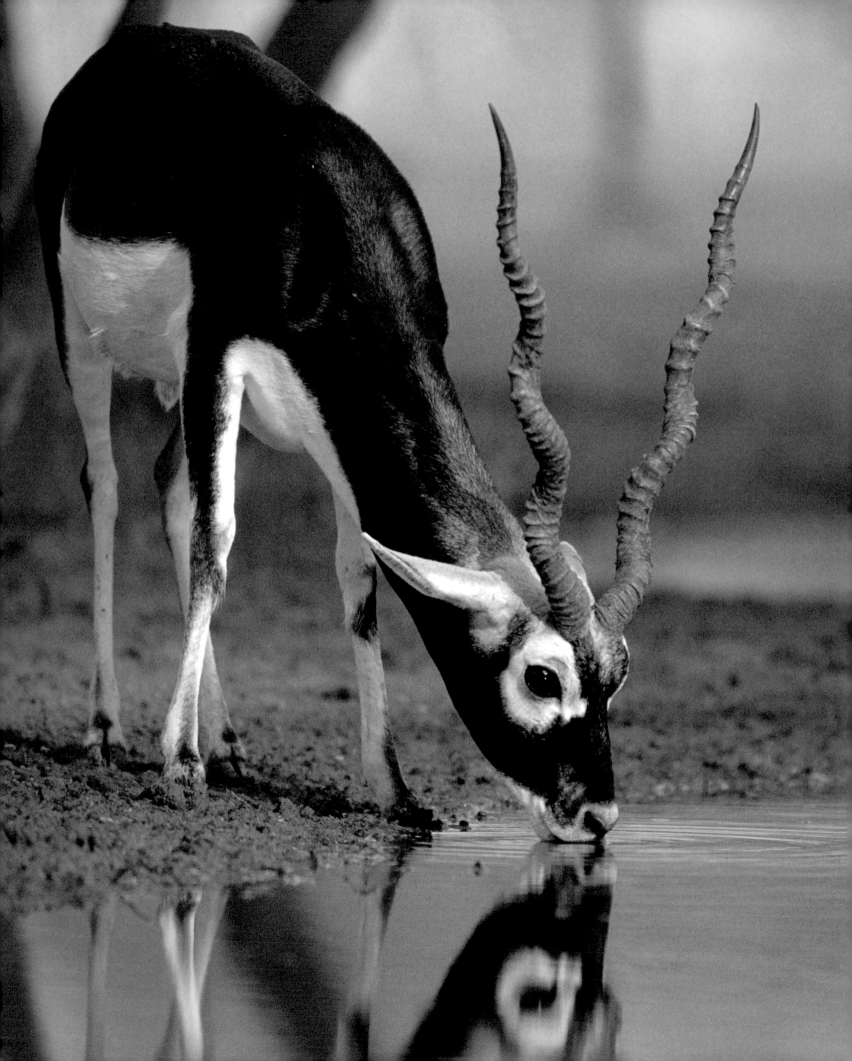

ASIA

From the scorching heat of the Thar in north-west India to the bitterly cold Tibetan Plateau and the Gobi in Mongolia, Asia's deserts cover every conceivable extreme of climate. Rolling sand dunes and gravel plains give way to high-altitude deserts that are beset by snow and ice for much of the year. Some of the world's most exciting wildlife inhabits these arid lands, from the almost mythical Snow Leopard of Tibet and the herds of wild horses and gazelles grazing the Turkmenistan steppe, to the Wild Bactrian Camels and elusive Brown Bears of the Gobi. While some species remain acutely threatened, others have been brought back from the brink of extinction and continue to roam across remote parts of some Asian deserts.

LEFT One of Asia's most stunning antelopes, the Blackbuck, lives on the arid grasslands that fringe the Thar Desert in India. Capable of withstanding long periods of drought, Blackbuck can derive adequate moisture from plant matter, but will always drink when the opportunity arises.

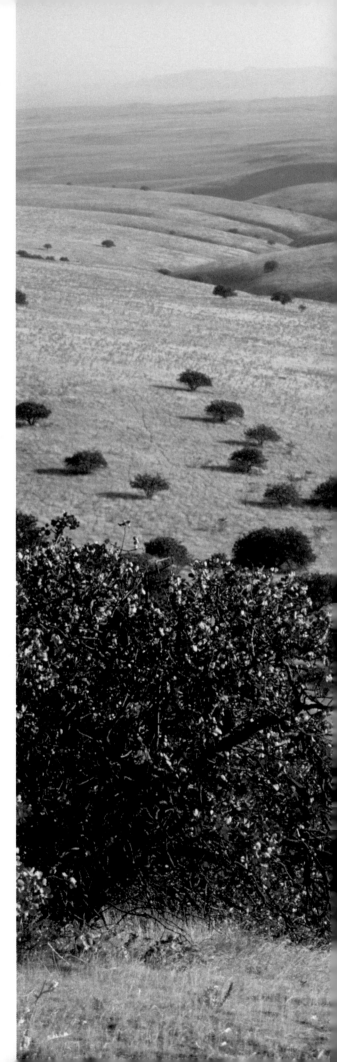

1: The Karakum Desert – The Heart of Central Asia

Central Asia is one of the world's most exciting regions from a wildlife perspective but also one of the least known by foreign naturalists. The great variety of different landscapes, spanning a spectrum from desert through to dense tracts of forest (both coniferous and broad-leaved), contains an extensive range of habitats supporting a rich diversity of wildlife. Not only is the overall species total impressive, but local rates of endemism can be high, reaching up to 20 per cent of those species present in certain locations. There are many mammals and birds of international conservation significance, as well as reptile, amphibian and invertebrate communities that are still being assessed and studied. Much remains to be discovered about this fascinating region.

Desert, sub-desert and steppe extend across much of this region, with one of the most important deserts in terms of wildlife being the Karakum. Covering roughly 80 per cent of Turkmenistan, a total of some 490,000 square kilometres (190,000 square miles), the Karakum lies east of the Caspian Sea and south of the Kyzylkum Desert, from which it is divided by the Amu-Darya river, historically known as the Oxus, which leads north into the Aral Sea (see below). *Kara-kum* means "Black Sand" in Turkoman, something of a misnomer for, although this is indeed a mostly sandy desert, the sand here is mostly red or pale brown. The Karakum is reasonably well vegetated by desert standards, with a typical cover of grasses and small shrubs, and is warmer and drier than those deserts to its north. Annual rainfall averages between 150 and 200 millimetres (6 and 8 inches), and temperatures vary from as low as -20°C (-4°F) in winter to summer highs in excess of 45°C (113°F).

The majority of the precipitation in the Karakum falls in winter and spring, and so most of the plants here are geared around this timescale. The ephemeral species are not capable of withstanding extreme drought and so have a rapid life cycle designed to take advantage of the relatively brief periods when there is adequate rainfall to promote growth. These plants are the first to appear after a period of rain; they are followed by perennials, most of which are grass species, and then by flowering shrubs. These two last groups generally have long root systems designed to reach moisture trapped in the sandy subsoil. As in most sandy deserts, rainwater percolates down through the sand until it reaches a metre (3 feet) or so below the surface. As sand exerts little capillary action, the moisture stabilizes at this depth, where loss from evaporation is minimized, and the subsoil therefore stays damp. It has been claimed that the protracted nature of this process is such that in certain locations plants growing today may be drawing moisture from rain that fell centuries ago – an extraordinary concept, if a difficult one to prove conclusively.

RIGHT The sweeping expanse of the Karakum Desert includes vast swathes of grassland studded with shrubs. These provide valuable shelter for passerine birds, a habitat for invertebrates and shade for mammals during the hotter months.

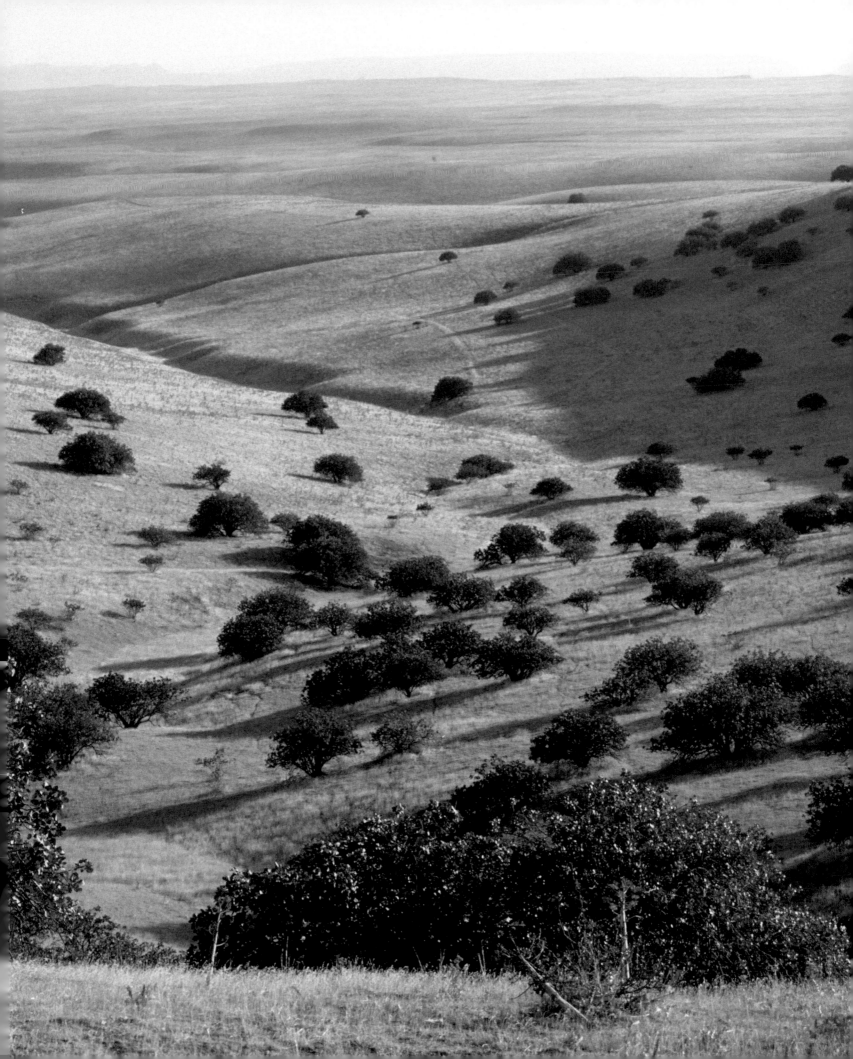

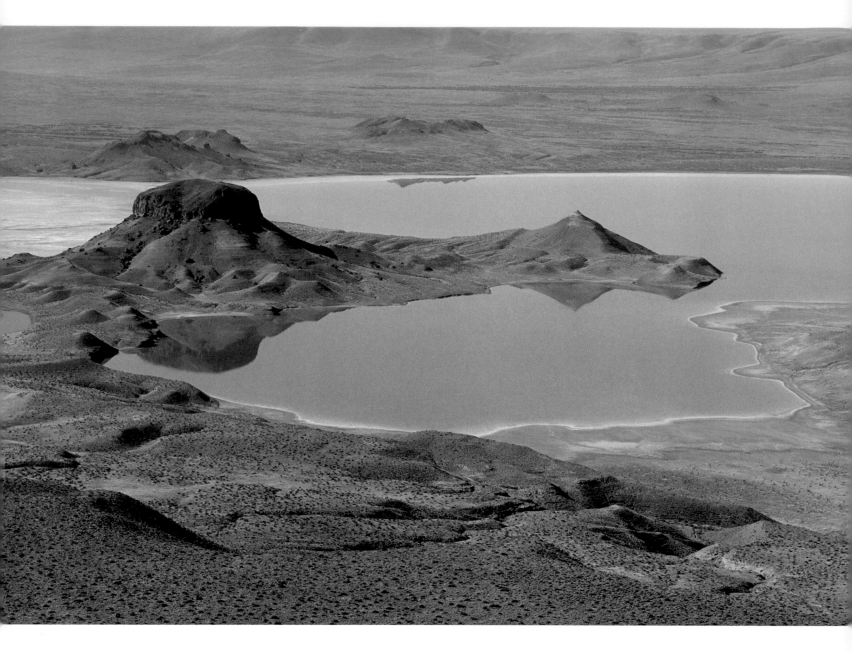

ABOVE The volcanic landscape of Badkhyz is a diverse patchwork of basalt outcrops, craters and saline depressions. The vegetation is diverse and the area supports a wide range of wildlife, with large numbers of grazing herbivores and an impressive array of birds.

Wildlife life here is plentiful and diverse. The Karakum is particularly important for reptiles, which include a wide variety of snakes as well as the engaging Horsfield's Tortoise *Testudo horsfieldi*. Emerging from hibernation in early spring, this species is widespread across much of the desert and lives on new shoots that sprout during the late winter season rains. It will avoid the heat of the day by burying itself in the sand, and may go back into hibernation as early as midsummer, once all the tender vegetation on which it depends has burnt off, by either digging its own burrow or adapting one made by a rodent. Other prominent reptiles in the Karakum include the Desert Monitor *Varanus griseus*, which can reach a length of up to 1.6 metres (63 inches) and is the largest lizard in this part of Asia. Feeding on a wide range of prey, including small mammals, invertebrates, birds and other reptiles, it can roam as far as 500 metres (547 yards) each day from its den and is capable of sprinting at up to 120 metres (394 feet) per minute to run down its food. Like most other desert reptiles, it lays its eggs in the sand, relying on the heat of the sun to bring about incubation. The young emerge in September, feeding up rapidly before going into hibernation later in the year.

RIGHT Eye-to-eye with a Desert Monitor, the largest lizard found in Central Asia's deserts. A formidable predator, this species is usually solitary by nature, but individuals can sometimes live in a loose association known as a "settlement".

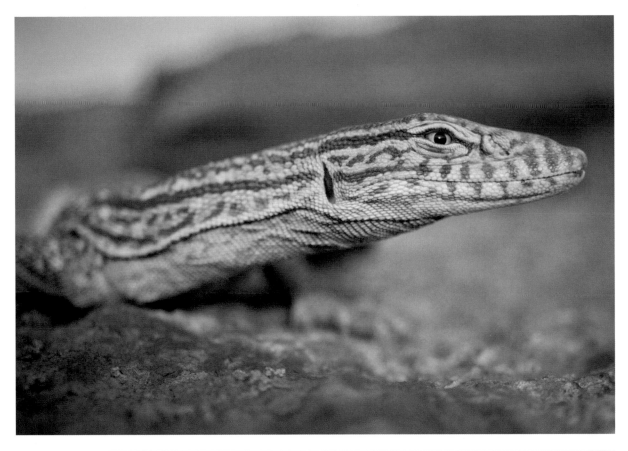

RIGHT The Horsfield's, or Russian, Tortoise is one of the most northerly distributed chelonians. It is capable of withstanding very low winter temperatures while it is in hibernation, when it digs burrows up to 2 metres (6 feet) deep for protection.

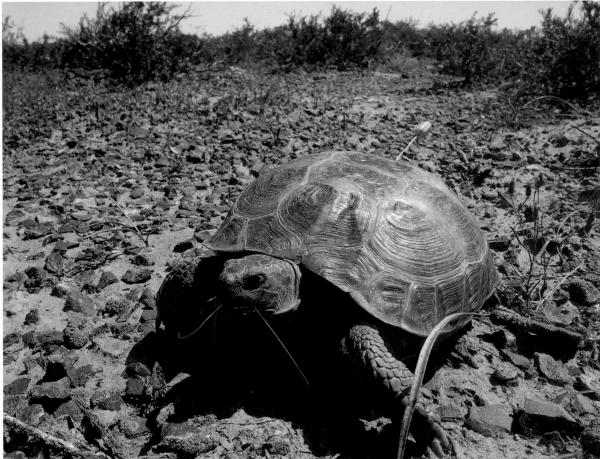

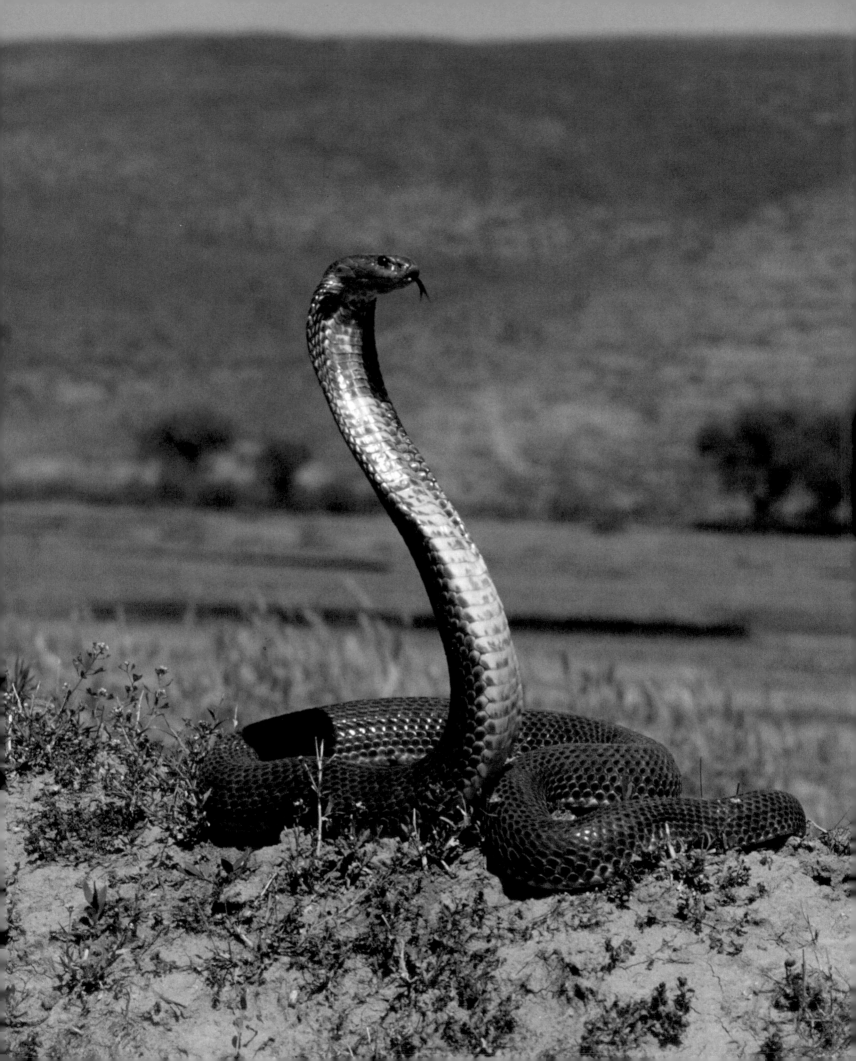

The most numerous group of mammals found in the Karakum are undoubtedly the rodents, particularly the jerboas. These diminutive but highly active creatures are widely distributed and very common, if not always easy to see, being mainly nocturnal. They are supremely adapted to desert life, with a range of features that enable them to cope with the harsh conditions. They are perhaps most remarkable for their speed and outstanding manoeuvrability – they can run as fast as 10 metres (11 yards) per second, twisting and turning rapidly in order to escape potential predators, and are capable of leaping 3 metres (3 yards) or more. These impressive running and jumping skills are made possible by their long hind legs, with their shorter forelegs used to dig networks of underground burrows. Jerboas also have excellent hearing and sight, their bulbous eyes affording them an almost 360° view.

One of the most wildlife-rich areas in Central Asia is the elevated plateau in the Badkhyz and Karabil regions in the far south-east of Turkmenistan, adjacent to the Karakum. With annual rainfall of between 250 and 290 millimetres (10 and 11½ inches), this is semi-desert, supporting an arid savannah-type ecosystem characterized by extensive stands of Wild Pistachio *Pistacia vera* alongside almost 1,200 other species of plant. This area once boasted an outstanding array of carnivores, ranging from Caspian Tiger *Panthera tigris virgata* (extinct locally since the nineteenth century and globally since the 1960s) through Leopard *Panthera pardus* (still present in small numbers) to Cheetah *Acinonyx jubatus* (last records here in the 1950s) and smaller cats such as Caracal *Caracal caracal* (still recorded, but rarely seen) and Wild Cat *Felis sylvestris* (common). Wolf *Canis lupus*, Striped Hyena *Hyaena hyaena*, Red Fox *Vulpes vulpes* and Asiatic Jackal *Canis aureus* are also present.

The reason for such a density of predators in the Badkhyz–Karabil was the presence of large numbers of prey animals, in turn attracted by the extent and diversity of good habitat. This ranged from dense riparian forest known as turai – the former haunt of the Tiger – to open short-grass steppe, where Cheetahs hunted the plentiful herds of Goitered Gazelle *Gazella subgutturosa*. Found across much of the Middle East (where the local subspecies is more usually known as the Sand Gazelle or Rheem), this species is a classic desert and semi-desert animal of the wider Karakum and other parts of Central Asia. However, it is vulnerable to disturbance and overhunting, and in many places has been locally exterminated or its numbers greatly reduced. The decline in its population was one of the main contributing factors behind the regional disappearance of the Cheetah, for which it was the chief prey species.

However, given adequate protection many of these animals are able to recover quite rapidly. Uncontrolled hunting of the Asiatic Onager or Kulan *Equus hemionus kulan* in the 1930s led

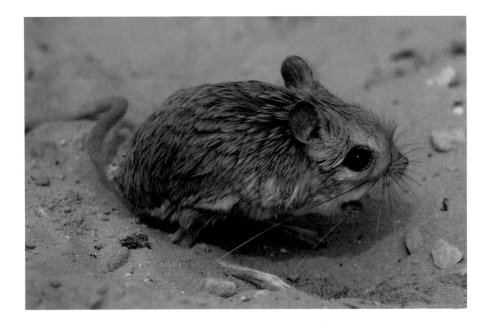

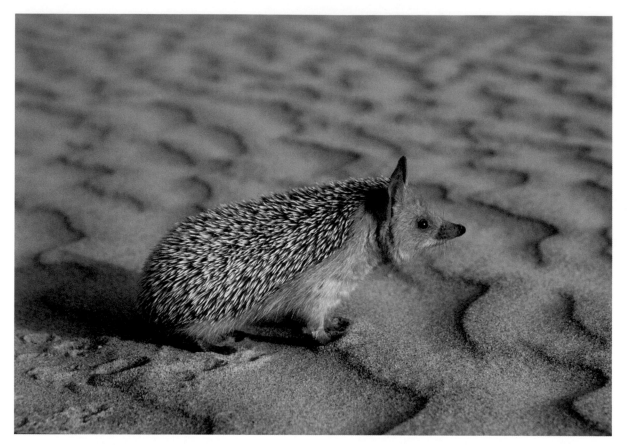

LEFT The Long-eared Hedgehog *Hemiechinus auritus* has a number of adaptations for desert life. It has slightly longer legs than its European cousin, so it can move easily across open sand, while large ears help it to radiate heat from its body.

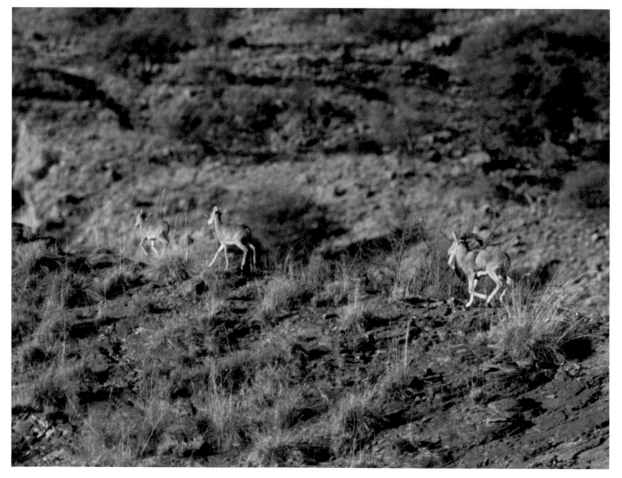

LEFT Hunted by humans for thousands of years, Urial are wary and usually flee at the first sign of disturbance. They are generally found on grassy slopes above the desert and steppe, and are highly adept at moving quickly over difficult terrain.

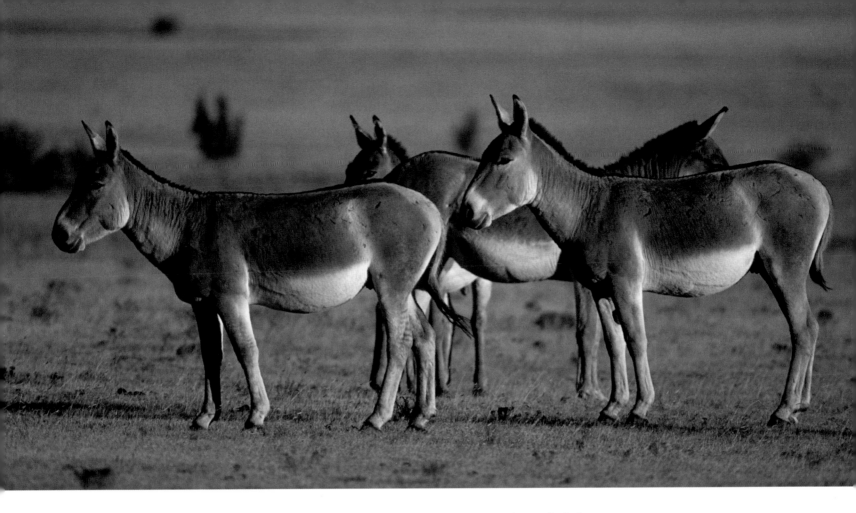

to the creation in 1941 of the Badkhyz reserve specifically to protect the rapidly declining population. Under strict protection the numbers of Kulan subsequently increased to reach several thousand during the mid-1990s, a population level which actually proved to be above the carrying capacity of the available habitat. As a result the Kulans began to move on to agricultural land, which prompted conflict with local farmers. Subsequent heavy poaching brought about another steep decline in their numbers, which dropped to as few as 300 in 2000, a lower figure than in the 1930s. There has been a partial recovery since then and today approximately 1,000 Kulan live in the reserve alongside several thousand Goitered Gazelle. Another notable ungulate also present on the reserve is the Urial or Wild Sheep *Ovis orientalis*. Much prized as a sport animal, this species has always endured heavy hunting pressure across its extensive range.

The uncontrolled hunting of wildlife is only one of the issues facing conservationists in the region. Environmental degradation is also a major concern, not least with regard to the Amu-Darya river, which has always played a major role in the region and provides a lifeline to an area otherwise characterized by desert. From its source in the Hindu Kush, the river flows north-westwards between the Karakum and Kyzylkum Deserts to the Aral Sea, once the fourth-largest lake in the world. However, during the 1950s and '60s a series of irrigation schemes, designed to help expand agriculture in the region, diverted the river flow to the extent that the volume of water carried by the Amu-Darya fell by as much as a half. Much of the reduction was a result of the construction of the 1,400-kilometre- (870-mile-) long Kara-Kum Canal, which carries water from the middle course of the river westwards along the northern foothills of the Kopet-Dag towards the Caspian Sea and has made possible the cultivation locally of an extensive cotton monoculture. However, construction defects in the canal have meant that half the water it carries seeps through its sides and bottom, distorting the local water table and causing serious salinization problems.

Meanwhile, the impact of the reduced river flow on the Aral Sea has been catastrophic. It has shrunk to 10 per cent of its former extent, dividing into three small lakes, in which salinity

ABOVE **Kulans are compact, powerful animals that are capable of running at speeds up to 70 kph (50 mph) with great endurance. They can be highly mobile, especially in summer when whole herds may need to travel vast distances in search of water.**

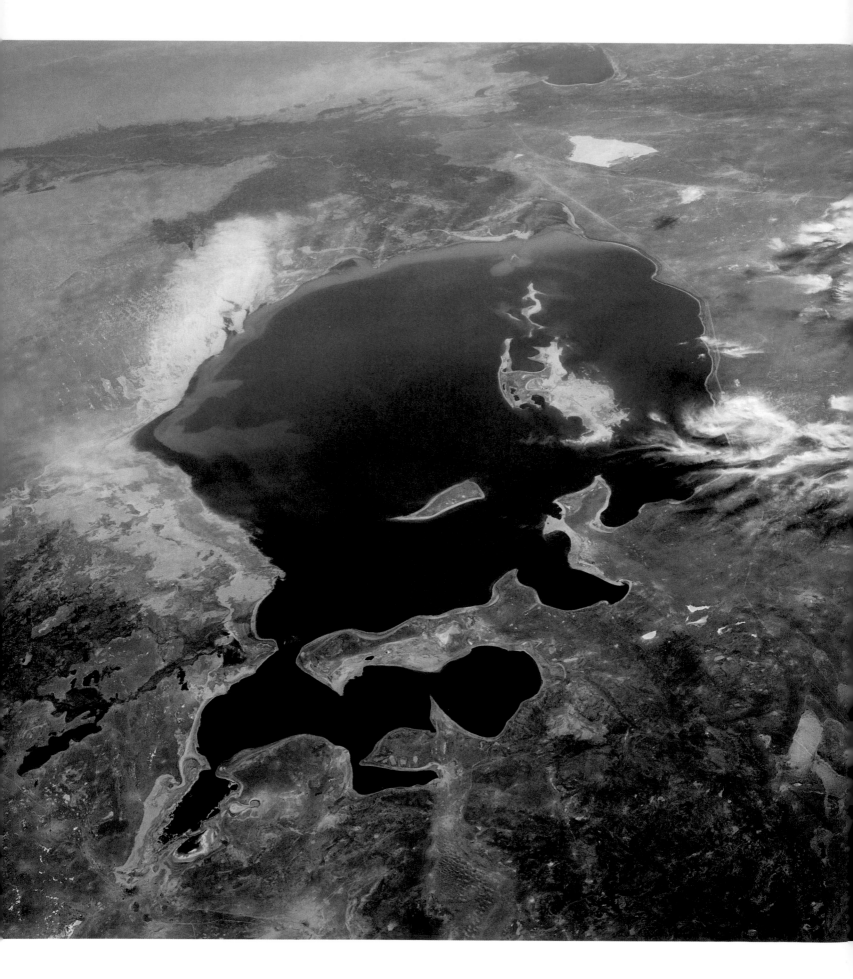

OPPOSITE This view of the Aral
Sea was taken by the space shuttle
Endeavour in 1985, when the Sea
was already shrinking as a result
of excessive drainage and the
diversion of the Amu-Darya river.
Today, only a fraction of the water
shown here remains.

levels have increased almost sixfold in recent years, killing off much of the wildlife the Aral
supported and prompting the total demise of its once prosperous fishing industry. If that were
not disastrous enough, the leaching of chemical waste previously dumped on the islands in the
middle has contaminated the local environment, an impact exacerbated by the uncontrolled
use of pesticides. These factors, together with the effect of salt-laden winds blowing out of the
desiccated lakebed, are having a negative impact on local agriculture. More worryingly, they are
also almost certainly responsible for some of the serious public health issues in the area, which
records abnormally high rates of infant mortality and congenital deformity.

The legacy of the Soviet era is not all bad, however. Under the USSR an impressive network
of protected areas was established across the region, a potentially fruitful legacy subsequently
inherited by the various "new" republics that emerged from the break-up of the Soviet Union
in the early 1990s. However, the financial structures that previously supported these areas have
largely collapsed since that time, with resulting reductions in the standards of administration,
field research and protection on the ground. At the same time the number and scale of the
threats facing wildlife in the region are growing; current problems include habitat loss,
degradation and disturbance, as well as improperly managed hunting tourism and high levels
of poaching for the illegal wildlife trade.

As a result, the populations and diversity of wildlife outside the protected areas are generally
declining, in some places acutely. This is particularly the case with animals of economic value,
such as Horsfield's Tortoise, many thousands of which are captured each year and exported for
the pet trade, mainly to Europe and the United States. Another species of particular concern
is the Houbara Bustard *Chlamydotis undulata*, which once bred widely across the region but is
reported to now be at the brink of extinction in many of its former haunts as a result of illegal
hunting, some of the latter being "sanctioned" by government officials.

However, the low human population density in many parts of the region does offer
opportunities for the extension of existing reserves and the creation of new ones, especially
since some of the countries in the region have indicated improved levels of commitment to the
funding of conservation initiatives. Some of these are directly linked to the development of
ecotourism and the creation of habitat corridors and buffer zones, all of which are potentially
significant developments.

BELOW The desiccated bed of
the Aral Sea is studded with
shipwrecks, poignant relics of
a fishing industry that once
sustained many local people.
One of the world's most shocking
ecological disasters, the demise of
the Aral Sea is a timely reminder
of man's ability to destroy.

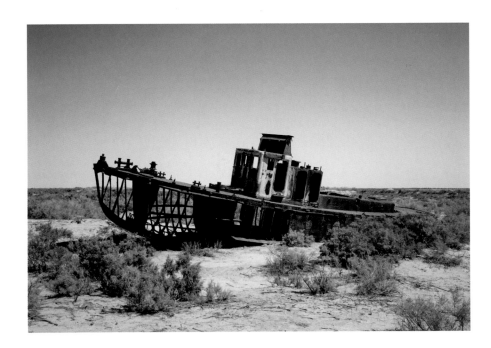

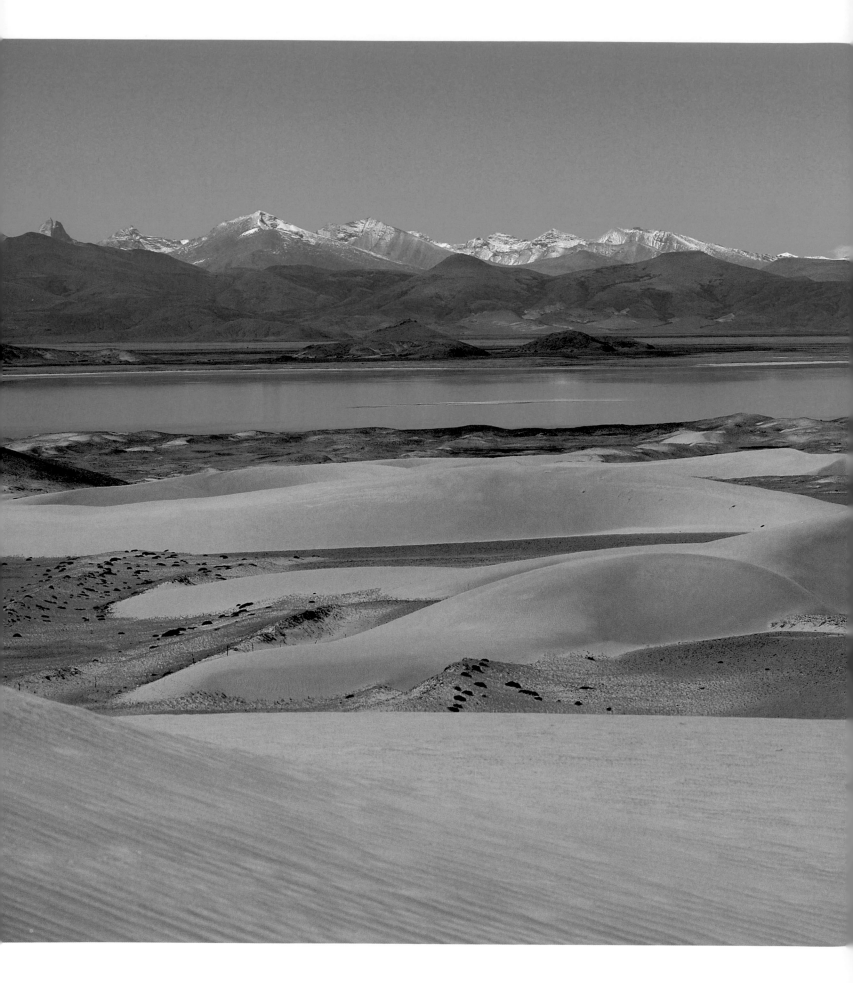

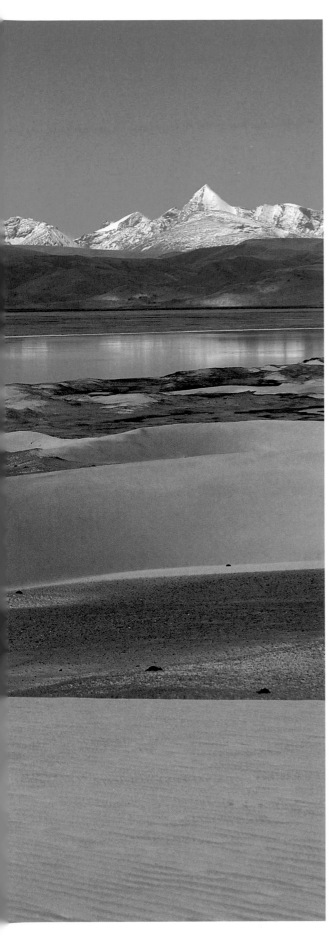

2: The Tibetan Plateau – the World's Highest Desert

Few places on earth are as inhospitable as the Tibetan Plateau. Covering some 2 million square kilometres (770,000 square miles), roughly the size of Western Europe, this vast and arid upland is one of the world's last great wildernesses. Surrounded by mountains, most significantly the Himalayas to the south and the Kunlun range to the north, the plateau is effectively a massive crust sitting on top of what was once molten rock, forced upwards by India as it collided into the rest of Asia millions of years ago, and has carried on forcing its way northwards ever since. The Himalayas continue to grow at a rate of 3 millimetres per annum, and the ongoing geological activity of the plateau itself is evidenced by the large number of boiling springs found there.

Some 85 per cent of the Tibetan Plateau lies above 3,000 metres (9,850 feet), with half of it higher than 4,500 metres (14,764 feet). It comprises several distinct topographical regions, their character determined by the various mountain chains and their associated drainage patterns. There are many lake basins in the plateau, of which the Qaidam Basin is the largest, at 650 kilometres (404 miles) long and 350 kilometres (217 miles) wide, but only the eastern and southern parts of the plateau have outlets to the sea. With the plateau lying in the rain shadow of the Himalayas, precipitation here is very low, rarely amounting to more than 50 centimetres (20 inches) per annum and almost invariably falling in winter as snow. However, this alpine desert plays a highly significant role in climate terms, and specifically with regard to rainfall elsewhere in Asia. As it heats up during the spring and summer, rather like a giant frying pan, its warmth draws moist winds from off the Indian Ocean. Although the rain they carry never reaches the plateau itself, as these winds head north they form the annual monsoon on which much of the Indian subcontinent depends.

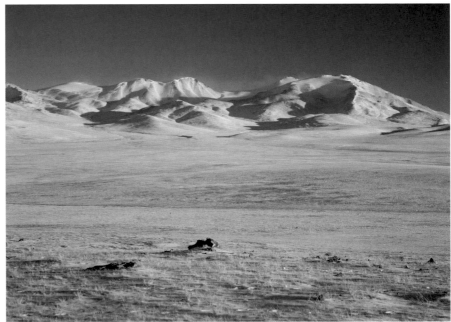

LEFT The epic scenery of Tibet spans a wide range of wildlife habitats, all equally specialized and demanding. This view of sand dunes and the Yarlung Tsangpo river looks beyond to the Himalaya range and the Annapurna massif, far right.

ABOVE Winter in Tibet is long and harsh. Many mammals and birds move to lower altitudes at this time, in search of shelter and food. The vast Chang Tang Nature Reserve is especially important for Wild Yak, Kiang and Chiru.

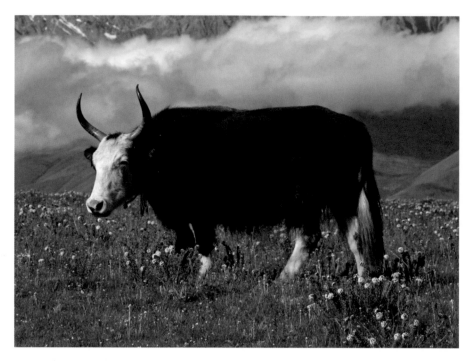

The plateau is characterized by almost constant high winds and persistently low temperatures. On winter nights the thermometer can fall below -30°C (-22°F), and although summer maxima in excess of 30°C (86°F) have been recorded, in no month does the average temperature exceed 10°C (50°F). Frost is an almost nightly occurrence for much of the year and there is extensive permafrost. Such extreme conditions mean that vegetation is generally sparse; the area is virtually treeless, for example, with only sheltered north-facing valleys supporting stands of spruce *Picea schrenkiana*, and relatively few plant species able to cope with the harsh environment of the open rocky slopes and gravel slews.

Conditions lower down are more congenial, if still tough. The steppes of the eastern part of the plateau, at around 4,200 metres (13,780 feet), support large populations of ungulates, which graze on the short grass of the open plains and are undoubtedly one of the great wildlife sights of Asia. Eleven species of ungulate occur on the plateau as a whole, including some of the last populations of Wild Yak *Bos grunniens*. Yaks have been domesticated for at least 2,500 years and are central to human life in much of Tibet, traditionally supplying the vast majority of the local population's immediate needs: milk, butter, cheese, yoghurt, meat, wool (for clothing and blankets), leather (for making boots, harnesses etc) and fuel (dried dung). They are also valuable as beasts of burden and are a common sight across the region. Wild Yaks, however, are a very different proposition. Very shy and extremely difficult to approach, they usually flee at the earliest indication of human presence, a response to many years of overhunting. Gone are the large Wild Yak herds of the nineteenth century; today only a few thousand animals survive in the remotest corners of the plateau, a particular stronghold being the Chang Tang Reserve, one of the largest single protected areas in the world.

ABOVE **Yaks are an integral part of the Tibetan scene. These domestic animals, which are sometimes crossbred with cattle, are smaller than their wild cousins and often have piebald coats. Both sexes have horns and can live for over 20 years.**

RIGHT **Wild Yaks live in remote parts of Tibet, and possibly also Kashmir, usually moving around in small herds. They feed on grasses, herbs and lichens and eat ice and snow for water. Only a few thousand Wild Yaks are now believed to survive globally.**

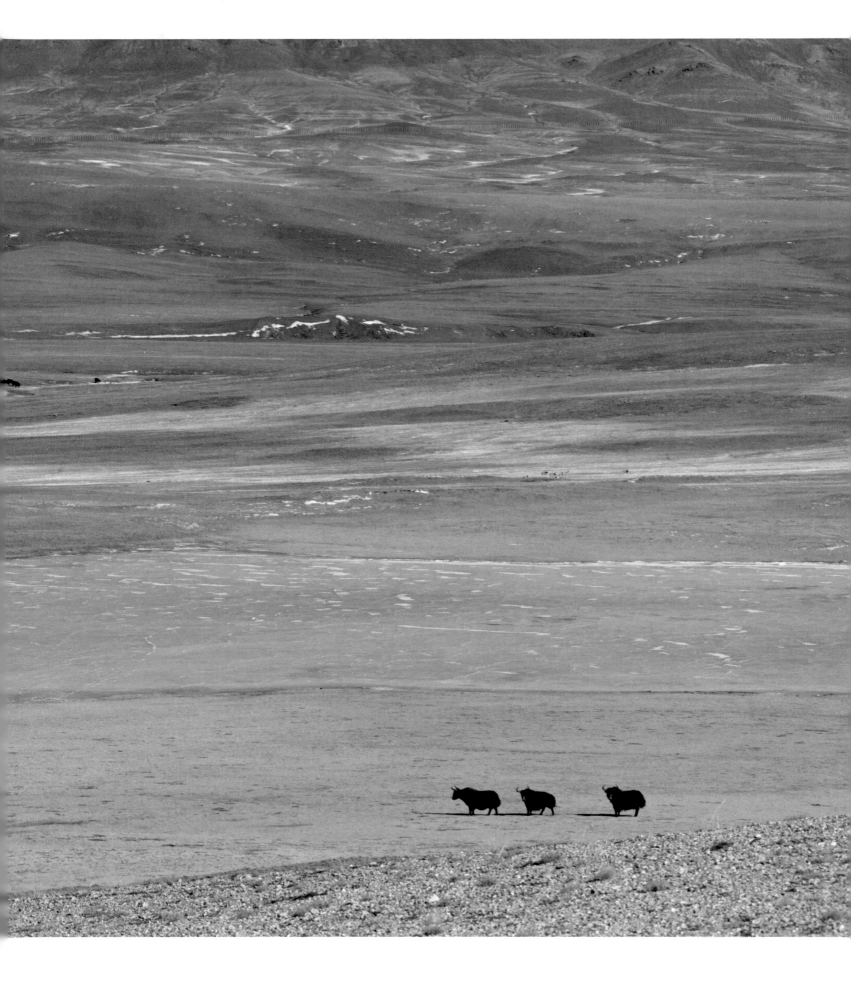

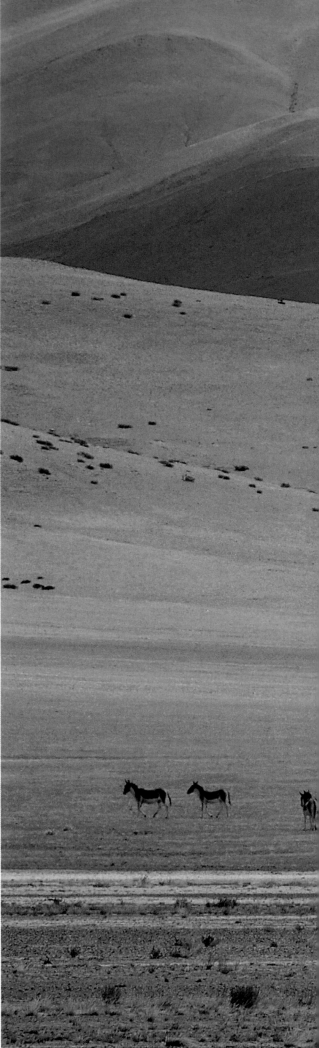

Also present in Chang Tang is the Tibetan Wild Ass or Kiang *Equus kiang*. In a region where much wildlife now turns tail and runs off at the first sign of human activity, the Kiang can be engagingly curious, often trotting or galloping for a few metres and then stopping to turn round and check what is going on. Although the largest of the wild equines, they are compact animals, standing 140 centimetres (55 inches) or so tall at the shoulder and with a characteristic and contrasting brown and white pelage. This is darker and thicker in winter, shedding in spring to give a warm cinnamon-toned coat in summer. Kiangs range widely in search of food and can be found across much of the plateau, including in the Qaidam Basin, one of the most arid sectors of all. Their overall numbers remain healthy and they have even increased in some areas in recent years, a development that has brought them into conflict with livestock herders over grazing land.

Early travellers to the Tibetan Plateau reported the existence there of unicorns, doubtless based on sightings of the endemic Chiru or Tibetan Antelope *Pantholops hodgsonii*, more than a million of which once inhabited the region. Male Chirus sport an impressive pair of horns, which can grow up to 70 centimetres (28 inches) in length and come into their own during the annual rut, which takes place in winter against a dramatic snowy backdrop. Males compete vigorously to retain or establish control over harems of up to 20 females. The sparring can be brutal and bloody, often resulting in the injury of one or both protagonists, and even occasionally in their death.

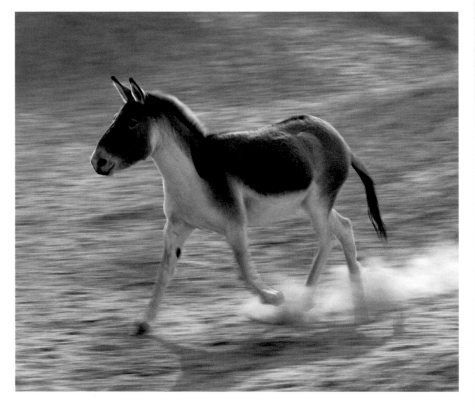

ABOVE The short, upright mane of the Kiang is typical of wild equids, as is the dark dorsal stripe. The reddish-brown coat contrasts with white underparts that extend up the neck. A thicker coat develops in autumn as protection against the winter.

RIGHT Kiangs live in close herds and generally move around together – often in single file and led by a mature mare. Bachelor herds often form in winter, but adult males are usually solitary and approach females in the late summer to form a mating harem.

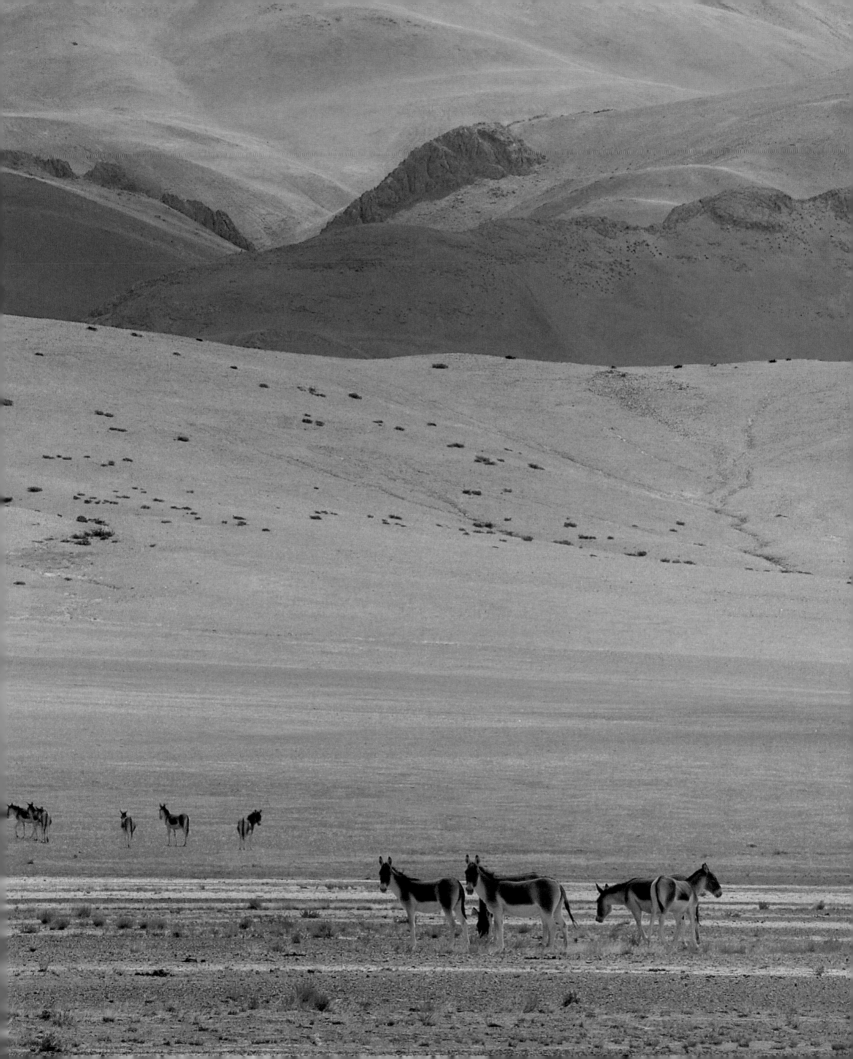

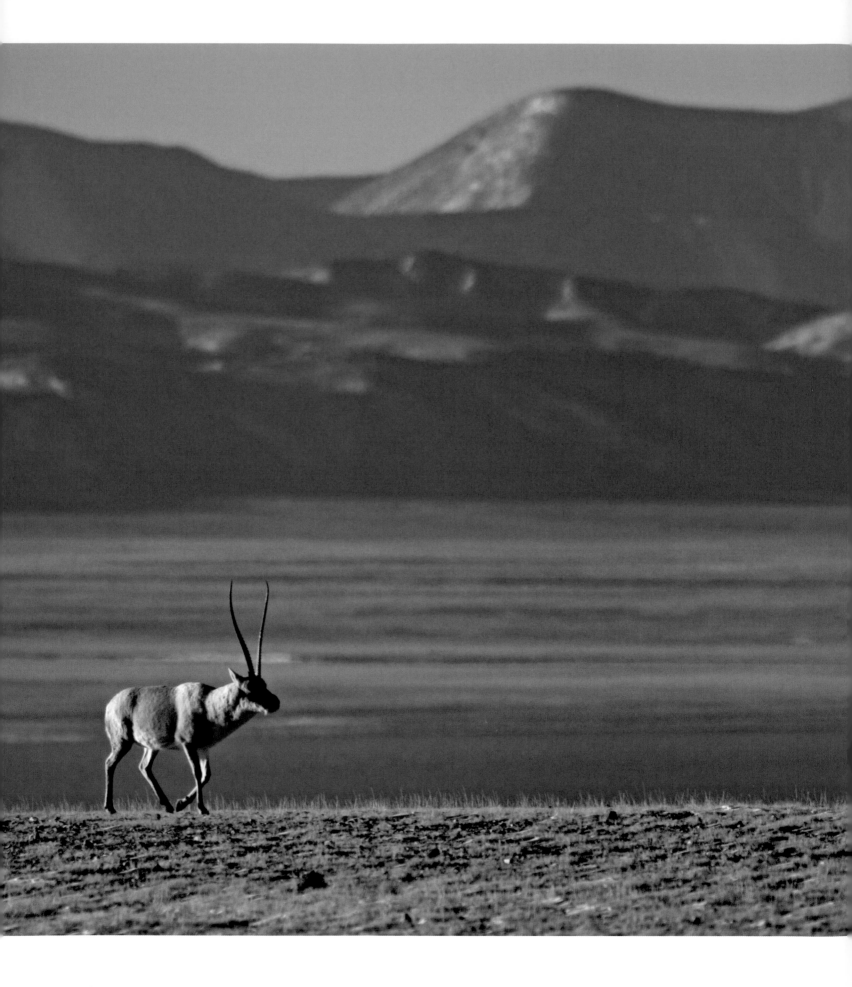

Chirus move extensively and conspicuously across the plateau in search of grazing and several distinct populations have been identified. Certain general rules apply to their behaviour, specifically the seasonal segregation of the sexes. The adult males migrate after the rut, only meeting up with the females again the following autumn. Meanwhile, in spring the females move north in large herds towards their calving grounds, the precise location of which remained obscure and little understood for many decades. Indeed, much remains to be discovered about the ecology and movements of the Chiru, but it is now established that the annual migration of the females takes them on a round trip of some 300 kilometres (186 miles).

During the late-twentieth century Chiru numbers were seriously affected by overhunting, caused by demand for their luxuriant undercoat. This yields what is arguably the warmest wool in the world, which was smuggled into India for weaving into highly prized (and very expensive) *shahtoosh* shawls. A single shawl requires the slaughter of up to five Chirus, however. In the years before the banning of this trade in 1975 as many as 20,000 Chirus were being shot annually. Conservation efforts since then, including the formation of the Wild Yak Brigade, an organization of volunteers working to protect indigenous wildlife in the area, have helped stem the rate of decline, but poaching continues to be a serious problem in such a vast and largely unpoliced area. Today it is likely that fewer than 75,000 Chirus survive and the number continues to fall.

The Chiru's chief natural predator is the Wolf *Canis lupis*. Wolves are widely distributed across the Tibetan Plateau, and prey on ungulates such as Chiru, Tibetan Argali *Ovis ammon* and Bharal or Blue Sheep *Pseudois nayaur* when they get the chance. Always opportunistic, the plateau's Wolves will also take Kiang when a sick or young animal presents itself, but more often than not they subsist on a diet of Marmot *Marmota himalayana* and even Black-lipped Pika *Ochotona curzoniae*.

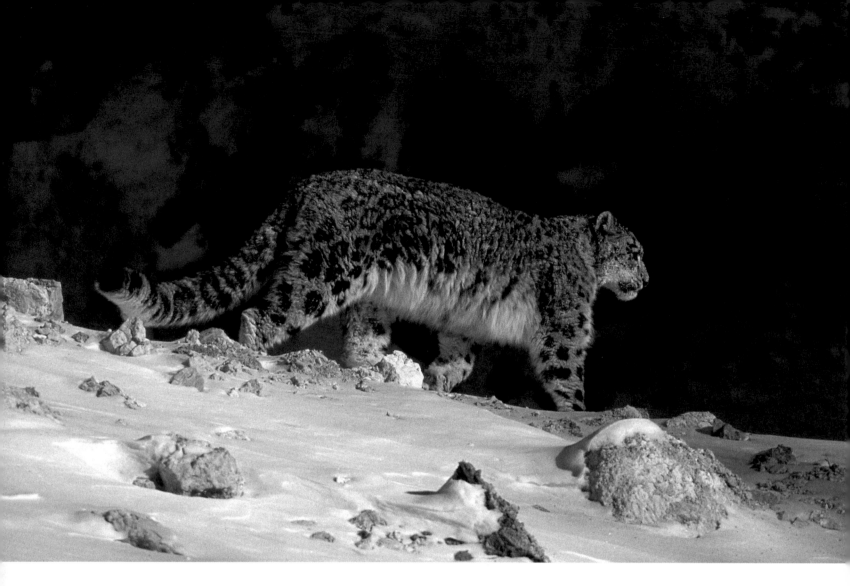

The Pika is the most numerous creature on the plateau, with an estimated population of some 1.5 billion, and it plays a central role in the local ecosystem. Its excavation of underground burrows aerates the soil and by breaking up the substrate creates essential opportunities for vegetation to take root, including the grasses that sustain the herds of wild ungulates and domestic livestock. Without the Pikas, there would be less vegetation and fewer grazing animals. They are also an important prey item for one of the plateau's other top predators, the elusive Tibetan Brown Bear *Ursus arctos pruinosus*. Early naturalists regularly encountered bears down on the steppe, but today they appear largely restricted to the more remote mountainous parts.

The Snow Leopard *Oncia oncia*, arguably the Tibetan Plateau's most glamorous animal, is also one of the world's most elusive. Although in recent years scientists and television film teams have successfully filmed Snow Leopards in the wild, it remains an enigmatic and little-understood species. This is largely due to its preference for inaccessible rugged habitat, particularly steep slopes with rocky outcrops, and whilst animals will occur in areas of open, flat terrain, this is usually only when crossing from one upland area to another. Snow Leopard density varies considerably throughout the plateau, but is generally low. In some favoured locations, however, the species appears not uncommon – at least, evidence of its presence in the form of tracks and scat can be surprisingly regular. The Snow Leopard's chief natural prey is the Bharal and so it is most usefully looked for in areas where there are good numbers of that animal. The most numerous wild ungulate on the Tibetan Plateau, the Bharal is also the most flexible in terms of habitat, ranging from the spartan arid steppes at lower elevations up to exposed mountain slopes at 5,000 metres (16,404 feet) and beyond.

ABOVE The iconic Snow Leopard is widely, but thinly, distributed across Tibet and is always difficult to spot. Supremely adapted to life in the snow and ice, it has a dense coat, a thick tail that it wraps around itself when at rest, and fur on the base of its paws that helps with traction on slippery surfaces.

Sadly, Snow Leopards are also partial to taking domestic livestock, which brings them into regular conflict with local herders. Although the leopards are officially protected, livestock owners often feel they have little option but to kill those that take their animals. Conservation initiatives are therefore being focused on ways of reducing the points of conflict, such as via the creation of predator-proof livestock corrals, a technique that has been used successfully in other parts of the Snow Leopard's range.

Birdlife on the high plateau is limited but includes some notable species. These include the Black-necked Crane *Grus nigricollis*, which nests in the marshes around the high-altitude plateau lakes. Some 70 per cent of the world's Black-necked Cranes breed here, wintering on farmland at lower – but still high – altitudes. The cranes are regarded as sacred in Tibetan culture and therefore suffer little direct molestation by humans, but their numbers are falling in the face of habitat loss and degradation, pollution and predation by feral dogs.

One of the most remarkable bird species in the world also nests on the lakes of the Tibetan plateau. The Bar-headed Goose *Anser indicus* spends the winter in the lowlands of peninsular India before heading north in spring on a journey that takes it over the Himalayas at heights of more than 10,000 metres (32,808 feet), higher than Mount Everest. It makes the return journey in autumn. How these birds survive in an atmosphere with such low oxygen levels is quite extraordinary, but is made possible by several factors: a large wing area, which helps them fly at high altitude; the presence in their bodies of sacs enabling the recycling of inhaled air and the extraction of more oxygen from it; and by a special haemoglobin in their blood, which absorbs oxygen more efficiently than that of other bird species.

With a strong tailwind Bar-headed Geese can fly at speeds of 140 kilometres (87 miles) per hour and more, passing over the highest parts of the Himalayas and ignoring alternative routes to the east and west that would take them north at lower, presumably more comfortable, altitudes. Why they take the toughest option is unclear, but one theory offered by scientists is that the origins of the migration go back to a time when the Himalayas were still being formed and were therefore much lower, with the goose breeding grounds on the Tibetan Plateau less affected by the rain-shadow effect and therefore more lush and well-watered. The geese continued to seek out these attractive conditions despite the Himalaya range gradually growing in size and height, a process so slow that the birds were able to evolve and adapt in ways that enabled them to cope with the slowly increasing elevation of the mountains.

The stunning landscapes of the Tibetan Plateau remain an outstanding area for wildlife but one that is under increasing pressure. The arrival of motorized transport in the region during the mid-twentieth century led to a steep decline in the numbers of many of the larger animals, as hunters were able to reach areas that were hitherto little disturbed and could then chase down animals and shoot them from vehicles using firearms of ever-increasing efficiency. In recent decades illegal hunting has continued to reduce the populations of species such as the Chiru and Wild Yak, and most of the larger mammal species are subject to increasing levels of disturbance as human activity in the area grows. More people are moving onto the plateau and the number of domestic livestock is expanding rapidly, which is intensifying pressure on grazing pasture and on the wild ungulates that depend on it.

Infrastructural development is also causing problems for wildlife: 2006 saw the completion of a new railway line that cut right across one of the Chiru's historic migration routes. Although underpasses were constructed at strategic points to allow the Chiru to move through unhindered, the development of infrastructure like this will potentially open up the area further to illegal hunting and other forms of undesirable exploitation. The challenge for the Chinese authorities will be to manage the process of modernization that they are proposing for the region in ways that allow the plateau's unique wildlife to survive and prosper.

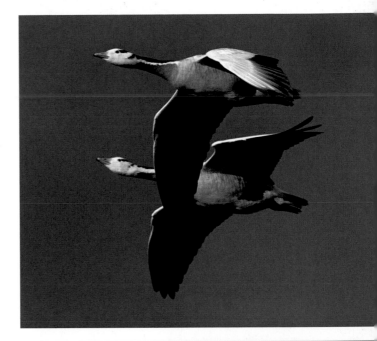

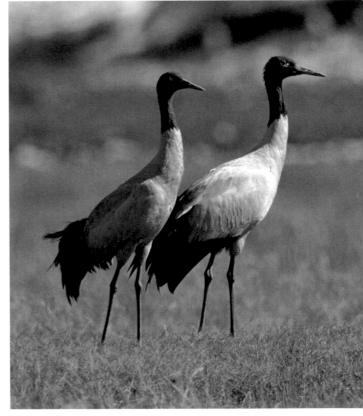

ABOVE TOP **Bar-headed Geese are remarkable migrants, undertaking one of the most demanding journeys in the animal world. Their round-trip flight between Tibet and their wintering grounds in India takes them high over the Himalaya range.**

ABOVE BOTTOM **Among the breeding birds that congregate around Tibet's upland lakes in spring and summer are Black-necked Cranes. Like all other cranes, they usually pair for life and strengthen their bond by dancing and bill-clapping.**

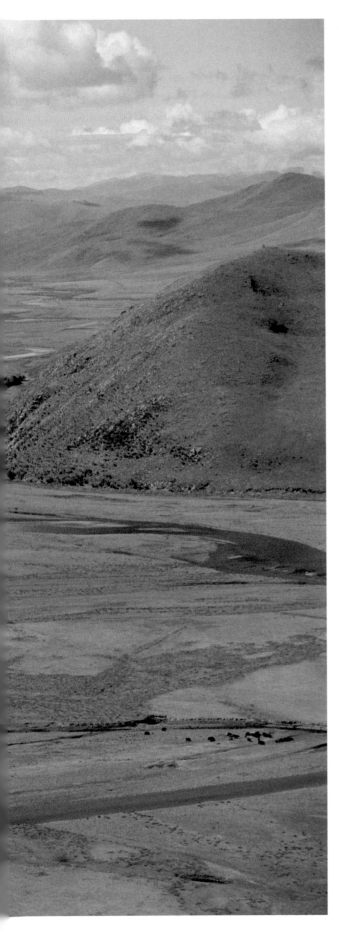

3: The Wild Camels of the Gobi

Asia's largest desert, the Gobi is one of the world's most extreme environments. With temperatures hitting 45°C (113°F) in summer and plunging to -40°C (-40°F) in midwinter, along with incessant strong winds and minimal rainfall, it is remarkable that it supports any life at all. Yet this bewilderingly vast expanse of sand, rock and gravel – it covers 1.3 million square kilometres (502,000 square miles) of southern Mongolia and northern China – supports a surprising diversity of wildlife, able to find a home in one of the planet's great wilderness areas. In particular, the Gobi is the last refuge of the wild Bactrian Camel *Camelus bactrianus*.

Much of the Gobi sits between 3,000–5,000 metres (9,850–16,400 feet) above sea level, and mostly on limestone. Once an inland sea, it is an extraordinarily rich area for palaeontology, with abundant dinosaur remains. These often lie near the surface and can be highly accessible, perhaps most famously at the Flaming Cliffs in the South Gobi, where the first-ever nest of fossilized dinosaur eggs was discovered. The whole region contains landscapes on an epic scale, defined by endless sweeping vistas and dramatic colours, ranging from the greys, browns and yellows of the rock and sand to the hazy green of springtime grasses and the purple sheen of wild desert onions in flower.

The Gobi environment is characterized by extreme aridity, with an average of less than 100 millimetres (4 inches) of precipitation each year. This median figure masks the fact that rain is not necessarily an annual event across the whole area; in some locations there may be several years of drought, during which many of the local springs dry up. They may not reappear for a long time after the next heavy rains, such is the time taken for underground reserves to be replenished. Given such a testing environment, vegetation needs to be resilient, a quality demonstrated by what is arguably the Gobi's most iconic plant, Saxaul *Haloxylon ammodendron*. Highly drought-resistant and tolerant of the saline conditions that prevail across much of the desert, this woody shrub reaches a height of about 4 metres (13 feet) and plays a central role in the desert ecosystem. It not only provides forage for animals but its roots help stabilize the sand and reduce levels of wind erosion and evaporation. However, Saxaul is not nearly as widespread in the more accessible parts of the desert as formerly, such is the level of overexploitation for firewood, and the disappearance of many of the more established stands is helping accelerate the process of desertification.

LEFT **While largely dry and barren, the Gobi Desert comes alive in spring if there is adequate rainfall. When the rivers flow they can sustain a variety of wildlife.**

ABOVE **Saxaul is a shrub found across much of Central Asia – in the Gobi it is almost the only tree species. In some favoured locations it forms dense stands.**

The most wildlife-rich part of the Mongolian Gobi Desert is known as the Great Gobi Strictly Protected Area (SPA), established in 1975 and consisting of two separate sections (known as A and B) that are approximately 350 kilometres (217 miles) apart and cover a total of 53,000 square kilometres (20,460 square miles). Very remote and largely free of human interference, Great Gobi A is home to the very rare and highly elusive wild Bactrian Camel. For many years the existence of genuinely wild Bactrian Camels was questioned by scientists, who believed that the camels living wild in the remoter parts of the Gobi were simply domesticated animals that had gone feral. Bactrian Camels were first domesticated some 4,500 years ago in Bactria, part of present-day Afghanistan, and were soon highly valued as long-distance pack animals capable of carrying heavy loads over difficult terrain and in all manner of weather conditions. They became the preferred beast of burden across much of Central Asia, and it was largely on the backs of camels that the goods forming the lifeblood of the famous Silk Road were carried.

Today it is scientifically established that wild Bactrian Camels are genetically distinct from their domesticated cousins. They are clearly different in physical appearance; the wild animals are smaller, leaner and noticeably more slender-legged. They have smaller, more pointed humps, and distinctly different seasonal coats. Their winter pelage is heavier and darker, while in spring they shed much of the outer wool and become more sandy-brown in colour. In overall demeanour and habits, Wild Bactrians are also less ponderous than domesticated camels; indeed, they are positively skittish and notoriously difficult to approach, their extreme wariness almost certainly due to their having been hunted extensively in the past.

Historically, wild camels were numerous across much of what is now south-west Mongolia and north-central China. Hunting and increasing levels of disturbance have caused their range to contract considerably in the last few decades, to the extent that there are now only two places in which the camels survive: the Great Gobi SPA, and the Lop Nur Nature Reserve in Xinjiang province in China. These vast sites support a combined total of some 1,000 or so animals, which live in scattered small herds, usually of up to eight to ten animals although sometimes comprising as many as 40 or 50, especially during the annual rut. The herds roam widely, following centuries-old pathways carved into the rock and sand by the passage of thousands of camel feet and which lead the animals between the very few sources of water in this unforgiving and barren landscape. Such water as there is often takes the form of brackish sludge, from which – amazingly – the camels are able to derive sustenance. In winter they will eat snow to get moisture. They can in any case go without drinking for many weeks, but when they do find a drinkable source after such time they can take in as much as 50 litres (13 gallons) in one session. No other large mammal is so well equipped to deal with the Gobi's harsh environment.

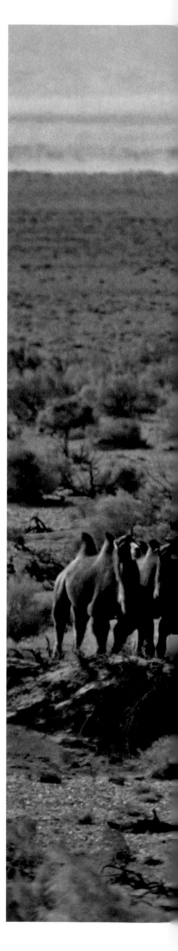

RIGHT Wild Bactrian Camels are highly endangered, extremely elusive and able to detect approaching humans at a range of a kilometre (²/₃ mile) or more. Driven by hunting and disturbance into the remotest corners of the Gobi, their numbers continue to decline.

LEFT Some of the world's foremost sites for dinosaur remains are in the Gobi, including the renowned fossil beds of the Nemegt Basin. Dinosaur eggs are regularly found here, along with intact skeletons and remarkable evidence of parent dinosaurs brooding their nests.

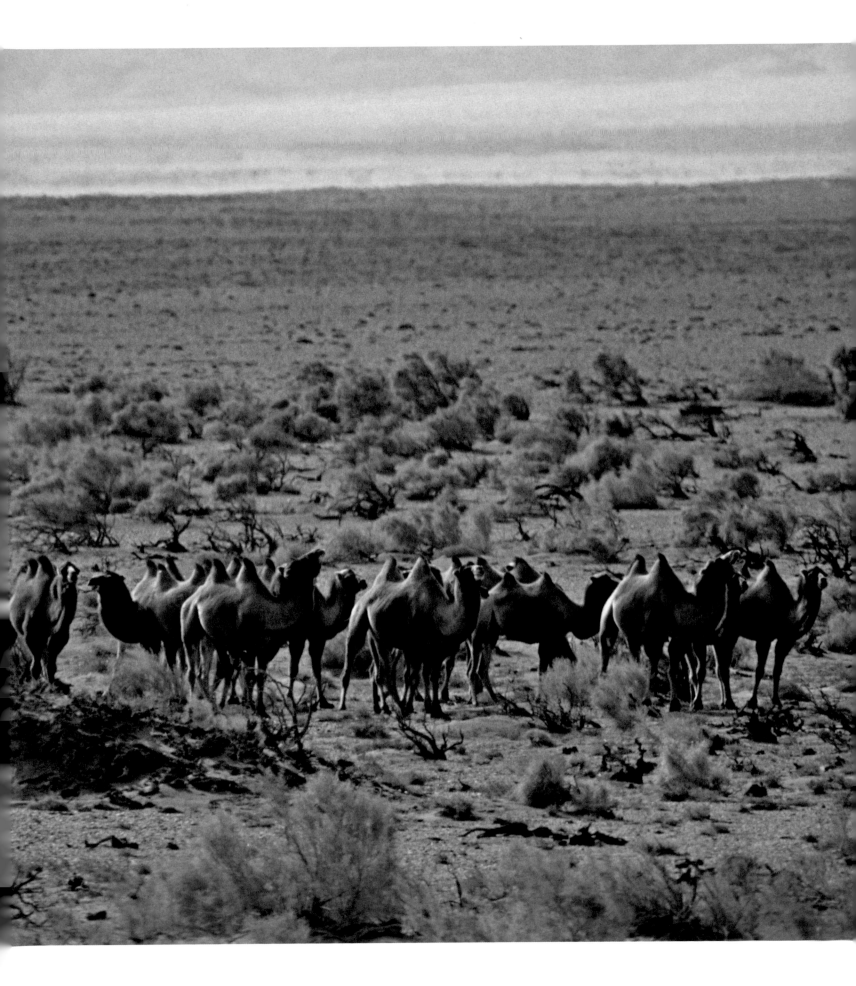

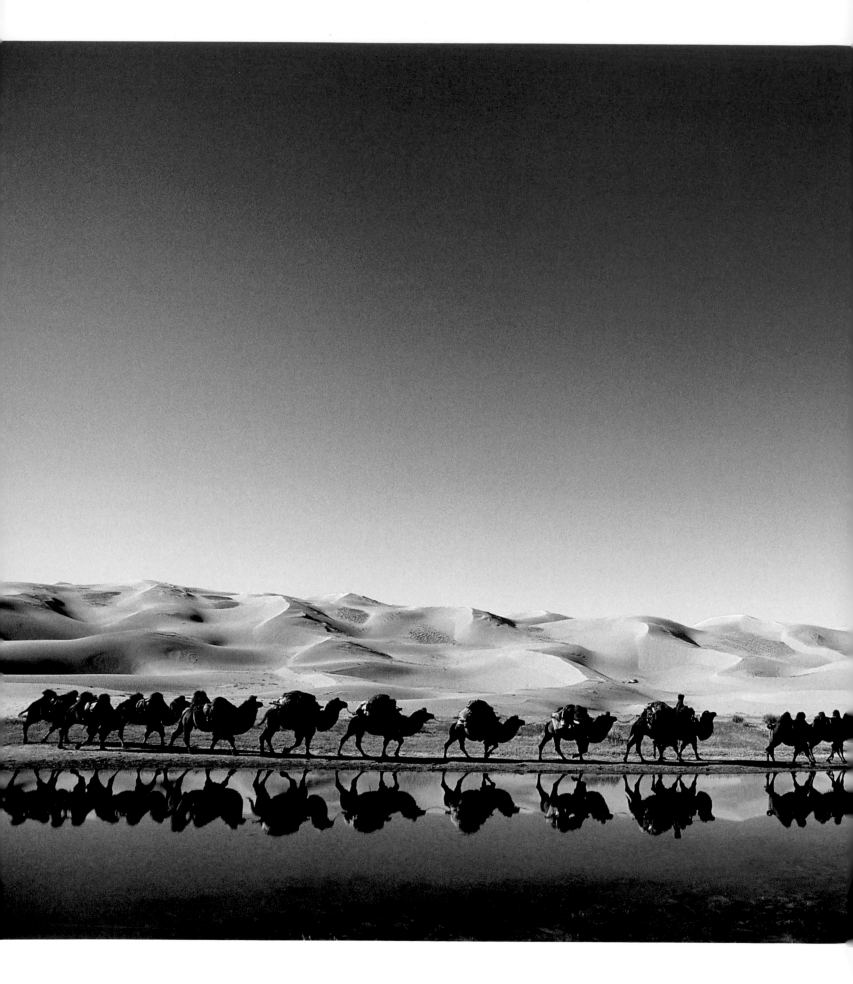

The availability of water and adequate grazing are the two chief determinants in where the camels go and how long they stay there. For much of the year they favour the more upland areas, as this is where the majority of springs are found, but they are notoriously elusive and even full-time researchers in the two main camel reserves can go for many days, even weeks, without seeing one. The most reliable time of year to find the camels is during the rut, which begins in November and reaches its peak in January and February. During this period the camels gather in larger groups than usual, as the male animals try to assert dominance over one another and establish mating rights over females. Competition is intense and, with a supercharge of hormones, male rivalry is expressed in various ways, ranging from teeth-grinding and nostril-flaring to tail-flapping and the streaming of urine over the tail and hindlegs. Males will enter into physical combat over females and injuries are not uncommon, with particularly enthusiastic individuals even becoming aggressive towards humans. Lone individuals may lose their natural caution and follow herds of domesticated camels to try and mate with females there, a situation which understandably brings them into conflict with herdsmen. Female camels usually leave the herd to give birth alone. One offspring is normal, but young camel mortality is high, with wolf predation a significant factor.

The wild camels live in the most unforgiving of environments, nowhere more so than at Lop Nur. This dry and dusty basin is relentlessly scoured by strong winds, which blow from the north-west for much of the year. These have eroded the soil and left freestanding columns and towers of layered sediment, called yardangs, extraordinary natural sculptures arranged in straight lines that mirror the prevailing direction of the wind. Lop Nur was once a vast permanent lake, fed by the River Tarim. However, during the twentieth century the lake became progressively smaller and it dried up completely in 1972.

The ecological deterioration of the area, and specifically the disappearance of Lop Nur as a permanent water body, was brought about by a combination of factors. Foremost was a reduction in the amount of water reaching the lake via the river system, as large-scale land reclamation, canal-building and irrigation further upstream reduced the amount of water reaching Lop Nur.

LEFT **Domesticated Bactrian Camels are the preferred beast of burden in the Gobi Desert, as they are able to carry large loads for great distances. Interbreeding between domestic and wild animals, however, is threatening the genetic integrity of wild camels.**

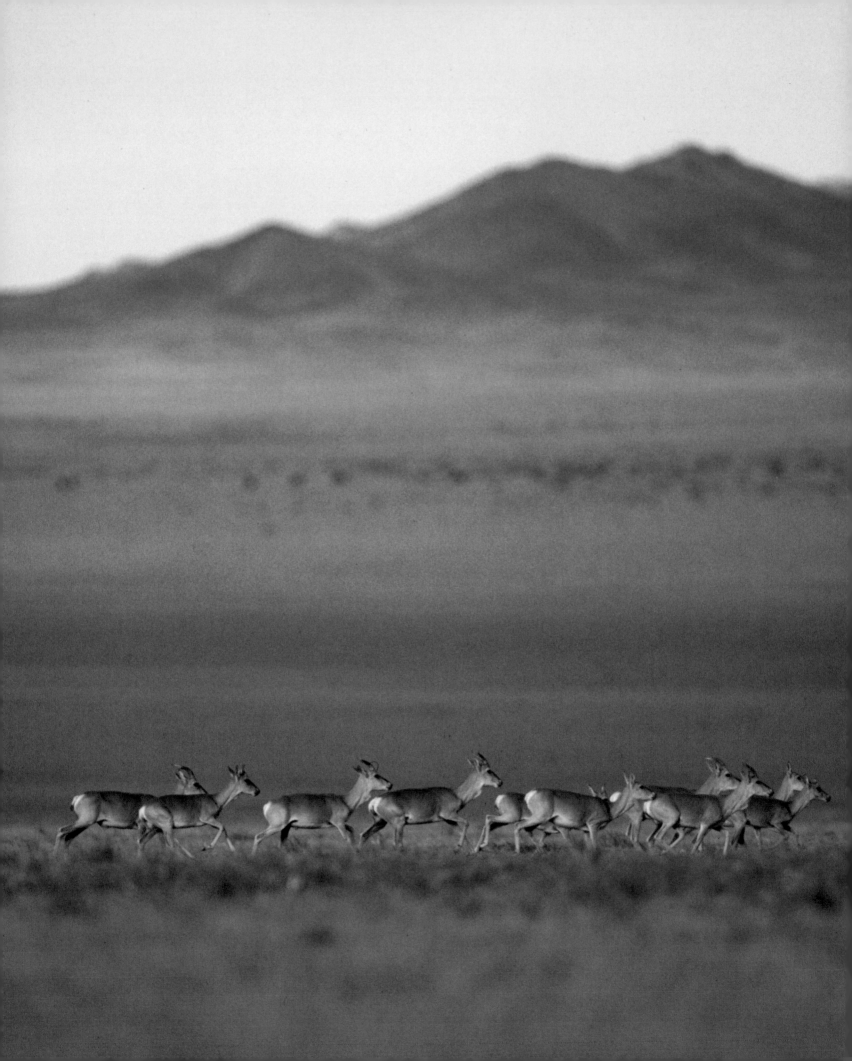

LEFT A small herd of Goitered Gazelles *Gazella subgutturosa* moving across the summer plains of the Gobi. Like all the region's ungulates, they are constantly on the move in search of fresh grazing and water.

Meanwhile, the surrounding desert was continually advancing, its shifting sands constantly changing the location and direction of the region's vulnerable watercourses. The process of desertification has been exacerbated by the cutting down of much of the riverine vegetation for firewood, including many of the stands of poplar that were once emblematic of the local landscape. Today, in a powerful reminder of the power of the desert and of the malevolent hand of man, the ex-lake bed features the petrified skeletons of former fishing-boats sticking out of the dusty clay and a plethora of exposed and bleached mollusc shells.

Between the 1950s and 1996 the Lop Nur area was used by the Chinese authorities as a test site for nuclear weapons. However cataclysmic this may have been, at least potentially, it may well have served to save the day for the local wildlife. The high security status of the testing site meant that it was well guarded and this doubtless helped protect the wild camels that lived in the area from poaching and disturbance. In 2001 Lop Nur was declared a nature reserve.

Wild camels are not the only wildlife attraction of the Gobi. Also found here, although hardly ever seen and teetering on the brink of extinction, is the Gobi Brown Bear *Ursus arctos gobiensis*. The only bear species to live in a truly desert environment, the Gobi Bear was not described to science until the 1940s, when the first confirmed sightings were made. Earlier reports of its existence had been largely dismissed, as it was thought bears could not survive in such arid conditions, and even today relatively little is known about its ecology and habits. Noticeably smaller than other races of Brown Bear, the Gobi Bear has a variable tan-coloured coat, sometimes showing a rufous hue, and often with a darker belly and legs. In appearance and behaviour it appears similar to the Tibetan Brown Bear (see page 38), but there is no evidence that the two populations ever meet or interbreed.

There may be as few as 45 Gobi Bears surviving today, almost all within the Great Gobi SPA. While largely safe there from human interference, the bears remain vulnerable to drought and the impact this has on their food supply. Supplementary food is provided by conservationists in spring to assist the bears as they emerge from their winter hibernation, and there have been relocation initiatives aimed at strengthening the otherwise increasingly limited gene pool of this critically endangered species.

RIGHT **The Gobi Bear is the rarest species of brown bear in the world, and one of the most difficult to find. Shy and largely solitary, the bears forage widely for food and are omnivorous, eating fruit, roots, lizards, invertebrates and carrion.**

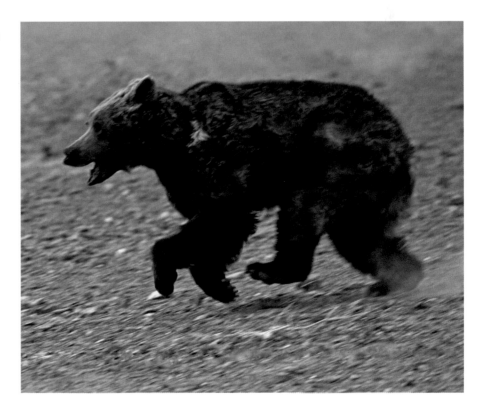

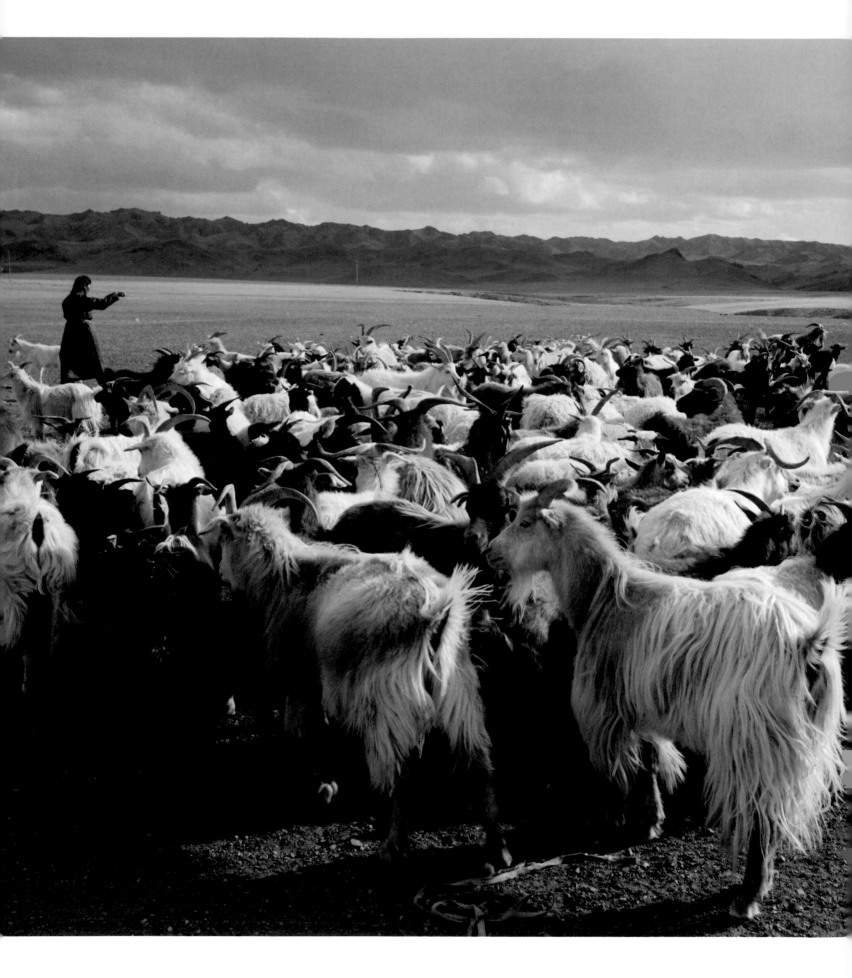

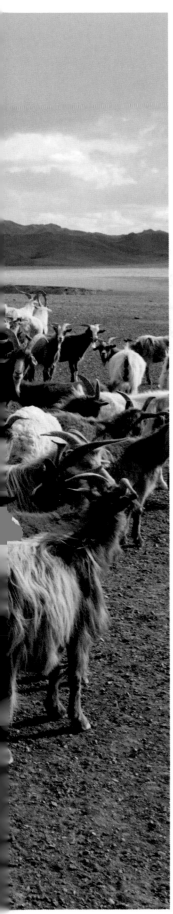

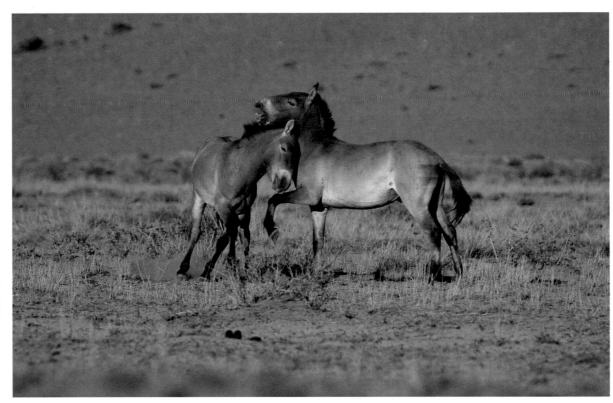

Other wildlife in the Gobi includes good numbers of Mongolian Wild Ass or Kulan *Equus hemionus luteus*. Several thousand range across the Great Gobi SPA, where they live in herds of up to a thousand. The Kulan is not the only species of wild equine known from the Gobi region; the other, Przewalski's Horse or Takhi *Equus przewalski*, is regarded by some authorities as the original "wild horse" and was once found across much of Mongolia. As a result of hunting and habitat disturbance (particularly competition with domestic livestock) the Takhi became extinct in the wild in the 1960s, but from a nucleus of animals held in zoos it was possible to reintroduce this flagship species to the wild in Mongolia in the early 1990s. Around two hundred animals now roam freely in two locations, Hustai National Park and Takhii Tal, which borders the Great Gobi SPA.

The value of the Gobi Desert for wildlife is now recognized on an international level – the Great Gobi SPA is one of the world's largest biosphere reserves, for example – and the network of protected areas that has been established in both the Chinese and Mongolian sectors offers a real lifeline to the wild Bactrian Camel and Gobi Brown Bear in particular. One of the main conservation priorities is to retain the wild camels' genetic purity and prevent their hybridization with domesticated camels – only one herd of wild animals is considered to have no contact at all with the latter. Poaching and the harassment of wildlife by, among others, illegal mineral prospectors, are continuing problems, as is the impact of a falling water table and increased human activity around the remaining reliable sources of water, which deprives wildlife of access. The authorities face an understandably tough job policing such a vast and remote area, and it is perhaps the camels' wariness of people and the sheer inhospitable nature of their favoured habitat that will prove to be the ultimate salvation of that species.

ABOVE First described in 1881 and named after a Polish explorer, the Przewalski's Horse, or Takhi, has now declined in numbers to the point of extinction in the wild. However, a captive breeding programme is supporting its reintroduction to the Gobi.

LEFT The presence of increasing numbers of domesticated livestock, such as goats, can cause problems for wild grazing animals such as gazelles. Competition over grazing inevitably arises and the gazelles are often driven on to more marginal land.

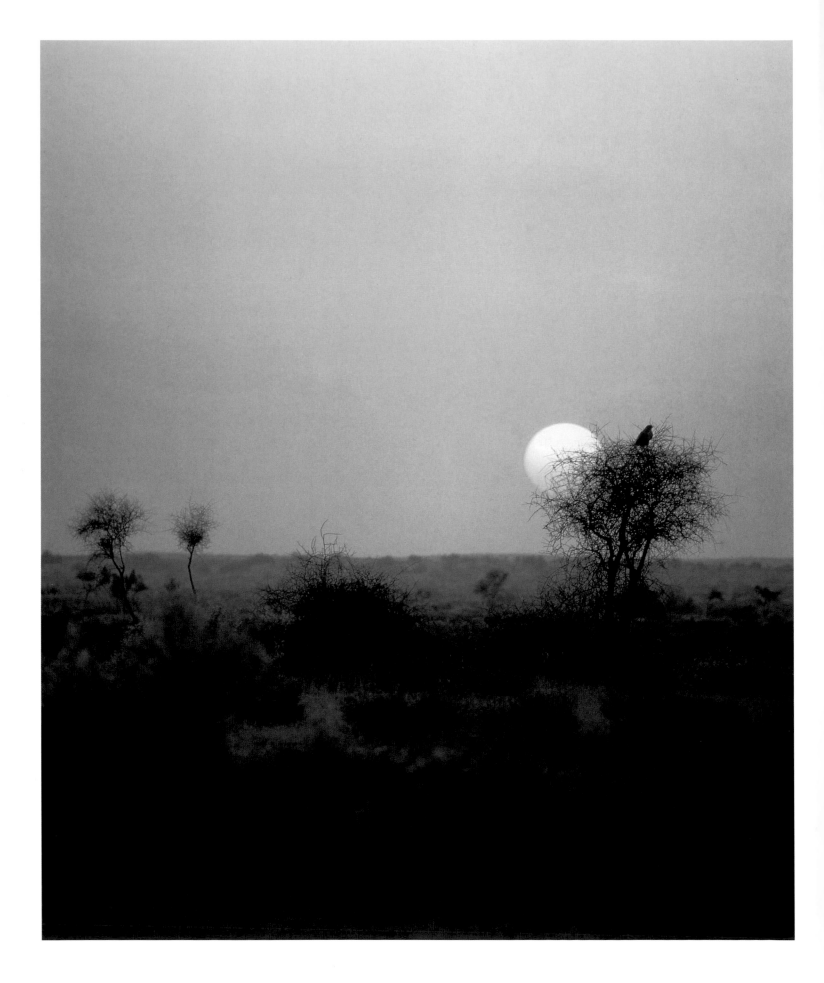

4: People and Wildlife in the Thar

Covering some 220,000 square kilometres (85,000 square miles), the Thar Desert extends from the Indus River in Pakistan eastwards as far as the Aravalli Hills in the Indian state of Rajasthan. It contains a vast range of different landscape types and habitats, with gravelly and sandy plains, rocky outcrops, gentle hills and areas of sand dunes, the latter reaching over 150 metres (490 feet) in height in some locations. There are also extensive areas of grassland and scrubby vegetation, especially in the central area of the desert around the Rajasthani town of Jaisalmer, one of the most popular points of access to the Indian sector of the Thar. Typical plants and shrubs here include Aak *Calotropis procera*, Khair *Capparis decidua*, Khejri *Prosopis cineraria* and Thor *Euphorbia caduca*, with grass species such as the flowering *Eragrostris plumosa* often conspicuous.

This is one of the world's least arid deserts, in the sense that some parts of it receive annual precipitation amounting to as much as 500 millimetres (20 inches). Most of this rain falls in July and August, during the annual monsoon, but such times of plenty are short-lived and conditions in the Thar are generally harsh. Temperatures can reach 50˚C (122˚F) in early summer and strong winds often prevail across the whole region, causing extensive sand blow and making life difficult for human and wildlife inhabitants alike. Nevertheless, this is a rich area for natural history and provides an opportunity to observe species that have become very scarce or extinct elsewhere in the Indian subcontinent.

The Thar is a major stronghold of the graceful Chinkara or Indian Gazelle *Gazella bennetti*, which can be seen easily across much of the desert, although its small and pointed hooves mean that it is less well adapted on areas of open sand than on the gravel plains. Chinkara are usually found in small groups, often of three animals, although occasionally up to 20 may be seen together. Both sexes have a pair of ringed horns, although the female's are vestigial in nature, and in the case of a mature male the horns can reach up to 30 centimetres (12 inches) in length. Males often spar with one another in disputes over females, and will also use their horns against potential predators such as foxes.

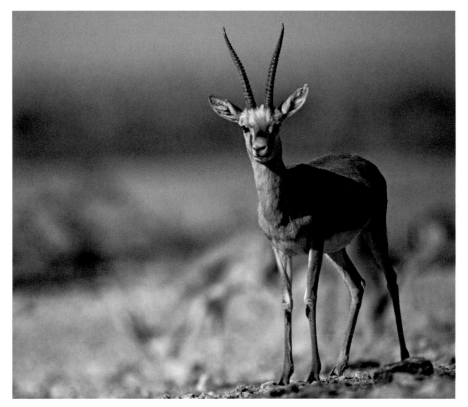

LEFT **The Chinkara is widely distributed across the arid regions of India. It appears able to tolerate people and can be seen in marginal areas near human settlements. It is traditionally protected by some communities, such as the Bishnoi.**

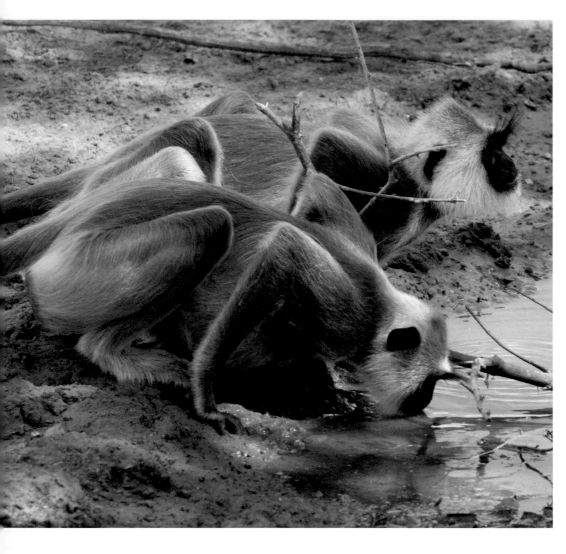

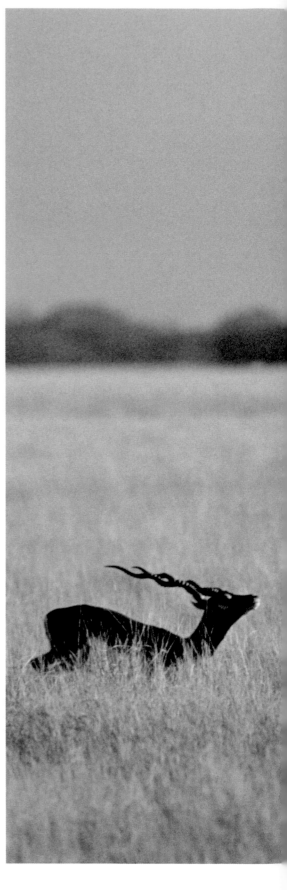

ABOVE Although not a classic desert species, Hanuman Langurs *Semnopithecus entellus* are found on the edges of the Thar, especially around villages. Individuals range widely in terms of coat colour, from silvery grey through to dark chocolate brown.

RIGHT Blackbuck have an iconic status in India, and often feature in art and literature. Animals of the open plains, they are always alert and on the lookout for danger. When alarmed, they often leap into the air, a behaviour known as "pronking".

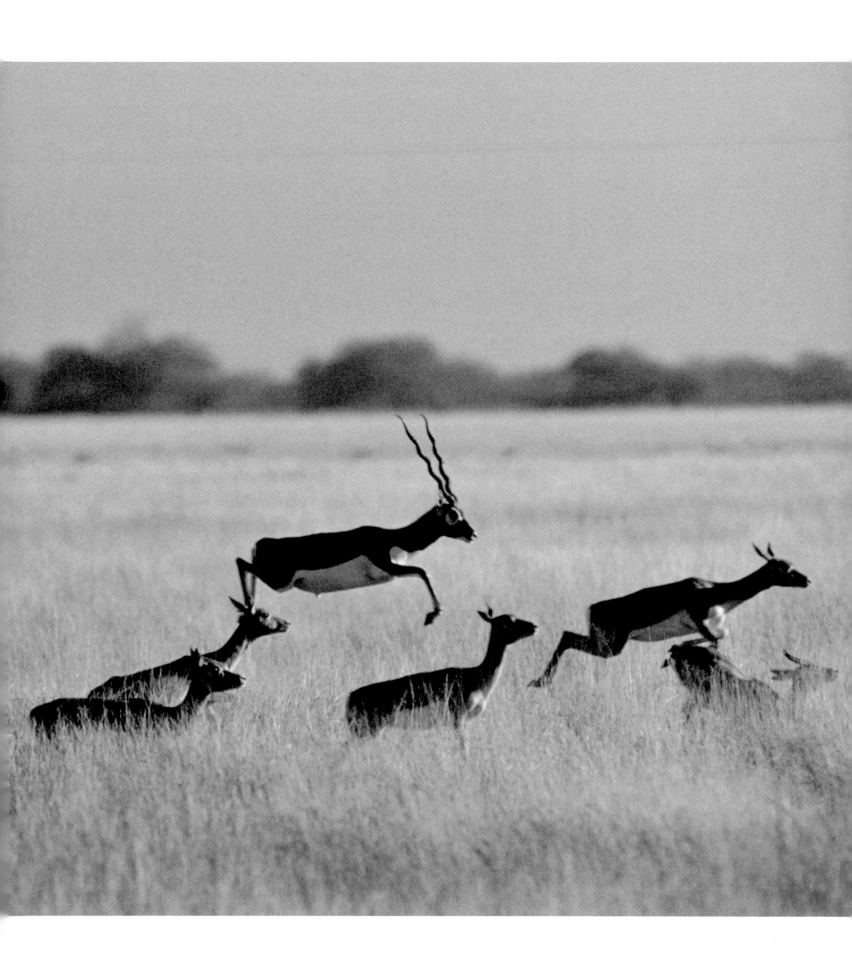

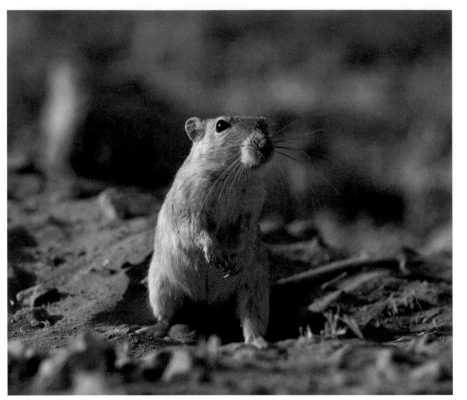

However, the Chinkara's chief defence is its swiftness – they are capable of running at speeds of up to 70 kilometres (43 miles) an hour and can outrun all natural predators with ease if they get an adequate head start. The importance of this advantage is clear in their behaviour – they are skittish, always alert, and constantly looking up when grazing and checking the horizon for potential threats. At the first sign of danger they will run off, often then pausing after a few hundred metres to turn round and look back at the source of their concern. Their senses of sight, scent and hearing are all equally well developed.

Chinkara are able to survive in the most arid of conditions. A specially adapted digestive system capable of extracting the maximum amount of water from anything ingested enables them to cope for lengthy periods without drinking. They derive adequate moisture for survival from the vegetation they eat and from the morning dew that gathers on it. Such is their ability to cope with acute drought that in some of the more inhospitable parts of the Thar they are the only large mammal present.

Also found in some parts of the Thar, although preferring the semi-arid short grasslands on its periphery, are groups of Blackbuck *Antilope cervicapra*, one of the most handsome of all antelopes. Endemic to the Indian subcontinent, Blackbuck live in herds of up to 70 animals, usually comprising females and youngsters under the "stewardship" of several males, one of whom will be dominant overall. The males have magnificent corkscrew horns, which were once much prized by sportsmen. Male Blackbuck are highly territorial, with ferocious battles sometimes taking place between competing males.

Historically, the chief predator of both the Chinkara and Blackbuck was the Cheetah *Acinonyx jubatus*. Cheetahs were once domesticated and trained to hunt antelopes, and they appear regularly in paintings from the Mughal period, for example. However, the last wild Indian examples of this magnificent cat were shot in the 1940s and probably the only viable population of Cheetah left in Asia today is to be found in Iran (see page 119). One of the main threats to the antelopes of the Thar now comes from feral dogs and Wolves *Canis lupus*, which are widely distributed but rarely seen. Foxes *Vulpes* spp. and Golden Jackals *Canis aureus* will try to take fawns when the opportunity presents itself.

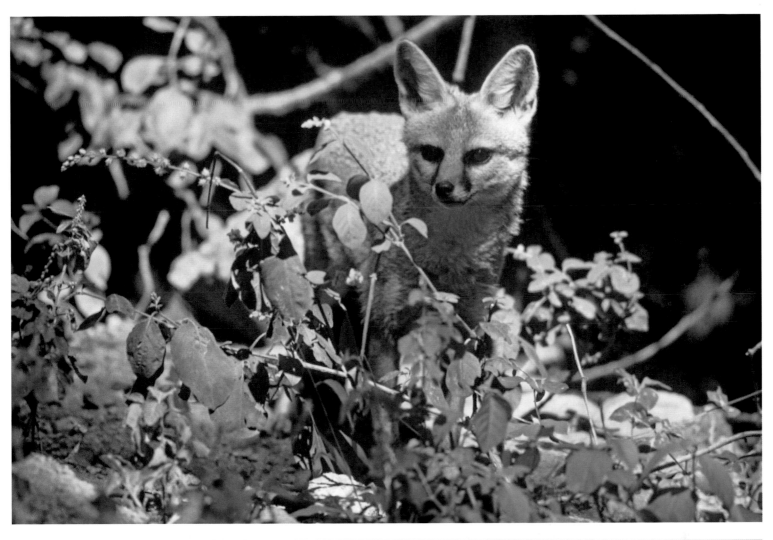

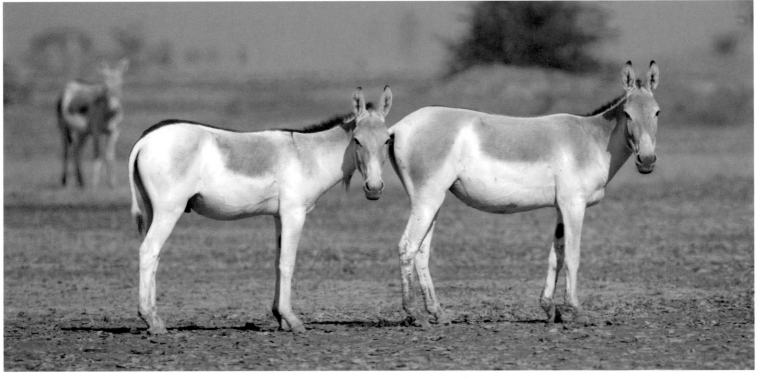

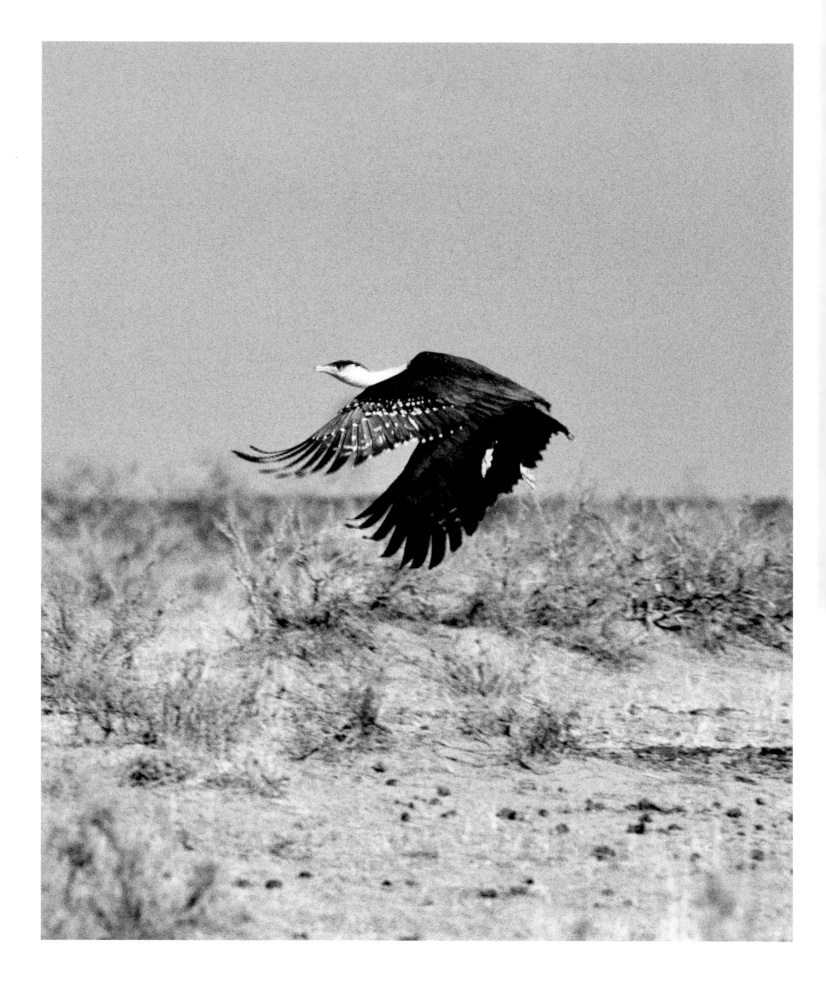

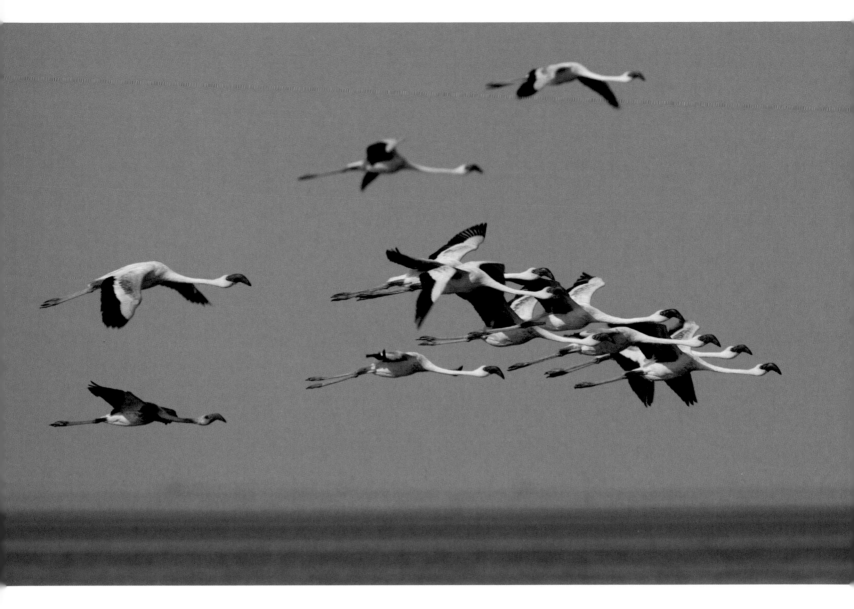

OPPOSITE **Rarely seen on the wing, the Great Indian Bustard is an impressive sight. Conservation measures are helping to ensure its survival in the Thar, but egg and chick losses are a serious problem in areas where livestock densities and levels of disturbance are high.**

Birdlife in the Thar is surprisingly prolific, with up to 300 species recorded. Raptors are well represented here, especially in winter when species such as Imperial Eagle *Aquila heliaca* and particularly Steppe Eagle *Aquila nipalensis* move into the area in large numbers. Sandgrouse are also hard to miss, especially at sources of water, to which they flock in vast numbers around dawn in order to drink. Smaller birds include several species of wheatear and lark, alongside arid zone specialists such as Indian Courser *Cursorius coromandelicus*.

At or near the top of most birders' target list is undoubtedly Great Indian Bustard *Ardeotis nigriceps*. With adult males standing 40 centimetres (15 ¾ inches) high and weighing in at some 14 kilograms (30 pounds), this is one of the biggest birds in Asia. Its favoured means of locomotion is a stately walk, accelerating to a trot when alarmed, and it will only take to the wing if seriously threatened, preferring to run away from danger. Once widely distributed across many parts of northern and central India and Pakistan, by the mid-twentieth century numbers of this magnificent bird were reduced to a perilously low level. This was mainly due to overhunting for meat and sport, but the species was also seriously affected by accelerating habitat loss as its preferred habitat of short-grass plains was increasingly converted to agriculture. Today numbers have partially recovered, but the total world population is unlikely to be much higher than 1,500 birds. Almost all of these are found in India, with as many as 70 per cent of those living in the Thar.

ABOVE **The salt pans of Kutch hold breeding colonies of both the Lesser Flamingo *Phoenicopterus minor* (shown here) and Greater Flamingo *Phoenicopterus ruber*. The flocks move on to the Indian plains once they have finished nesting, taking their grey-brown young with them (bottom left).**

BELOW AND RIGHT The village of Khichan in Rajasthan is famous for the thousands of Demoiselle Cranes that arrive for the winter months. They are fed by villagers, who admire them for their pair fidelity and mainly vegetarian habits. Special enclosures have been built to feed the birds, which increase in number each year. The site has become a tourist attraction, and the commitment expressed by the community to these wild birds makes it an unusual and rewarding place to visit.

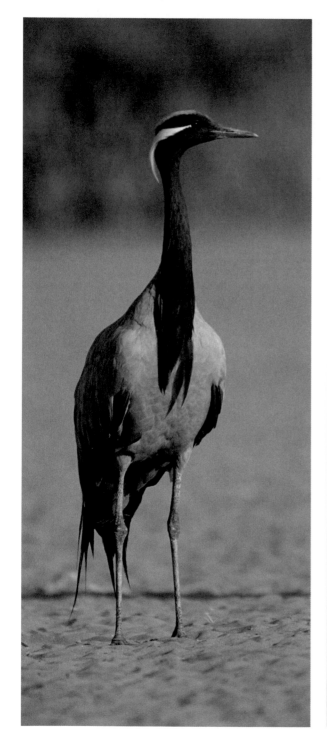

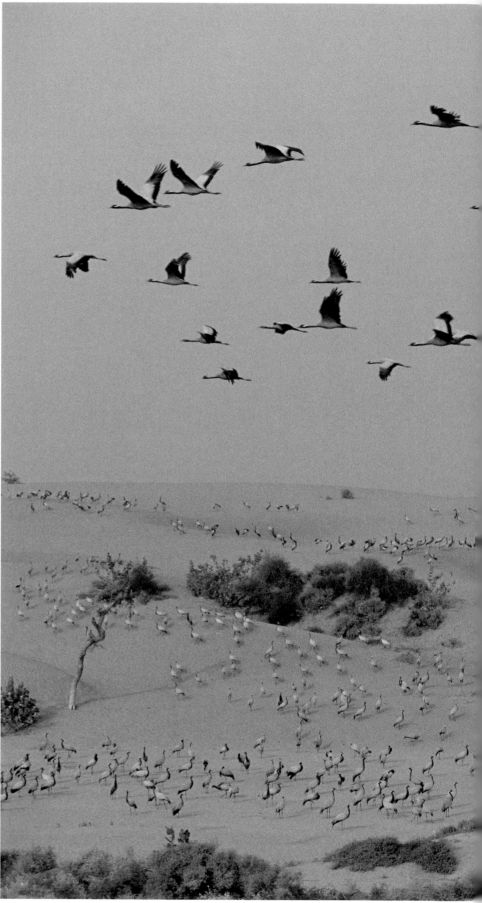

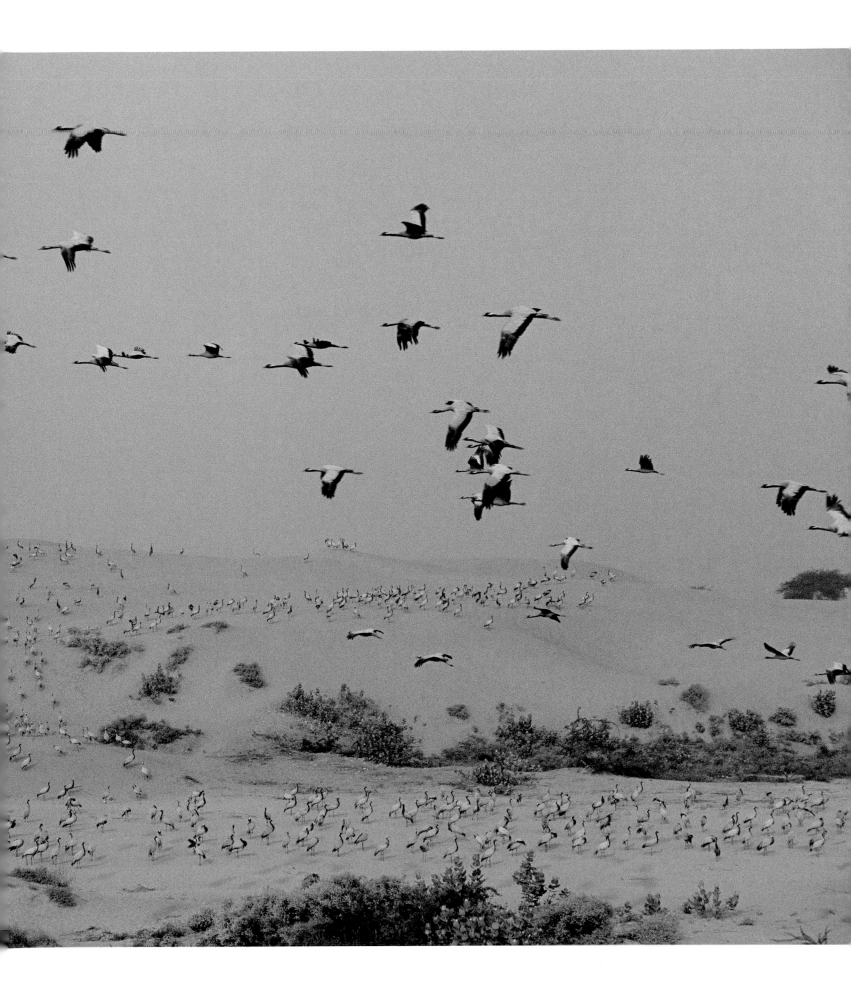

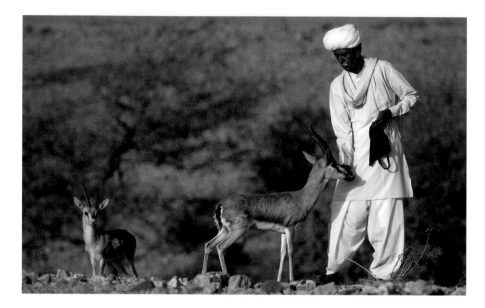

Very shy, and highly vulnerable to disturbance, the bustards usually live in small family groups of up to six individuals, but may congregate in larger numbers when breeding, a time when the males perform an impressive courtship display, inflating the air sac on their neck and ruffling up their feathers. Females usually lay only one egg, in a scrape in the ground – many clutches are lost to trampling by the large numbers of domestic livestock that roam over the desert, and so reproductive rates are generally low.

A second species of bustard, the Houbara Bustard *Chlamydotis undulata*, also occurs in the Thar Desert as a winter visitor from its breeding quarters in central Asia. The current population is a mere shadow of its former self, with numbers greatly reduced in recent decades as a result of overhunting. Much of this decline can be attributed to falconers from the Arabian Gulf, where the species had already been hunted to the point of virtual extinction, turning their attention to other countries where Houbaras were still to be found. Although now technically illegal, the hunting of this threatened species still takes place, especially in Pakistan, where the granting of special hunting permits continues to have a serious impact on the species.

Such issues notwithstanding, one of the more remarkable aspects of the Thar is the way in which certain local communities, notably the Bishnoi people in Rajasthan, live in close harmony with their environment and with the desert wildlife in particular. Inhabiting the area around Jodhpur in particular, the Bishnoi derive their name from the words *bish*, meaning 20, and *noi*, meaning nine, a reference to the 29 basic principles guiding their faith, which is a sect of Hinduism. These principles are based on great reverence for all forms of life, including a prohibition on the killing of animals and the felling of trees. The Bishnoi provide food for local wildlife, and will even bury dead animals they find and erect gravestones to them. There are even cases of Bishnoi women breastfeeding orphan fawns.

The protection afforded to wildlife in areas inhabited by the Bishnoi is such that these have become havens for a variety of mammals, including the Blackbuck, Chinkara and Nilgai *Boselaphus tragocamelus*. The Blackbuck is particularly sacred to the Bishnoi, being considered by them to be the reincarnation of one of their spiritual leaders, and it is therefore carefully protected. As a result, Blackbuck thrive near Bishnoi settlements, a significant factor behind the recovery in numbers of this species after catastrophic declines due to overhunting elsewhere in India.

Another extraordinary example of positive human interaction with wildlife occurs each year at the village of Khichan near Jodhpur. A few years ago local villagers began putting out food for passing migratory birds, specifically Demoiselle Cranes *Anthropoides virgo*, which the villagers admired for their vegetarian habits and monogamy (the birds pair for life). Today, in one of India's greatest wildlife spectacles, as many as 10,000 cranes may gather here during the winter months,

BELOW The salt pans of Kutch not only support flamingos and other specialized creatures, but also sustain one of India's largest salt industries. This mix is emblematic of today's arid lands, where human activity and wildlife often sit in uneasy coexistence.

arriving from August onwards and sustained by the 500 kilograms (1,102 pounds) of millet, sorghum and barley that are provided for them on a daily basis. The food is put out at dawn and, once fed, the birds retreat to the huge sand dunes surrounding the village before dispersing further to the surrounding farmland until late afternoon, when they return to the village for the second feed of the day. At all times the cranes are conspicuously wild, often spooked by the slightest change to their "routine" and always approaching the village cautiously. They remain in the area until early March, when they head north towards their breeding grounds in Central Asia.

To the south of the Thar lies Kutch, a district within the state of Gujarat and which, although not part of the desert proper, contains areas that are highly arid outside the rainy season and support a variety of drought-tolerant wildlife. This includes the principal refuge for the Indian Wild Ass *Equus hemionus khur*, which inhabits a tract of scrub-dotted seasonal saline marshland known as the Little Rann. Originally found much more extensively across India and Pakistan, including in parts of the Thar, the asses retreated to the Little Rann in the face of hunting and disturbance. During the monsoon this area floods, leaving temporary grass-covered islands known as *bets*, on which the asses feed. However, after a month or so the water dries up, the vegetation withers and the landscape becomes harsh and desiccated. During this time the asses tend to live among the permanent stands of *Prosopis juliflora* that persist on the *bets* and along the periphery of the saline flats, and they can often be seen plodding steadfastly across the scorching saline flats in search of grazing.

Today the Thar Desert is under increasing pressure. The construction in 1986 of the Rajasthan (or Indira Gandhi) Canal made possible the irrigation of many thousands of square kilometres of marginal land, which in turn has helped fuel a significant increase in the human population of the Thar. Now regarded as the most densely populated desert in the world, the Indian side of the Thar has a population density estimated at 85 people per square kilometre (⅓ square mile). This has serious implications for the desert ecosystem, particularly in terms of the impact of increased numbers of domestic livestock, for example. Overgrazing is devastating sections of the desert, causing soil erosion and damaging fragile plant networks, with environmental degradation also resulting from other forms of economic activity such as limestone mining. With only relatively small areas of the Thar officially protected, much of the desert's fascinating wildlife is increasingly at risk.

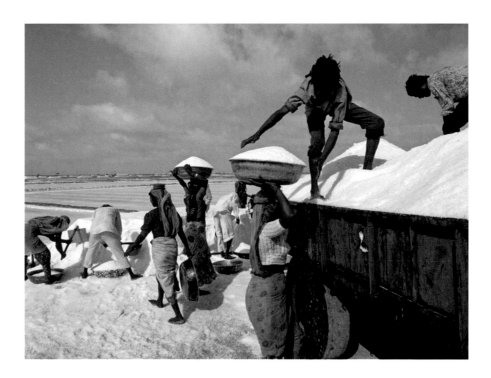

AUSTRALASIA

The Australian interior is largely made up of desert, but it is far from being the lifeless environment of popular imagination. While conditions are certainly harsh, a wealth of wildlife thrives in a mosaic of highly specialized habitats. Among the birds are some of the most colourful representatives of the parrot family, while a bewildering array of reptiles includes a desert-dwelling python and the bizarre Thorny Devil. Conservation issues range from the dilemma over the large population of feral camels to how best to protect vulnerable native mammals, such as the Bilby and Mulgara. The water that periodically fills this region's ephemeral lakes underlines just how unusual desert environments can be.

RIGHT The Woma is a distinctively marked snake and one that thrives in a desert environment. The term "woma" or "wama" means snake or python in one of the Aboriginal languages. Like other pythons, this species lays eggs rather than giving birth to live young.

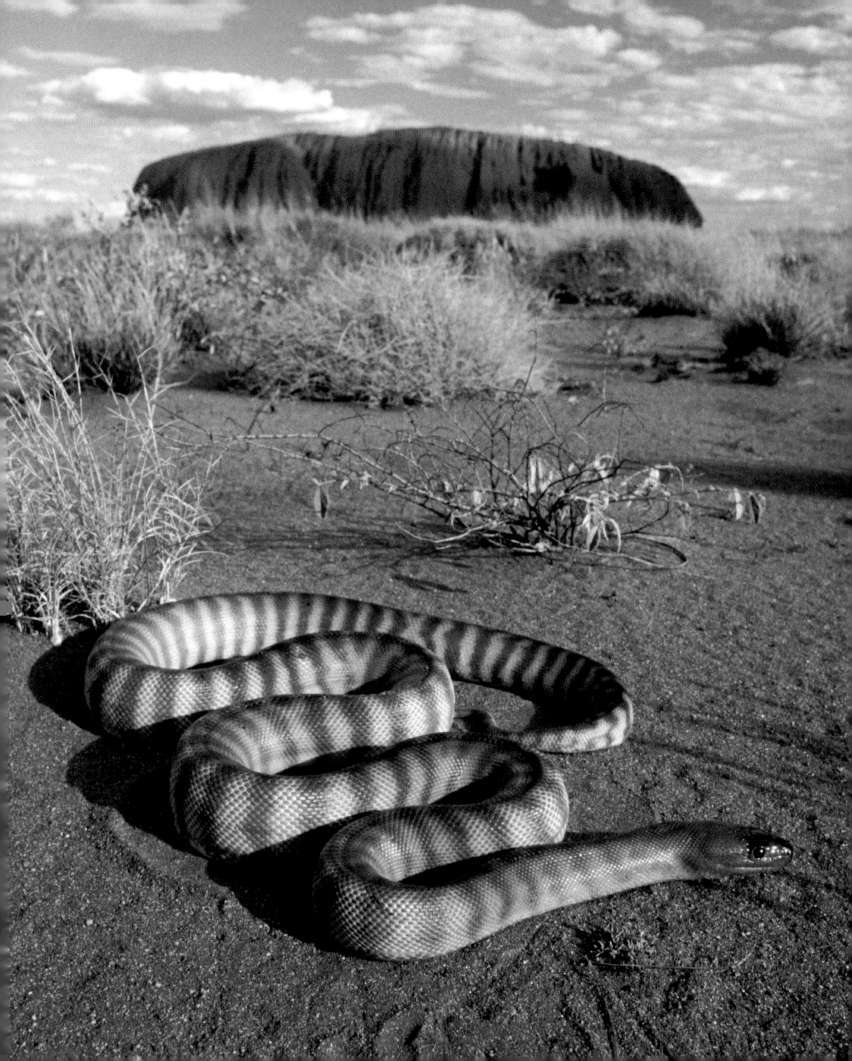

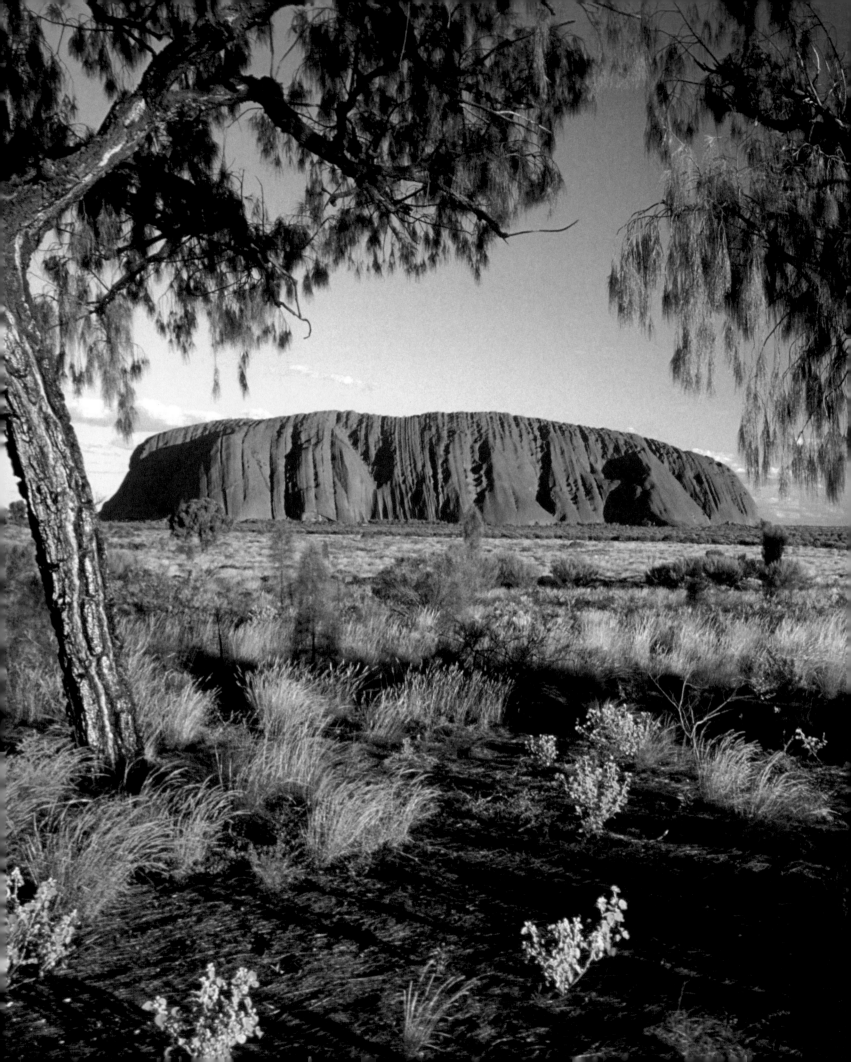

5: Uluru and Australia's Red Centre

Uluru, also known as Ayer's Rock, is one of the world's great natural wonders. Located in the heart of Australia, in the southern part of that country's Northern Territory and at the far-eastern end of the Great Sandy Desert bioregion, this large lump of arkose sandstone is probably the biggest single piece of rock in the world – 348 metres (1,142 feet) high, covering 3.33 square kilometres (1⅓ square miles) and with a circumference of 9.4 kilometres (6 miles). What one sees is in fact just the summit of a much larger piece of rock, with most of its bulk lying underground, possibly to a depth of several kilometres. Technically Uluru is an inselberg, a relict from Gondwanaland now marooned in a landscape from which the major mountain formations have been comprehensively eroded over millions of years. This process has left Uluru and Kata Tjuta, a series of 36 domed rock formations also known as The Olgas and located 25 kilometres (15 miles) to the west, standing proud above the vast surrounding desert.

Whatever its origins, Uluru is far more than just a rock. It has a mysterious and compelling personality, and few visitors are unmoved by their first sight of its intense rust-coloured form. The changing colours and light patterns that dance across it are legendary, and it has long had a special significance for the local Aborigines, the Anangu. Caves around the base of Uluru contain hundreds of paintings depicting traditional Aboriginal life and in recent years the wishes of the indigenous inhabitants have been increasingly respected in terms of how Uluru is presented to the public and what activities are allowed upon it. Climbing is, therefore, now discouraged at the request of the Anangu, who continue to regard Uluru as central to their spiritual life. Culturally and physically, this remarkable place is the single most powerful emblem of the so-called Red Centre, the heart of Australia's desert region, and it also serves as an icon for the country at large.

The Great Sandy Desert covers 405,200 square kilometres (156,450 square miles) and extends west from Uluru into the state of Western Australia and then across as far as the Kimberley. A further desert, the Gibson, lies to the south. The landscape typically comprises extensive and gently undulating sand plains, with dune fields, gravelly rises and rocky outcrops. Rainfall is generally minimal, the average annual total ranging from almost nothing in some locations to up to 300 millimetres (12 inches) in particularly well-favoured sites, such as Uluru. Most rain here falls during the period January–March, often as a result of fierce thunderstorms, and coinciding with the tropical monsoon in the north. There are few permanent water sources, the majority of which are located around the periphery of the desert. Most of the true desert watercourses are ephemeral and only flow after particularly heavy rainfall, although permanent and semi-permanent waterholes known as soakages or soaks – some spring-fed, others formed when rain is trapped near ground level above an impermeable layer of rock – constitute one of the most reliable sources of water. In terms of temperature, the average daytime maxima in the desert range between 22°C (72°F) and 40°C (104°F), with extremes a few degrees below freezing point in winter and in excess of 45°C (113°F) during the summer.

LEFT **Australia's Red Centre is dominated, both physically and emotionally, by Uluru, or Ayer's Rock. This sandstone outcrop is a defining symbol of the desert, and its diverse habitats make it an excellent place to search for wildlife.**

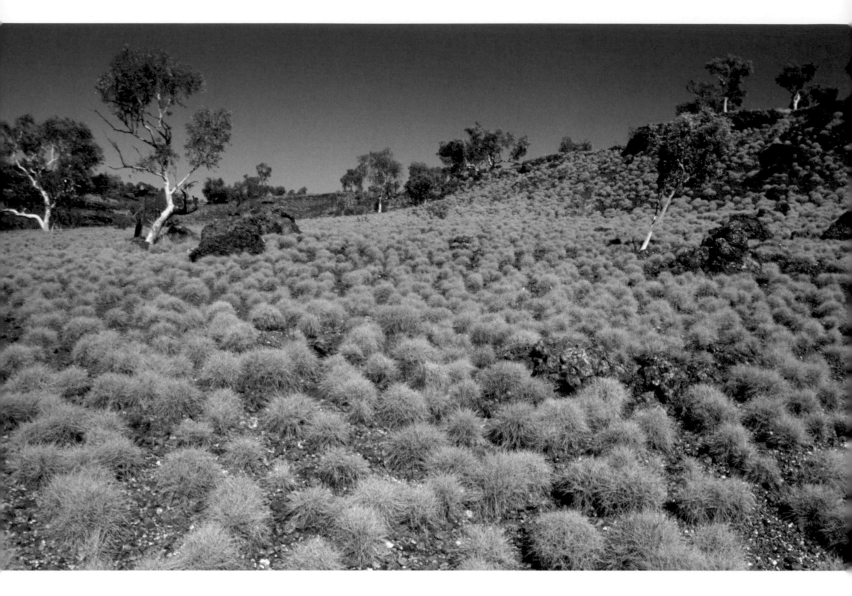

ABOVE **Clumps of spinifex cover vast swathes of the Australian desert. With over 30 different species identified, this is one of the most resilient plants. It is able to withstand extreme drought and provides a valuable habitat for small birds in particular.**

Tussock grassland prevails across much of the desert, dominated by species such as spinifex, *Triodia* and *Plectrachne*. Spinifex forms vast swathes of dense hummocks and shows classic desert adaptations; the razor-sharp, pointed leaves curl in on themselves as a moisture-retention device, while the tussocks maintain vast root systems which not only enable the plants to obtain adequate moisture from the soil but also serve to stabilize the extensive dune systems on which they grow. Spinifex is particularly valuable to wildlife, its tangled structure providing useful shelter for birds, reptiles, small mammals and invertebrates, and its seeds serving as an important food source for rodents in particular.

Scattered throughout the desert are groves of shrubs and small trees, the distribution of these often tied to seasonal watercourses and the presence of soaks. Species such as Mulga *Acacia aneura*, Desert Walnut *Owenia reticulata*, Desert Bloodwood *Corymbia opaca* and Desert Oak *Allocasuarina decaisneana* are typical, with colour provided by flowering shrubs such as *Grevillea* spp., Crimson Turkeybush *Eremophila latrobei*, Magenta Emubush *E. alternifolia*, Slender Fuchsia *E. decipiens* and the desert roses, *Gossypium* spp. Damp gorges, such as those associated with Uluru, are home to a particularly specialized plant community, which includes several endemics, and the bigger, wetter soaks can support swamp-type vegetation otherwise unknown in the desert.

The ecology of the Mulga in particular exemplifies how local plants have developed to cope with the rigorous desert conditions and how they play an important role in the desert ecosystem. Mulgas are widespread across much of Australia and are hugely variable, with a single population

OPPOSITE TOP **Spinifex Pigeons** *Geophaps plumifera* **often gather at water in the early morning and evening, but forage for food during the hottest part of the day. This gives them an advantage over other birds, which are usually less active at that time.**

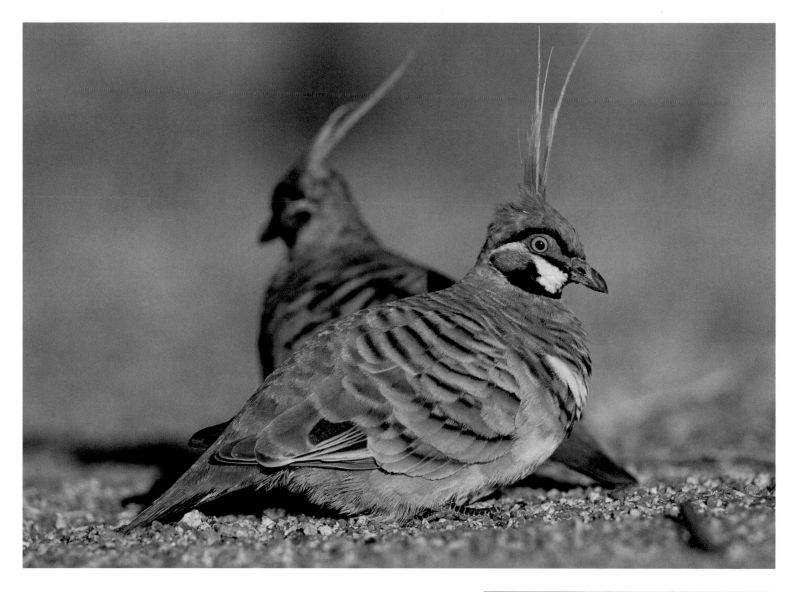

or stand containing up to 20 different "types"; scientists are continuing to assess whether some of these, at least, merit recognition as separate species. All Mulgas demonstrate a range of special features that have helped make them one of the dominant plants in this arid environment. First, they have classic desert foliage – their leaves (not really leaves at all, but flattened leaf stalks) are small and elongated to minimize transpiration, and silvery-green in colour to help reflect heat. The angle at which the leaves grow is designed to funnel the maximum amount of rainwater down towards the trunk base and into the root system – each Mulga has a large taproot that can extend several metres underground. The leaves also have a high protein content, which may enable the plant to survive difficult periods more effectively.

During particularly dry spells Mulgas will shed their leaves, reducing moisture loss even further and providing a useful mulch around their trunk and roots to help retain whatever ground moisture may be present. Further sustenance comes from the association that Mulgas maintain with mycorrhizal fungi, which act as a source of nutrients and thereby reduce the plants' dependence on water. Mulgas are also "nitrogen-fixers", their roots harbouring bacteria that convert atmospheric nitrogen into compounds that help enrich the otherwise nutrient-poor desert soil and thereby benefit other plant species. Although Mulgas cannot survive bush fires in the way that species such as Eucalyptus can, the intense heat of a fire will crack open the seedpods and release the seed within for germination. If left undisturbed and growing in suitable conditions, Mulgas can live for up to 200 years.

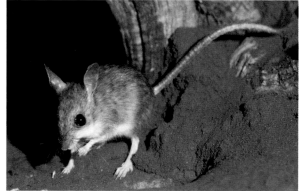

ABOVE **Although Spinifex Hopping Mice are widely distributed across desert habitats, their populations fluctuate greatly from year to year according to conditions.**

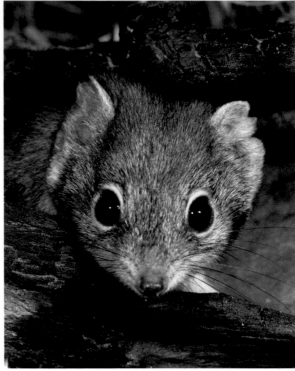

Wildlife in the Great Sandy Desert is surprisingly diverse, and the area around Uluru is a particular hotspot, although this may be partly explained by the fact that it has been more intensively studied than many other parts of the desert. The rock, and 1,326 square kilometres (512 square miles) around it, including Kata Tjuta, were designated Uluru-Kata Tjuta National Park in 1977 and a World Heritage Site ten years later on account of their cultural, landscape and ecological significance. Wildlife is indeed prolific here – so far recorded are 21 species of native mammals (and six non-native), 178 species of bird, 72 species of reptile and many thousands of invertebrates. These impressive totals are in part a result of the microclimate that is generated by Uluru itself and which extends the variety of ecological niches in the vicinity. Rainfall locally is higher than in the wider desert beyond, and niches and fissures in the rock provide rare opportunities for life forms that are dependent on living within water and which therefore struggle to survive elsewhere in the desert; small rock pools can teem with shrimps, for example. These damper conditions also make it possible for several species of amphibian to survive on and around Uluru. Especially notable among these is Main's Frog *Cyclorana maini*, which endures periods of drought by burying itself underground and surviving on water that it has absorbed into its body during times of plenty. Upon the return of rain, the frog will dig itself out, feed, reproduce and then stock up its water reserves before going underground once more. At times, usually when there is a heavy downpour, hundreds of the frogs may emerge simultaneously in a sort of amphibian chorus line, all making a strange call rather like the bleating of a particular farm animal – hence their alternative English name, Sheep Frog.

ABOVE LEFT **Spending much of the year buried in mud, awaiting the return of rainfall, Main's Frog is a difficult amphibian to find. It is an opportunistic breeder and has an accelerated life cycle, whereby tadpoles can become frogs in as little as two weeks.**

ABOVE RIGHT **The Crest-tailed Mulgara *Dasycercus cristicauda* is a carnivorous marsupial from the central deserts of Australia. It lives in burrows, emerging at night to hunt for invertebrates. It is vulnerable to predation by feral cats and foxes.**

OPPOSITE **Flocks of cockatoos are a frequent sight in the outback, as they commute between roosting sites, food and water. The open woodland and scrub around Alice Springs is a good place to look for the beautiful Major Mitchell's Cockatoo *Lophochroa leadbeateri*.**

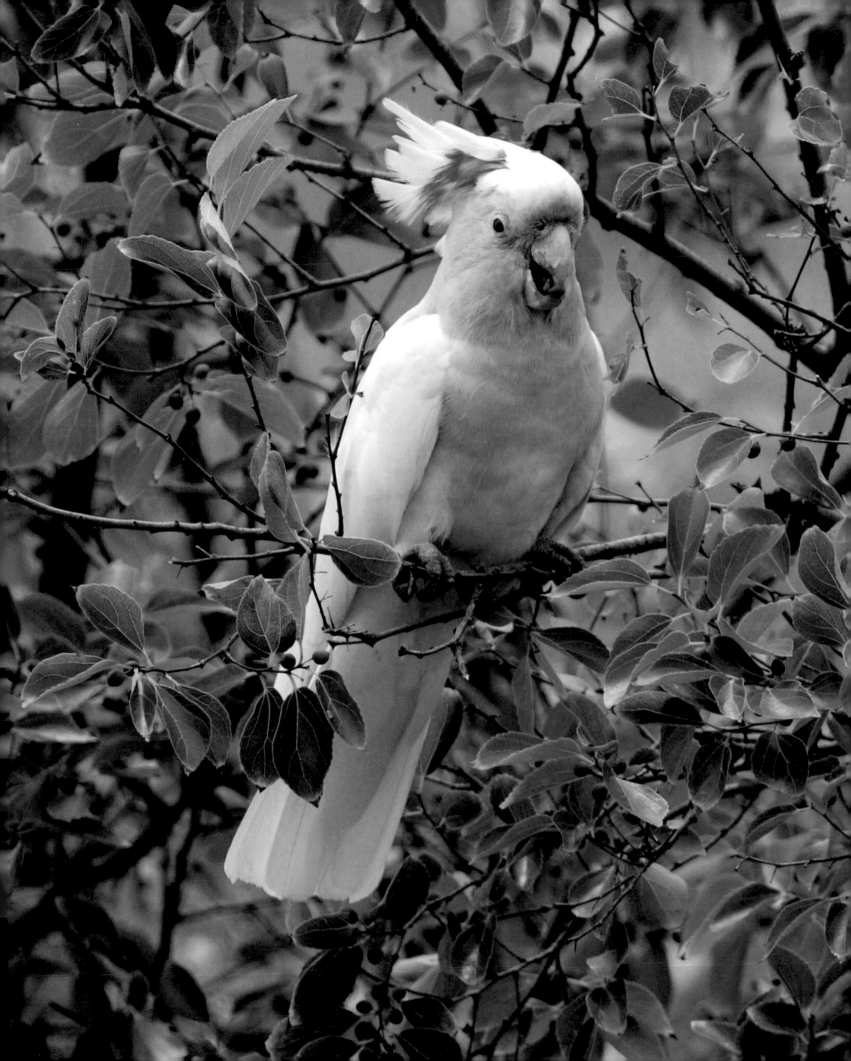

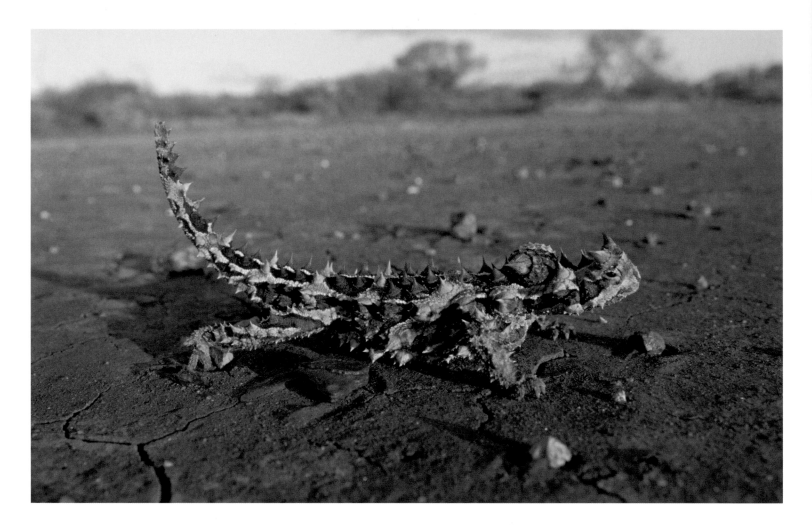

Thorny Devils can live for up to 20 years and feed exclusively on ants. Mating takes place after an elaborate courtship ritual and the female later lays her eggs in an underground chamber, from which the young devils emerge, unattended, a few weeks later.

OPPOSITE There are over 50 species of parrot in Australia, almost all of them endemic. Like many of those found in the more arid areas, the Mulga or Many-coloured Parrot *Psephotus varius* usually lives in pairs or small family groups.

Uluru-Kata Tjuta National Park is home to one of the highest diversities of reptiles known from the arid parts of Australia. The majority of these are lizards and skinks, but the reptile total includes more than a dozen snake species, among which is the Woma *Aspidites ramsayi*, a type of python which can grow up to 3 metres (10 feet) in length. Womas usually live underground in old burrows excavated by monitor lizards or mammals, and prey primarily on rabbits and lizards. While, like all pythons, Womas are capable of constriction, it seems that when they encounter prey underground they kill their victim by crushing it against the sides of the burrow, there not being adequate space for a "normal" constriction manoeuvre. Although they remain widely distributed in the Great Sandy Desert and across much of western and central Australia, there is evidence to suggest that Womas may be in serious decline in some areas, possibly as a result of predation by feral cats and foxes.

One of the most remarkable reptiles found in the Red Centre is the Thorny Devil *Moloch horridus*. Fairly common, and perhaps best looked for as they bask – albeit at unknowing risk – on tarmac roads, these extraordinary-looking lizards can grow up to 20 centimetres (8 inches) long. They have a cryptic body pattern that provides highly effective camouflage against the desert landscape and move along in a characteristic jerky motion, reminiscent of a wind-up toy, and with their tail raised. The spines that cover their body are not poisonous, but are sharp enough to deter most predators. This creature's bizarre appearance is not, however, its most remarkable aspect. In an adaptation that almost defies belief, the Devil is able to channel any moisture that collects on its body, either from rainfall or dew, towards its head via a system of external capillaries and hygroscopic grooves located between its spines. This network converges at its mouth, enabling it to drink – surely one of the most astonishing examples yet revealed of the ingenuity of nature when faced with a challenging environment.

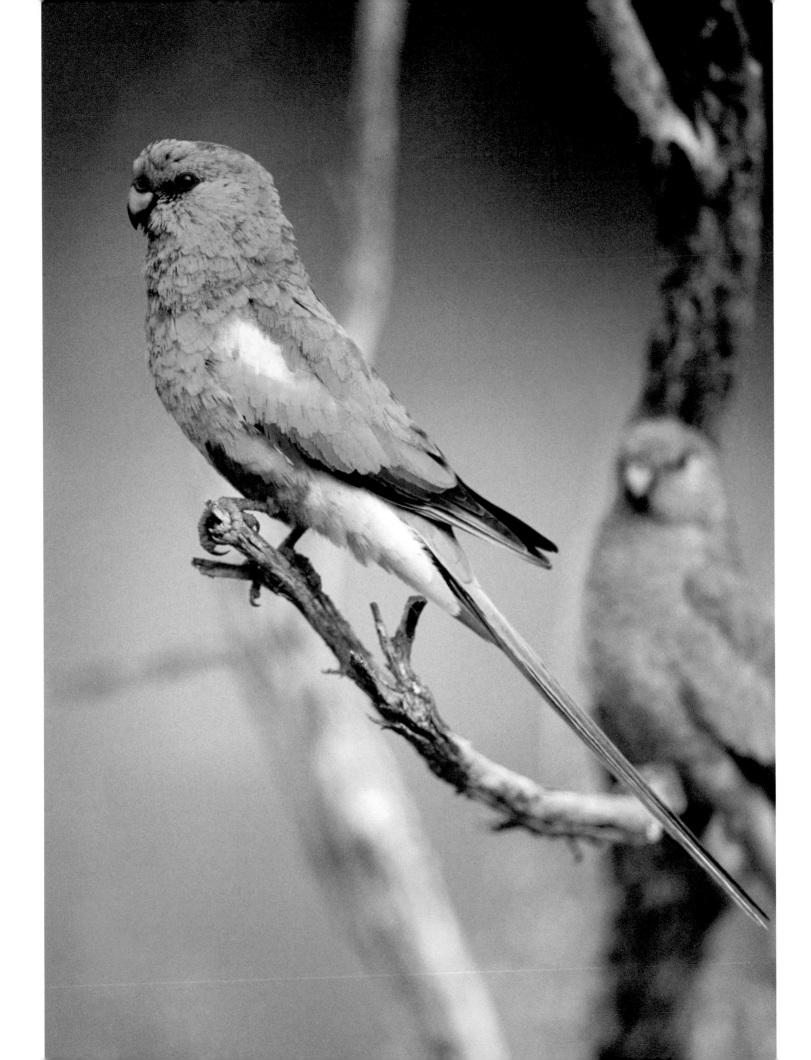

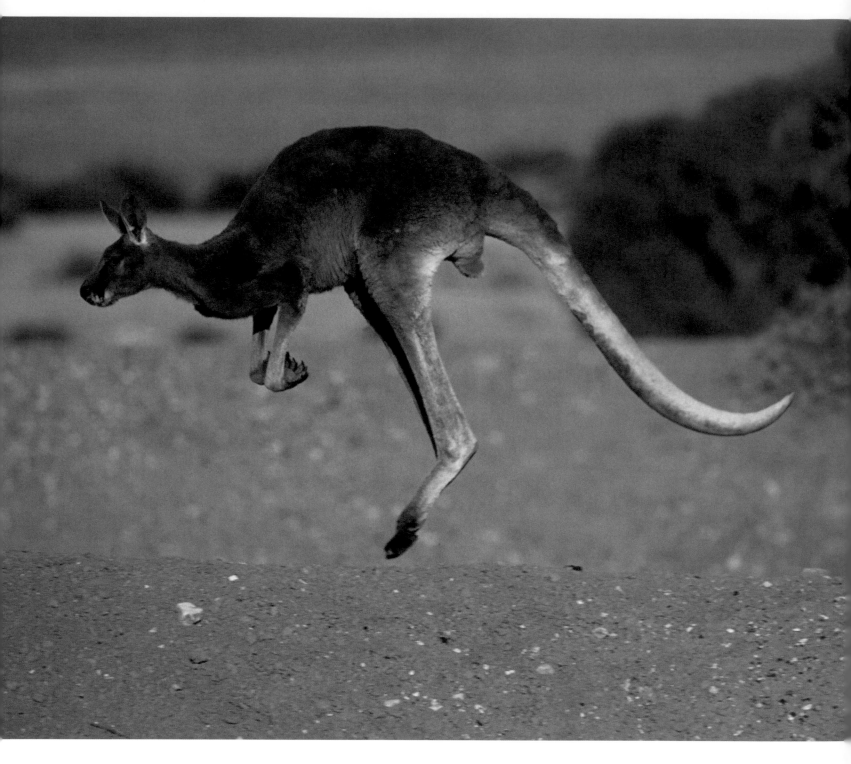

ABOVE Kangaroos are widespread across the Australian desert. The Red Kangaroo *Macropus rufus* is the continent's largest native land mammal, and adult males can stand up to 2 metres (6.5 feet) tall. Kangaroos need shade and favour lightly wooded terrain.

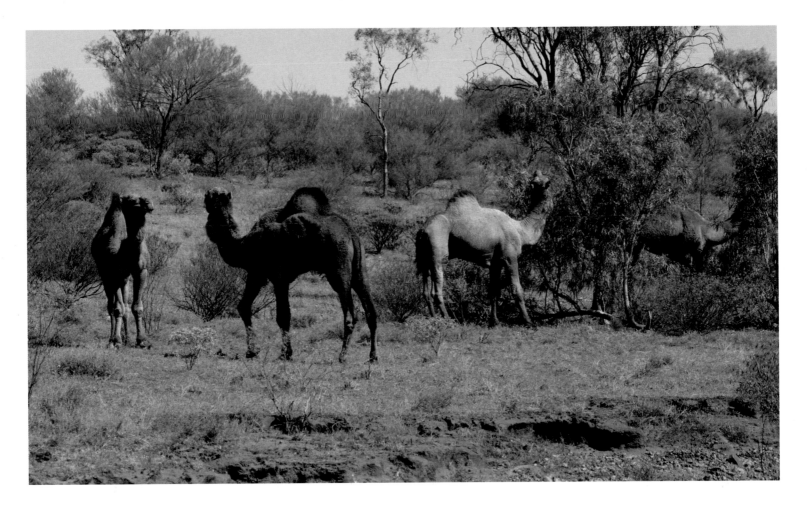

Mammals are well represented in the Great Sandy Desert but are not necessarily easy to see. Many of the indigenous species are nocturnal, moving around only when temperatures are cooler, and they are unlikely to be chanced upon. For most casual visitors mammal sightings will be limited to Dingos *Canis lupus dingo*, which often hang about the local campsites, and Kangaroos *Macropus* spp., or a fleeting glimpse of a Spinifex Hopping Mouse *Notomys alexis* briefly illuminated by torchlight at night before it bounds off into the darkness. However, as so often elsewhere in Australia, it is the non-native interlopers that steal the desert headlines. Among the most obvious of these are the herds of feral Dromedary *Camelus dromedarius* that roam the area. The ancestors of these animals were imported in the nineteenth century for use primarily as pack animals, but with the advent of the motor car in the early twentieth century they became increasingly redundant and were turned out into the desert. Here they have prospered and today their descendants form the only truly "wild" population of the species, thereby assuming a special ecological significance of their own. However, with over one million feral camels now estimated to be living in Australia today, their impact on the environment – mainly through grazing pressure – is a growing cause for concern. So much so that in 2009 the Australian government announced a controversial cull aimed at eradicating 650,000 feral camels.

However, at least camels do not prey on native mammals; the very high populations of feral cat and Red Fox *Vulpes vulpes* most certainly do, while the non-native Rabbit *Oryctolagus cuniculus* successfully outcompetes native herbivores in the grazing stakes. The impact of two centuries of introduced fauna on indigenous Australian desert wildlife is clear: historically, 46 species of native mammal were found at Uluru, for example. Today fewer than half that number remain. Plans are being made for the reintroduction of certain species when the appropriate conditions can be met, but until the numbers of so-called pest species are brought under control in potential release areas it is hard to see how any such programme would be sustainable.

ABOVE Australia's increasing feral Dromedary population prompts continuing debate. They are having a serious impact on native vegetation and water resources in some areas, but opponents still object to the government's aerial cull and maintain that it is cruel.

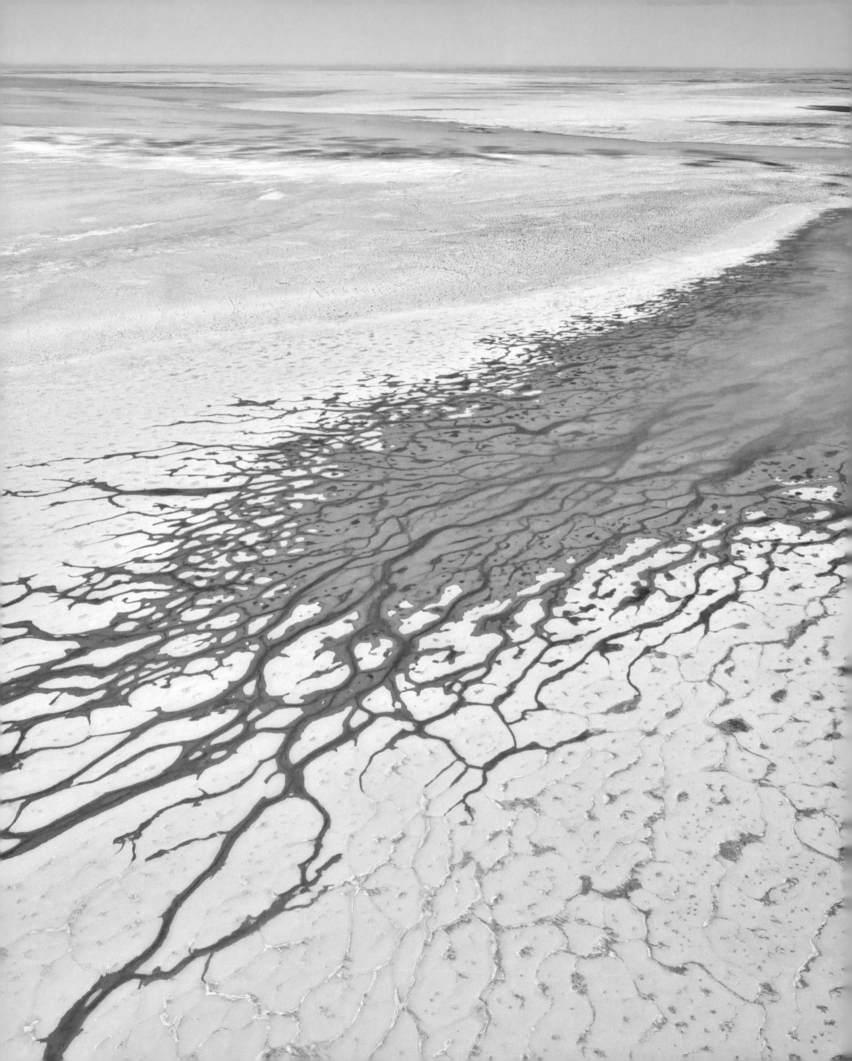

6: The Simpson Desert and the Inland Sea of Lake Eyre

Covering some 580,000 square kilometres (224,000 square miles) of Australia's arid centre, the Simpson Desert straddles three states – Northern Territory, Queensland and South Australia – and comprises a range of different landscapes, from dunefields to stony plains and low eroded ranges of hills. It also includes one of the world's largest internal drainage basins, the Eyre Basin. Several major river systems feed this basin, including the Cooper, Diamantina, Eyre, Georgina and Strzelecki, as well as a host of smaller streams and watercourses, but there is no outlet to the sea and so the basin itself is characterized by salt pans resulting from the seasonal and ephemeral processes of flooding followed by rapid evaporation. For much of the time these pans are covered by a crust of salt that can be up to half a metre thick and capable of withstanding the weight of a truck.

Lake Eyre itself is one of the world's largest salt lakes and, at some 15 metres (50 feet) below sea level, the lowest point in Australia. Although some water remains in parts of the lake and surrounding salt pan for most of the time, the lake itself fills only irregularly, the amount of water reaching it being determined by the seasonal monsoon that affects Queensland to the north and east. In years when the monsoon is quite light, little or no water percolates across country to reach the basin via the Warburton Groove. However, every few decades the rains are heavy enough to ensure that the lake fills up, occasionally to a depth of several metres. As the lake floods, the salt crust forming most of its surface during periods of drought begins to dissolve, raising the salt level in the water initially to saturation point. However, as more water floods into the lake, so the salty water sinks, submerging underneath the fresh and drinkable water that builds on the surface. On such occasions the lake and surrounding area burst into life, a seemingly miraculous transformation after months, if not years, of intense and seemingly lifeless drought.

Generally low-lying, the wider Simpson Desert ranges in altitude from below sea level to a little over 300 metres (980 feet) above. Much of the landscape comprises red sand dune systems, the vegetation characterized by clumps of grasses such as spinifex and cane grass, as well as by scattered patches of scrub, including Gidgee Trees *Acacia georginea* in the inter-dune areas. The density and extent of this vegetation are determined by local rainfall patterns, although with precipitation in this region rarely amounting to more than 200 millimetres (8 inches) per annum, plant cover is invariably scant unless exceptional conditions apply. However, along the watercourses that occur in the north-eastern part of the Simpson, known as the "Channel Country", greater botanical diversity occurs throughout the year, with stands of Coolibah trees *Eucalyptus coolibah* in particular. A dramatic change comes to the desert in times of rainfall and flood, when the parched landscape can erupt in a blaze of ephemeral flowers, including great swathes of the brilliant yellow Fleshy Groundsel *Othona gregorii*.

LEFT **One of the Australian desert's great natural features, Lake Eyre is fed largely by water from the Warburton River. The river carries rainwater south-west and feeds it into the lake, which can swell to a depth of 2 metres (6 feet) or more.**

BELOW One of Australia's most
engaging native mammals, Bilbies
live either singly or in pairs. The
decline in their numbers has
prompted various conservation
campaigns, including a captive
breeding programme. There is
even a National Bilby Day, which
is held every September.

As a result of the presence of the more varied habitats sustained by the watercourses and periodic flooding, the Simpson enjoys greater levels of biodiversity than most other areas of the Australian desert. Some 35 species of native mammal, 22 amphibians, 13 fish and at least 125 species of reptile have been recorded to date. Mammals include two interesting carnivorous marsupials, the Hairy-footed Dunnart *Sminthopsis hirtipes* and the Crest-tailed Mulgara *Dasycercus cristicauda* (see page 68). Both species are voracious predators, preying on small rodents, reptiles and arthropods, and demonstrating a ferocity that belies their size – the latter rarely reaches a body length in excess of 25 centimetres (10 inches) and the former is even smaller. Evidence suggests that desert-dwelling predators such as these rarely, if ever, drink water, deriving all the moisture they require from their prey. Somewhat larger, meanwhile, approximately the size of a small cat, is the Greater Bilby *Macrotis lagotis*. Once widespread across much of Australia, this engaging and iconic mammal is now much declined in numbers – mainly as a result of predation by feral cats and non-native Red Fox *Vulpes vulpes* – and restricted to desert areas, including the Simpson. Bilbies are omnivorous, foraging for a range of prey from insects to seeds and bulbs, and like almost all other Australian desert mammals, they are almost exclusively nocturnal and therefore hard to view well.

Much more readily seen in the Simpson is the Dingo *Canis lupus dingo*, Australia's "wild dog". The history of the Dingo in Australia is a curious one and still the subject of research, but it is likely that the species was first brought to Australia as a domestic animal by Asian seafarers. The earliest surviving fossil remains for Dingoes are most likely from Thailand, dating back almost 6,000 years and predating the earliest found in Australia by 1,500–2,000 years. This would indicate an original and close link with the Indian Wolf *Canis lupus indica*, although Dingoes are perhaps best regarded as a type of feral dog. It is clear that the indigenous Aborigines developed an early relationship with Dingoes, using them as food, guard dogs and possibly when hunting.

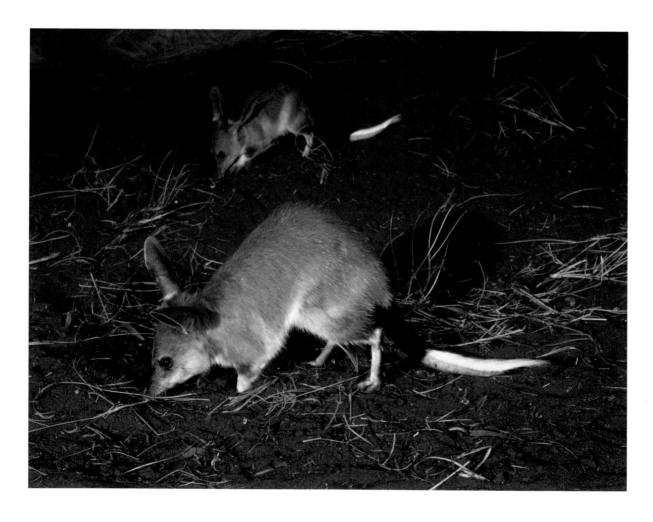

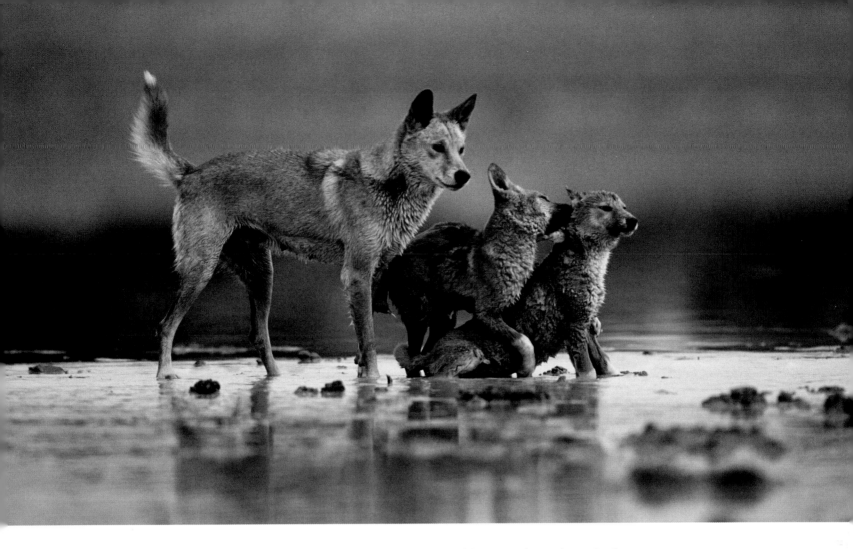

Today, Dingoes are found in every Australian state except Tasmania and are widespread and common in much of the outback. Their adaptability and resourcefulness enable them to survive in the harshest of desert regions, demonstrating typical canid behaviour in the sense that they operate socially in groups and are highly flexible in terms of diet, taking anything from carrion and small mammals to larger animals such as kangaroos, which they will hunt as a pack. Dingoes also have an undeniable propensity for preying on sheep and their "pest" status means that vast numbers are shot and trapped. As a result, the species has been virtually wiped out in many farmland areas across Australia. Traditionally regarded as an "alien predator" itself, the Dingo is now under re-evaluation in a continent that is now full of non-indigenous species. Scientists have recently highlighted the role played by Dingoes in controlling the numbers of kangaroos, high densities of which can cause overgrazing, as well as the Red Fox, a species that was itself introduced by settlers and is now responsible for the destruction of many native rodent species.

Meanwhile, the fate of the Dingo is also under threat from another direction: Dingoes are increasingly mating with feral domesticated dogs, so the numbers of genetically "pure" Dingoes are falling. Although some relatively isolated populations survive in the remoter desert areas, only on islands is it likely that "pure" Dingoes will survive.

Outstanding among the many reptiles found in the Simpson region is the endemic and highly specialized Lake Eyre Dragon *Ctenophorus maculosus*. Reaching lengths of up to 7 centimetres (2¾ inches), the little creature is found only on the seemingly inhospitable salt flats of Lake Eyre, where it feeds primarily on ants and shelters from the heat in burrows under the buckled salt crust. When temperatures are very high, the dragon seeks cooler conditions by burrowing down into the mud below the salt crust, and when the lake periodically floods, the dragon will move towards the sandy shores of the lake and take up temporary residence there, moving back on to the salt flats when the waters recede.

ABOVE **Dingoes are relentlessly persecuted across much of Australia, although they are protected in most areas of public land. Social animals, they live in family groups and often hunt cooperatively, mainly preying on kangaroos and wallabies.**

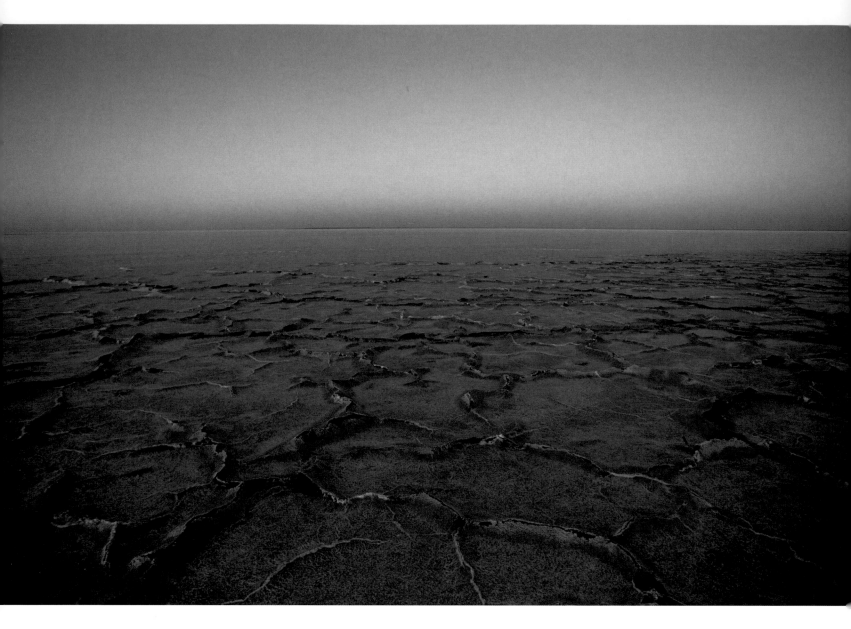

Over 230 species of bird have been recorded locally, a surprisingly high total for a desert region and one that is greatly enhanced by the presence of waterbirds, for which life is made possible here by the erratic inundation of Lake Eyre. Landbirds include a few specialities, notably the Eyrean Grasswren *Amytornis goyderi*, which is best looked for in clumps of Sandhill Cane Grass *Zygochloa paradoxa*. First described for science in 1875, this bird was subsequently considered extinct until it was recorded again in the early 1960s and again in 1976. It has since become clear that it is in fact rather common within its restricted range, its secretive habits and the remoteness of its preferred habitat serving to belie its true status.

However, it is the waterbirds that steal the show here every few years. Attracted by the floodwaters that slowly and erratically make their way here, usually from the north and a process that can take several months, the hundreds of thousands of birds of up to 60 species that congregate here in times of plenty include several that take advantage of the rich conditions by establishing temporary breeding colonies locally. Among them are several species of wildfowl, including Grey Teal *Anas gracilis* and Pink-eared Duck *Malacorhynchus membranaceus*, as well as Black Cormorant *Phalacrocorax carbo*, Silver Gull *Larus novaehollandiae*, Gull-billed Tern *Gelochelidon nilotica*, Banded Stilt *Cladorhynchus leucocephalus*, Red-necked Avocet *Recurvirostra*

ABOVE **Lake Eyre has extensive, salty clay and mudflats, on which hardly anything can survive. Only when water comes flooding back does life become more evident, with waterbirds congregating to feed on the shrimps and other forms of aquatic life that appear.**

OPPOSITE **The Lake Eyre Dragon survives in extremely harsh conditions. Its pale skin reflects the heat, while its sunken eyes are black-rimmed with fringed lids to help cope with wind and glare. This male is keeping a look out for females and rival males.**

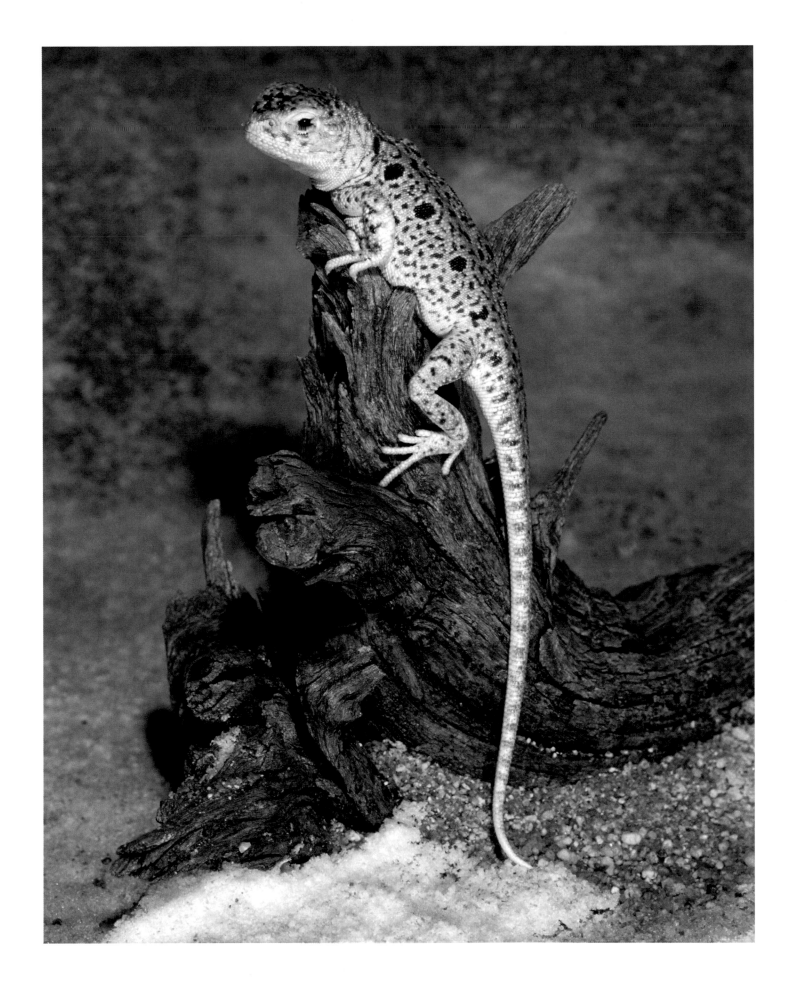

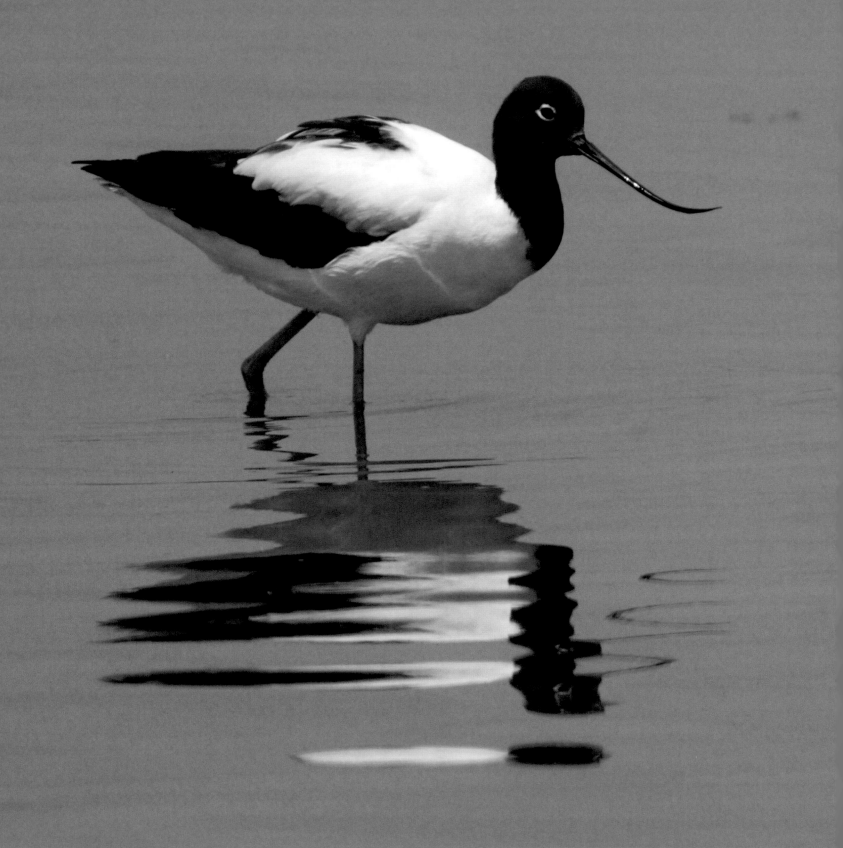

OPPOSITE Among the several million birds that flock to Lake Eyre when water levels rise is the Red-necked Avocet, which breeds here in good numbers when conditions are favourable. It scoops up tiny aquatic organisms with sideways sweeps of its bill.

RIGHT Pink-eared Ducks are usually among the first waterfowl to appear at temporary inland lakes. They require shallow water and filter microscopic plants and invertebrates with their specialized bill, which has special sieving grooves known as lamellae.

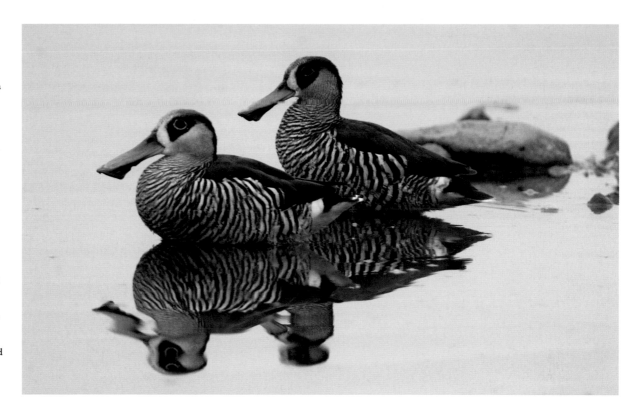

novaehollandiae and Australian Pelican *Pelicanus conspicillatus*. The latter is known to fly several hundred kilometres in large numbers to take advantage of the floodwaters at Lake Eyre.

At these times the water teems with crustaceans and fish, all on an accelerated lifecycle to take maximum advantage of the temporary conditions. Particularly notable among the fish are the Lake Eyre Golden Perch or Yellowbelly *Macquaria ambigua* and the Lake Eyre Hardyhead *Craterocephalus eyresii*, known only from Lake Eyre and its associated river systems. The hardyhead has the highest known salinity tolerance of any freshwater fish in Australia but still dies off in vast numbers when floodwaters recede and salinity levels rise. Approximately twenty million hardyheads were estimated to have died immediately after the floods of 1974–75, which filled Lake Eyre to the brim. Yet this "boom-and-bust" cycle is an intrinsic part of the ecology of this species and indeed of all desert wildlife.

Lake Eyre has witnessed that level of flooding only three times in the past 150 years, but recent years have seen a series of back-to-back floods that have sustained impressive water levels. In the second quarter of 2009 the lake filled to a depth of 1.5 metres (5 feet) and attracted thousands of birds, including many pelicans, which established breeding colonies on islands in the lake. Flooding on an even greater scale occurred in May and June 2010, with many normally dormant creeks flowing with water, and by early 2011 the cataclysmic rains that caused such devastation in Queensland have produced a volume of water that was filling Lake Eyre. Some forecasters are predicting that the lake could flood to a depth of 6 metres (20 feet) or so, the first such occurrence for 35 years. As a result, it could remain full of water for up to two years, providing a bonanza for local wildlife.

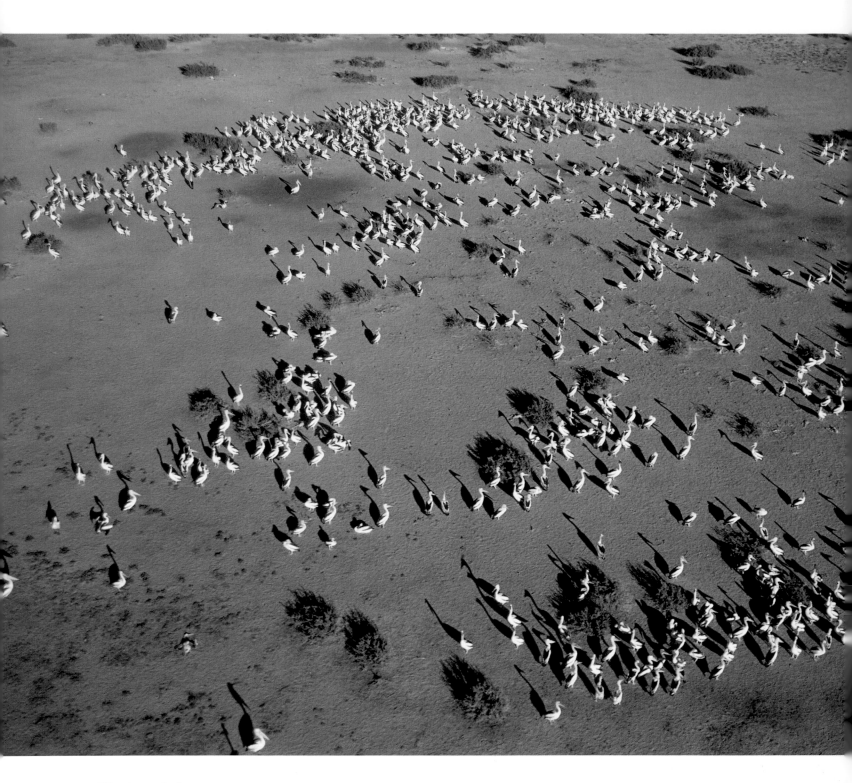

ABOVE **When the water levels are right, vast numbers of pelicans gather at Lake Eyre to nest. The pelicans make a rudimentary nest on the ground and lay one to three eggs. Usually only one chick survives, having outcompeted its sibling(s) for food.**

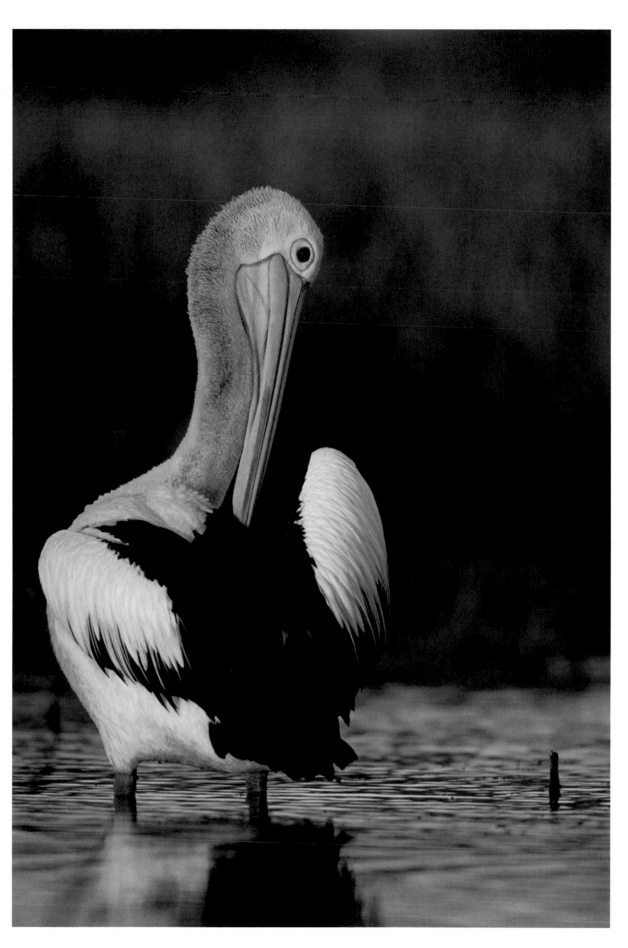

RIGHT Evidence suggests that the pelicans fly here from hundreds of kilometres away, forsaking their normal haunts on the coast to take advantage of the temporary conditions inland. When not feeding, they spend long periods resting and preening.

MIDDLE EAST

The desert occupies a central place in the hearts and minds of people in the Middle East. Traditionally the home of the Bedouin, it has witnessed dramatic changes in recent decades following the discovery of oil in the region. As modernization has rolled across the seemingly infinite dunes and gravel plains, so the local wildlife has been forced into retreat, with many iconic species driven almost to extinction. Conservation efforts are helping redress this loss, from the recently reintroduced Arabian Oryx that now roam the rose-red sands of Wadi Rum to the extraordinary Bald Ibises nesting near Palmyra and the handful of Cheetahs that still stalk the gazelles of the Kavir Desert.

RIGHT Arabian Oryx usually live in small groups and have few natural predators. Wolves and hyenas will occasionally try and take a fawn or sickly animal, but the oryx's speed and impressive horns are more than a match for most such encounters.

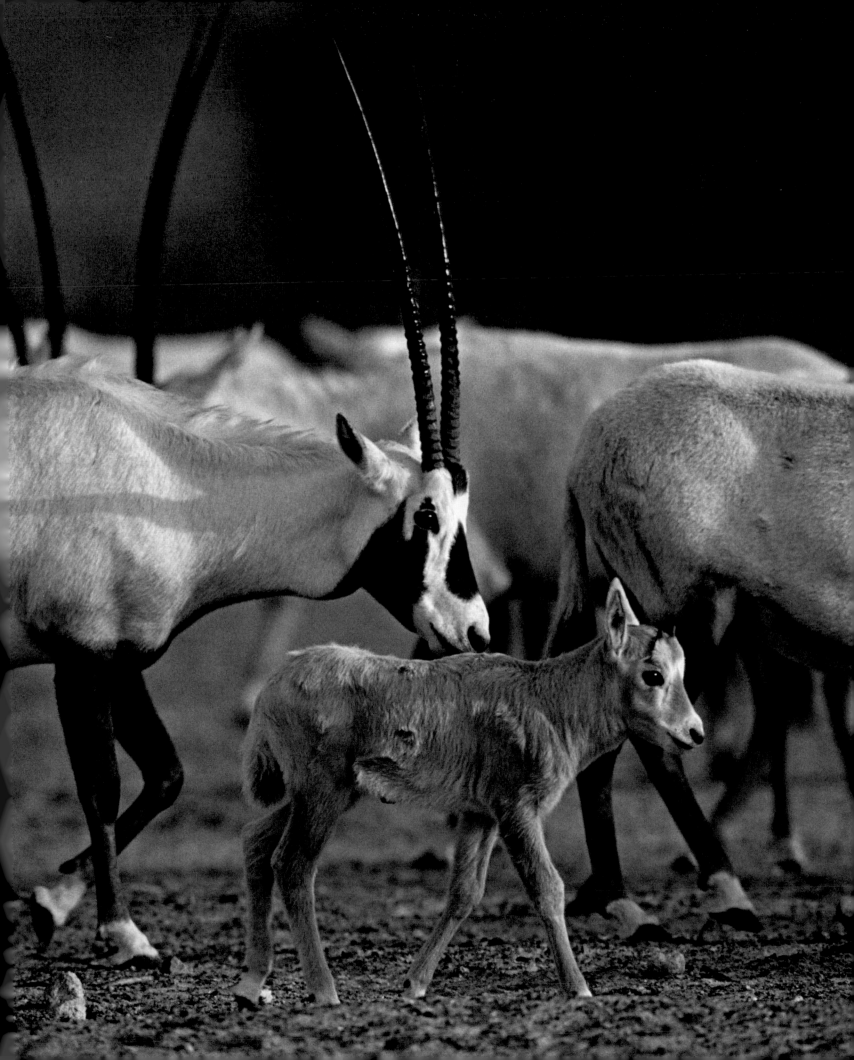

7: Wildlife on the Frontier: Wadi Rum

Few landscapes, regardless of their type, are as worthy of superlatives as Wadi Rum. This spectacular area, deep in the south of Jordan, offers some of the most breathtaking desert scenery anywhere in the world and in many respects is little changed from when TE Lawrence, "Lawrence of Arabia", was active here during the time of the Arab Revolt against the Turks during the First World War. Lawrence was deeply struck by the beauty and majesty of Wadi Rum, recalling how "Deep alleys, fifty feet across, divided the crags, whose plans were smoothed by the weather into huge apses and bays, and enriched with surface fretting and fracture, like design … They gave the finishing semblance of Byzantine architecture to this irresistible place: this processional way, greater than imagination…".

A visit to Wadi Rum today still prompts such responses. The epic scale of the vast sandstone buttresses, reaching 1,700 metres (5,577 feet) at their highest point and towering over the 2 kilometre- (1¼ mile-) wide sandy wadi bed below, is nothing if not overwhelming. The dramatic sculptural qualities of the rock, fissured and carved by millions of years of wind, sand and water erosion, can be mesmerizing, especially at sunrise and sunset. A myriad canyons, enfilades and gullies dissect the vast rocky bastions, forming a maze of corridors and dead-ends that serve as a reminder that this is an extreme landscape, very much at the frontier of human experience and with all the romantic notions that engenders. Furthermore, Wadi Rum supports an interesting diversity of wildlife and encapsulates many of the conservation issues that face deserts today.

Wadi Rum is part of the Afro-Arabian Rift system, perhaps more widely known as the Great Rift. Among the world's most remarkable geological features, it is the only one that can be seen clearly from the moon and at a mere 40 million years old is a relative newcomer, geologically speaking. Extending for 6,500 kilometres (4,000 miles) from Lebanon south to Mozambique, the Rift cleaves its way from the heart of the Middle East down along the Red Sea before suddenly veering due south through the Ethiopian Highlands, Kenya and Tanzania. Strung along its length is an epic chain of dramatic features in their own right, including a sequence of lakes, escarpments and open plains. Indeed, the Great Rift is not a single element but a complex series of separate rift systems that are all interconnected and, indeed, still evolving as the associated tectonic plates continue to shift, grind and jostle their way about.

RIGHT **The majestic red sandstone scenery of Wadi Rum was immortalized in the 1962 film** *Lawrence of Arabia,* **and much of it would still be recognizable to TE Lawrence himself.**

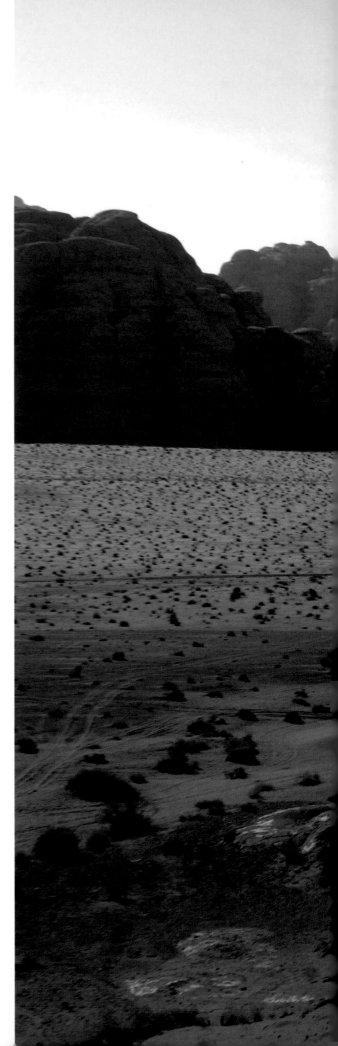

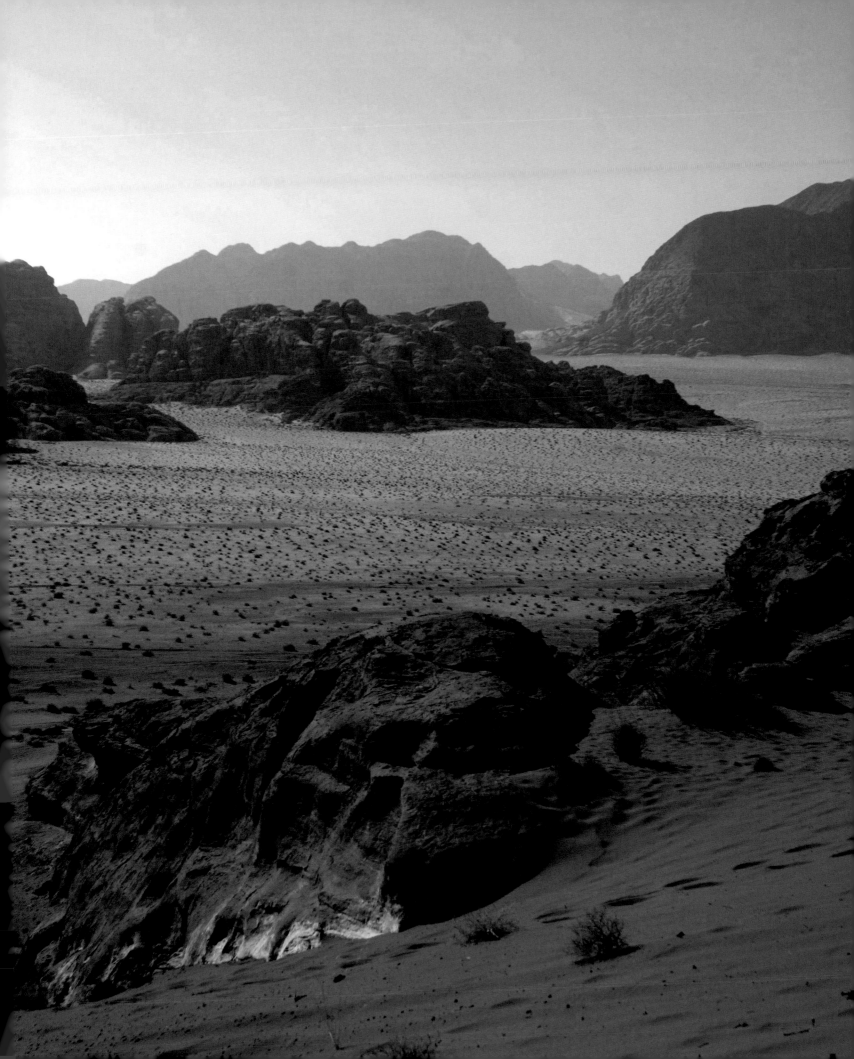

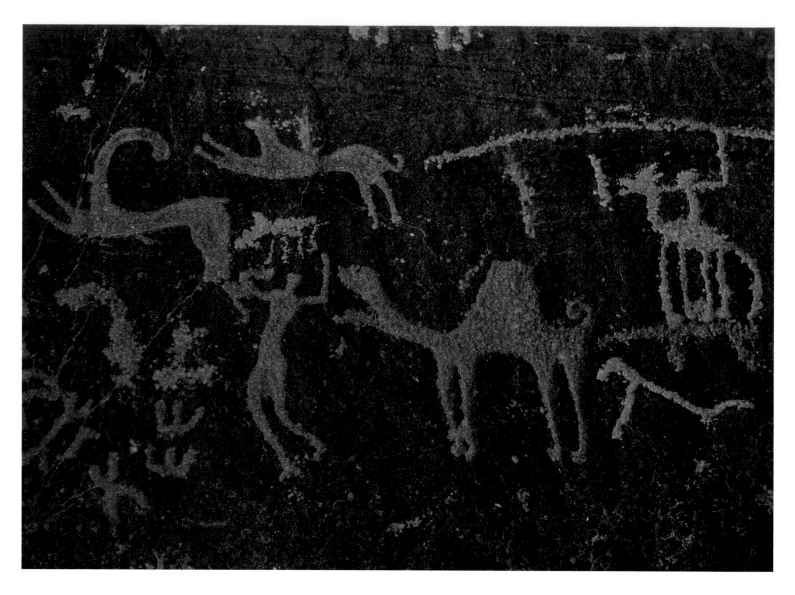

Hundreds of petroglyphs and rock paintings are known from Wadi Rum, giving an insight into the varied wildlife that once lived here. Many depict hunting scenes, showing quarry such as gazelle, ibex and oryx.

With evidence of human presence going back many thousands of years, Wadi Rum was an important centre for the Nabateans, who as early as the sixth century BC were controlling passage along it from their capital at Petra, some 100 kilometres (62 miles) to the north. An important stage in the traditional overland route for the transportation of precious goods from south Arabia, such as frankincense and myrrh, Wadi Rum was strategically vital. It was also a significant site for wildlife, with petroglyphs incised into the rock faces testifying to the historical presence in the area of oryx, ibex and ostrich. In more recent years this part of Jordan, and indeed adjacent parts of Israel, have become celebrated for traffic of a different sort: they sit on one of the world's major flyways for migrating birds, particularly raptors, with many millions of birds funnelling through this narrow neck of land every spring and autumn.

Resident birds at Wadi Rum include many flagship desert species. Up to ten species of wheatear have been recorded, for example, with both Mourning Wheatear *Oenanthe lugens* and White-crowned Black Wheatear *Oenanthe leucopyga* being common breeders. Bar-tailed Desert Lark *Ammomanes cincturus* and Desert Lark *Ammomanes deserti* are also plentiful and best looked for on the sand and gravel plains. One of the most colourful avian residents is the Sinai Rosefinch *Carpodacus synoicus*, another regular breeding species but one that sometimes evades good views. However, patiently staking out a source of water in the early morning or late afternoon can pay dividends, as the birds will often come to drink.

ABOVE The Sinai Rosefinch is Jordan's national bird. It is closely associated with Wadi Rum and also Petra, where it can often be found perching on the dramatic Nabatean ruins. The brightly coloured male contrasts with the dowdy, sandy-brown female.

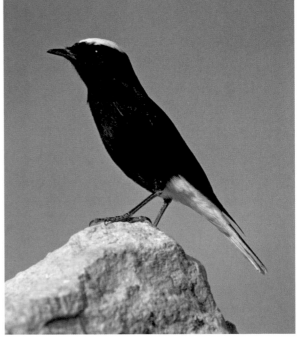

RIGHT AND FAR RIGHT Perched conspicuously on rocks or posts, wheatears are one of the most noticeable birds in Wadi Rum. Both the Mourning Wheatear (right) and the White-crowned Black Wheatear (far right) are commonly seen.

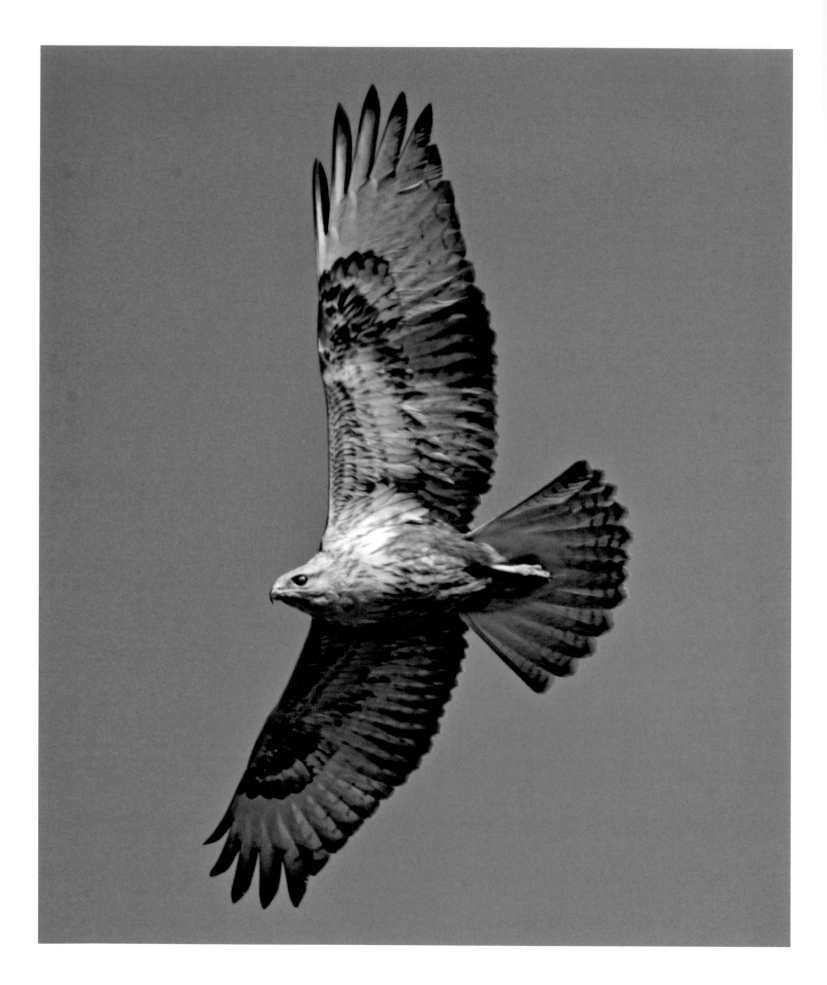

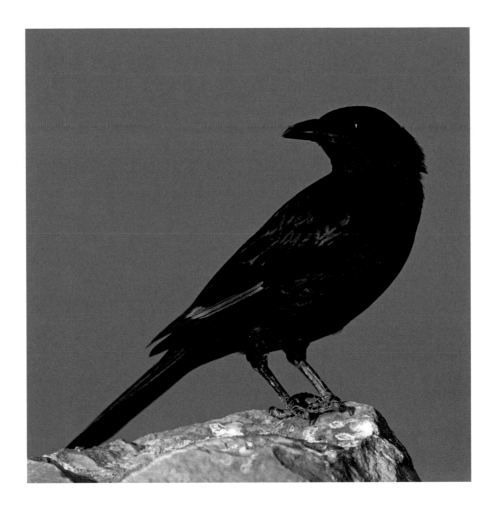

One of the most charismatic bird species locally is Tristram's Grackle *Onychognathus tristramii*, a regular sight as it flies around the rock faces in pairs or small groups. The echo of the grackle's calls in one of the many chasms here is arguably the defining sound of Wadi Rum and the bird itself never fails to disappoint, especially when seen at close quarters. The glossy black plumage is fused with blue and purple, and the rust-coloured primary wing feathers show flashily when seen overhead against a bright sky. One of the most famous locations for this species is Petra, where birds can easily be seen as they wheel around against the magnificent backdrop of the Nabatean ruins.

Birds of prey are well represented at Wadi Rum, with many thousands passing through the area during spring and autumn migration en route to and from their breeding grounds in Eastern Europe/Western Asia and wintering quarters in Africa. At peak season over a thousand birds can be seen in a single day, with three species usually predominant: Honey Buzzard *Pernis apivorus*, Steppe Buzzard *Buteo buteo vulpinus* and Steppe Eagle *Aquila nepalensis*. Over thirty species of raptor have been recorded here in total, including several notable breeding species. These include Common Kestrel *Falco tinnunculus* and Long-legged Buzzard *Buteo rufinus*, the latter often to be seen soaring overhead. There are also several pairs of Sooty Falcon *Falco concolor*, an elegant and dashing raptor that preys almost exclusively on smaller birds and times its breeding cycle so that its young hatch just as the annual southward passerine migration begins, thereby ensuring a plentiful supply of food for its chicks. Also present in small numbers are Short-toed Eagles *Circaetus gallicus*, which started breeding here in the early 1990s for the first time in Jordan in over a century. This species feeds primarily on snakes, and can sometimes be observed hovering over rocky slopes searching for potential food items as they bask in the sun.

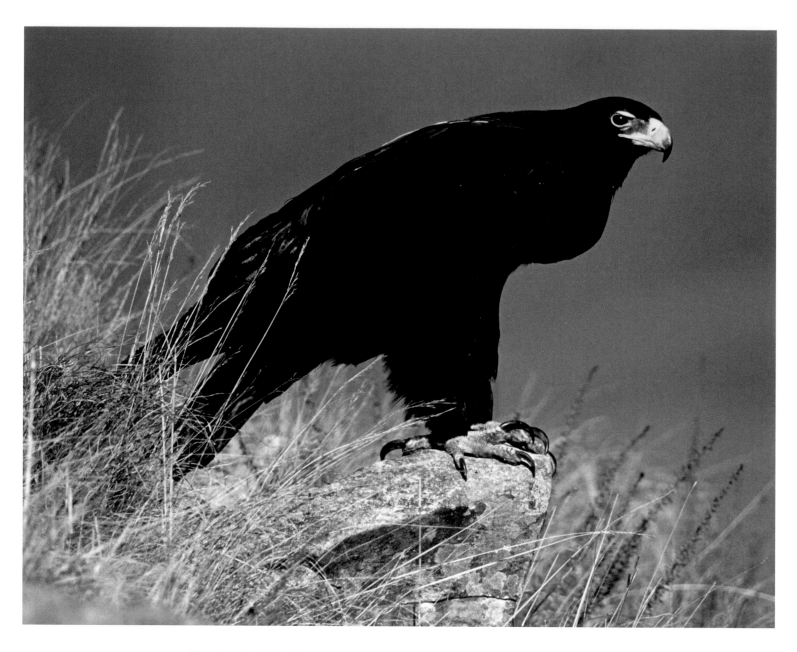

Verreaux's Eagle is hard to spot anywhere in the world, but especially in the Middle East where it is highly localized and probably declining. Although pairs are usually loyal to their breeding sites, they will not tolerate disturbance.

Top of any birder's list, however, is probably Verreaux's Eagle *Aquila verreauxii*. This magnificent bird is thinly distributed across the mountainous areas of Arabia but numbers everywhere are very small and records are erratic, to say the least. Years may go by without any evidence of their presence in a particular location and then suddenly a pair will take up residence. While Wadi Rum is a traditional site for this species, it appears that only a single pair is present and they sometimes disappear for long periods. Breeding does not take place here every year, underlining the vulnerability of this species to factors such as disturbance and changes in its food supply. It is believed that the eagles at Wadi Rum feed primarily on Rock Hyrax *Procavia capensis*, but much remains to be established about this raptor and its requirements.

Three species of owl are known to be resident at Wadi Rum, including the elusive and enigmatic Hume's Tawny Owl *Strix butleri*. This strictly nocturnal species is restricted to rocky areas in the deserts of the Middle East but is almost certainly under-recorded and may well be more common than records suggest. Little is known of its ecology and behaviour and there is only one record of its nest. Finding this species in Wadi Rum is reliant, as with most nocturnal birds, on familiarizing oneself with its call and then carefully searching likely perches with a torch.

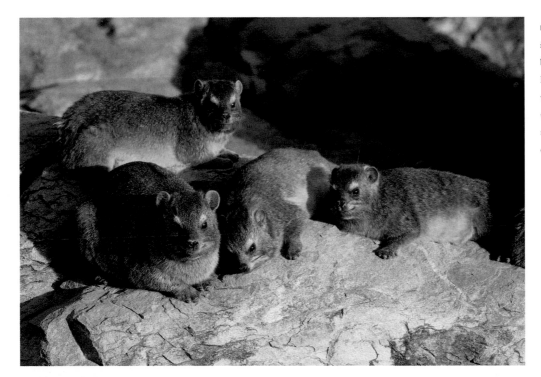

LEFT Hyrax are widely distributed in the mountains of Wadi Rum, but they are not easy to see. Best located by their distinctive whistling alarm calls, they live in small family groups and spend much of their time sunbathing on rocky ledges.

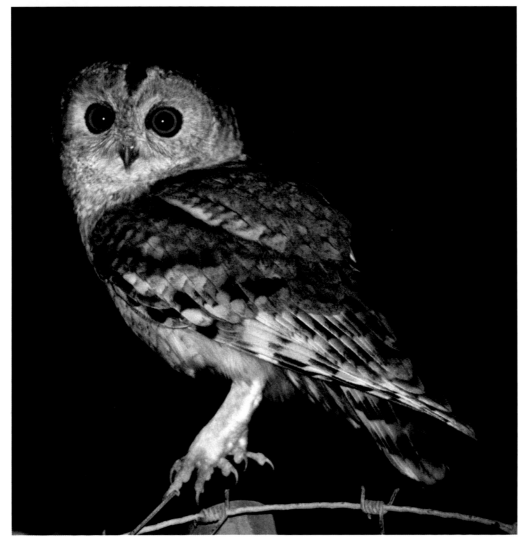

LEFT Although one of the hardest birds to see, Hume's Tawny Owl is proving to be more widely distributed than previously believed. It is certainly present in Wadi Rum, and increasing numbers are being recorded elsewhere in the region.

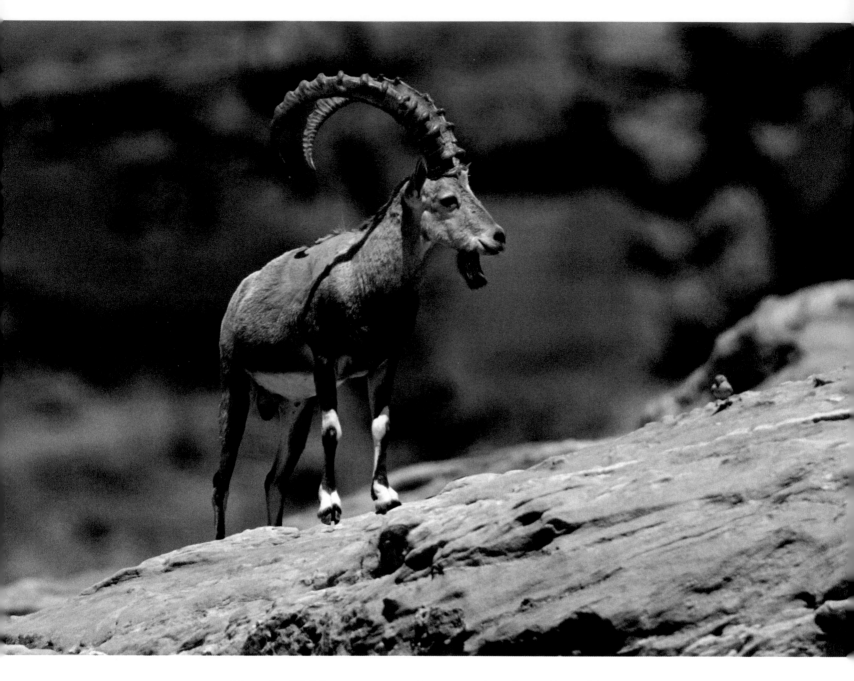

ABOVE **Mature male Nubian Ibex sport an impressive pair of horns. These are used most dramatically in the annual rut in aggressive tussles between rivals. Ibex usually live in small groups and rarely leave the rocky slopes above the wadi floor.**

Mammals in Wadi Rum are, as in many desert regions, limited in numbers and diversity. Many of the larger species once found here have either become extinct or their numbers severely depleted as a result of overhunting. A few decades ago Dorcas Gazelles *Gazella dorcas* were a common sight, but a mere handful now remain, found only in the remoter parts of the area. The Arabian Oryx *Oryx leucoryx* also once roamed the wadi, but was extinct in Jordan by 1940. The only large ungulate to survive in Wadi Rum was the Nubian Ibex *Capra nubiana*, its preference for precipitous terrain largely inaccessible to humans helping ensure that it managed to avoid the hunter's gun more often. Although it remains not uncommon here, numbers are falling, probably as a result of illegal hunting.

As the area's ungulate populations were decimated, so the predators that depended on them came under increasing pressure. Not only was their prey base disappearing but they were also directly persecuted by humans. This was particularly the case with Wadi Rum's former top predator, the Arabian Leopard *Panthera pardus nimr*. Until the mid-twentieth century this beautiful cat was apparently quite common in and around Wadi Rum. It was an animal of the

BELOW The smallest subspecies of leopard, the Arabian Leopard, is facing extinction in the wild. It has vanished from much of its formerly extensive range and survives in only a handful of locations. Captive breeding programmes may help, but only if a suitable habitat can also be preserved.

mountains rather than the open desert, but was driven to almost certain local extinction before scientists were able to study it in any detail. Fearful of potential attacks on their increasing numbers of livestock, local Bedouin regularly shot and trapped the leopards, which traditionally would have preyed on ibex. However, as those animals declined due to overhunting, so leopard attacks on sheep and goats became more frequent. The conflict this prompted with local livestock owners could have only one winner. The combination of too little prey and constant harassment and persecution therefore appears to have wiped out the leopard in Wadi Rum, although there have been unconfirmed reports in recent years of leopard tracks and scat. So it is just possible that a very few survive in the remoter rocky areas.

The Arabian Leopard is under severe pressure across its entire Middle Eastern range. Probably fewer than 200 survive in total, scattered widely and in small populations. These are located in Israel, including up to ten in the Negev Desert and even fewer in the Judean Desert, as well as in Saudi Arabia, Yemen and Oman. Nowhere do numbers appear to be doing anything other than holding their own at best, and there is concern that some of the smaller and more isolated populations are no longer genetically viable. As the region's human population has expanded, so the Arabian Leopard has been forced to retreat. Its future almost certainly lies with the captive breeding programmes that have already been set up to ensure that it does not become extinct.

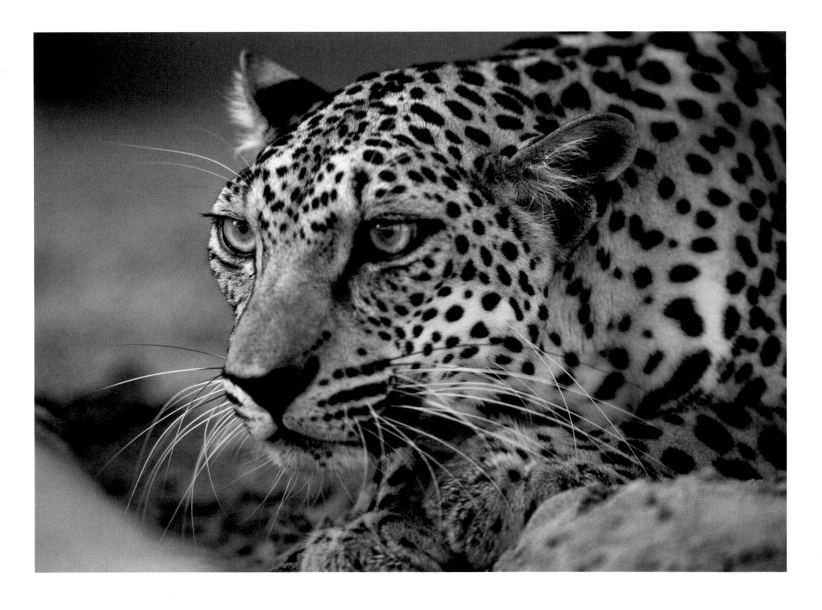

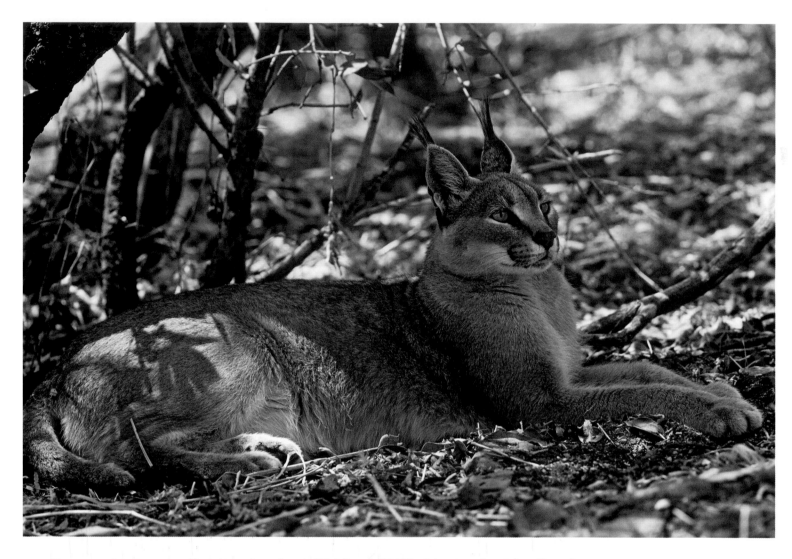

The other main predator in Wadi Rum is Wolf *Canis lupus*, another victim of heavy human persecution. Wolves have traditionally been shot on sight by local people, who also lay traps and poisoned bait for them. The indiscriminate nature of these practices has a potential impact on other predators such as Striped Hyena *Hyaena hyaena* and Caracal *Caracal caracal*, as well as animals of no possible threat to livestock, such as Sand Cat *Felis margarita*. Meanwhile, evidence suggests that the trapping and shooting of gamebirds such as Chukar *Alectoris chukar* and Sand Partridge *Ammoperdix heyi* is suppressing their respective populations, as there is plenty of available habitat. The illegal shooting of ostensibly protected species remains a problem; in a particularly depressing episode a few years ago, the body of one of the sole breeding pair of Verreaux's Eagles at Wadi Rum was dumped outside the office of the Royal Society for the Conservation of Nature in Rum village.

Such incidents exemplify the dilemma of desert wildlife conservation. In a few decades the once plentiful populations of mammals and large birds once found in the Middle East have been reduced to a fraction of their former numbers, while human attitudes have remained in a time lag from which they are only now slowly emerging. Traditional antipathies to predators such as raptors, Leopard and Wolf can be difficult to overcome, as can the view that ungulates such as gazelles and ibex are anything other than good eating. Simultaneously, man's impact on wildlife has increased dramatically, from the use of pesticides on intensively managed farmland through the overgrazing of desert and sub-desert habitats to the increased availability of firearms and

BELOW Tolerant of highly arid conditions, the Striped Hyena is nocturnal and rarely seen. Most records of it in the Wadi Rum area relate to tracks and anecdotal sightings. Hyenas are persecuted because of the perceived threat they pose to livestock, but attitudes are changing.

motor vehicles in hitherto remote areas. This has been a time of change also for the local people of Wadi Rum, who in a few years have moved from a largely nomadic existence to one of semi-permanent settlement.

Yet there is heartening evidence that attitudes here are gradually changing. Over 700 square kilometres (270 square miles) are now covered by the Wadi Rum Protected Area, designed as the vehicle through which sustainable ecotourism can be developed in the area and new opportunities created for local people to benefit from the protection of nature, including working as guides and wildlife protection wardens. Conservation measures are bearing fruit, and in 2009 twenty Arabian Oryx were released into the wild at Wadi Rum as part of a long-term reintroduction project. The sight of these iconic animals galloping out of their pens into freedom in the open desert could not fail to offer hope for the future.

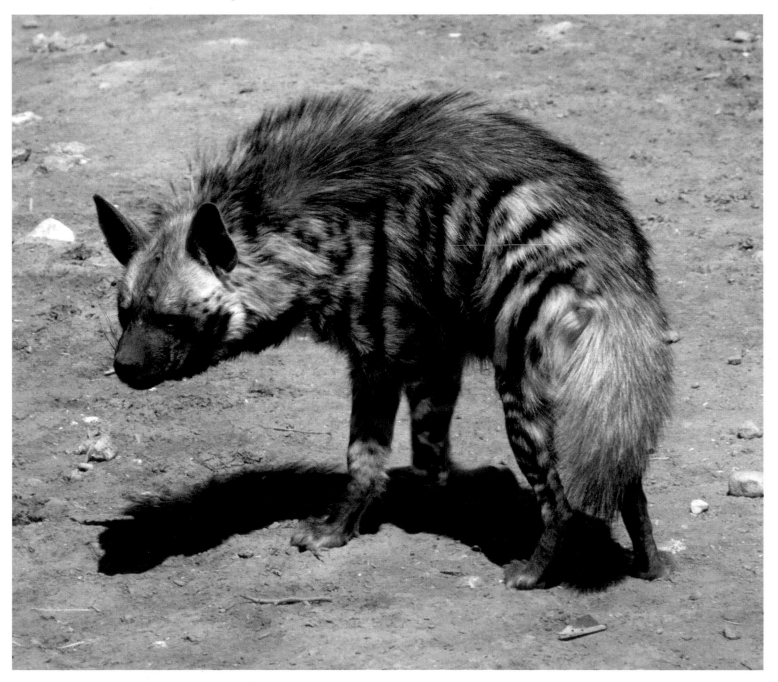

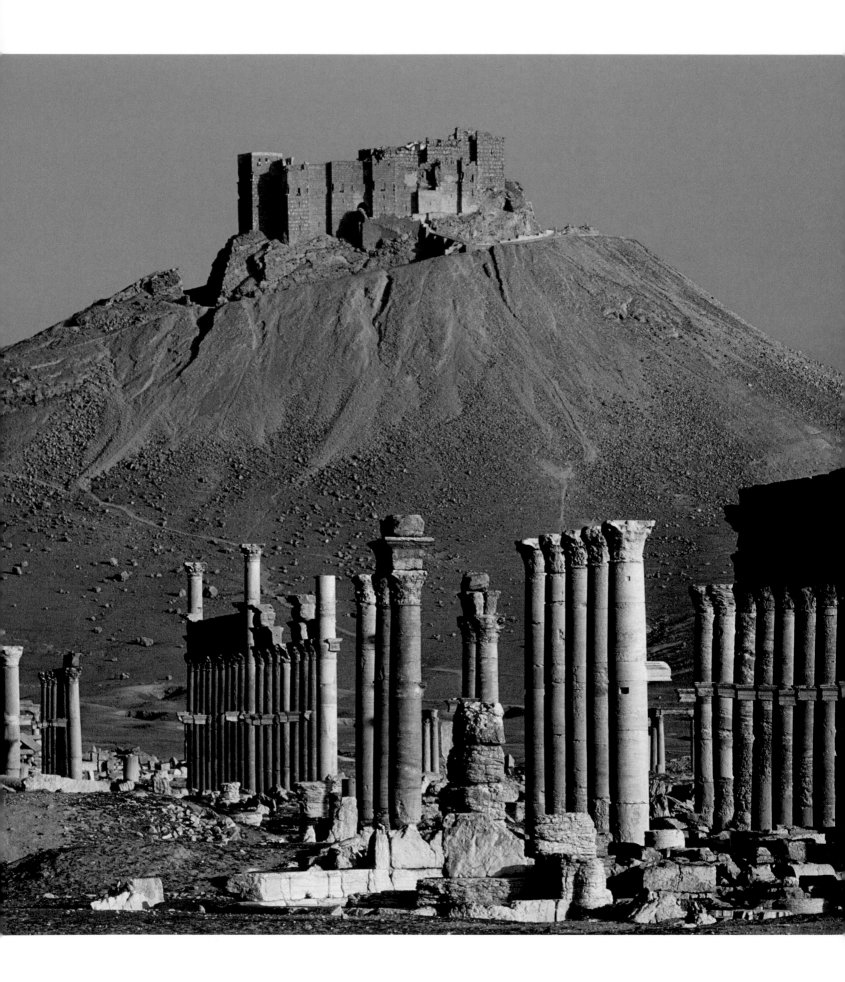

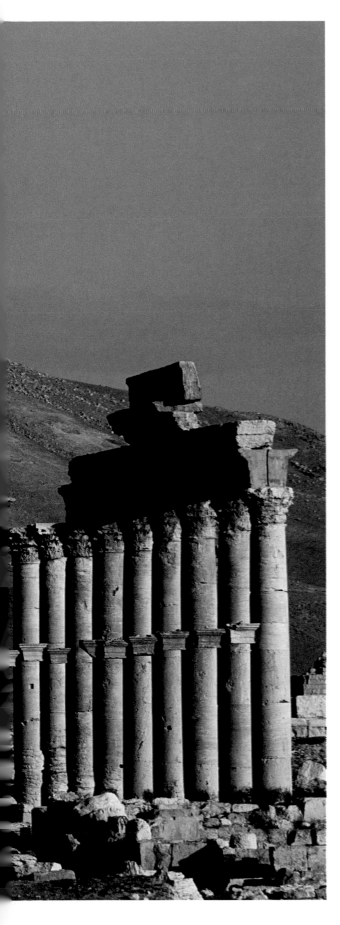

8: The Lost Ibises of Palmyra

In 2002 one of the most remarkable events in recent ornithological history took place. News was released concerning the discovery of a relict breeding colony of Northern Bald Ibis *Geronticus eremita*, deep in the heart of the Syrian desert and hitherto unknown to science. This bizarre-looking bird was once found in parts of the European Alps and across North Africa and the Middle East, but by the early 1990s it had declined to the point at which fewer than a hundred pairs survived. These were divided into two populations: one in Morocco, where wild birds were living in a small number of scattered colonies, and the other at Birecik in Turkey, where the progeny of a formerly large wild colony were maintained in semi-captivity in a last-ditch attempt to rescue them from extinction. The two populations were regarded as ecologically and morphologically distinct from each other, one of the most obvious differences being that the eastern population was naturally migratory whereas that in Morocco was sedentary.

Historically the Bald Ibis was widely distributed in Syria but was considered to have become extinct there by the 1950s, mainly as a result of overhunting. The sole remaining eastern population was therefore believed to be that at Birecik. The last wild birds had died out here in 1989, but a controversial captive breeding programme nearby had at least ensured that the species survived locally. During the winter months the birds, which currently number about 60, are kept in large aviaries; they are released each spring and nest on nearby cliff ledges. They show no signs of moving far from the vicinity and appear to have lost the ability or inclination to migrate.

However, the continued appearance of occasional birds in Eritrea, Saudi Arabia and Yemen during the 1980s and '90s indicated that a wild colony almost certainly persisted somewhere in the Middle East. Exactly where remained unknown until April 2002, when seven birds were found nesting on cliffs near the celebrated ancient city of Palmyra, in the middle of the Syrian desert. Field surveys had been carried out in earnest early that year following reports from Bedouin nomads and local hunters that indicated that the species still survived in the area. Up to three pairs were breeding at the site at that time, but despite a total of over 20 young fledging in the years that followed, by 2010 the total population had fallen to just three birds.

One of the reasons for this decline was the failure of the immature birds to return to the breeding site each spring after their inaugural migration south. The seasonal movements of the eastern population of the Northern Bald Ibis had puzzled scientists for years, but satellite-tagging studies of the adult Syrian birds now indicate that they migrate down the Red Sea and winter in the highlands of Ethiopia, a 6,000 kilometre (3,800 mile) annual round trip. Where the young birds of each year spend the winter is still unclear, but they do not appear to congregate or return with the adults. These migratory habits make the Syrian ibises highly vulnerable, as it is impossible to ensure adequate protection for them over the entirety of their migration route. Indeed, one young Syrian bird was tragically shot in Saudi Arabia in September 2009 on its way south, and three birds released from the Birecik colony were electrocuted when they alighted on power pylons in Jordan the previous year.

LEFT The magnificent ruined city of Palmyra, once ruled over by Queen Zenobia and conquered by the Romans, lies at the heart of the Syrian desert. Herds of wild ass, gazelle and oryx were once a common sight here, but were wiped out by overhunting.

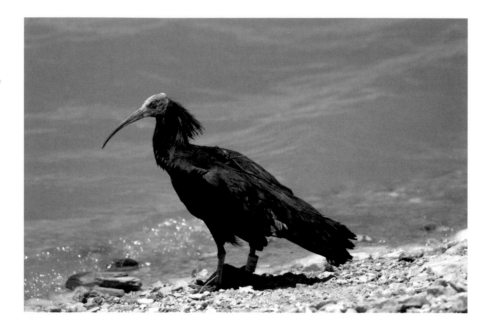

The discovery of breeding Bald Ibises in the middle of the Syrian desert in 2002 shook the ornithological world. Knowledge of their migratory habits is currently imprecise, so ringing and satellite tagging are being used to track their movements.

With the Syrian population of Bald Ibises having probably fallen below the point of viability, conservationists are looking at ways in which human intervention might help. In a high-profile political gesture between the governments of Syria and Turkey, six ibises were brought from Birecik in 2010 to help bolster the fragile breeding population at Palmyra. Should this colony regain its strength, there are certainly possibilities for range expansion. Fieldwork indicates that there are as many as 15 former nesting sites in the general area of the sole surviving colony and that these supported hundreds of Bald Ibises as recently as the 1960s. It was a fatal combination of intense hunting pressure, the indiscriminate use of pesticides and the overexploitation of the surrounding rangelands on which the birds feed that drove them to the brink of extinction.

This picture is replicated across much of Syria, which was once rich in wildlife. Until the mid-nineteenth century the Syrian desert supported large herds of wild ass – the Syrian Onager *Equus hemionus hemippus* – as well as gazelles *Gazella* sp., Arabian Oryx *Oryx leucoryx* and Arabian Ostrich *Struthio camelus syriacus*. Although traditionally hunted by the local Bedouin, all these creatures were able to survive the relatively low levels of subsistence hunting to which they had been subject for thousands of years. This situation was to change dramatically with the advent of motorized transport and improved firearms. Suddenly the desert became less remote, and even the swiftest of animals was incapable of outrunning a car. The levels of butchery became intense and reached a peak in the years immediately during and after the First World War, when the region was overrun by vehicles and military personnel. Numbers of gazelle were decimated, the Arabian Oryx was hunted to local extinction and the last wild Syrian Onager was shot in 1927 as it approached a waterhole. This species became totally extinct shortly thereafter when the last specimen died in a European zoo.

The Arabian Ostrich followed the same fate a few years later. Today the Syrian desert plains are largely devoid of large mammals and much of the habitat is seriously degraded, mainly as a result of overgrazing by domestic livestock. Hunting remains a major conservation concern here, with large numbers of illicitly held firearms and the widespread shooting of birds and other wildlife. There are also depressingly high levels of illegal trapping, using mist nets, in the desert oases around Palmyra – and, indeed, across many parts of the Middle East and the eastern Mediterranean. In Syria alone this so-called "fig-bird" trade probably accounts for several hundred thousand of birds every year. "Fig-birds" are served as delicacies in restaurants across the Middle East and demand is such that this is big business, with refrigerated lorries transporting the dead birds every day from central collection points. Many of the victims are migratory species passing

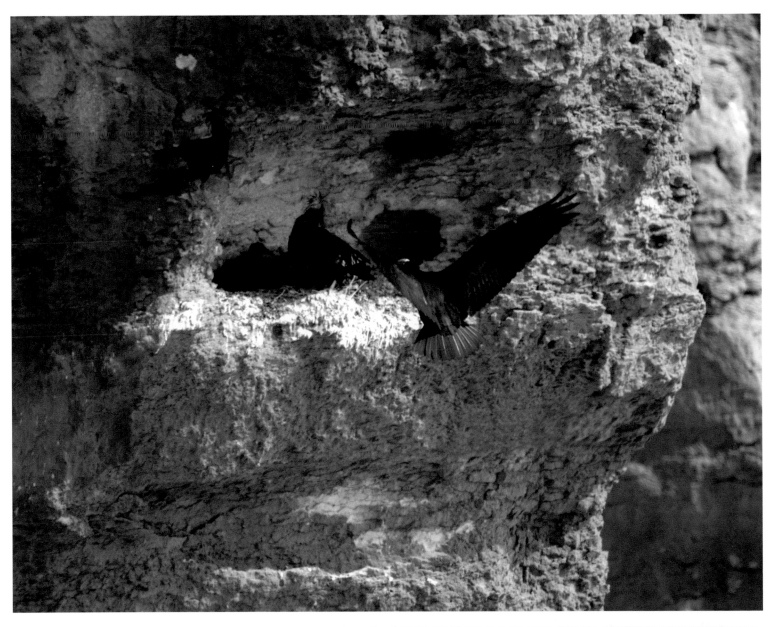

ABOVE The handful of Bald Ibises nest on a remote cliff face. While chicks are raised successfully most years, they face many hazards and mortality rates during migration are high. Only human intervention will boost numbers in the wild Syrian ibis colony.

RIGHT A basket of "fig-birds", netted in a Syrian oasis and destined for the table. The trapping and shooting of birds is a problem across much of the Middle East and Mediterranean. Improved environmental awareness should help reduce the death toll.

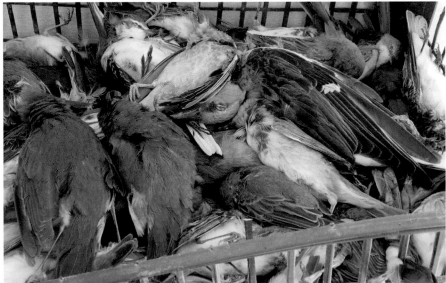

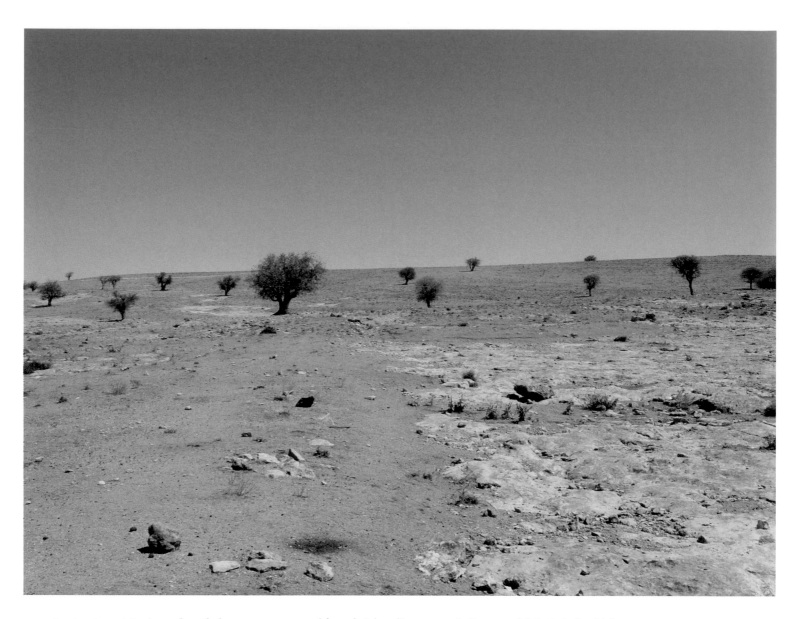

ABOVE Once heavily wooded with Wild Pistachio, the hills north of Palmyra were cleared of most trees decades ago. Overgrazing by domestic livestock is preventing regeneration. As a result, the area is desertifying and urgent conservation measures are required.

through the area en route to and from their breeding quarters in Europe and Asia, including birds such as Golden Oriole *Oriolus oriolus*, Nightingale *Luscinia megarhynchos*, Common Redstart *Phoenicurus phoenicurus* and Blackcap *Sylvia atricapilla*.

However, there are grounds for a potentially more hopeful future. The discovery of the Bald Ibis in Syria has galvanized conservation within the country and added support to initiatives already underway in the country's first operational protected area at Al-Talila, for example. Established in 1991 as a way of rehabilitating an important tract of the *badia* or Syrian steppe, protecting local wildlife (including the reintroduction of vanished species) and exploring the possibilities of supporting local communities through ecotourism, this flagship reserve lies 30 kilometres (18⅔ miles) south-east of Palmyra.

The fate of the *badia* rangelands, which cover approximately half of Syria, continues to be a source of conservation concern. Traditionally inhabited by subsistence pastoralists and their flocks of sheep, this fragile ecosystem is characterized by flat or undulating plains covered in small shrubs and annual grasses, with seasonal wetlands and some areas of rocky outcrop and upland plateaux. Although rainfall averages about 120 millimetres (4¾ inches) per annum, it is highly erratic, with hardly any rain falling in some years and then perhaps as much as 200 millimetres (8 inches) or more over the next twelve-month period. The amount of vegetation was historically variable, therefore, but in recent decades both the density and diversity of plant cover has been

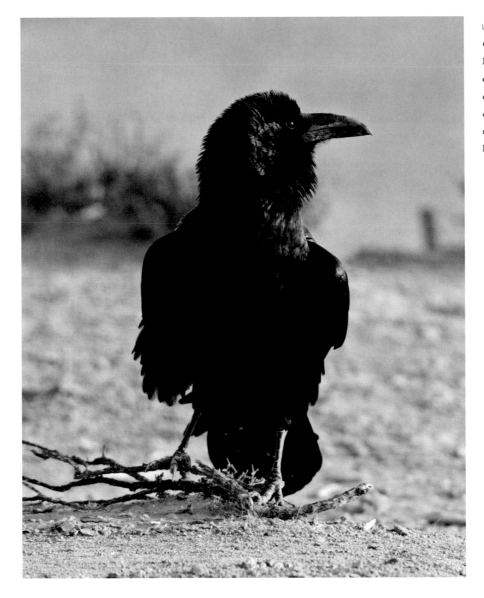

LEFT **The Brown-necked Raven** *Corvus ruficollis* **is a classic Middle Eastern desert bird. It is often seen soaring overhead and calling raucously. Their varied diet ranges from berries, small reptiles and invertebrates to sickly lambs and roadkill.**

severely compromised by a massive increase in the number of sheep grazing the *badia*, up fivefold between 1950 and 1998, for example.

Meanwhile, the human population has also increased greatly and brought additional pressures to bear. For example, the widespread and uncontrolled sinking of wells is damaging the water table and affecting the distribution and condition of the indigenous vegetation. Equally, the *ad hoc* cultivation of the *badia* – particularly to grow barley, a practice that is now banned – has seriously degraded many areas. Owing to the proliferation of motorized vehicles, much of the steppe is now subject to off-road driving, which can destroy vulnerable plant communities and disturb sensitive species of mammal and bird. Illegal hunting and the persistent and indiscriminate use by local shepherds of poisoned bait, ostensibly to kill wolves, also continue to have a negative impact on a wide range of wildlife. The overexploitation of natural resources is also a major issue: extensive areas of scrub cover (particularly of Wild Pistachio *Pistacia atlantica*, one of the largest tree species found locally) are cleared for use as firewood and are often uprooted rather than sustainably harvested. This exposes the soil below to the erosive effects of wind and water.

The combination of overgrazing and removal of vegetation is causing acute desertification across much of the *badia*. With every passing year, an ever-shrinking area of vegetation is called upon to sustain a constantly increasing number of livestock. Levels of biodiversity and agricultural productivity have both fallen markedly, and most conservationists consider that a critical point

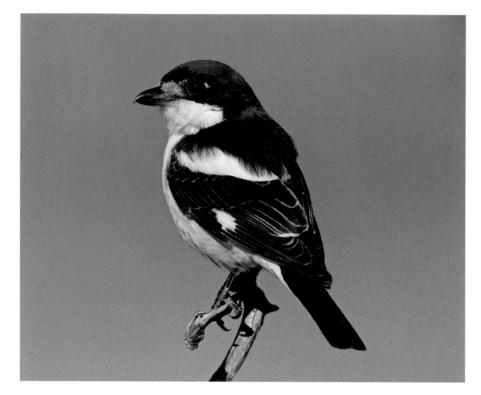

RIGHT Spring and autumn bring a wealth of birds travelling through Syria. Isolated patches of desert vegetation often contain migrants that have stopped off to rest and feed. These include many warblers and up to six species of shrike, such as the Woodchat Shrike *Lanius Senator* pictured here.

has now been reached. Sadly, this is not before many of the iconic wildlife species dependent on the *badia* landscape have either passed into extinction or declined to the point of extreme rarity. Meanwhile, the nomadic lifestyle and cultural heritage of the local human population have also been compromised by the degradation of their environment, with people as much affected as the wildlife alongside which they have lived for thousands of years.

However, at Al-Talila efforts to restore the *badia* and rebuild its ecosystem are yielding fruit. Habitat restoration initiatives such as re-seeding, replanting and sustainable grazing management are changing the scoured and barren character of the overgrazed landscape of the 1980s to one rich in the diverse types of vegetation that older local inhabitants remember from several decades ago. This transformation has made possible the reintroduction to the reserve of both Sand Gazelle *Gazella subgutturosa marica* and Arabian Oryx, the latter being the first of their species with the prospect of living wild in Syria for over half a century at least. Perhaps most critically, the involvement of local people has been central to the reserve's establishment and management. Traditional camel-grazing rights, for example, have been respected and built into the reserve's management plan, and an environmental education centre has been built to explain and interpret the local ecosystem and natural history to local residents and outside visitors alike. Those responsible for protecting Al-Talila, its habitats and wildlife are recruited from local communities and in some cases include ex-hunters, now persuaded that wildlife can be of more value to them alive than dead.

The discovery of the Syrian Bald Ibises in particular has demonstrated the potential value of ecotourism in the *badia*. Increasing numbers of overseas naturalists are now visiting Syria and helping to strengthen the country's nascent conservation movement. Further discoveries – such as the sighting in March 2007 in the north of the country of over 1,500 Sociable Lapwings *Vanellus gregarius*, a "Critically Endangered" species which only a few years previously was believed to have a world population of only a few hundred – have served not only to underline Syria's great appeal as a wildlife tourism destination but also emphasize the importance of scientific research in a country where clearly much remains to be discovered.

RIGHT There are generally few birds in the desert, but it is the place to look for larks. The Temminck's Lark *Eremophila bilopha* is a common sight on the stony plains of Al-Talila. The male's distinctive "horns" come with his summer plumage.

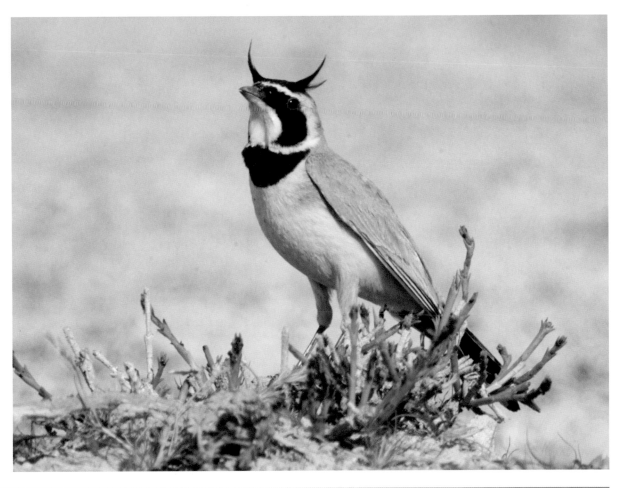

BELOW The *badia* steppe in Syria is home to a substantial migrant population of the very rare Sociable Lapwing. This recent discovery has underlined just how important the country is for birds, offering real potential for the development of ecotourism.

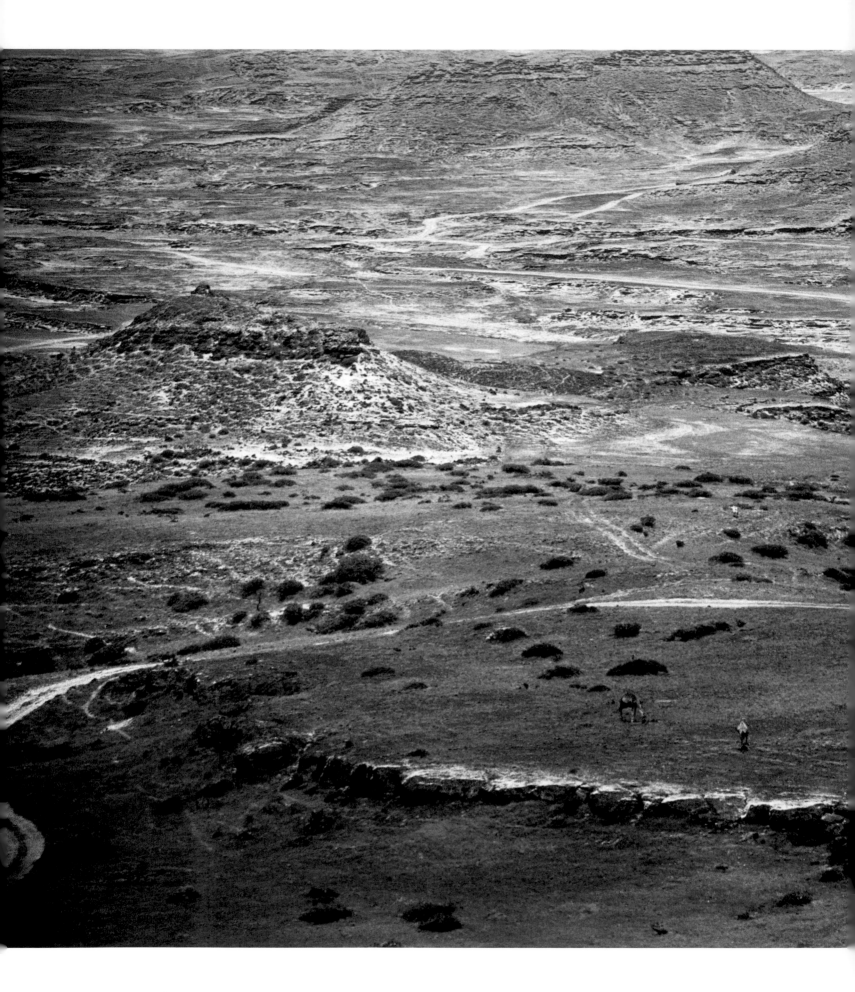

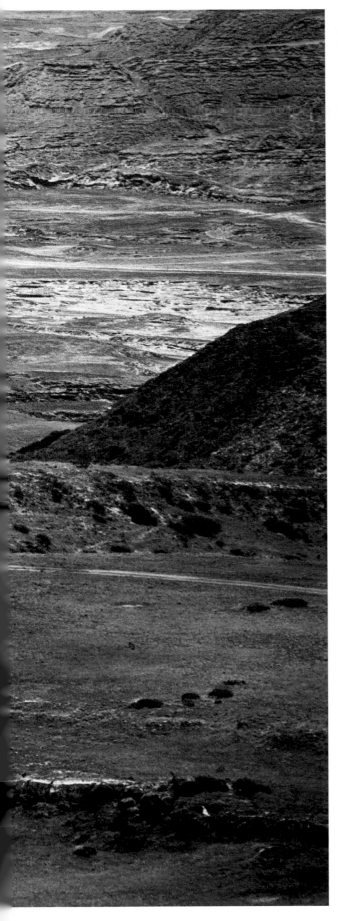

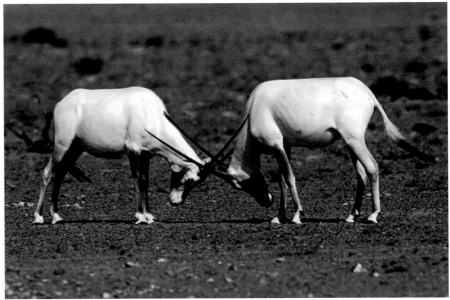

9: The White Oryx of Arabia's Empty Quarter

First described to science by the German naturalist Peter Simon Pallas in 1777, the Arabian Oryx *Oryx leucoryx* has always enjoyed a special, almost magical, status. Able to survive in the harshest of environments, to go without water for weeks, and with the ability to seemingly disappear at will into the desert, this striking antelope was traditionally revered by the Arabs for its resourcefulness and stamina. It also carried associations with virility and played an important role in Bedouin folklore. This potent mix of imagery fuelled the imagination of the first Europeans to explore Arabia, who saw in the fabled oryx a vision of the unicorn, an almost mythical white animal with a horn (or two). In more recent times the oryx became a conservation icon, rescued from the brink of extinction and symbolic of man's efforts to help save his environment.

Historically found across much of the Middle East, from present day Iraq and Syria south into the vastness of the Arabian Peninsula, the Arabian Oryx is supremely adapted for life in the open desert. Its white coat reflects solar rays, helping keep the animal cool in summer. During the colder winter weather, the white hairs stand on end, revealing the black skin below, which then absorbs warmth from the sun. Oryx cope readily without drinking for extended periods, deriving enough moisture from the vegetation they eat. Splayed hooves allow them to pass easily over soft sand and also serve as effective shovels, for the digging of hollows in the sand in which to shelter from sandstorms. They have few natural predators, with only the Wolf *Canis lupus* posing a real threat and only then to young or sickly animals. A fully-grown oryx can inflict serious injuries with its horns should it get caught.

LEFT **Much of Oman is extremely arid, but the southern fringe has an annual monsoon called the Khareef. For a few weeks the landscape is transformed by fresh vegetation. The boundary between the rainfall zone and the desert beyond can be seen here.**

ABOVE **Arabian Oryx usually live in small herds comprising a mature male and a few females, accompanied by their young. Sub-adult males are often solitary, but will sometimes join with others to form a bachelor herd. Male oryx frequently spar with each other.**

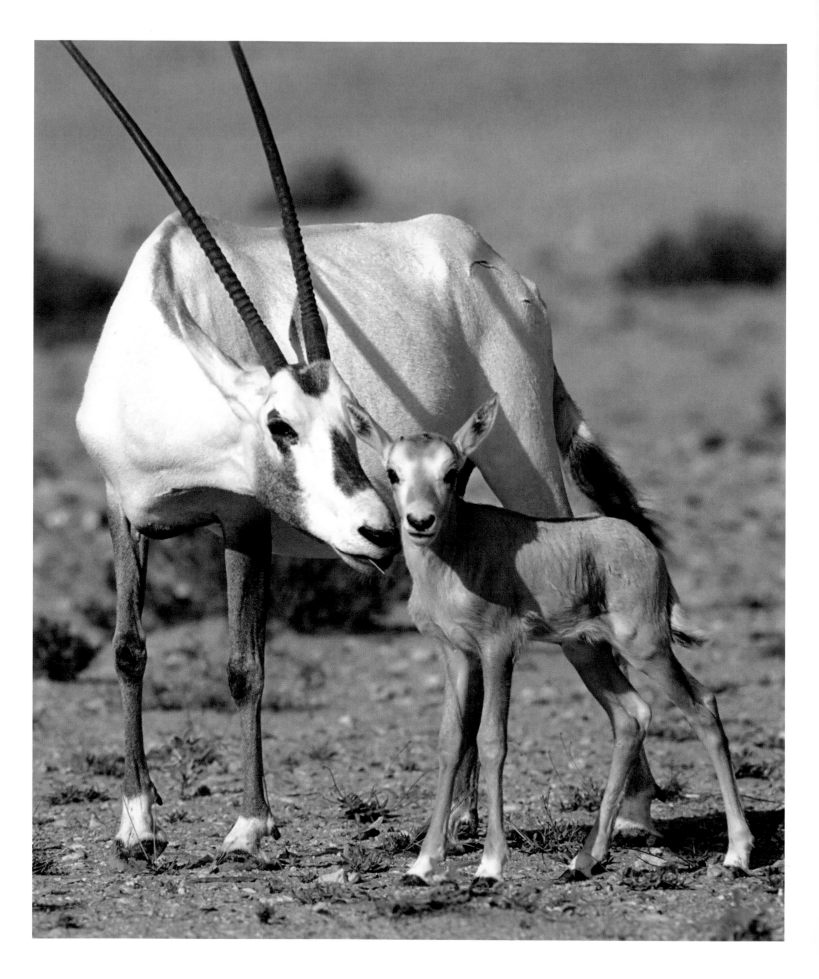

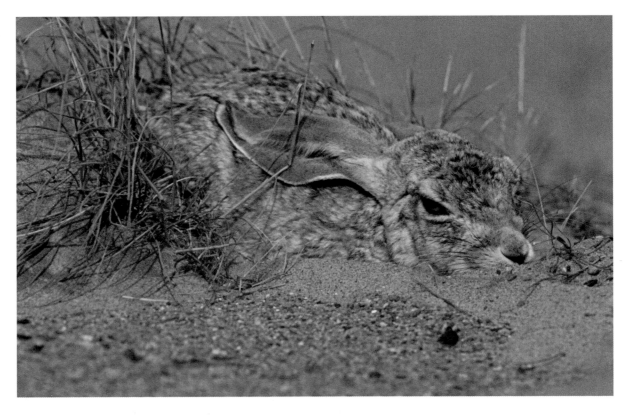

OPPOSITE Oryx breed once a year
if conditions are good, and usually
give birth to a single calf. The
sandy-brown coat camouflages
the calf while its parent goes off
to graze. Young oryx are quickly
on their feet after birth and soon
able to keep up with the herd.

The final heartland of the oryx was the Rub al-Khali or so-called Empty Quarter. This central region of the Arabian Peninsula is not only the world's most extensive sand desert – it covers an area roughly the size of France, and in places the dunes are over 300 metres (1,000 feet) high – but it also includes tracts of inhospitable gravel and pebble-strewn plain, as well as salt flats or *sabkhas*, its huge expanses punctuated periodically by rocky outcrops. Conditions between April and October are fierce, with temperatures in the shade – of which there is precious little – rising to 50°C (122°F) or more; the sand temperature can reach as high as 80°C (176°F). The dunes of the Rub al-Khali often run for many kilometres in parallel lines, fashioned and trammelled by the prevailing winds and constantly changing colour in a palette of oranges, reds, purples and pinks. Given the aridity of the region – in some places it may not rain for two decades or more – the vegetation is unsurprisingly limited. Diversity levels are low, with only half a dozen or so plant species typically present in those locations able to sustain life at all. Most plants maintain the long root systems required to reach down below the surface of the sand, where evaporation levels are very high, to the little moisture that exists in the subsoil.

Despite these unpromising conditions, there is a variety of interesting wildlife here, much of it mainly active at night. Larger mammals include Mountain Gazelle *Gazella gazella* and the much scarcer Sand Gazelle or Rheem *Gazella subgutturosa marica*; Cape Hare *Lepus capensis* and Rüppell's Sand Fox *Vulpes rueppelli* are widespread and common, the latter feeding largely on rodents and invertebrates. Much less regularly recorded, and highly localized, is the Caracal *Caracal caracal*, now the largest cat species present in the deserts of central Arabia following the regional extinction of the Cheetah *Acinonyx jubatus* in the first half of the twentieth century. The Leopard *Panthera pardus* still just about hangs on elsewhere on the Peninsula, but is not found in the Rub al-Khali. The Wolf is still present, however, but is very rarely seen. The race found in Arabia is generally recognized as a separate subspecies, *Canis lupus arabs*, and is smaller and paler than most other Wolf races. It also has different habits, rarely occurring in packs larger than four or five and often found singly or in pairs. The purity of some Arabian Wolf populations has been called into question, as their brown eyes denotes likely interbreeding with feral dogs (a pure Wolf will always have yellow eyes).

RIGHT Hares are common in the
desert, but usually only seen when
they are flushed from a clump of
grass or scrub. They are not
burrowers, but will excavate
depressions in the sand to help
them withstand extreme
temperatures or high winds.

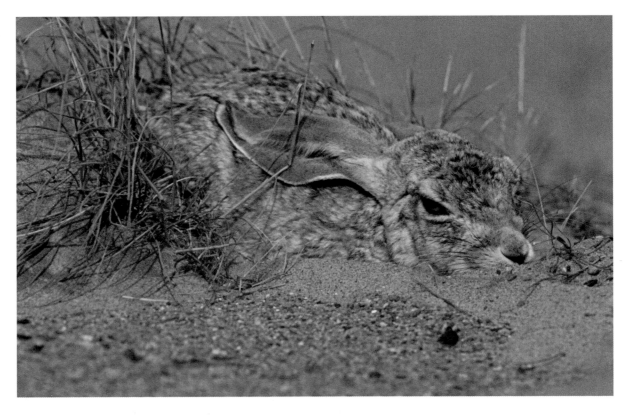

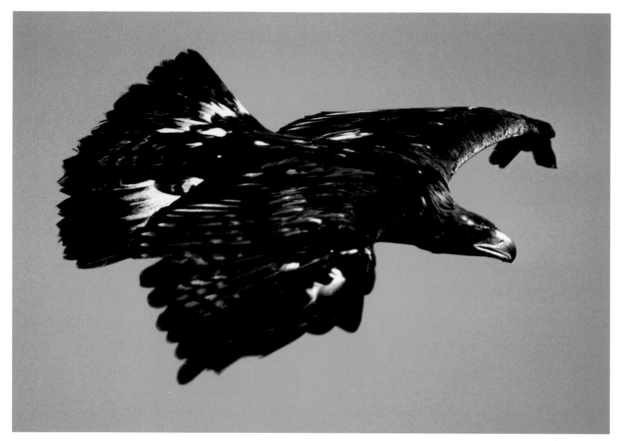

LEFT The Golden Eagle *Aquila chrysaetos* is recorded in many parts of Oman, and there are small breeding populations in some desert areas. In the absence of large trees, the eagles have adapted to nesting on the top of shrubs, where they build a large platform nest.

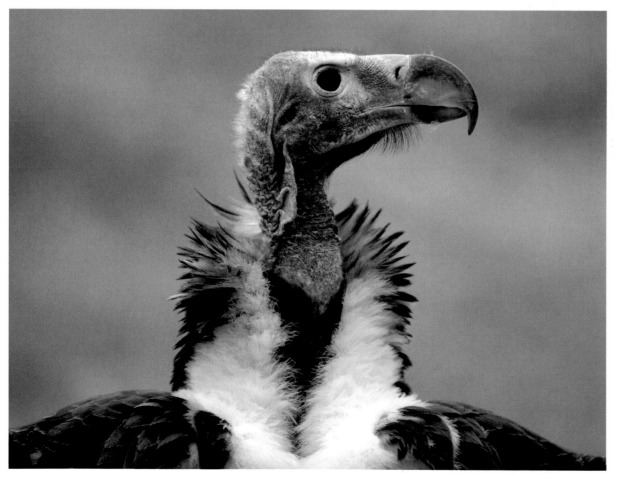

LEFT Vultures rely on an adequate supply of carrion and the increase in domestic livestock and human refuse has helped maintain their numbers. The Lappet-faced Vulture *Torgos tracheliotis* is one of the largest species and is usually dominant at a carcass.

Birdlife in the Empty Quarter typically includes several species of lark, large raptors such as vultures and eagles, and the Houbara Bustard *Chlamydotis undulata*, once a widespread breeding species here but now rare. One of the more revealing aspects of the Rub al-Khali is how the magnetic draw of a water source will lure birds seemingly out of thin air; a survey team once created a small pool out of a canvas liner, filled it with water and left it overnight. At dawn the next morning some thirty birds of twelve different species had gathered to drink, including two types of migratory warbler never recorded from the area before.

Historically the Rub al-Khali proper had few permanent inhabitants, with most of the local Bedouin living around its edges and venturing into the centre only during the cooler winter months, when periodic rain produced new pasture on which they could graze their camels. The first expeditions to the area by Europeans were not made until the 1930s, when Bertram Thomas and Harry Philby made the first journeys across what was then one of the world's last great unexplored wildernesses. Most famously, Wilfred Thesiger crossed the Empty Quarter twice in the second half of the 1940s. Each one of these men recorded the wildlife they saw en route, noting a surprisingly diverse range of birds, mammals and invertebrates. Their holy grail, however, invariably proved to be the increasingly rare and elusive oryx.

Arabian Oryx are highly mobile, moving endlessly across the desert in search of grazing. They have been recorded travelling as much as 30 kilometres (20 miles) in one night and are seemingly capable of detecting rainfall at a range of several kilometres, as they will set off towards it in anticipation of the fresh grasses it might provide. Although they prefer to eat grasses, they will browse on a wide variety of vegetation and will even dig for tubers and roots. Even so, there is little sustenance available in the harshest parts of the Arabian desert and this probably accounts for the fact that the Arabian is the smallest of the oryx species, standing only a metre (3 feet) or so high at the shoulder. The availability of adequate food also appears to be a key determinant in herd size: when conditions are good, herds can reach 20 or 30 or even more, but five or so is more usual.

BELOW **The Honey Badger or Ratel** *Mellivora capensis* is one of Arabia's most elusive mammals – it is widely distributed, but rarely encountered. A muscular and aggressive animal, it has powerful claws for digging up a range of prey and tearing open bees' nests.

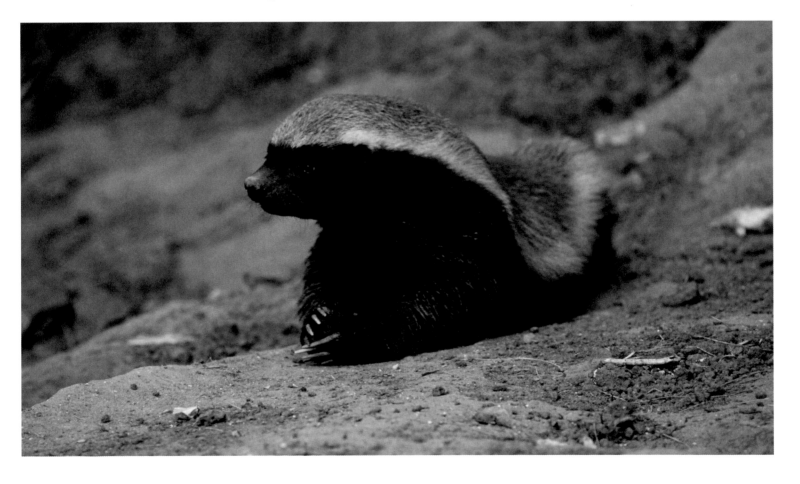

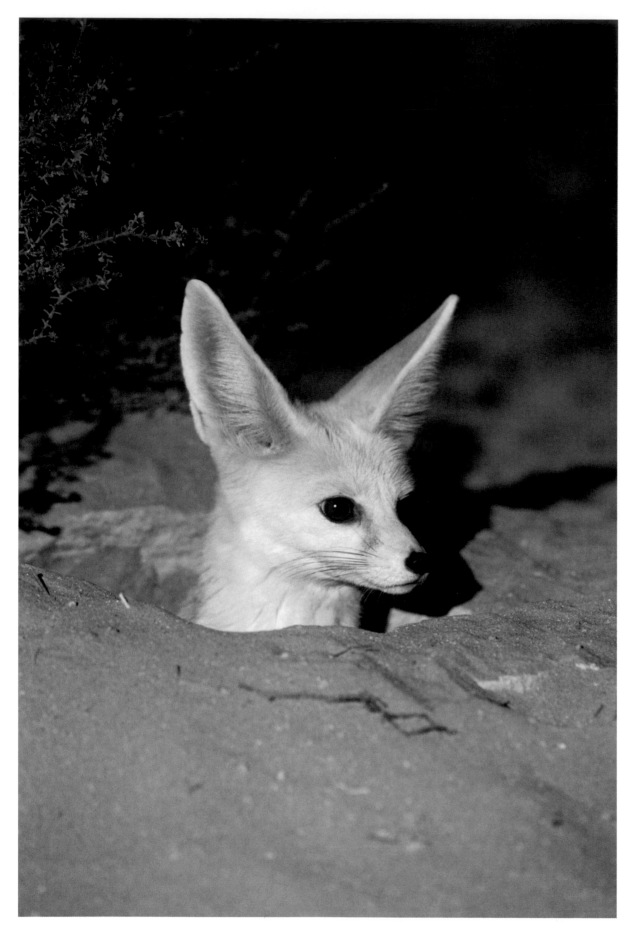

LEFT Like many desert creatures, Rüppell's Sand Fox *Vulpes rueppelli* is nocturnal and spends daylight hours in an underground den. Diminutive yet tough and resilient, Sand Foxes are common across Arabia and North Africa.

The downturn in the Arabian Oryx's fortunes, as with so many of the region's larger desert mammals and birds, was brought about by the advent of motorized transport and modern firearms in the early years of the twentieth century. The traditional human inhabitants of the Arabian desert, the Bedouin, had always killed gazelle, oryx and ostrich for food and hides. They traditionally hunted on foot, using bows and arrows, and the number of animals they killed was invariably small. The arrival of modern firearms changed the situation dramatically. It suddenly became possible to kill larger numbers of animals more quickly, and the concept of killing for "sport" took root. Meanwhile, vehicles were able to penetrate terrain that hitherto had been accessible only on foot or by camel, and to cover distances in a matter of a few hours which previously would have taken days. Suddenly the remote was within reach, and the quieter corners of the desert were opened up to human interference. Such was the unsustainable rate of slaughter – there are accounts of entire herds of gazelle being butchered by machine-guns, for example – that the populations of larger mammals went into freefall.

By the 1960s the numbers of oryx in particular were critically low and the spectre of imminent extinction was rearing its head. By this time, however, a captive population had been established at Phoenix Zoo in the USA under the programme "Operation Oryx". Expanded from an initial nucleus of fewer than ten animals taken from the rapidly dwindling wild population, the programme proved highly successful and soon it was possible for oryx to be exported from Phoenix to other zoos, thereby safeguarding both the diversity of the gene pool and the future of the species, at least in a captive context.

Operation Oryx proved to be the salvation of the Arabian Oryx for, a few years later, in 1972, the last wild animals were shot by a hunting party somewhere on the borders of Oman, Saudi Arabia and Yemen. Once the appropriate conditions and better security had been established, it became possible to turn attention towards the reintroduction of the species to the wild using captive-bred animals. The location chosen for the return of the oryx was the Jiddat al-Harasis, a remote plateau in the heart of Oman and located on the edge of the Empty Quarter. Characterized by extensive gravel plains, this landscape is notable for the heavy mists that often cloak it in the early morning, drenching the sparse local vegetation. These are good conditions for oryx, which are mostly sustained by grazing on the wet foliage.

ABOVE **The largest of the lark species found in the Omani desert, the Hoopoe Lark *Alaemon alaudipes* can be distinguished by its long bill. Like many desert birds, it will often run away from danger rather than taking to the air.**

BELOW **The Jiddat al-Harasis is classic oryx country and also home to several thousand gazelles and a range of other wildlife. This includes ibex, wolf and endangered birds such as the Houbara Bustard, which is virtually extinct in other parts of Arabia.**

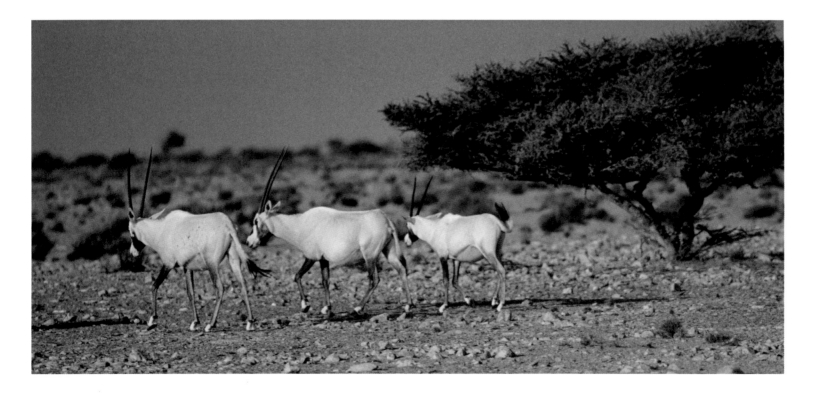

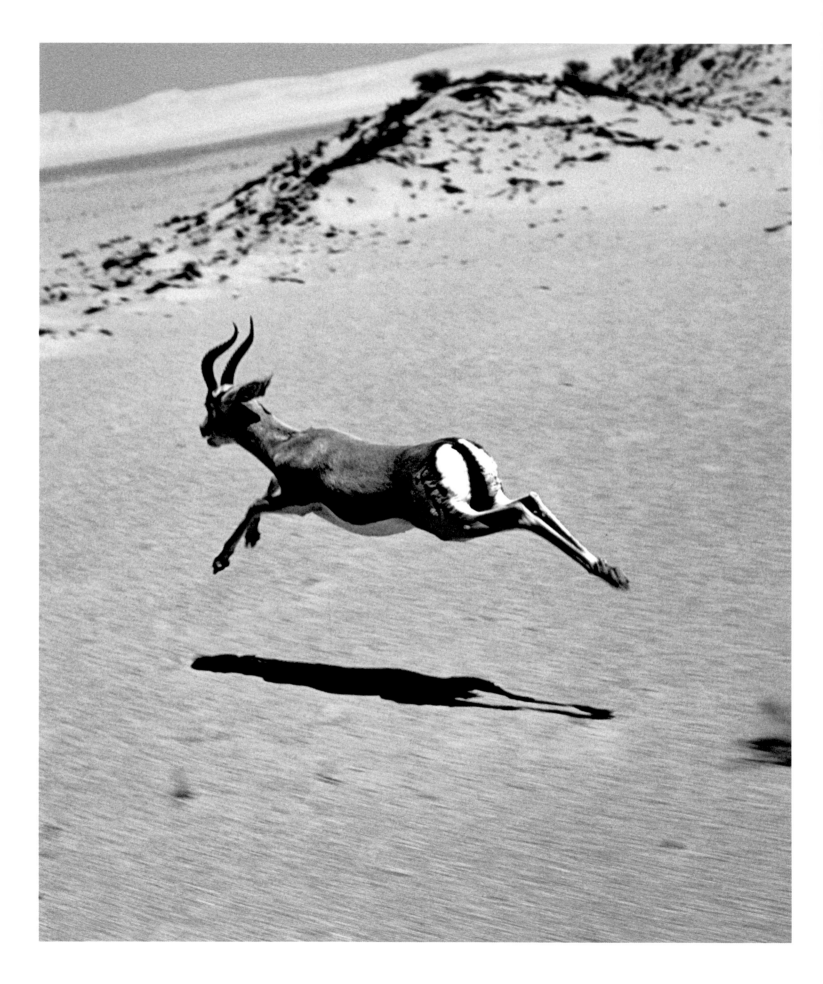

OPPOSITE **Gazelles can sustain speeds up to 80 kph (50 mph) for several minutes, usually enough to escape predators such as Cheetah and Wolf. With such predators now so scarce, the main threats to the gazelle are illegal hunting, disturbance and habitat loss.**

After the arrival in Oman of the first five oryx from Phoenix in the early 1980s, numbers grew rapidly until by 1995 a free-ranging population of 400 or so was resident in the Jiddat. The project became the flagship of the Sultanate's conservation programme, and the oryx served as an icon for the modern renaissance of the country under its ruler, Sultan Qaboos. But then disaster struck. The very success of the project meant that it was no longer possible to keep such a close eye on so many animals, which were wandering in groups of various sizes over an area of some 3,000 square kilometres (1,200 square miles). Organized bands of poachers moved in and proceeded to capture the oryx, mostly to order, to supply the private zoos of wealthy individuals elsewhere in the Gulf and Arabian Peninsula. Many of the animals died in the capture process or in the subsequent attempts to smuggle them across the desert and out of Oman.

Today, only a few score Arabian Oryx remain in Oman, among them just a handful of breeding females. This particular herd, such a success story in its earlier years, is effectively doomed, no longer sustainable without the introduction of new stock from elsewhere. This is hardly likely to be forthcoming, as the Omani authorities have meanwhile removed 90 per cent of the protective designation over the Jiddat al-Harasis so that hydrocarbon exploration can be carried out there in earnest. With the whole area and its wildlife now clearly under threat, UNESCO took the decision in 2007 to relieve the Jiddat of its World Heritage Site status – the first time anywhere in the world that this had been done.

This recent turn of events in Oman flags up the vulnerability of even the most remote desert regions, particularly when lucrative commodities potentially lie beneath the sand and rock. Prospecting for oil, in particular, has already opened up many desert areas in the Middle East and elsewhere to other forms of exploitation, and wildlife has generally been the loser in such situations. Yet there are grounds for some optimism; the conservation and environment agenda is becoming a harder one for governments of the region to ignore and, however mixed the story of the Omani oryx reintroduction might be, this species is prospering elsewhere in Arabia. Reintroduced herds of Arabian Oryx are now thriving in Israel, Saudi Arabia and the United Arab Emirates, and the species has recently been returned to the wild at Wadi Rum in Jordan (see page 97). Oryx breed well in captivity, and globally there are now several thousand held in captive breeding programmes. The species seems secure, but it is clear that in future the focus will need to be very much on maintaining the long-term security and wellbeing of those animals that are returned to the wild.

LEFT **The discovery of oil and other valuable natural resources has transformed Gulf states in many ways. The region's deserts are no longer remote and undisturbed, but are increasingly affected by development and new infrastructure.**

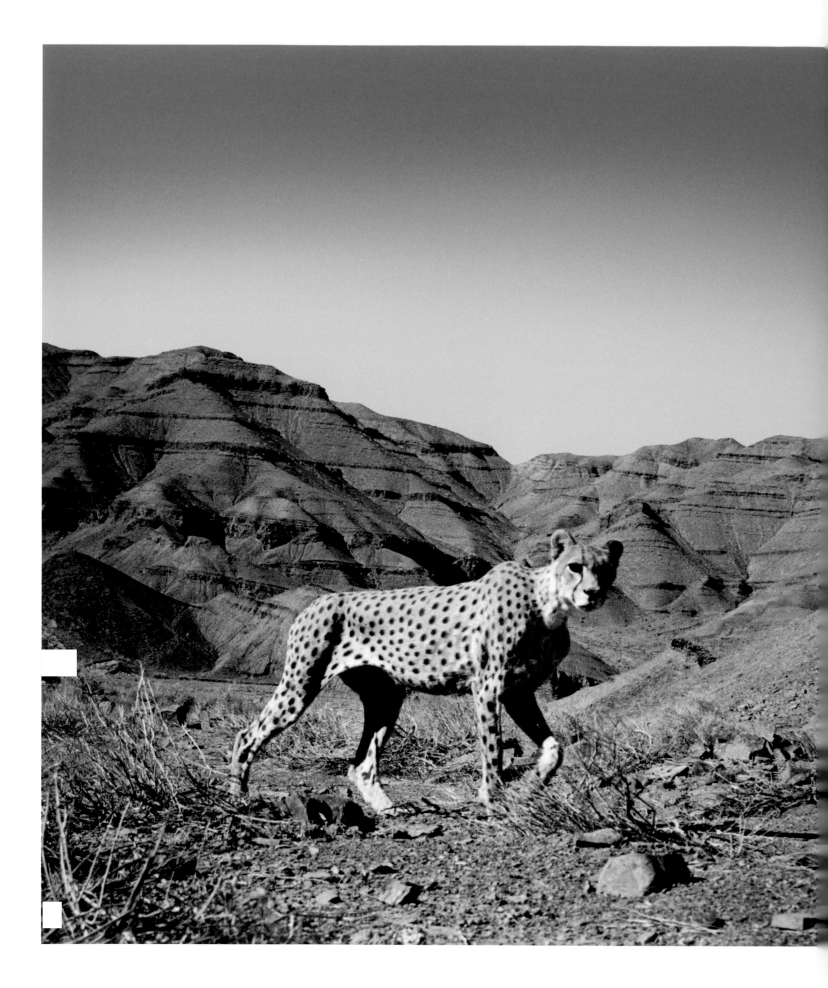

10: The Last Big Cats of the Kavir

A century and a half ago, much of the Middle East was populated by a diverse community of wild ungulates. The mountains and forests were home to sizeable numbers of ibex, wild sheep and deer, while the lowland steppes and desert lands were roamed by large herds of wild ass, oryx and gazelle. These in turn supported a wide range of predators, not least in Persia (now Iran), which had populations of most of the big cats, including Tiger, Lion, Leopard and Cheetah. However, by the mid-twentieth century the incessant – and increasingly effective – persecution of these predators by humans had combined with habitat loss and a declining prey base to drive many of them to extinction or extreme rarity. Today only the Leopard and the Cheetah survive in Iran, albeit in greatly reduced numbers and the latter on the very brink of disappearing entirely. Some of the last populations of both are found in the area of the Dasht-e Kavir or Kavir Desert, a vast basin that forms part of Iran's arid central plateau.

The Kavir receives very low levels of precipitation, in some locations rarely amounting to more than 100 millimetres (4 inches) in any one year. Vegetation is limited and mostly confined to the small gullies and watercourses on the desert fringe, where species such as *Artemesia* spp. and *Tamarix* spp. can be prominent. The Farsi word *kavir* means "salt land", a reference to the prevalence in this desert of salt flats and saline wetlands. Extreme summer temperatures and very high rates of evaporation have prompted the formation of extensive areas of salty crusts and efflorescences, which inhibit or prevent plant growth. Only highly salt-tolerant plants – so-called halophytes – can thrive here, and the Kavir is noted for these very specialized communities.

Not surprisingly, the Kavir is largely devoid of human life. Few people live here, and agriculture is impossible over large areas. It has always been regarded as one of the most difficult deserts in the world to journey across. One nineteenth-century British traveller described a view of part of the Kavir from an elevated ridge: "At our feet lay what looked like a frozen sea, but was in reality a deposit of salt, which entirely filled the hollow in the plains towards the south, and stretched away as far as the eye could reach on either side, glittering in the sun like a sheet of glass."

At the western end of the Kavir is the Kavir Protected Area, which covers some 700,000 hectares (1,700,000 acres) and part of which is a national park. It includes salt pans and alluvial plains, as well as a chain of low mountains, and supports an interesting avifauna including breeding Houbara Bustard *Chlamydotis undulata* and classic desert species such as Crowned Sandgrouse *Pterocles coronatus* and Cream-coloured Courser *Cursorius cursor*. Lammergeier or Bearded Vulture *Gypaetus barbatus* is a flagship species periodically reported from the mountainous parts of the area. The Kavir was also once renowned for supporting populations of most of the classic Iranian large mammal species, including Onager *Equus hemionus onager*. Although the Onager is now extinct in the park, other species have survived here, albeit in greatly reduced numbers. These include a handful of Cheetahs, *Acinonyx jubatus*.

LEFT **Notoriously shy and few in number, the Cheetahs of the Kavir are hard to find. The best chance of seeing one is on film, thanks to a network of camera traps. Cheetahs hunt by day and are most active in early morning and late afternoon.**

LEFT Tracks and scat provide scientists with essential information about the Kavir's Cheetahs. Cheetahs have non-retractable claws which help them maintain traction while chasing prey and which give them a very distinct footprint.

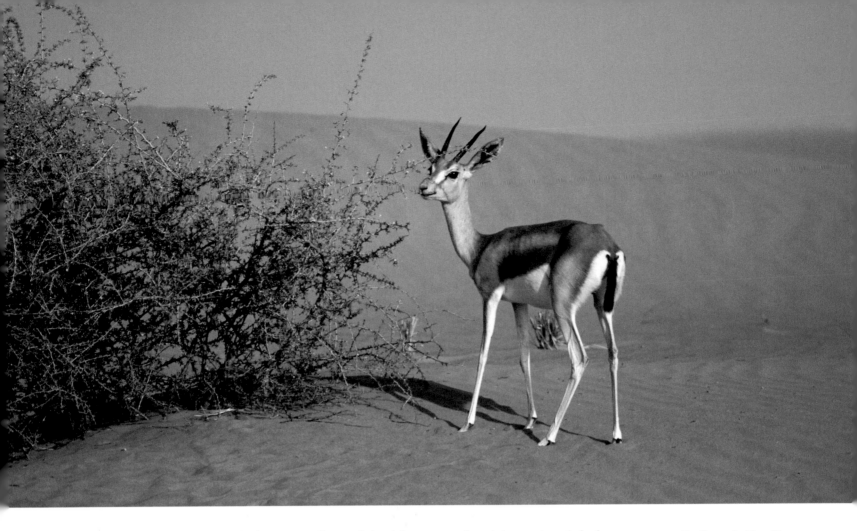

Cheetahs are more usually regarded as African mammals, and that continent indeed remains their stronghold, but they were also once widely distributed across much of the Middle East and West Asia, from the Levant south to the Arabian Peninsula and east through Iran, north to Kazakhstan and east again to Afghanistan, Pakistan and India. Asiatic Cheetahs are now regarded as a distinct race, *Acinonyx jubatus venaticus*, and they were once common and widespread in suitable habitat across Iran. However, their numbers declined markedly during the mid-twentieth century as the populations of their main prey species – Goitered Gazelle *Gazella subgutturosa* and Jebeer Gazelle *Gazella dorcas* – fell dramatically due to excessive hunting. Cheetah numbers recovered slightly following the introduction of conservation measures protecting both them and their prey in the 1950s, but outside Iran the fortunes of the species continued to deteriorate. By the 1970s the Cheetah was extinct over almost all of its former Middle Eastern and Asian range. Only Iran still supported a viable population, then estimated at between 200 and 300 individuals, with occasional records still reported from Pakistan.

Throughout much of its Asian range the Cheetah inhabited desert or sub-desert habitats, preying primarily on gazelles. A diurnal and cursorial hunter that relies on its excellent eyesight and speed, the Cheetah is a superb running machine. Capable of extraordinary acceleration and of reaching speeds of almost 120 kilometres (75 miles) an hour, it can cover 7–8 metres (23–26 feet) in just one stride and can make four strides in a single second. Its small aerodynamic head and long tail, the latter used as a counterbalance when turning suddenly in mid-sprint, are characteristic features. However, superficial similarities between its spotted coat and that of the Leopard have always resulted in confusion by the non-expert and those unfamiliar with both species, a situation which historically has helped obscure their distributions within Iran. Traditionally, their respective habitat preferences helped differentiate between the two, but in recent years this has been a less useful distinction.

ABOVE **Gazelles are the Cheetah's favoured prey. It will get close before charging, singling out one gazelle and running at full speed. Once within reach, the cheetah will knock the gazelle off balance with its front paws and seize it by the neck to asphyxiate it.**

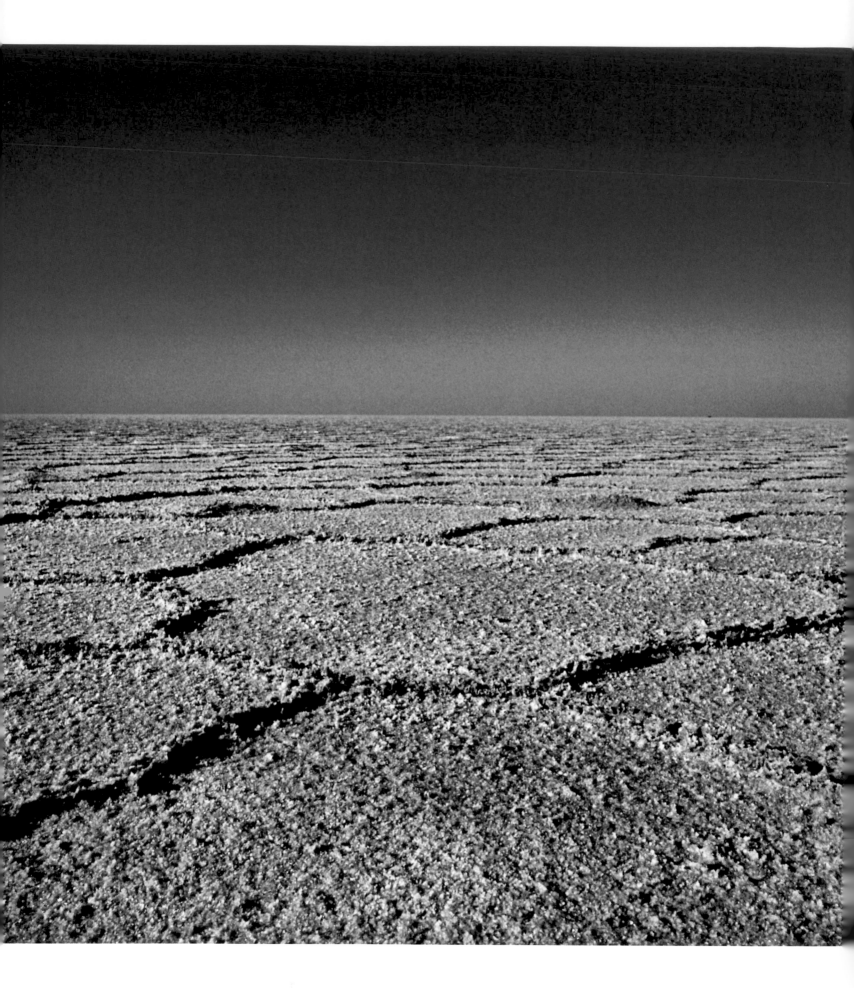

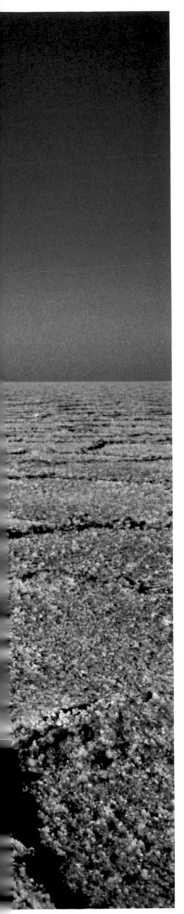

The surviving Iranian population of Cheetahs came under intense pressure following the country's 1979 revolution, after which wildlife conservation was considered less of a national priority. Extensive areas of Cheetah habitat became subject to increased human disturbance and a dramatic expansion in the numbers of domestic livestock, which served to displace the wild ungulates on which the cats preyed. Uncontrolled hunting also had a dramatic impact on the gazelle population, in particular. As a result, it appears that the surviving Cheetahs were forced to change their behaviour, moving into more inaccessible terrain where there was less harassment from humans and a more reliable prey population. This took the Cheetahs away from their favoured desert or steppe environments into rather atypical, more mountainous terrain, where they are less well equipped to hunt. Here they resort to taking animals such as Urial *Ovis orientalis* and Persian Wild Goat *Capra aegagrus*, rather than their preferred gazelle of the open plains, and while this prey may be more plentiful it is likely that the Cheetahs have to work harder to catch it.

This pattern of behaviour is noticeable in the Kavir, where Cheetahs tend to avoid the open desert and live in the foothills around the desert fringe. Here they hunt along seasonal watercourses and small valleys, seeking to locate prey which they then chase down. They mostly feed on Urial and Wild Goat, but will also take smaller mammals such as Cape Hare *Lepus capensis*. The Cheetah population in the Kavir is small, but with only 60–100 animals now estimated to survive in total across the whole of Iran, almost all on the country's central plateau, it is a very important nucleus.

Although African Cheetahs are generally well studied, relatively little is known about Asiatic Cheetah ecology and behaviour. Precise information on aspects such as territory size, reproduction rates and movement patterns remains scant, and until more is known about this elusive animal it is difficult to ensure that its requirements can be met within Iran's network of protected areas. Although the species is legally protected in Iran, direct persecution by humans continues, and Cheetahs are still killed by farmers fearful of potential attacks on their livestock. In addition, at least one or two Cheetahs are run over on the country's roads every year. Drought and habitat degradation, often the result of overgrazing, are further factors serving to limit their

LEFT The crystallized salt flats of the Dasht-e Kavir are among the most extensive in the world. Almost devoid of life, they present a formidable barrier to all animals, and were traditionally regarded by local people as a place inhabited by evil spirits.

BELOW Cheetahs live in areas that have shrubs or large rocks for essential shade. They usually hunt over the open desert and steppe, but in the Kavir they often frequent ephemeral watercourses where they seek hares and other types of prey.

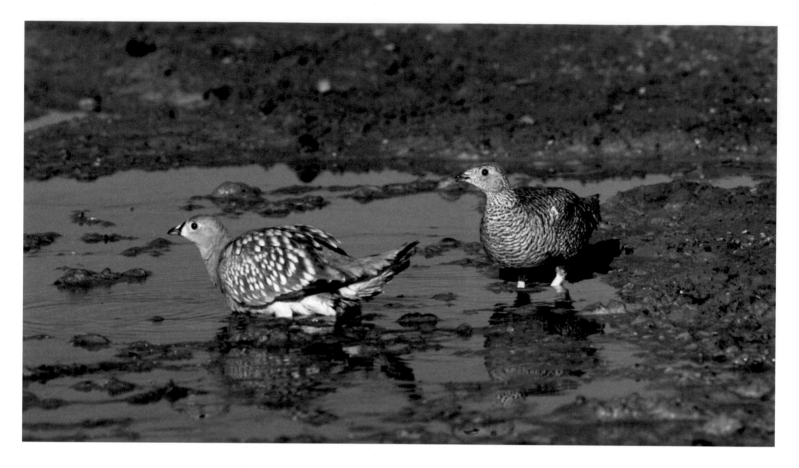

ABOVE **The Crowned Sandgrouse** *Pterocles coronatus* is a common breeding species in the Kavir. As with most sandgrouse, the sexes differ in plumage, with the male (left) being more colourful and more boldly marked.

hunting and breeding success and jeopardize the future survival of the species in Iran. As ever, the availability of prey is paramount, alongside the availability of safe den locations in which female Cheetahs can bear and raise their cubs.

The protection of the Cheetah has now been made a major priority by the Iranian authorities, and the United Nations Development Programme and Wildlife Conservation Society have been involved in initiatives to help secure the animal's future in the country.

To try to understand their ecology, several Cheetahs in the Kavir have been fitted with GPS collars. It is hoped that monitoring these animals will reveal information about ranging patterns, habitat preferences and connectivity between Cheetahs. This last aspect is especially important – with the surviving animals widely spread in isolated populations that may be unable to naturally interconnect, there are concerns over the long-term viability of the gene pool.

One interesting aspect is the potential competition between Cheetahs and other carnivores. In the Kavir, and indeed elsewhere in Iran, Cheetahs occupy the same type of terrain as the Persian race of Leopard *Panthera pardus saxicolor*, Striped Hyena *Hyaena hyaena* and Wolf *Canis lupus*, all of which may compete with Cheetahs for prey and will even predate Cheetahs themselves. It is likely that their presence serves to inhibit Cheetah hunting success.

As part of the same telemetry study project, Leopards have also been collared. The fate of the Leopard in Iran to some extent mirrors that of the Cheetah, but the former's preference for more rugged and inaccessible terrain has helped ensure that its decline has been less cataclysmic, although it may always have been more numerous than the Cheetah and is still subject to extensive direct and indirect persecution. Leopards are shot, poisoned and trapped across Iran, despite being legally protected, and although they are thinly distributed across much of the country's mountainous areas, numbers are everywhere very small and the range of the species highly fragmented. This remains an exceedingly difficult species to see.

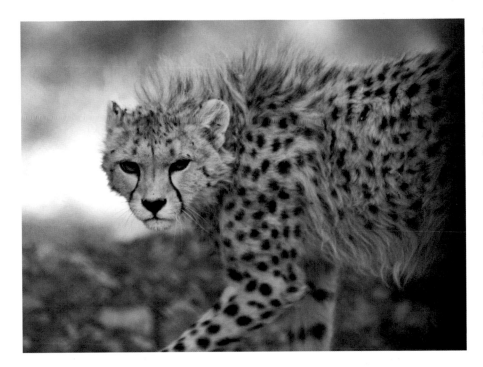

The Persian Leopard is regarded as one of the largest of the leopard races, with mature males standing as high as 75 centimetres (30 inches) at the shoulder and weighing up to 90 kilograms (200 pounds). They live mostly on Urial and Wild Goat, but will resort to taking livestock and other, smaller prey. Several hundred Leopards are estimated to survive in Iran, with a few hundred more of this Persian race surviving in neighbouring countries to the north and east. Poaching for their fur remains a problem, with Leopard pelts a regular sight in regional markets, and with hunting pressure particularly intense in some locations it is likely that many isolated populations are already at, or below, a sustainable threshold.

Both of Iran's two surviving big cats face a difficult future. The more immediate dilemma is that facing the Cheetah, its numbers already at such a low ebb that the next ten years will be critical in deciding whether the Asiatic race of this elegant predator will survive in the wild. With scientific research now in hand in an attempt to understand the Cheetah's ecology, there is every prospect that a conservation plan can be put in place to secure the future of the species, but its long-term prospects must surely hinge on whether the populations of its natural prey can be restored to something like their previous levels. For that to happen there must be adequate safeguards protecting the appropriate habitats, as well as management agreements with livestock herders that allow grazing pasture to be stocked at a sustainable rate that does not lead to ecological degradation and desertification. Only then can the Cheetah once again hunt the open arid plains of the Kavir and forsake the marginal habitat to which it has been forced to retreat in recent decades.

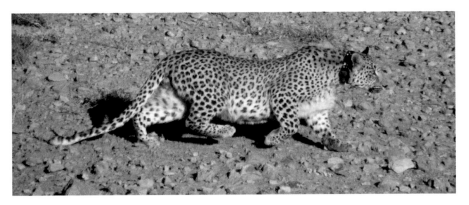

EUROPE

While there are officially no true deserts in Europe, the south-east corner of Spain is the closest the continent gets to a desert environment. With minimal rainfall, summer temperatures approaching 45°C (113°F), almost constant sunshine and a harsh desiccating wind, conditions in this area are comparable to the more famous drylands of Africa and Asia. The Tabernas area in particular supports a range of desert-loving plant species and reptiles, alongside specialized birds such as sandgrouse, Stone-Curlew and Trumpeter Finch, all of which are at home in what is effectively an outpost of the Sahara on mainland Europe. A network of coastal lagoons also provides a habitat for waterfowl and migratory waders.

LEFT Bee-eaters are widespread and common summer migrants to the arid lands of Iberia. They are easy to spot in the Tabernas and Cabo De Gata areas, as they hawk for bees and other invertebrates from prominent perches. They nest colonially in sandy banks and return to the same breeding site every year.

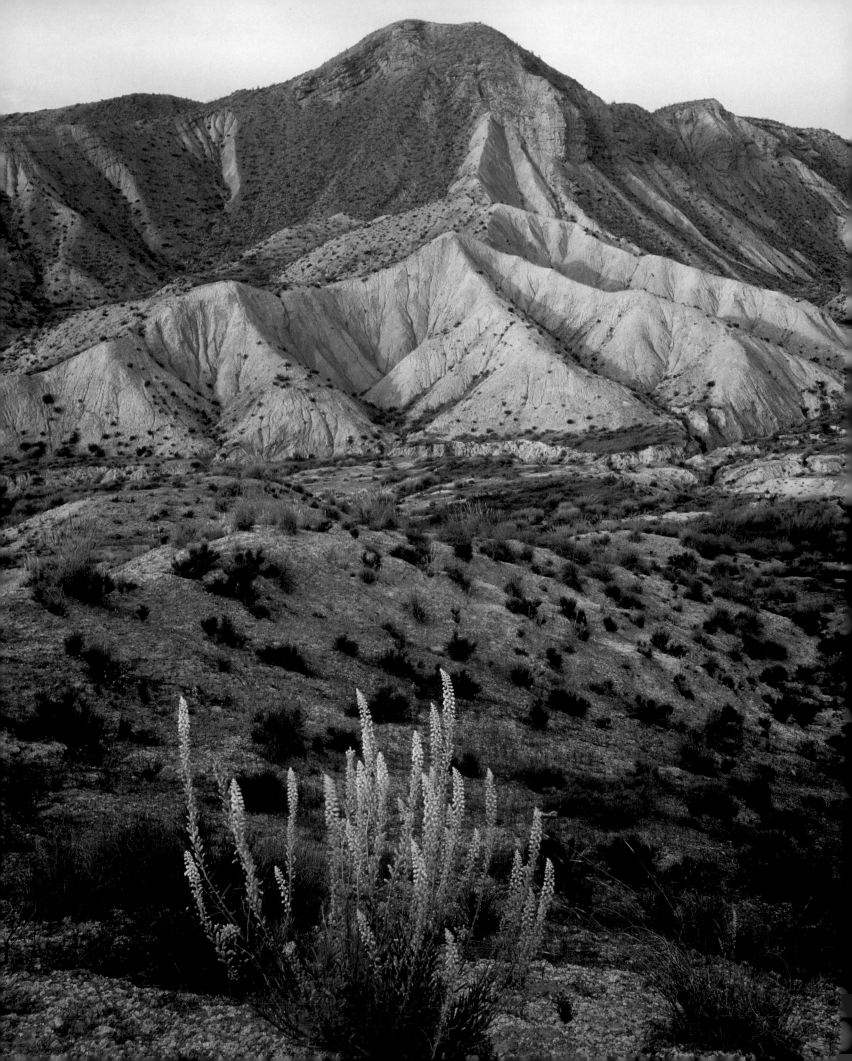

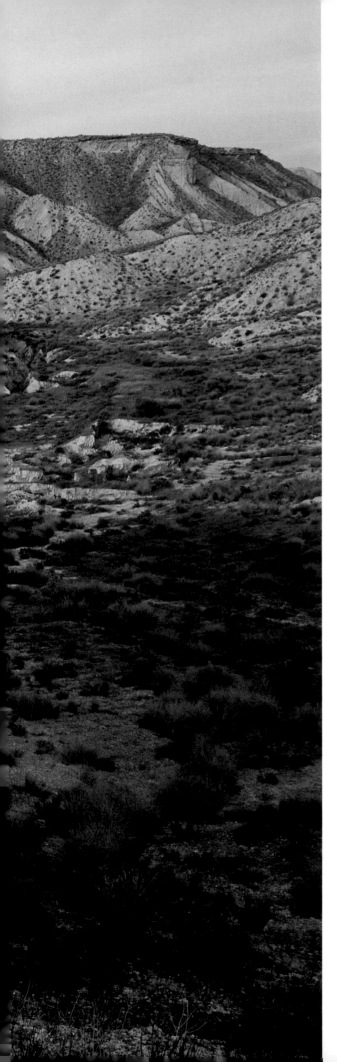

11: The Desert Birds of Tabernas

Arguably the closest Europe has to a true desert, the Desierto de Tabernas is located in south-east Spain, some 20 kilometres (12 miles) north of the city of Almería. A shallow depression between the Sierra de los Filabres to the north and the Sierra Alhamilla to the south, the area's fossilized coral reefs serve as a reminder of how, during the Miocene period eight million years ago, it formed part of the sea floor. Since cut off from the Mediterranean by tectonic movement, it is now one of Iberia's most unusual and distinctive landscapes, characterized by dramatic complexes of ridges, plateaux (known as "badlands") and deep gullies or *ramblas*, gouged out by natural processes of erosion. The *desierto* itself is almost completely devoid of trees.

With an average of less than 220 millimetres (9 inches) rainfall annually, this is one of the driest places in Europe. Rain falls on fewer than six days per annum on average, often in such violent and concentrated bursts that flash floods can result, roaring down the *ramblas* and capable of causing extensive destruction. Many of the watercourses are ephemeral and remain dry for much of the year. Yet this stark and seemingly inhospitable landscape, 11,475 hectares (28,355 acres) of which is protected as a *paraje natural*, supports a range of endemic plants and arid zone wildlife, including species for which this parched corner of the Iberian peninsula represents their only toehold on mainland Europe.

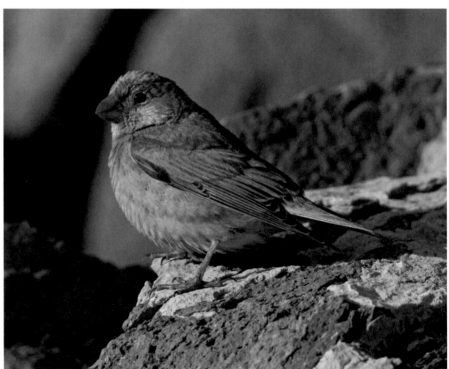

LEFT The folds in the Tabernas landscape are a reminder of the region's tumultuous geological history. Vegetation is generally scant and almost absent on the more exposed slopes, with springtime flowers soon burning off as summer advances.

ABOVE The diminutive Trumpeter Finch is a Tabernas speciality, with an established breeding population. The birds are well camouflaged and often escaping detection until the last second, when they fly away uttering their distinctive call.

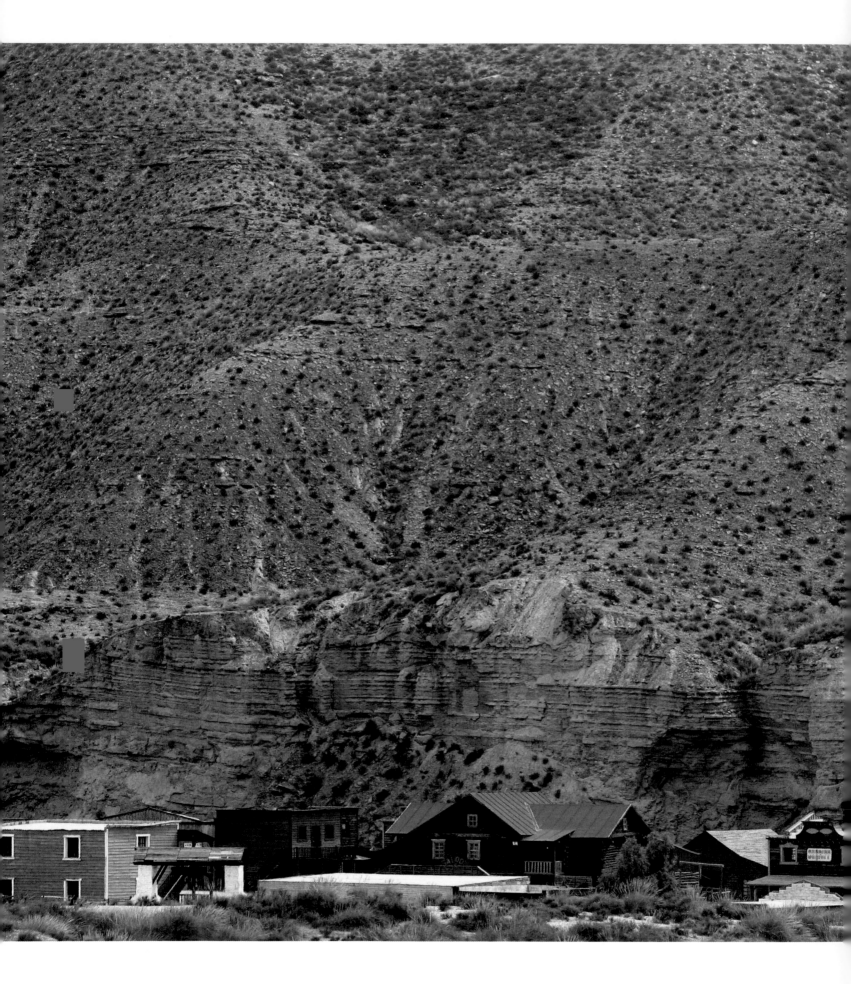

Despite being one of Europe's most distinctive areas for natural history, this part of Spain achieved notoriety of a different type in the 1960s and '70s when it was used as a location for the filming of the so-called "Spaghetti Westerns", including some starring Clint Eastwood. To the untrained or less discerning eye, the local landscape provided a convincing scenic alternative to more expensive locations such as Arizona and New Mexico, and a whole suite of films was made here. Today this cinematic legacy survives locally in the form of film sets built to resemble Western towns, some of which are still working locations, while one, "Mini-Hollywood", is run as a theme park complete with a Wild West film set and daily Western show.

Film stars may come and go, but much of this bleak and harsh landscape remains largely unaffected by human activity. Few areas within it are suitable for cultivation and its most defining characteristics are arguably those that make it such an immediately hostile place. Temperatures, for example, are positively epic – daily maxima above 40°C (104°F) are regular in high summer, and in winter the thermometer can drop below freezing point. Frequently harsh winds intensify these extremes. Sunshine levels are among the highest in Europe, a factor that contributes to the bleached and desiccated appearance of the landscape – there can be few places more scorching on a mid-afternoon day in June than the open plateaux of Tabernas. Although certain bird species seem to revel in these conditions, most wildlife is to be found in the more hospitable conditions afforded by the *ramblas*, along which small streams often run. The more permanent of these provide a lifeline for a host of species that otherwise would be unable to survive here.

Climax vegetation along the *ramblas* comprises extensive stands of Tamarisk *Tamarix* spp., Oleander *Nerium oleander* and Giant Reed or Spanish Cane *Arundo donax*, which provide excellent habitat for a range of passerine birds, both resident and migratory. Endemic plants include Lilac-flowered Toadflax *Linaria nigricans*, found only in the province of Almería, and Afro-Iberian specialities such as *Pteranthus dichotomus*. Clumps of the highly localized *Euzomodendron bourgaeanum* can be seen along the gully sides.

LEFT A Wild West-style settlement in deepest Spain may seem bizarre, but the Tabernas landscape is reminiscent of the American badlands, and an obvious stand-in for Western films. The cliffs above are frequented by birds such as Rock Sparrow and Black Wheatear.

BELOW Sheltered locations often harbour Dwarf Fan-palm, the sole European representative of the palm family. It can withstand temperatures as low as -12°C (10°F) and recovers quickly after bushfires, regenerating from the scorched stumps.

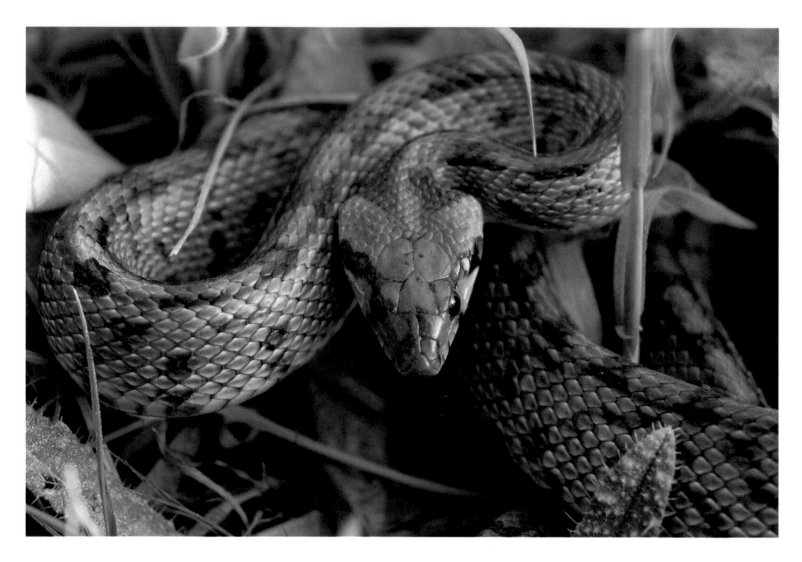

Reptiles abound in Tabernas. They include the Ladder Snake *Rhinechis scalaris*, a large species reaching up to 160 centimetres (63 inches) in length. Mainly ground dwelling, it also climbs well and moves easily over rocky terrain in search of prey.

Particularly interesting is the parasitic *Cynamorium coccineum*, its bizarre phallic-shaped form sprouting out of the bare gravel. The vegetation along the ramblas supports a host of small birds, particularly warblers such as Sardinian *Sylvia melanocephala* and Subalpine *Sylvia cantillans*, as well as Rufous Bush Chat *Cercotrichas galactotes*. In winter the bushes can be alive with Chiffchaffs *Phylloscopus collybita*, which pass the winter here after breeding in northern Europe.

The rocky slopes along the ramblas are the haunt of birds that favour tracts of broken ground, such as Blue Rock Thrush *Monticola solitarius*, Rock Bunting *Emberiza cia*, Rock Sparrow *Petronia petronia* and Black Wheatear *Oenanthe leucura*. The latter are particularly common, and often seen perching on prominent rocks from which the males deliver their scratchy song. The Tabernas area is also home to three of the classic Mediterranean "exotics" – Bee-eater *Merops apiaster*, Hoopoe *Upupa epops* and Roller *Coracias garrulous*. These are perhaps best observed when nesting in cavities in cliff faces or banks of exposed sand. Whereas this is the normal breeding habitat for Bee-eaters, both Hoopoe and Roller usually nest in trees, but are forced to choose alternative sites in the absence of any here. Hoopoes are ground-feeders, strutting around areas of bare soil or short grass, probing it with their long and decurved beak in search of insects. Surprisingly inconspicuous, given their extravagant plumage, they often pass unnoticed until they fly up from the ground, their flashy black-and-white wings and seemingly random flight pattern catching the eye. Rollers, however, can be easy to spot as they sit like sentinels on telegraph wires or a protruding dead branch surveying the ground below for invertebrates or small reptiles. Meanwhile, the distinctive "pirrup-pirrup" call of Bee-eaters overhead as they hawk for insects is one of the defining sounds of summer in this corner of Spain.

OPPOSITE **Classic arid zone birds** like Black-bellied Sandgrouse are common in this part of Spain. They need to drink every day and have breast feathers that are specially adapted to absorb water. This enables parent birds to carry vital moisture back to their young.

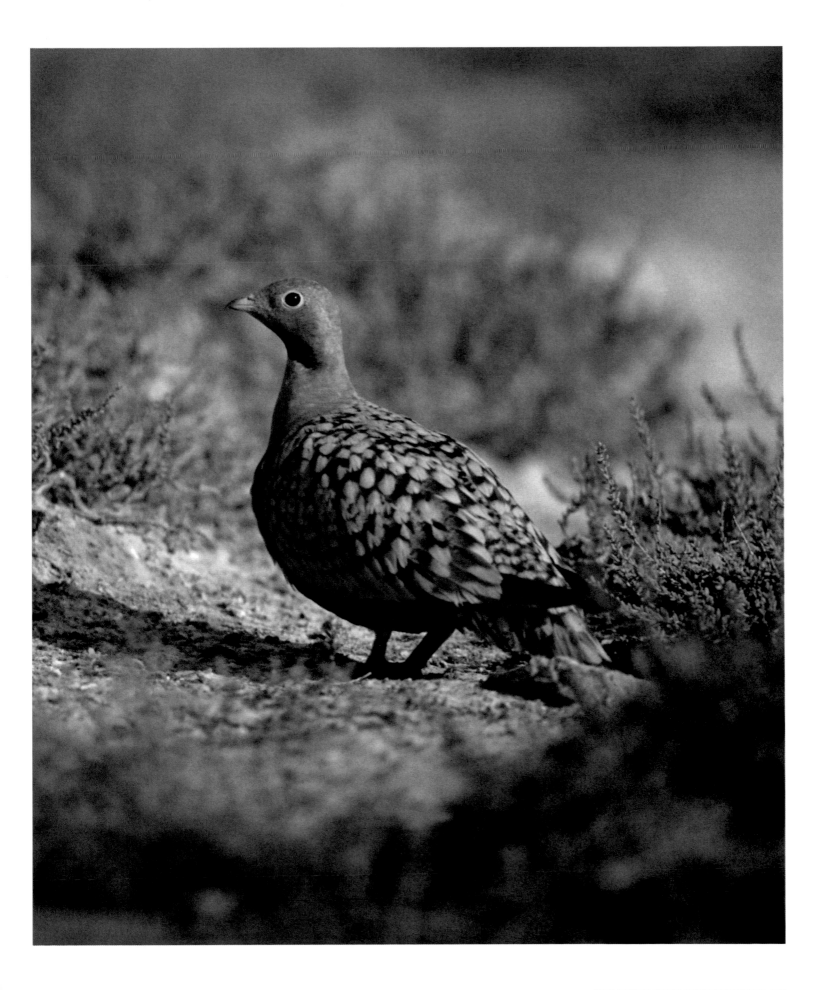

BELOW **Spiny-footed Lizards** *Acanthodactylus erythrurus* are a common sight around Tabernas. The brightly coloured males are very territorial during the breeding season, defending their territory against rivals and chasing any passing females.

Many of the avian specialities that draw wildlife enthusiasts to Tabernas are classic "steppe" species, birds that are dependent on wide, undisturbed open spaces and are therefore under increasing pressure as this type of habitat becomes scarcer across Europe. There are good numbers of Stone-curlew *Burhinus oedicnemus* here, for example. This enigmatic bird is crepuscular and nocturnal, and so not always easy to locate during the middle of the day, when it spends its time resting in any available shade. At dusk, however, it becomes active and its eerie cries are a characteristic sound of the open plateaux at night as birds roam around in search of food. A summer migrant to Europe from Africa (although resident in this part of southern Spain), the Stone-curlew has decreased across much of its range as a result of agricultural intensification and disturbance. Spain is home to approximately 70 per cent of the remaining European population and the Tabernas area supports one of the highest densities anywhere in the country.

The plateaux also support small numbers of Black-bellied Sandgrouse *Pterocles orientalis*, usually only seen as they whirr overhead on fast wings, often giving a characteristic purring note as they pass by. Like other steppe-loving species, the sandgrouse is struggling to survive in modern Europe. It depends on traditional, low-intensity forms of farming, in particular the availability of fallow fields, and has lost much suitable habitat to development and afforestation. There are also a few pairs of Little Bustard *Tetrax tetrax* here, a bird similarly affected by modern agriculture across much of its range. This a relatively unobtrusive species for much of the year, but during the breeding season the male birds engage in an extravagant courtship display in an attempt to attract females. Standing in a prominent location, often on a small rise in the ground, the male bird will inflate its boldly-patterned neck and utter a series of calls before making short jumps into the air. If he is successful, females (the species is polygamous) will gather around the floor show and mating will ensue.

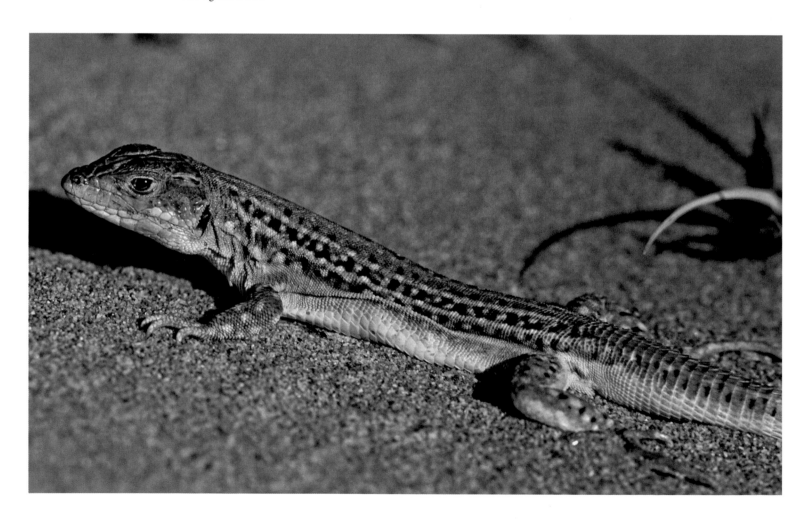

One of the iconic birds locally is the Trumpeter Finch *Bucanetes githagineus*. This desert-dwelling species occupies a range extending from the Canary Islands and North Africa through the Middle East and into Pakistan and India. In the European context its requirement for very sparsely vegetated and arid steppe terrain is met in the Tabernas area, which represents the European headquarters for this often elusive species. Although Trumpeter Finches often nest semi-colonially, with several pairs frequenting the same area, they are nomadic in nature, dispersing over large areas, especially after breeding. Their precise location at any one time is generally determined by the presence of what are often ephemeral sources of water. However, attention is often drawn by their distinctive buzzing call (actually their song), which resembles the sound of a toy trumpet and from which they derive their common name.

Larks are well represented here, with Calandra *Melanocorypha calandra*, Lesser Short-toed *Calandrella rufescens*, Short-toed *Calandrella brachydactyla* and Thekla *Galerida theklae* all present. The real local prize for birders, however, is Dupont's Lark *Chersophilus duponti*, a few pairs of which are resident in the area but are notoriously difficult to find. This species is found only in Iberia and North Africa and, unlike many other lark species, appears unable to adapt well to farmland, favouring open steppe. Highly terrestrial, it rarely flies, preferring to run from danger.

As elsewhere in Spain, raptors are common here and regular species include Kestrel *Falco tinnunculus*, Peregrine Falcon *Falco peregrinus* and Bonelli's Eagle *Hieraaetus fasciatus*, for which this is one of the best sites in the region (although numbers are declining). Migratory species such as Lesser Kestrel *Falco naumanni* and Montagu's Harrier *Circus pygargus* pass through in spring and autumn. Both Eagle Owl *Bubo bubo* and Scops Owl *Otus scops* are present, the latter only in summer, a time when the unusually mechanical "song" of the Red-necked Nightjar *Caprimulgus ruficollis*, another Iberian speciality, can be heard at night from areas of open scrub.

RIGHT **The Algerian Hedgehog *Atelerix algirus* is generally smaller and paler than the European Hedgehog *Erinaceus europaeus*. It can be spotted by torchlight in the *ramblas* as it forages for invertebrates, fallen fruit and seeds.**

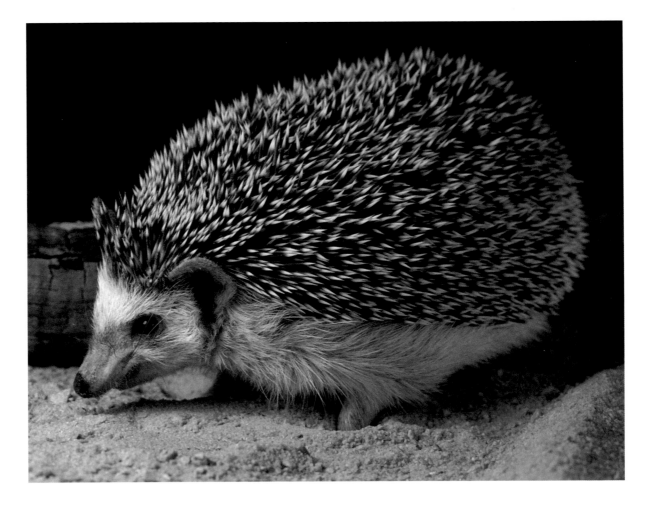

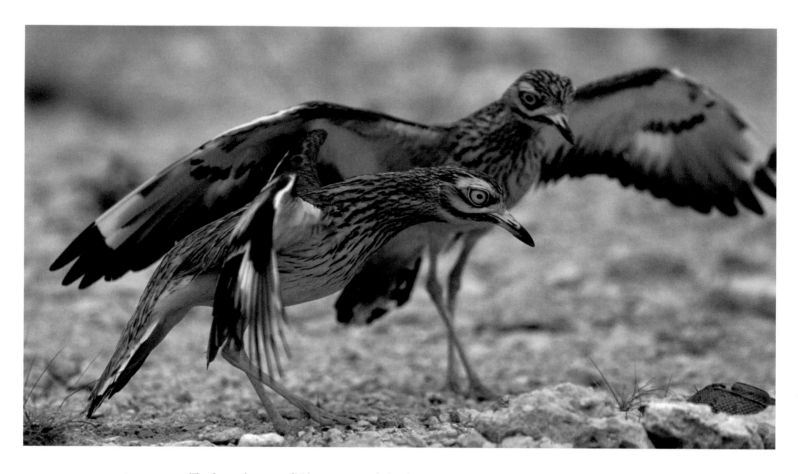

ABOVE **Supremely camouflaged when in their preferred habitat of stony plains, Stone-curlews often avoid detection until they fly away, when their black-and-white wing pattern is very distinctive. Tabernas is home to a healthy breeding population.**

The desert character of Tabernas was underlined in early 2002, when a group of Cream-coloured Coursers *Cursorius cursor* arrived here, presumably from their traditional quarters in North Africa. Three pairs of this desert-dwelling species remained to breed and rear young, the first such record for mainland Europe. There have been further non-breeding records from the general area since then, so permanent colonization remains a real possibility.

One other area in this part of Spain where the coursers have also been recorded is around Cabo de Gata, a peninsula some 50 kilometres (30 miles) south-east of Tabernas. This vast *parque natural* and biosphere reserve covers almost 50,000 hectares (125,000 acres), extending both west and east of the *cabo* proper. As arid as the Tabernas desert, it is characterized by similarly harsh landscapes, with extensive tracts of barren volcanic rock, stony and gravelly plains, dune systems and coastal saline lagoons. The plateaux support many of the bird species found in Tabernas, with some of them even more numerous here, and the *salinas* attract a range of waterbirds, including blue riband species such as Audouin's Gull *Larus audouinii*, Marbled Teal *Marmaronetta angustirostris* and White-headed Duck *Oxyura leucocephala*, as well as Greater Flamingo *Phoenicopterus ruber*, which are often present in their hundreds (up to 3,000 have been recorded) and have attempted to breed here.

The inhospitable terrain and harsh climate of Tabernas and Cabo de Gata have traditionally helped protect their unique habitats from excessive human disturbance and destruction. However, in recent years a range of pressures has been building, not least infrastructural projects such as road- and house-building, and in some areas the proliferation of unsightly greenhouse agriculture is having a negative impact, both visually and in terms of disturbance to fragile indigenous flora. A major solar energy installation is already in place in Tabernas, with more related activity likely in future, and some of the coastal dunes and *salinas* have been seriously compromised by insensitive development. This remains a largely remote and unspoilt corner of Spain, but the sensitivity of its habitats is such that relatively little change could spell disaster for the wildlife that lives here.

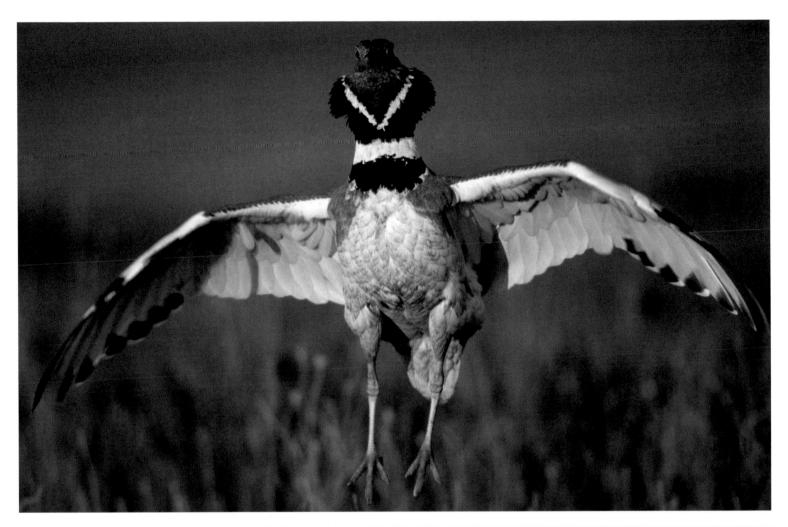

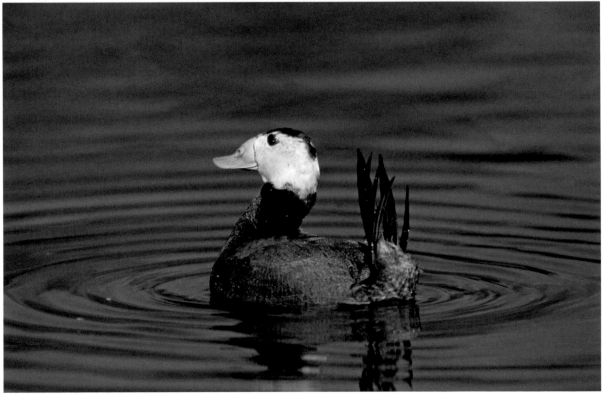

ABOVE A displaying male Little Bustard, as he leaps from the ground with his wings outspread. This behaviour is designed to attract the attention of passing females, and is accompanied by a distinctive grating call. At other times of year Little Bustards can be hard to find.

RIGHT The coastal *salinas* in this part of Spain are home to the globally endangered White-headed Duck, which is increasing in numbers in this area. In spring, the blue-billed males can be seen in display, with their tail feathers held erect.

LEFT Cabo de Gata is the most south-easterly point of the Iberian Peninsula, and an outstanding place for wildlife. It has a particularly diverse flora, with over 1,000 species of plant recorded here (a good number of which are endemic).

BELOW An early start is usually essential for tracking down Dupont's Lark, which is best located by listening for its distinctive and rather melancholy song. The birds are often in full voice by 5am, but they are very scattered and hard to spot.

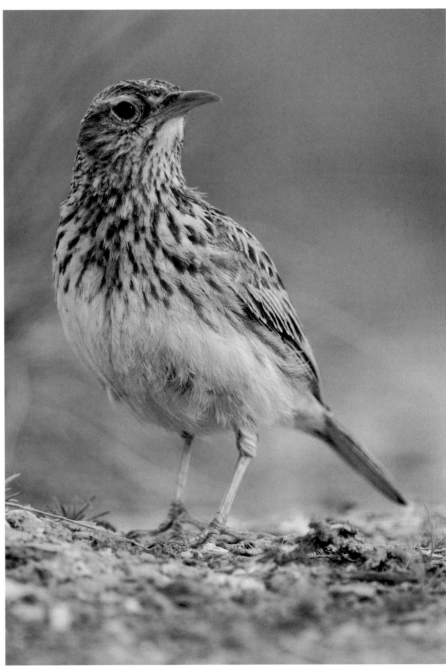

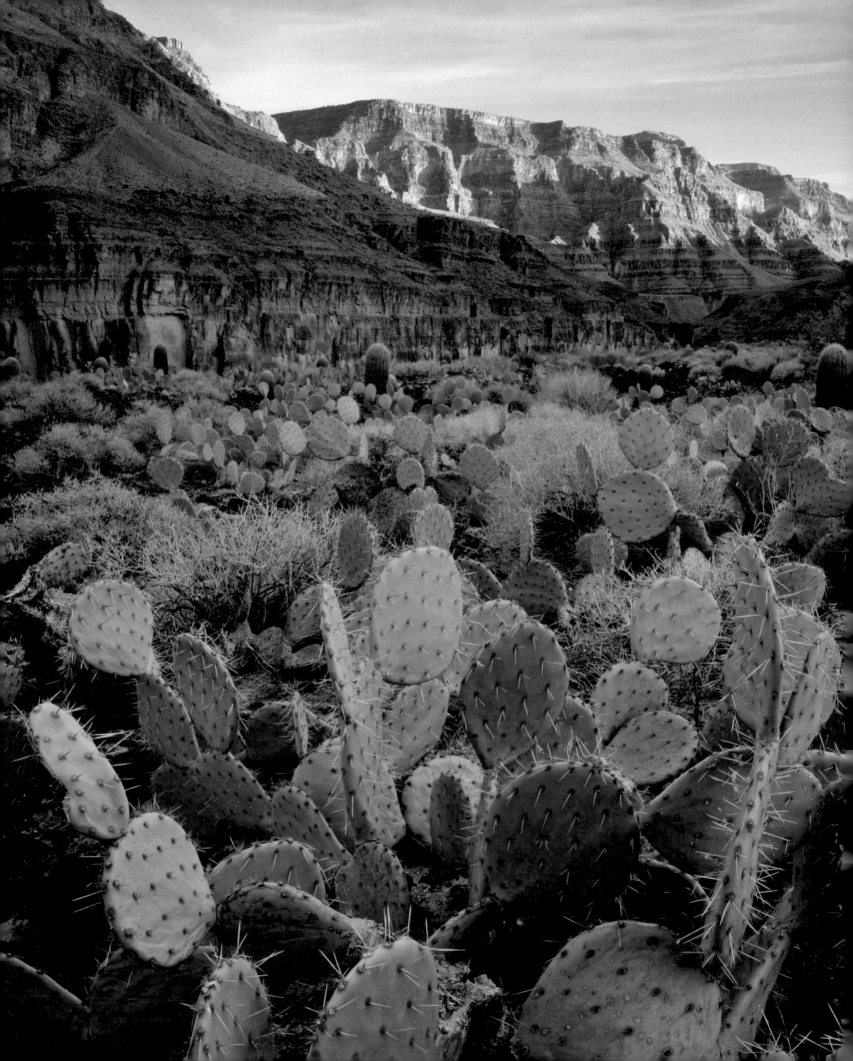

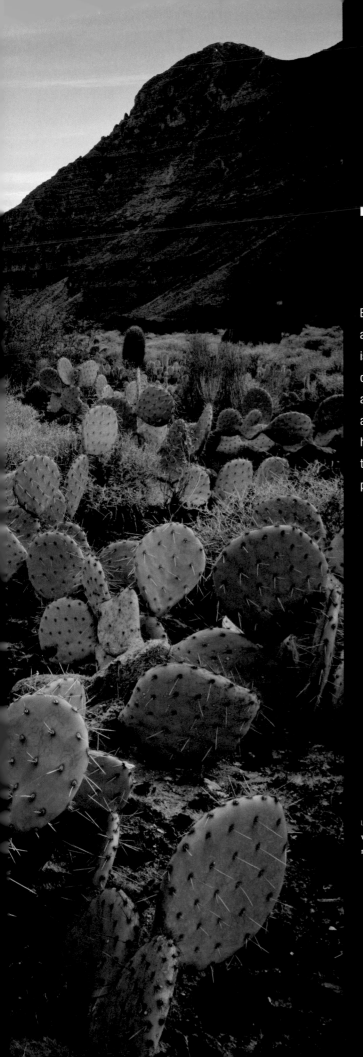

THE AMERICAS

Etched into the imagination of millions of movie-goers, the great deserts of the United States and Mexico are simultaneously familiar and remote. Perhaps most surprising, however, is their diversity, which is born of the huge variety of ecological niches that make up the deserts of the American West. Dominated by botanical icons, such as the Saguaro Cactus and the Joshua Tree, these arid and often mountainous tracts support herds of Pronghorn and Bighorn Sheep, and big cat predators such as Puma. Their location on avian migration highways also brings a plethora of waterbirds to the desert lakes. Thousands of kilometres to the south, the Atacama in Chile can claim to be the driest place on the planet, but even here populations of highly specialized birds and plants still exist.

LEFT The deserts of the Americas are perfect cactus habitat, with a wide variety of species that often grow very densely. Impenetrable thickets of cactus are widespread and provide important shelter for many small mammals and invertebrates, as well as breeding habitat for birds.

12: The Saguaros and Joshua Trees of the American South-West

For a late twentieth-century audience reared on an intensive diet of television and the movies, the desert landscapes of the south-western United States are perhaps most immediately associated with cowboy films and road movies. With the desert providing a suitably dramatic backdrop to either gun-toting action or free-spirit adventure, the cinematic emphasis has traditionally been on the hostile and empty character of the landscape here. Yet while these deserts are indeed an inhospitable environment for much of the year, they are far from being empty. The Sonoran Desert ecoregion, for example, which covers some 223,000 square kilometres (86,000 square miles) of the south-eastern and south-western sections of California and Arizona respectively, as well as the western half of the Mexican state of Sonora and much of upper Baja California, can claim one of the greatest diversities of vegetation of any desert in the world, as well as being home to an outstanding avifauna and almost 60 species of reptile, including the legendary Gila Monster *Heloderma suspectum*.

To the north-west of the Sonoran Desert lies the Mojave Desert, extending over some 57,000 square kilometres (22,000 square miles) of south-eastern California, southern Nevada and north-western Arizona. Although most of the Mojave lies between 1,000 and 2,000 metres (3,300 and 6,600 feet) above sea level, this desert also includes Death Valley, which includes the lowest point in the United States and where in high summer temperatures have exceeded 55°C (131°F). Much drier than the Sonoran Desert to its south-east, where annual rainfall can exceed 600 millimetres (24 inches) in some places, the Mojave rarely receives more than 250 millimetres (10 inches), and its vegetation reflects this difference. In particular, the Mojave is widely celebrated as the home of the iconic Joshua Tree *Yucca brevifolia*.

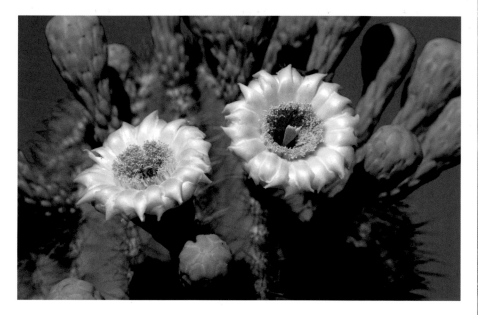

ABOVE **Saguaro flowers open only for a few hours. By first light, after their nocturnal blooming, bees and other pollinators are taking advantage of the rich pollen supplies. By early afternoon the blooms have already started to wither.**

RIGHT **The Saguaro cactus thrives on warm, rocky slopes. This** *bajada* **habitat is one of the most biodiverse in the whole ecosystem, with a wide range of plants and wildlife. Small springs at the foot of the inclines are especially attractive to birds and mammals.**

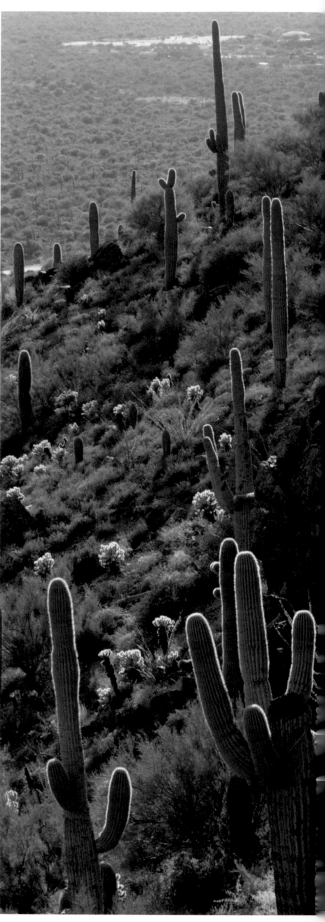

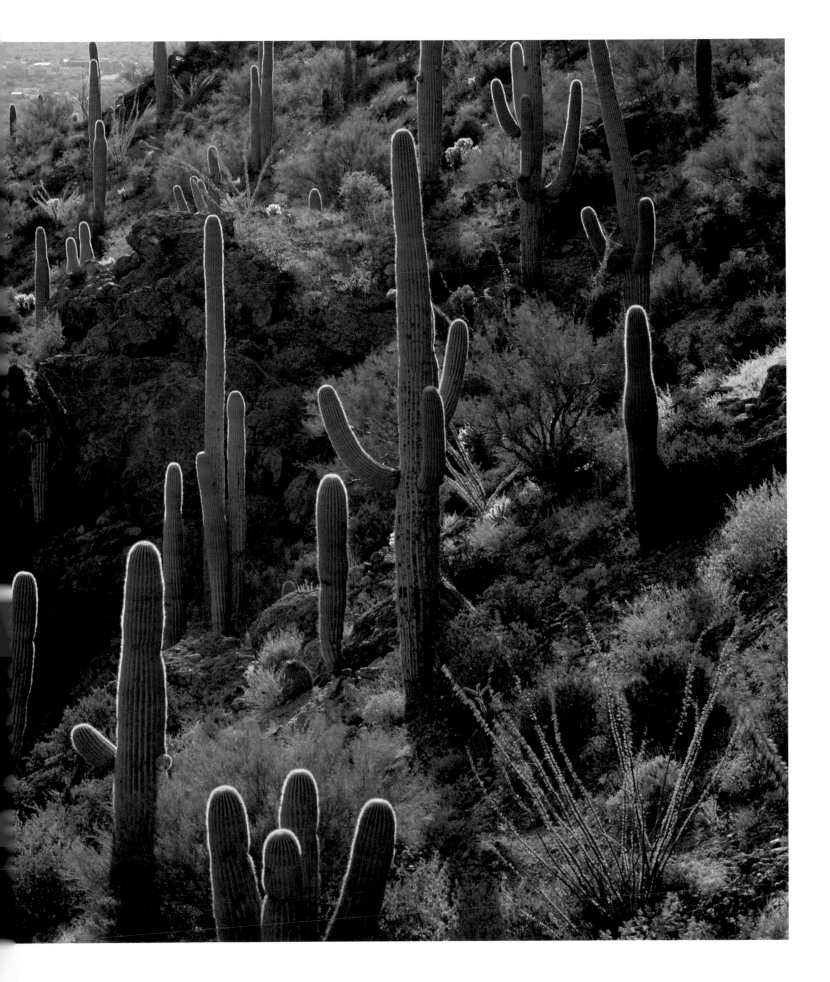

LEFT Whether an individual cactus blooms or not is subject to many different factors and is often difficult to predict. Yellow, white and pink are the most typical flower colours, as with this Beavertail Cactus *Opuntia basilaris*, a common species in the Mojave and Sonoran Deserts.

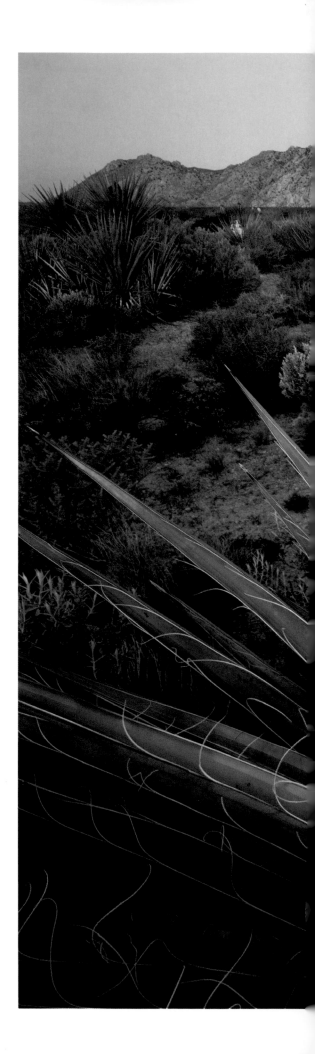

RIGHT The Mojave Yucca *Yucca schidigera* can grow up to 5 metres (16 feet). Its crown of bayonet-shaped leaves gives rise to its alternative name, Spanish Dagger. The bell-shaped flowers appear in spring in a tight cluster in the middle of the crown.

The Sonoran Desert is renowned for its cacti and other succulents, but one species stands out as a familiar symbol of the desert ecosystem here: the Saguaro or Arizona Giant Cactus *Cereus giganteus*. Saguaros are found up to elevations of about 1,000 metres (3,300 feet) over southern Arizona and northern Sonora state, as well as west into some parts of southern California. Their distribution is patchy, however, reflecting their particular requirements and sensitivities. They prosper best in the lower Sonoran elevations, where summer rains provide the warm and wet conditions required for the germination of Saguaro seeds. The California desert receives most of its rainfall in the winter, when temperatures are cooler, and this clearly serves to inhibit the Saguaro there. In Arizona the plant is most common on hot, south-facing slopes, in what is known as the *bajada*, the interface between mountain and plain, where the rocky terrain supports a wide variety of cacti as well as many species of woody and spiny shrubs and a wealth of colourful flowers in spring.

The Saguaro is a slow-growing but potentially large plant. After ten years of growth, often in the sheltered environment provided by a so-called "nurse tree", a young Saguaro may still have reached only 20 centimetres (8 inches) or so in height, but if local conditions remain good for the next few decades it can attain 10 metres (33 feet) and veterans of 15 metres (50 feet) have been recorded. The oldest Saguaros may be 200 or more years old, with a girth of 3 metres (10 feet) plus and carrying as many as thirty or forty "arms". These limbs, which contribute so much to the Saguaro's sculptural and undeniably anthropomorphic character, begin to appear when a Saguaro reaches about 2.5 metres (8 feet) in height and are often formed when the plant's extremities are damaged in some way (for example, through obstruction by the canopy of a protective nurse tree) and cannot continue growing upwards; they sprout sideways instead.

Saguaros usually have a single trunk which, together with the limbs, forms the central component in this plant's impressive water-storing capacity. Paramount in this respect is the actual structure of the plant, essentially a robust cylinder of wooden rods surrounded by an

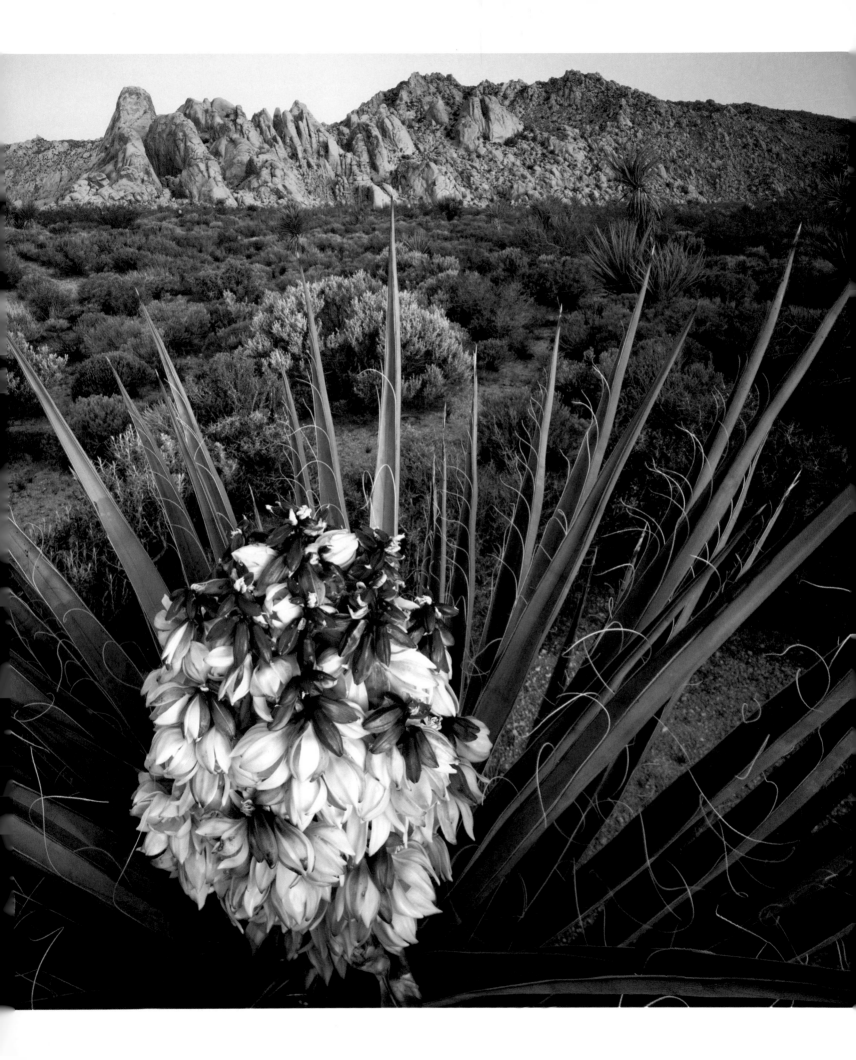

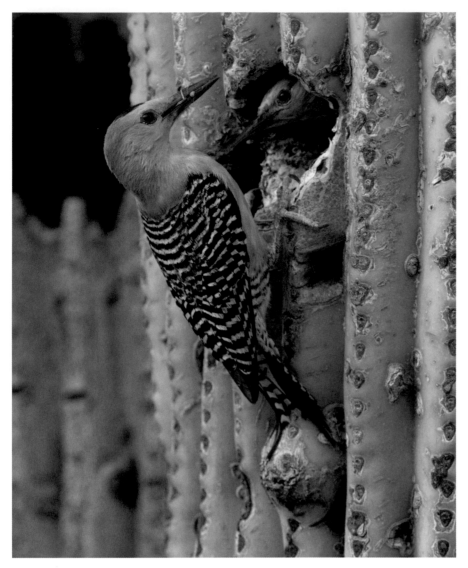
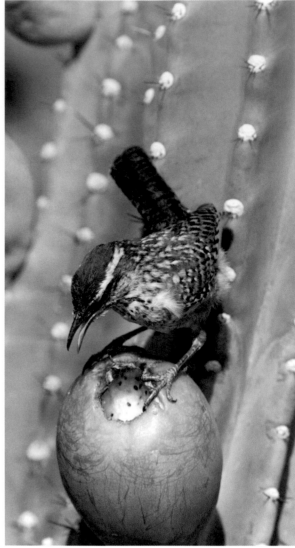

absorbent pulpy tissue and encased in an outer skin made of ribs and grooves, giving it a fluted appearance. The skin can expand and contract, enabling the Saguaro to absorb water and then retain it within the pulpy tissue; the bigger the plant, the more water it can store, so older specimens are therefore best placed to withstand periods of severe drought and can visibly increase their size after heavy rain, as they absorb and store extra water reserves. When they are "full", the skin appears less fluted and discernibly distended, and once fully charged with water a Saguaro can survive for several years before needing to refill its internal reservoirs. Further adaptations help the Saguaro retain moisture and minimize water loss, including the waxy quality of its outer skin and the downward-pointing direction of its spines, which serves to direct rainfall towards the base of the plant. An extensive root system that runs horizontally just below the surface helps secure the plant firmly in loose or rocky terrain and also provides a wide catchment network through which to absorb moisture when it rains.

Late spring is Saguaro flowering season. Each of the rather sickly-smelling creamy-white flowers will bloom for only a few hours, developing and opening in response to heat stimulus. Most buds therefore appear on stem tips facing east and south, where they are exposed to maximum sunlight. The flowers comprise a garland of petals attached to a tube about 10 centimetres (4 inches) long, in the bottom of which is a rich nectar. This attracts a range of creatures, which in reaching into the flower to seek the nectar serve to pollinate it – this is essential for the Saguaro, which can only be fertilized by cross-pollination. Each flower will start

ABOVE LEFT **A common sight around Saguaro cacti, the Gila Woodpecker may use the same nesthole for several years. Newly excavated nest holes are not used straight away, however, as the woodpecker must wait for the sap to harden before moving in.**

ABOVE RIGHT **The Cactus Wren** *Campylorhynchus brunneicapillus* **lives primarily on insects, but takes advantage of the Saguaro's seasonal fruit. It also nests in Saguaro and other cacti, building its nest in an existing hole or in a dense clump of spines.**

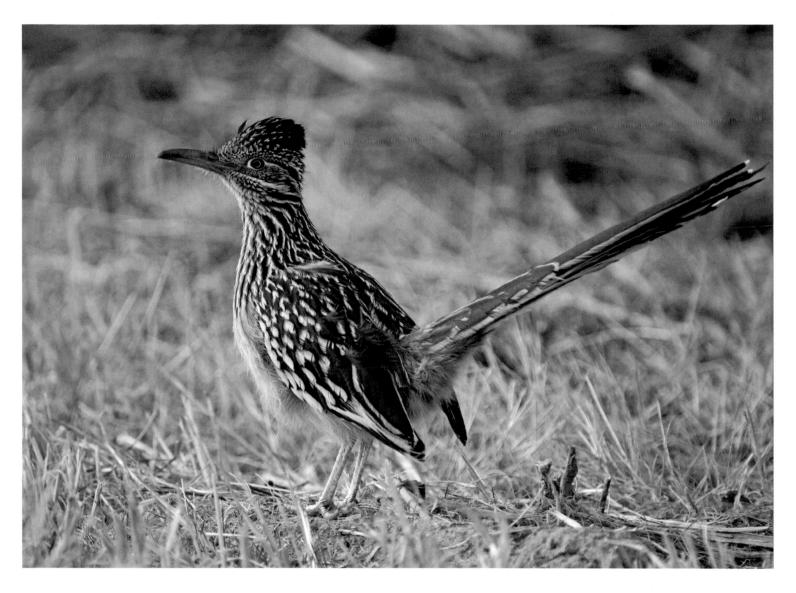

to bloom after dusk and will usually be fully open by midnight, being visited first by bats and flying insects before diurnal pollinators take over at sunrise. By noon the flowers begin to close and die off, subsequently forming a red fruit which is a popular food for many types of desert wildlife. Although each Saguaro flower has only a brief lifespan, because not all the flowers on an individual plant will bloom at the same time, a large specimen can extend its flowering period to over a month or more.

Several desert-specialist bird species enjoy a strong ecological association with the Saguaro, including Gila Woodpecker *Melanerpes uropygualis*, Gilded Flicker *Colaptes chrysoides* and White-winged Dove *Zenaida asiatica*. The first two species excavate nest sites inside the cactus, drilling through the outer skin and layer of pulp into the internal cylindrical structure, where they then peck out a cavity. Their efforts can leave Saguaros literally peppered with holes, and sometimes with big gaping wounds; yet these rarely cause serious problems for the plant, which is able to form a callus over any exposed water-storing tissue, thereby sealing it off and preventing possible infection. Meanwhile, the largely migratory White-winged Dove is one of the Saguaro's most important pollinators, feeding extensively on the plant's flower pollen, nectar, fruit and seed. So close is the relationship that the dove times its arrival in the Sonoran Desert with the Saguaro's flowering season.

Despite being protected by law, smaller Saguaros are vulnerable to theft and larger ones to vandalism, although sometimes they do strike back. There is at least one documented incident

ABOVE **Perhaps the most iconic American desert bird, the Greater Roadrunner *Geococcyx californianus* is a member of the cuckoo family and can run at speeds up to 32 kph (20 mph). Its varied diet includes insects, small birds and mammals, and reptiles.**

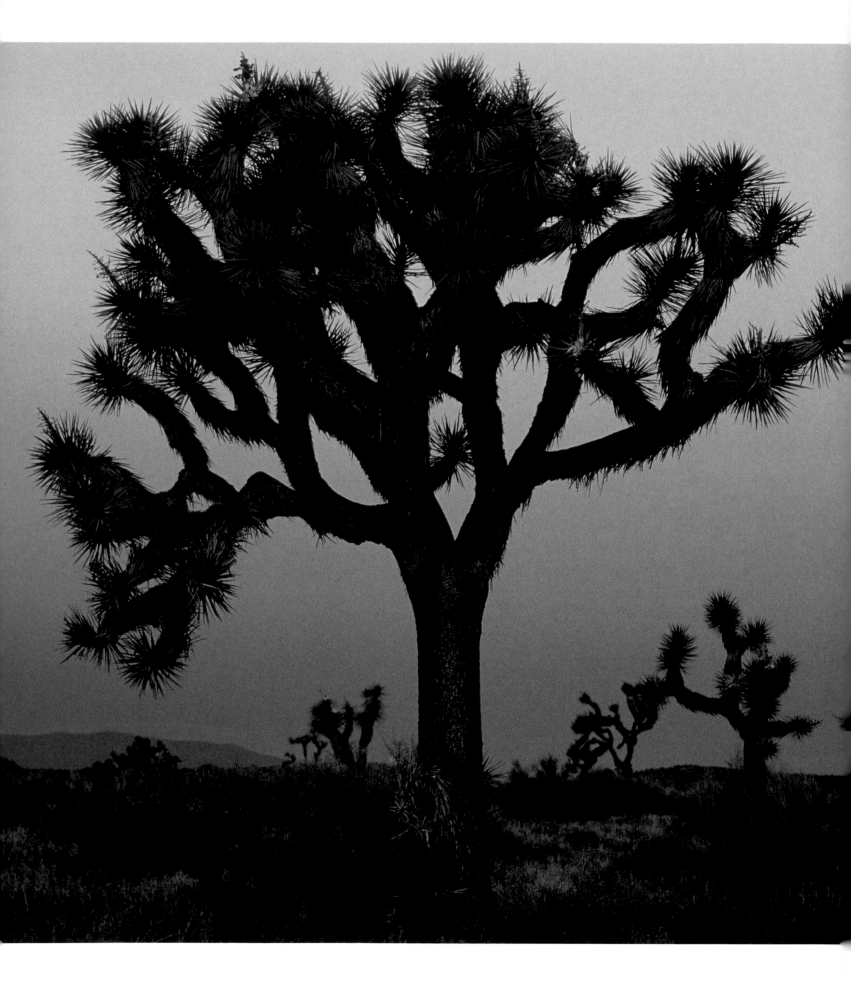

LEFT Distinctive they may be, but Joshua Trees have not always been popular. John C Fremont travelled through parts of the Mojave in 1844 and wrote how "their stiff and ungraceful form makes them to the traveler the most repulsive tree in the vegetable kingdom".

RIGHT Drifts of Desert Poppies *Eschscholzia glyptosperma* carpet the desert after winter rains. Spring-blooming annuals have to germinate, bloom and set seed within a short season; their seeds then wait in the ground for the rain to return.

of a large Saguaro being shot at repeatedly by a man with a rifle, only for the damaged plant to then collapse on top of its assailant, killing him. Development and infrastructure projects such as road-building and suburban sprawl have also taken their toll on this magnificent plant. Today one of the best places to see Saguaros in their full sculptural glory is the Saguaro National Park near Tucson, Arizona.

If the Saguaro stands as a beacon for the Sonoran Desert, then the remarkable Joshua Tree fulfils a similar role in the Mojave. These impressive trees with their shaggy limbs strike a charismatic pose across the landscape, their often contorted and unlikely outlines assuming an almost cartoon-like character at times. A type of yucca, the Joshua Tree is the largest member of that family and mature specimens can reach heights of 15 metres (50 feet) or more and live to be at least 300 hundred years old. Ascribed their English name by Mormon pioneers, who saw in the tree's upward-reaching branches the supplicating arms of the prophet, Joshua, guiding them westwards, these trees flower in spring but need conditions to be just right. A seemingly essential part of the equation is a sharp freeze, which scientists believe damages the growing end of the branches and thereby stimulates flowering. The creamy-white flowers are produced in panicles and pollination is courtesy of the Yucca Moth *Tegeticula maculata*, which spreads pollen while visiting different trees and laying its eggs. Joshua Trees can also reproduce vegetatively from their roots, a useful asset following devastating fires, for example. One of the best sites to see Joshua Trees, which are endemic to the United States, is the Joshua Tree National Monument in the Little San Bernadino Mountains, which separate the Sonoran Desert from the Mojave and are home to wildlife typical of each ecosystem.

The largest reptile in the Mojave is the Desert Tortoise (*Gopherus agassizii*), a much-declined species but one that still survives in the Mojave in reasonable numbers. Here it is found primarily on the washes and alluvial fans, where it feeds on a variety of vegetation, from flowers to grasses and cacti. Spring and autumn are the best seasons to look for tortoises, for they are at their most

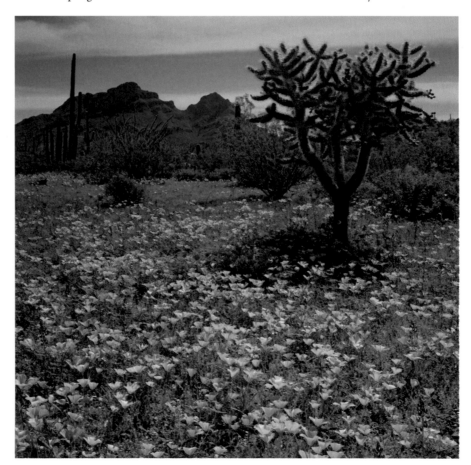

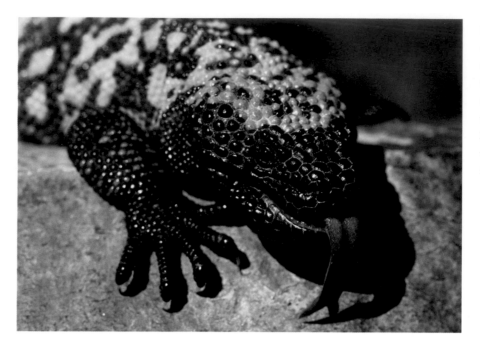

active then; much of the rest of the year is spent in a state of dormancy in underground burrows, which they excavate to escape both the intense summer heat and what can be very cool winter temperatures. Desert Tortoises face a range of threats, both natural (predation by mammals, reptiles and birds) and man-made (disturbance and habitat degradation, collection for the illegal pet trade, roadkill) and are under threat across much of their range.

The Mojave is also home to the largest desert spider, the Desert Tarantula *Aphonopelma chaleodes*. Reaching a total span of 10 centimetres (4 inches), the tarantula is a fearsome sight but not one that many visitors come across. Tarantulas are shy and retiring creatures, usually only emerging from their burrows at dusk for nocturnal forays across the desert floor in search of prey such as grasshoppers, beetles and small rodents. They are cursorial hunters, meaning that they chase down their prey, as opposed to the "sit-and-grab" approach adopted by many other species of arachnid. Stands of Joshua Trees are favoured tarantula habitat, with spider burrows sometimes located in soil crevices at ground level near the trunks of the trees. Although tarantulas will bite humans only when greatly provoked, their bite can be painful and too close an encounter is best avoided.

Interestingly, the tarantula is itself prey to a quite remarkable group of insects, the tarantula hawk wasps *Pepsis* spp. The female wasps seek out tarantulas as hosts for their larvae in what is an extraordinary if rather macabre process. They locate the spiders by smell, entering occupied burrows to lure out the resident and then sting it. The tarantula is quickly paralysed by the wasp's venom, soon becoming comatose; the wasp then drags it to a hole, lays a single egg upon its body and then covers the spider in soil, leaving only a small entrance; it may even reuse the spider's own burrow for this purpose. The egg later hatches and the wasp larva then feeds on the living body of its incapacitated host before eventually emerging through the entrance as an adult wasp.

The existence of such remarkable adversarial relationships underlines the interconnectedness of the natural world and thereby the compelling need to protect the wider landscapes and wildlife of the Mojave and Sonoran Deserts. The complexity and fragility of these environments is such that they are highly vulnerable to a growing range of pressures, including a rapidly expanding human population that is greedy for land and water resources. The encroachment of agriculture, especially along river valleys, is already a major problem in some areas, as are the overexploitation of groundwater reserves and certain aspects of tourism, particularly uncontrolled off-road driving which can be disastrous for desert plant communities, for example. Non-native and invasive species are meanwhile threatening indigenous flora and fauna and compromising the integrity of what is a complex but highly sensitive ecosystem.

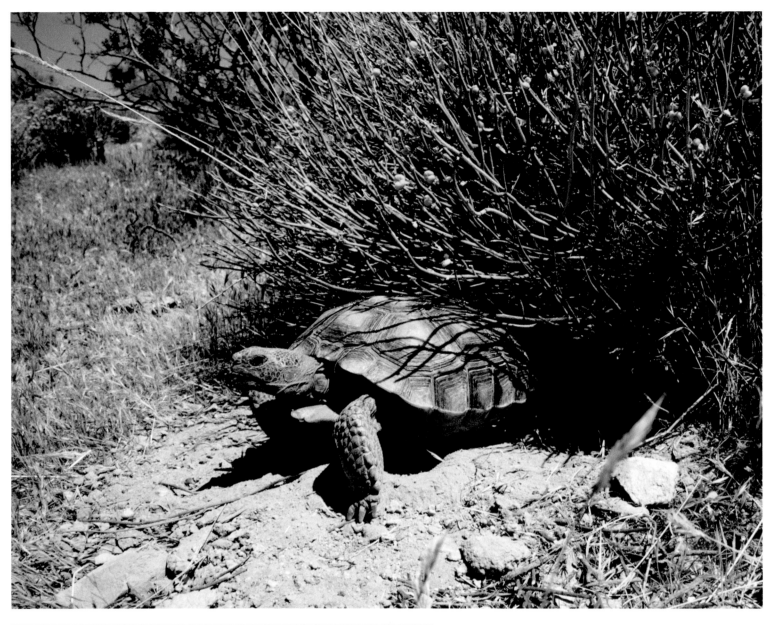

LEFT The Tarantula Hawk Wasp is considerably smaller than some of the spiders it tackles and has to move nimbly to avoid being bitten itself. Once it has paralyzed the tarantula by stinging it, the wasp drags it back into its burrow and lays an egg on its body.

ABOVE Desert Tortoises can survive for up to a year without drinking, deriving moisture from the vegetation they eat. Strong front claws enable them to dig hibernation chambers and summer "pallets", shallow burrows where they escape the heat.

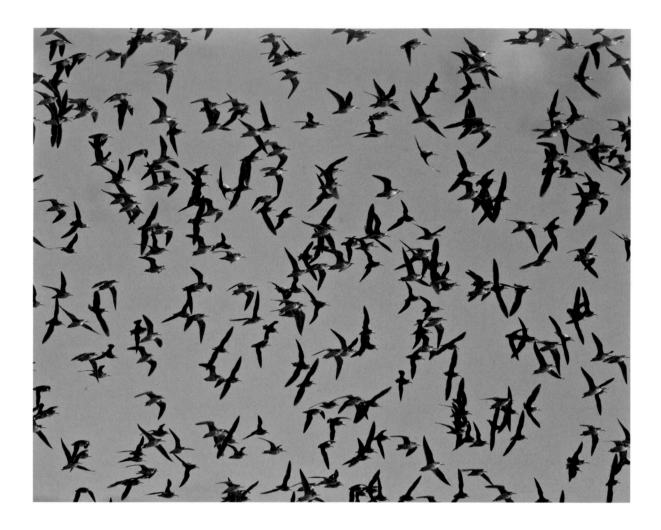

13: The Bird Lakes and Bristlecone Pines of the Great Basin

ABOVE Spring and autumn bring millions of migratory waterbirds to the lakes of the Great Basin. At peak times the skies are filled with flocks of waders, such as these Wilson's Phalaropes, which feed from the lakes before continuing on their journey.

OPPOSITE Low water levels at White Rock Bay on Utah's Great Salt Lakes. Antelope Island, in the background, is the largest island in the lake and a protected state park. It is home to Pronghorn Antelope, which were reintroduced in 1993.

The Great Basin covers a little over 500,000 square kilometres (200,000 square miles) of the central western United States, extending over most of the state of Nevada and over half of Utah, as well as smaller sections of three other neighbouring states. Located in the rain shadow of the Cascades and Sierra Nevada, this region is predominantly high-altitude desert, with annual precipitation rarely amounting to more than 300 millimetres (12 inches) and with much of it falling as snow during the winter. Summer thunderstorms can bring cataclysmic downpours. The climate is generally harsh, with high summer temperatures and prodigiously low values in winter. Sunshine levels are high all year round.

Rather than one large basin, the Great Basin actually comprises very many smaller ones and their associated watersheds, with geologists and geographers continuing to wrangle over the Basin's precise extent and configuration. Most authorities now accept that the Mojave and Sonoran Deserts mark its southern boundary, and that the divide of the drainage basin of the Columbia River denotes its northern edge. Overall, this is a rugged upland landscape of isolated mountain ranges, valleys and open plateaux, with the highest peaks topping 3,700 metres (12,140 feet) and the lowest basins still above 1,000 metres (3,280 feet). Evaporation rates are very high, and little water sinks into the table below ground. Ephemeral lakes may appear after particularly heavy rainfall or snow melt, and although there are streams leading through this forbidding environment, none ever reaches the ocean. Locked within the basin by the surrounding mountain ranges, they simply ebb away into the sand and rock.

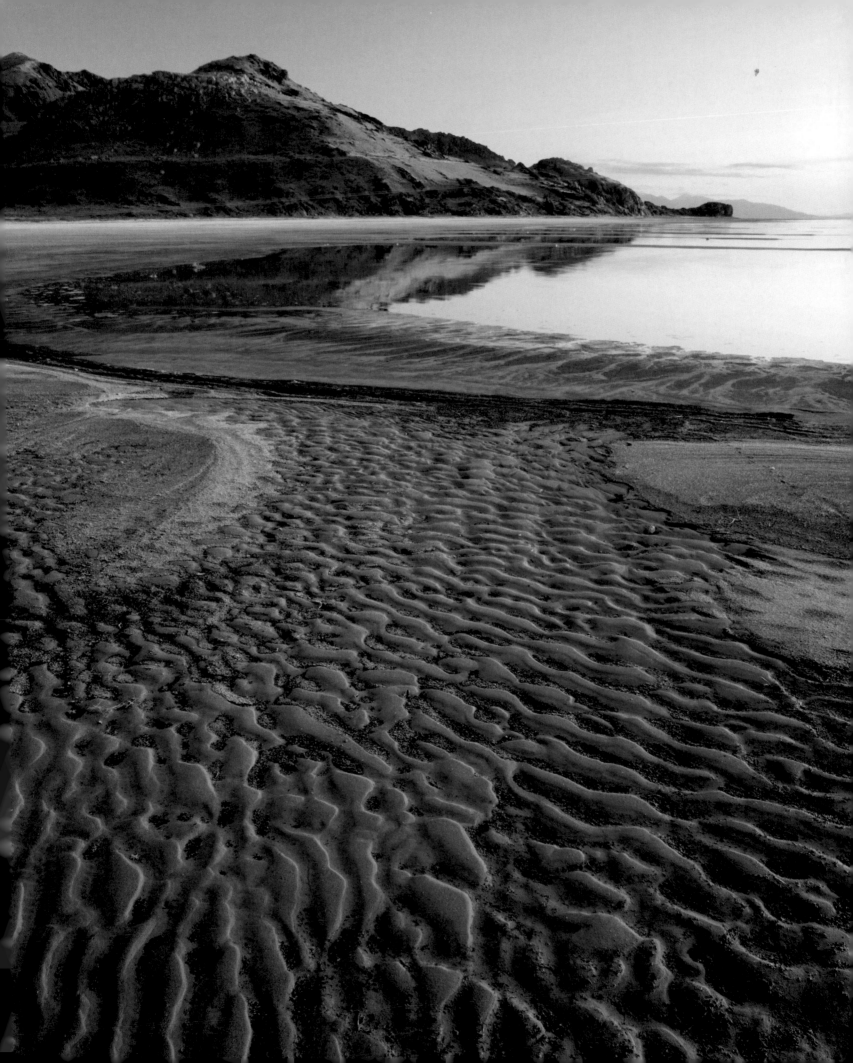

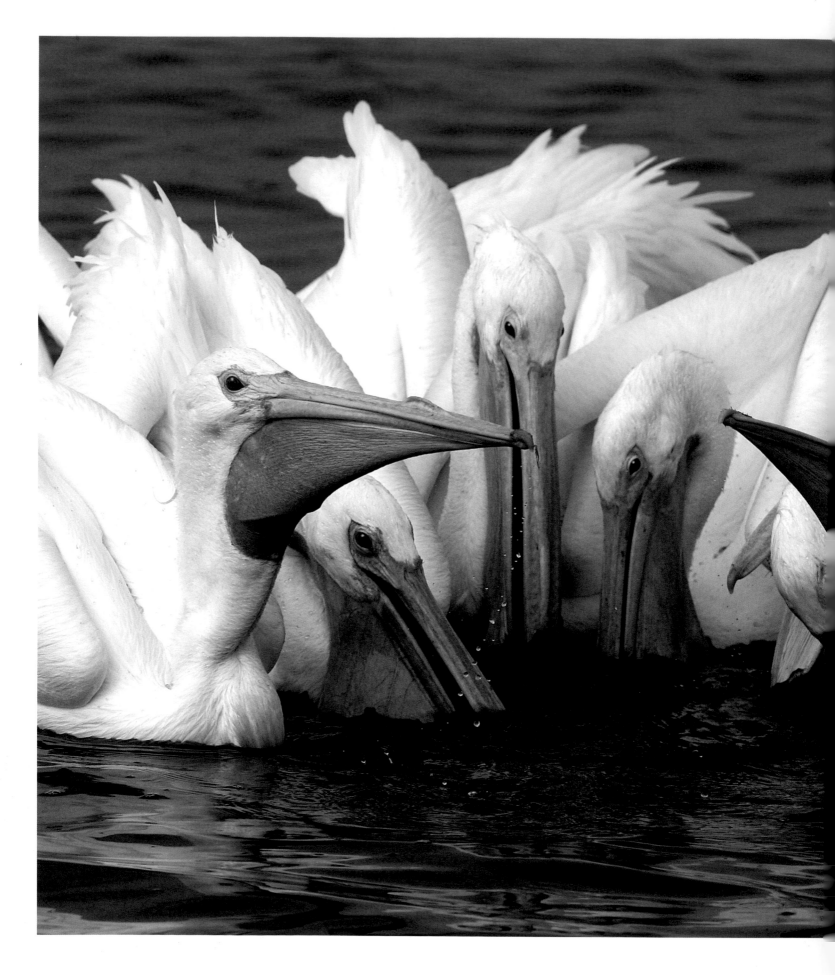

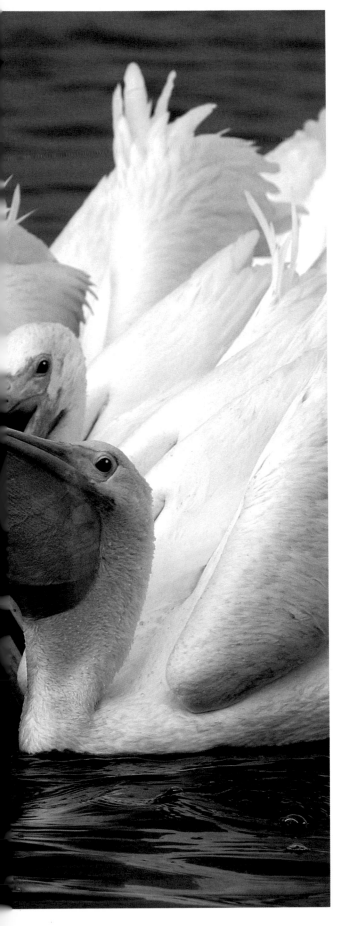

There are, however, permanent water features in the Great Basin Desert and some of these are on a quite epic scale. Covering more than 4,000 square kilometres (1,500 square miles) of open water and surrounding shallow marshland, the Great Salt Lake is the largest salt lake in the Western Hemisphere and arguably the most important natural feature in the Great Basin. With no outlets to the sea, the lake is highly saline, its salinity varying between 4 and 28 per cent, depending on precise location, season and rainfall patterns. Although the lake has no permanent fish populations, it is noted for the phenomenal blooms of brine shrimps and brine flies that occur here. These attract vast numbers of birds and, as an oasis in an otherwise extremely arid area, the lake is one of the most important sites on the Pacific Flyway, the avian migration path that extends from Alaska to Mexico and beyond.

The lake is particularly valuable to migratory waterbirds, with an estimated six million birds using it and its associated habitats in an average year. These include half a million or so Wilson's Phalaropes *Phalaropus tricolor*, slightly fewer Red-necked Phalaropes *Phalaropus lobatus* (with 280,000 seen here on a single day!) and American Avocets *Recurvirostra americana*. Some 40,000 of the latter breed here, alongside 30,000 Black-necked Stilts *Himantopus himantopus*, 150,000 California Gulls *Larus californicus* and up to 20,000 American White Pelicans *Pelecanus erythrorhynchos*. During May and June, and again in September and October, the mixed congregations of birds make for an unforgettable spectacle.

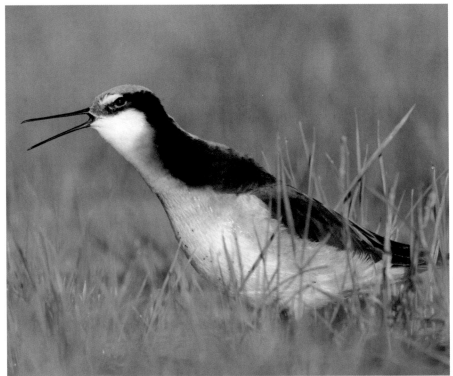

LEFT **Gunnison Island in the Great Salt Lake has an important colony of American White Pelicans, with several thousand nesting here each spring. Pelicans are very sensitive to disturbance and whole colonies will abandon their eggs and young if disrupted.**

ABOVE **Like all members of their genus, female Wilson Phalaropes are more brightly plumaged than males during the spring. They pursue the males and defend territory, but once their eggs are laid they migrate, leaving the males to rear the young.**

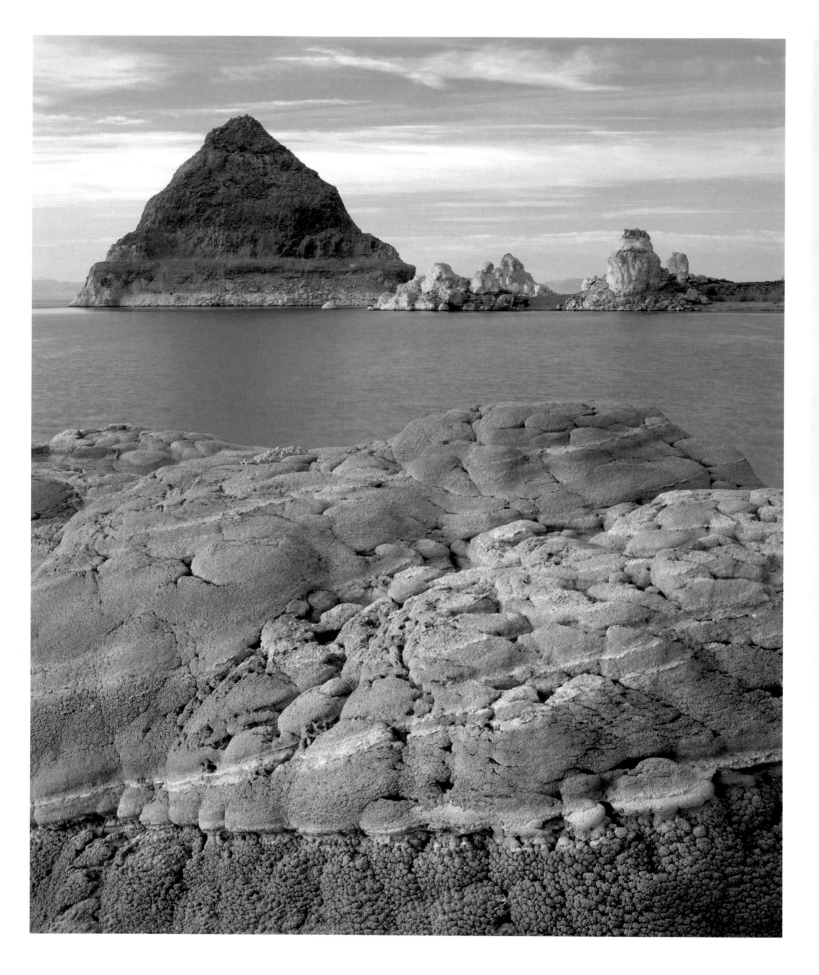

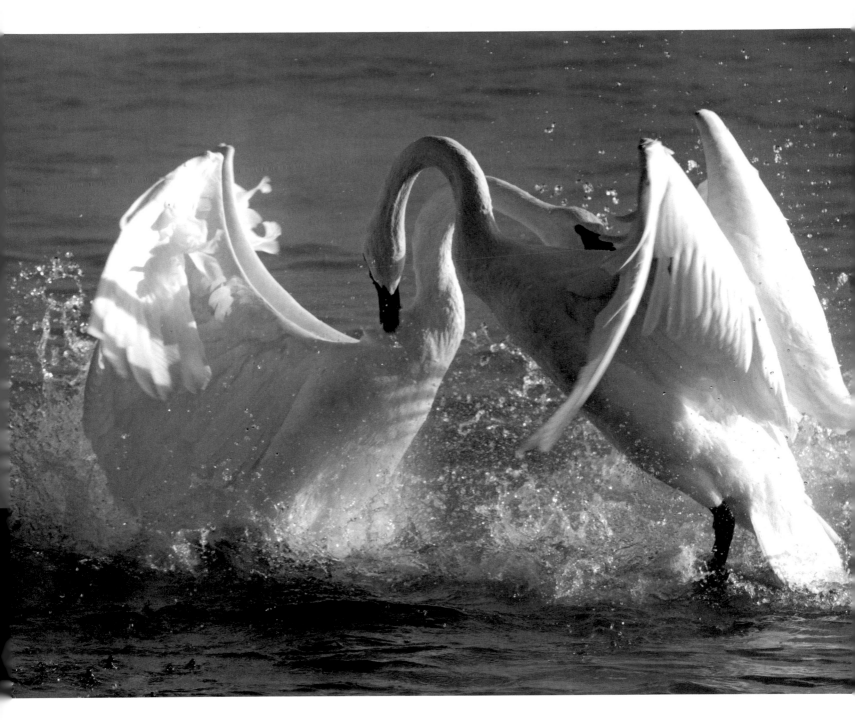

Other important wetlands in the Great Basin include Franklin Lake and Ruby Lake, a few kilometres apart from each other in neighbouring Nevada. Together these lakes and their marshes – a closed-water system fed by more than 160 springs, and so with generally good levels of water – are another major hotspot for birds regionally. The extensive wetlands here are in generally excellent condition and consistently attractive to a range of resident, breeding and migratory birds. Nesting species include White-faced Ibis *Plegadis chihi* and several types of wildfowl, including Trumpeter Swan *Cygnus buccinator*, recovering from near extinction regionally, and the highest density of Canvasback *Aythya valisineria* anywhere in the world. The numbers of wading birds at any one time are critically determined by water levels and by the extent of exposed edges along which they can feed, but at peak times in autumn and, to a lesser extent, spring, it is possible to see many thousands of waders of up to 20 species in a single day.

Although much of the Great Basin is privately owned, many of the key areas are protected by government decree. Among these is the Great Basin National Park, established in 1986 and which includes the Lehmann Caves National Monument, a protected site since the 1920s. Located in the far east of Nevada, the park covers a wide variety of terrain from valley floors at 1,500 metres (4,900 feet) elevation up to the 3,982 metre- (13,064 feet-) high Wheeler Peak. It is characterized by a diverse range of vegetation, through sagebrush plains and saltbush scrub through pinyon pine and juniper woodland up to the treeline, where there are some of the finest stands of Great Basin Bristlecone Pine *Pinus longaeva*.

The three species of bristlecone pine are endemic to the United States and are considered by scientists to be the oldest living single organisms, with the most mature specimens of *Pinus longaeva* estimated to be not far off 5,000 years old and found in California's White Mountains. Throughout their limited range the pines grow on or near the tree line, and the arid climate, windy conditions and short growing season – usually only eight to ten weeks – mean that their rate of growth is extremely slow. Even the oldest specimens rarely reach more than 17 metres (56 feet) in height, although their girth can exceed 10 metres (33 feet).

RIGHT Owens Valley in California lies on the western edge of the Great Basin. The sagebrush habitat is typical of this area, and home to mammals such as Pronghorn Antelope, jackrabbits, cottontails and smaller creatures such as ground squirrels.

LEFT The smallest member of the fox family in North America, Kit Foxes are arid zone specialists and mainly nocturnal. In spring, females give birth to up to six or seven pups. Like all foxes, their diet is varied and includes fruit, flowers, rodents, rabbits, reptiles and birds.

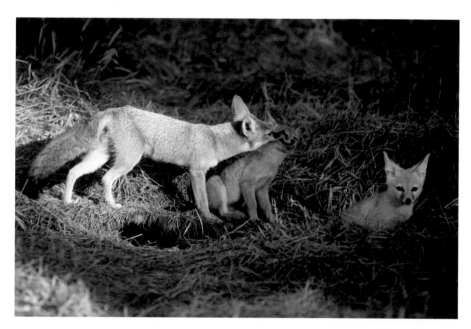

LEFT With outsized ears, the Black-tailed Jackrabbit is very distinctive. In addition to ensuring an extremely good sense of hearing, large ears also act as a cooling system. Heated blood circulates through the thin ear tissue and cools as it does so.

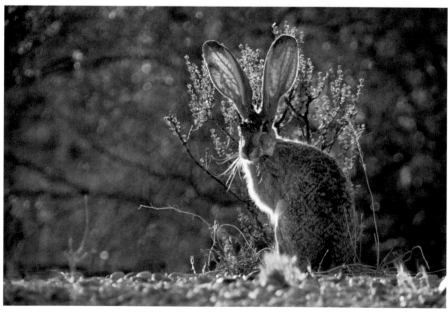

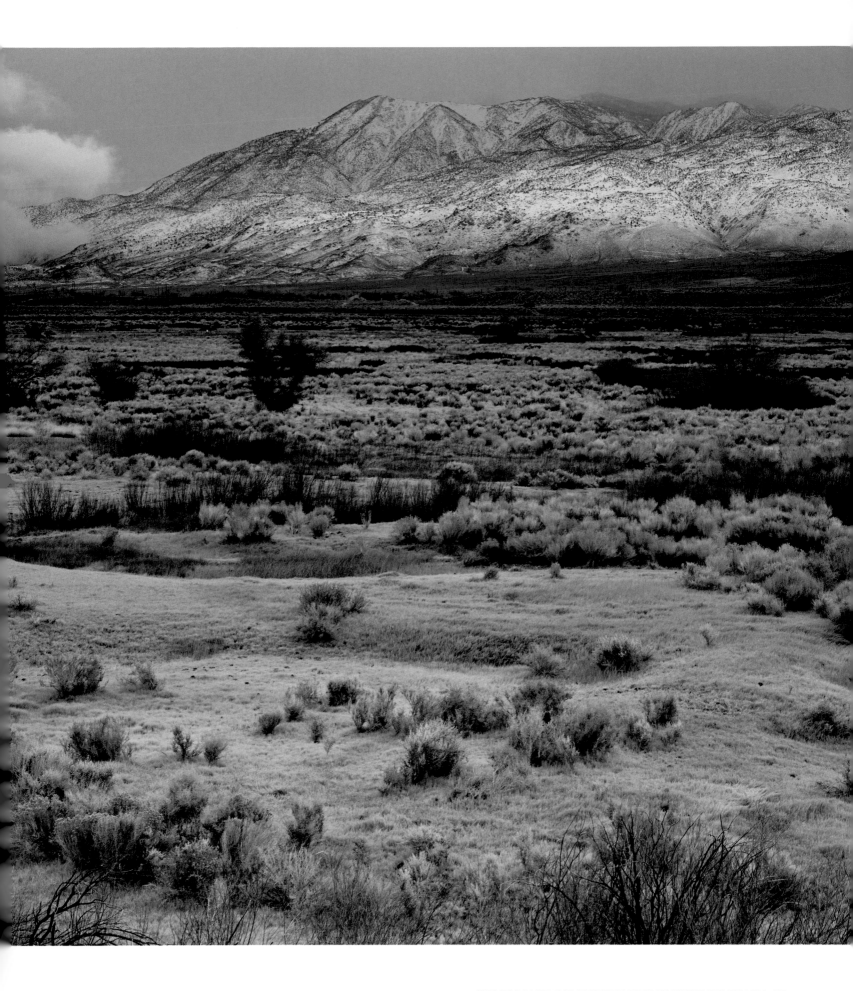

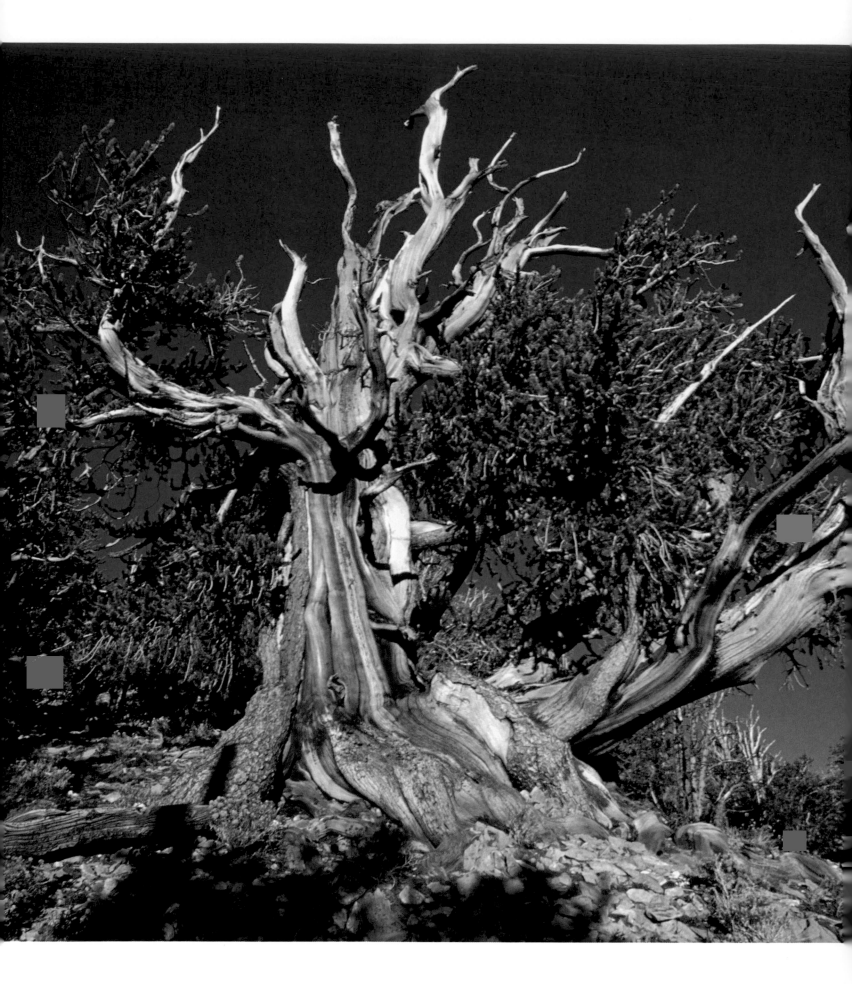

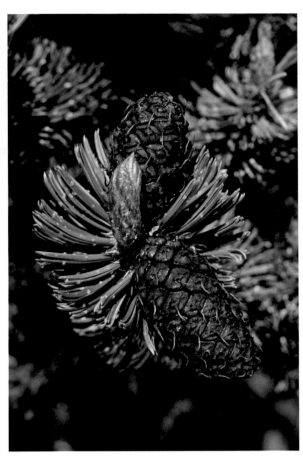

Bristlecone pines grow on outcrops of dolomite, which reflect the sun more effectively than the surrounding and predominant sandstone, thereby helping to keep the root area of the trees cooler and less desiccated than would otherwise be the case. Hardly any other tree species are able to withstand the harsh conditions of this environment, particularly on the dolomite soil, and so the Bristlecones benefit from having little competition, often forming dense stands. Interestingly, the oldest specimens are found in the most exposed sites, growing on their own. Their isolation is thought to help them survive fires resulting from lightning strikes, as the lack of ground cover and other vegetation prevents the flames from reaching them.

Almost 1,000 other plant species have been recorded within the Great Basin National Park to date, and wildlife is also rich and diverse, reflecting the elevational variety and diversity of niches. Over 70 species of mammal have been recorded here. The sagebrush desert and grassy plains support herds of Pronghorn *Antilocapra americana*, for example, along with Coyote *Canis latrans* and Kit Fox *Vulpes macrotis*. A supporting cast of prey species, such as Black-tailed Jackrabbit *Lepus californicus*, Desert Cottontail *Sylvilagus audubonii* and White-tailed Antelope Squirrel *Ammospermophilus leucurus* are also present here.

LEFT **Bristlecone Pines are iconic** features of the Great Basin, with several living specimens older than the pyramids of Egypt. The trees have a survival strategy to withstand periods of drought-induced stress or storm damage by sealing off damaged limbs.

ABOVE LEFT **Bristlecone Pines are** so-called because of the long, hooked spine that grows on the scales of the cones. The trees they grow on are so slow growing that the cones can take two years to mature to a length of 7.5 centimetres (3 inches).

ABOVE RIGHT **Before developing** into mature cones, the Bristlecone's flowers bring a rare blast of colour to the trees. Reproduction rates are very slow, which is one reason why Bristlecones are dwindling in numbers.

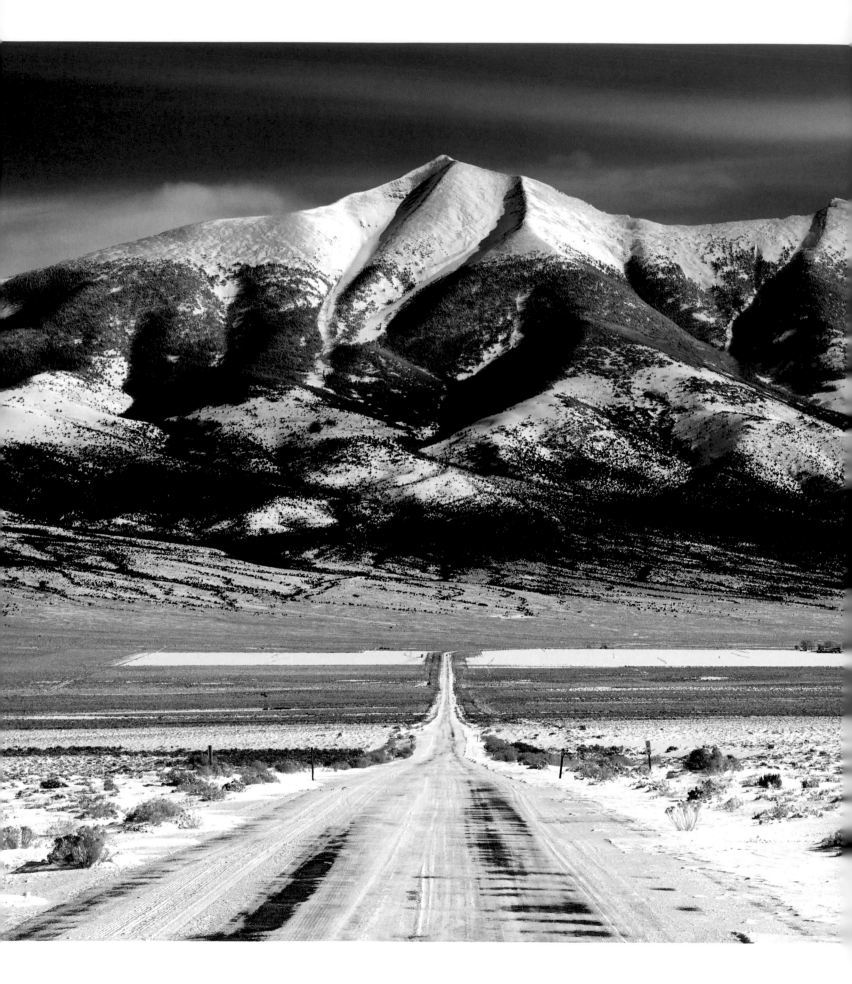

The mountainous areas of the Great Basin National Park are home to both Puma (also known locally as Cougar or Mountain Lion) *Puma concolor* and Bobcat *Felis rufus*, but neither is readily seen. As with all wild cats in the New World, a sighting is more a matter of chance and good luck than anything else. The park's Pumas prey largely on the Mule Deer *Odocoileus hemionus* that are abundant here, but they will also take Bighorn Sheep *Ovis canadensis*. The latter were reintroduced to the area some three decades ago following their local extinction earlier in the twentieth century as a result of overhunting. Avian predators include the resident Golden Eagle *Aquila chrysaetos*, here at one of its highest densities in North America, and the iconic Bald Eagle *Haliaetus leucocephalus*, a common winter visitor.

The return of large mammals such as the Bighorn Sheep to parts of the Great Basin, and the protection of some of their predators, are two notable conservation successes of recent years. Yet a range of pressures is building in the region that pose threats to the wildlife that lives there. Although important blocs of landscape are publicly owned, i.e. by either the state or federal authorities, some critical areas – particularly along the valleys, which harbour especially important habitat types – are in private hands and therefore vulnerable to development. Enormous population growth in recent decades has seen the expansion of the region's urban centres and placed new pressure on land and specifically on water resources. Increased recreational activity on some of the basin lakes has also had a negative impact on wildlife. Meanwhile, grazing by domestic livestock has resulted in extensive habitat degradation at lower altitudes; currently less than ten per cent of the Great Basin is regarded as comprising pristine habitat unaffected by human activity. Habitat fragmentation is a particular problem. Mining has resulted in contamination, and intensive irrigation for the cultivation of crops such as alfalfa has increased levels of salinization in some locations.

LEFT Winters in the Great Basin are harsh and long. Temperatures can remain well below freezing for weeks and snow is often deep and persistent. Wildlife can be hard to find at such times, but 70 per cent of North America's mammal species have been recorded here.

BELOW Pumas are well equipped to cope with cold weather and remain active in all but the worst conditions. Hunting singly, they typically kill animals larger than themselves. They hunt in all types of terrain, but ideally need cover to hide their approach.

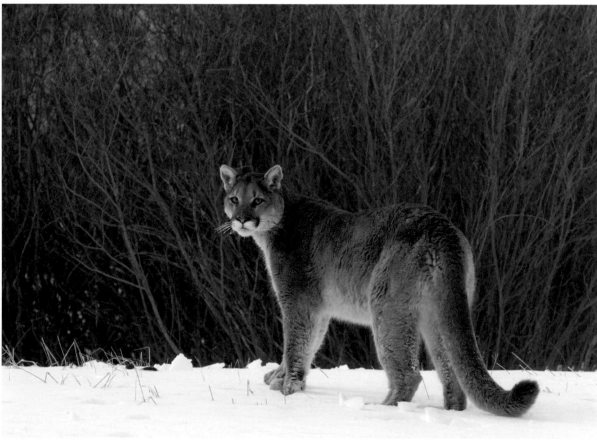

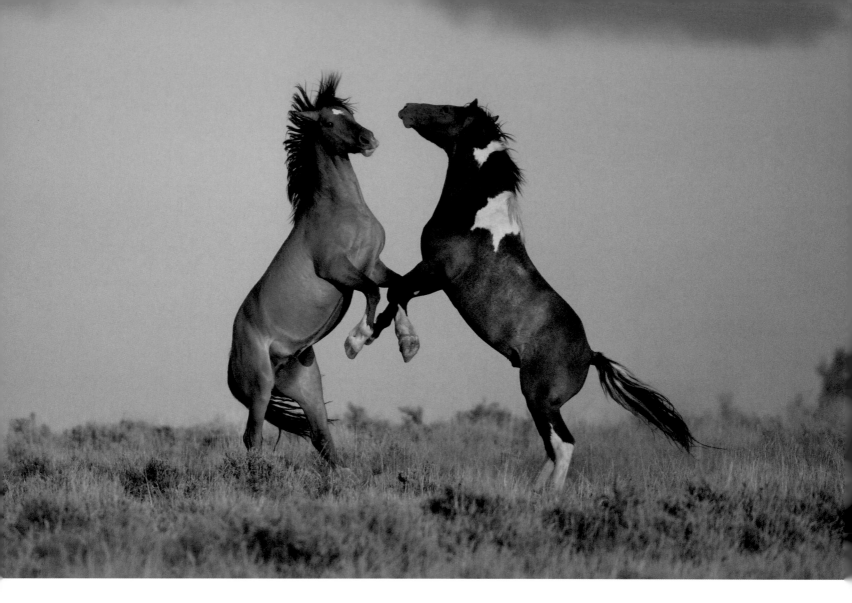

ABOVE The history of the wild horse in North America is complex, but the many thousands of feral horses that roam parts of the West, including the Great Basin, are the focus of an increasingly controversial round-up programme.

One other significant issue in the Great Basin is the impact of invasive non-native species. The most infamous of these is arguably the annual grass, Cheatgrass Brome *Bromus tectorum*. This European species was introduced to the region during the late nineteenth century, probably as a contaminant in imported seed. It has since spread widely, and now dominates extensive tracts of sagebrush steppe, the region's main indigenous habitat type at lower elevations. It is valued by ranchers, however, because of the spring forage it provides for their livestock, but in terms of wider habitat impact it has serious implications. Cheatgrass Brome has essentially replaced a range of indigenous grass species and leaves a large amount of dry herbage at the end of its short growing cycle. This in turn leads to a greater fire risk than that posed by native species, and in some locations the incidence of wildfires has increased from once every few decades to now every four to six years. The regularity and intensity of these fires destroys the sagebrush and indigenous grasses, while the Cheatgrass Brome is able to re-establish itself rapidly, thereby further consolidating its position.

However, perhaps the most contentious conservation issue currently in the Great Basin surrounds the region's wild horses. Approximately 38,000 wild horses are estimated to be running wild in the United States, distributed across ten western states. They have traditionally been regarded as feral domestic livestock and in the past have been culled – many thousands were slaughtered for pet food during the first half of the twentieth century, for example. Although attitudes towards both wild horses and feral donkeys (known as "burros") have changed in recent decades, they are still regarded in some quarters as a problem in terms of their impact on grazing land and the competition they represent to ranch cattle. In recent years a controversial programme

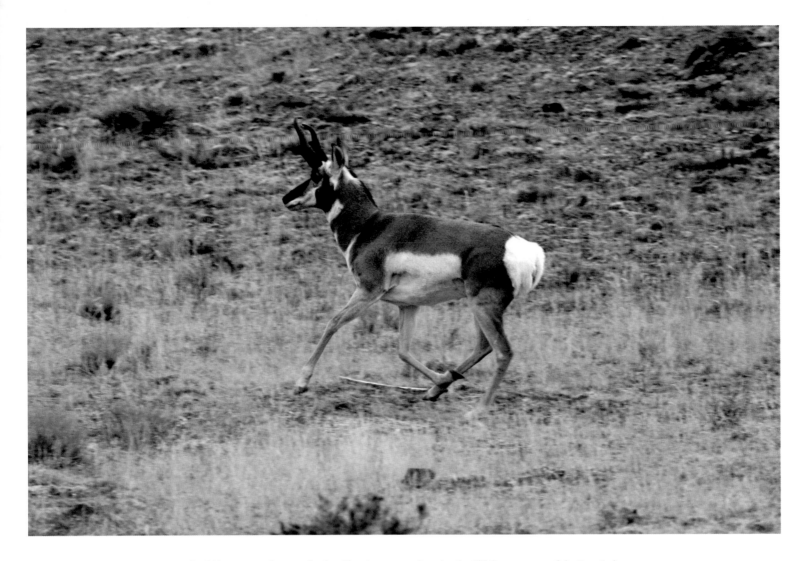

ABOVE In 1850 over 40 million Pronghorn were estimated to be living in North America; by 1920 overhunting had reduced this to 13,000. Protection and habitat management have helped numbers to increase, and herds have been reintroduced in the Great Basin.

of wild horse round-ups or "gathers" has been carried out by the US Department of the Interior's Bureau of Land Management, which is responsible for the management of public rangelands. The horses are chased, usually involving the use of helicopters, and then captured and taken away to holding corrals before being offered for adoption and relocation to private ranches. In many cases the stallions are also gelded.

Concern has been expressed by some ecologists that the fragmentation and depletion of the wild horse herds may be destroying unique genetic material. Fossil remains indicate that the world's horses originated in North America, from where they spread to Eurasia via the land bridge that once existed between present-day Alaska and Russia. The traditional view has been that these horses became extinct in their home continent during the last Ice Age, some 10,000 years ago. Only with the arrival of the Spanish in the 1500s were horses believed to have returned to the Americas, with a small number of these "mustangs" subsequently escaping and proliferating in the wild. However, this version of horse history is now being reassessed in the light of archaeological evidence indicating that horses almost certainly continued to live wild in North America into historical times. Some of the current wild horse herds may therefore represent a last genetic link to these native animals. Horses were the continent's original grazer, pre-dating classic herbivores such as bison and bighorn sheep, and were therefore a critical lynchpin in the wider ecosystem. Some conservationists are therefore arguing that today's wild horses should no longer be regarded as a problem, and instead be managed in such a way as to allow them to regain their former role as part of America's native fauna.

14: Life on the Frontier in the Chihuahuan Desert

The most southern and eastern of North America's desert regions, the Chihuahuan Desert is also the continent's second largest (after the Great Basin Desert, page 150), covering over 360,000 square kilometres (139,000 square miles) of the south-western United States and northern Mexico. This is life on the edge, not just in terms of physical location – straddling two countries and several separate states – but also with regard to habitat and environment. With its northern half bisected by the Rio Grande, the Chihuahuan Desert reaches across to the warmer, lower-lying Sonoran Desert on its north-western side; its central and southern sections are flanked by the Sierra Madre Oriental and Occidental. Much of the desert sits on a plateau of between 600 and 1,500 metres (1,970 and 4,920 feet) above sea level, comprising a series of shallow basins covered by grassland, cactus savannah and scrub-dotted plains, as well as an extraordinary expanse of gypsum dunes, the so-called White Sands of the Tularosa Basin in New Mexico. There is also a large number of freshwater desert pools, supporting important populations of fish and other aquatic life. Rocky outcrops and mountain ranges add diversity and dramatic scenic variation, and rising dramatically from the desert floor is a series of isolated upland formations – the so-called "sky islands" – which are among the most ecologically important sites in the whole of the Americas.

BELOW **Big Bend National Park in Texas** is the largest protected area of Chihuahuan Desert and home to some of the cacti that characterize this ecosystem. These include many species of Agave, which were traditionally used for medicine by local people.

RIGHT **The Rio Grande forms the boundary** between the United States and Mexico, and the permanent presence of water helps to maintain a variety of riparian habitats. Some of the best birding in North America can be enjoyed at Big Bend.

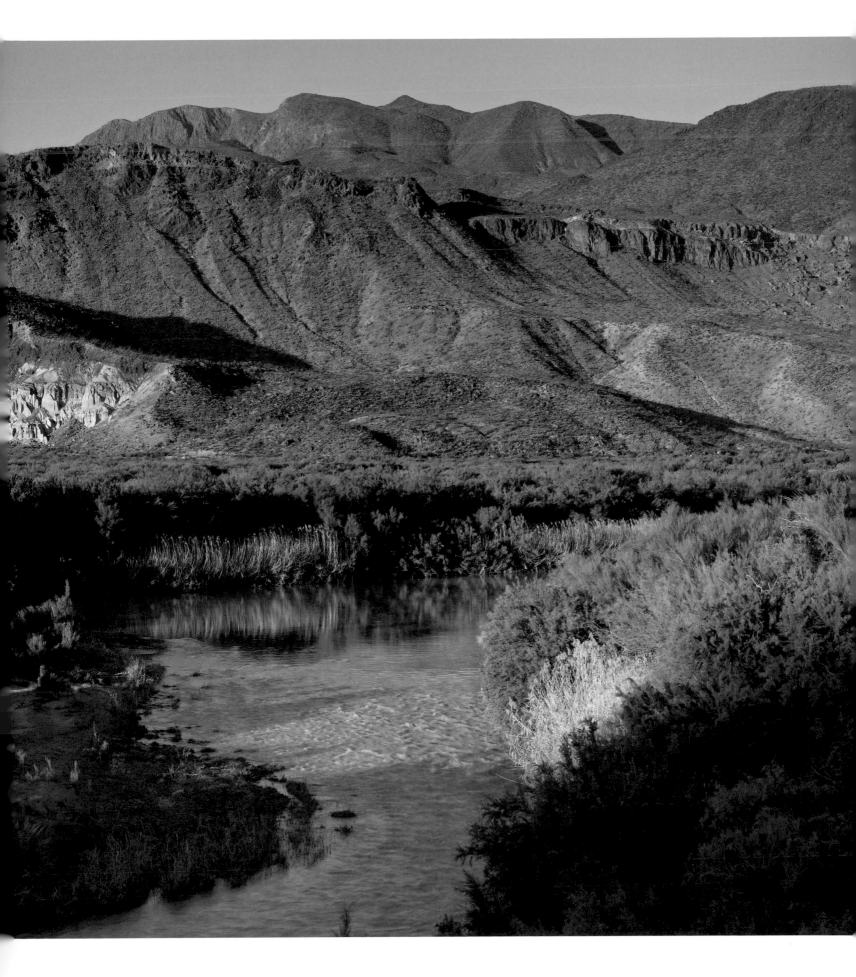

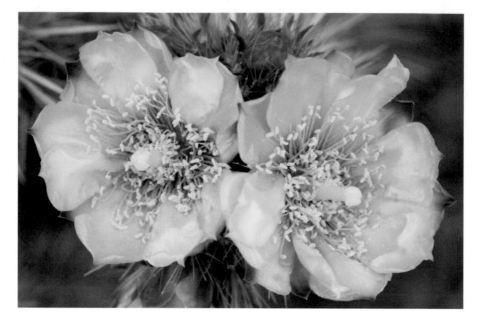

The altitude of the Chihuahuan Desert means that winters are more severe than in the Sonoran Desert, for example. Frosts are common in the north, and temperatures here can drop well below freezing. Rainfall varies across the desert, but rarely amounts to more than 250 millimetres (10 inches) per annum. This is largely due to the rain shadow created by neighbouring mountain ranges, an effect which means that the southern section of the desert – shielded by the Sierra Madre on both sides – receives less rainfall than further north. Most precipitation takes the form of thunderstorms during the period July to October, with very little rainfall occurring outside these months. A superb display of wildflowers usually follows the rain, although the magnitude of this spectacle is closely linked to the actual amount of precipitation. Generally speaking, several consecutive days with rain will prompt a more extravagant flowering, as it helps ensure that the protective casings – also known as inhibitors, and in which the seeds of many species are protected when dormant – break down properly and thereby release their contents for germination. The inhibitors resist less significant amounts of rain, which in turn saves the wastage of seeds that germinate when it is too dry and therefore will not be able to complete what is an accelerated life cycle even in optimum conditions. It is a finely tuned process.

The Chihuahuan Desert is particularly noted for its succulents and cacti, with over 400 species recorded here. Cacti such as *Opuntia* (including those species more usually known as prickly pears) are especially common and widespread, as are several types of yucca. These include the Soaptree Yucca *Yucca elata*, one of many desert plant species which traditionally provided the local native Americans with virtually all their needs; Soaptree leaves and fibre were used to make mats, baskets, clothing and footwear, and the trunk and roots were ground to yield a substance traditionally used as soap and shampoo.

Vegetation diversity changes in the riparian environment along the Rio Grande, for example, as well as at higher elevations, where rainfall is appreciably higher. Here the desert gives way to mixed woodland, mainly composed of oak, juniper and *pinyons* (*Pinus* spp.), with coniferous forest on the highest peaks. Down below, much of the desert is covered in scrub, comprising key indicator species such as Tarbush *Flourensia cernua*, Ocotillo *Fouquieria splendens* and particularly the ubiquitous Creosote Bush *Larrea tridentate*, whose new leaves have a resin-like coating, hence its alternative popular name of Greasewood. It also has a strong and distinctive smell, especially when its leaves are shaken or crushed, and after heavy rainfall the desert can be redolent of its pungent aroma.

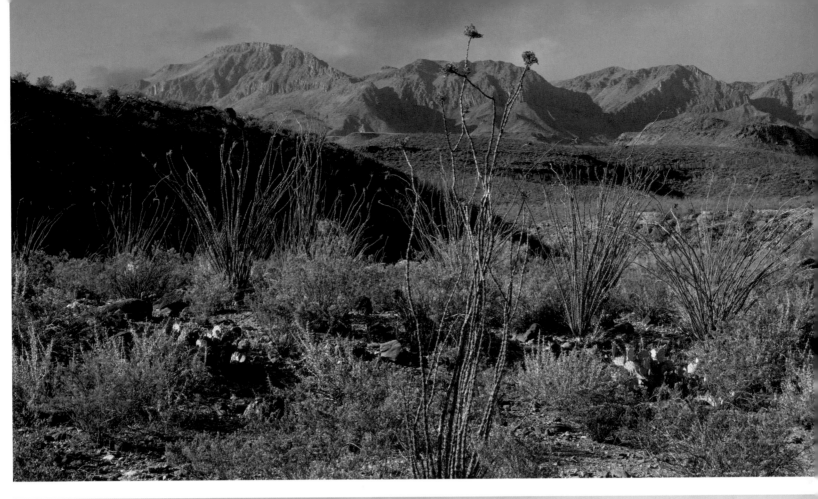

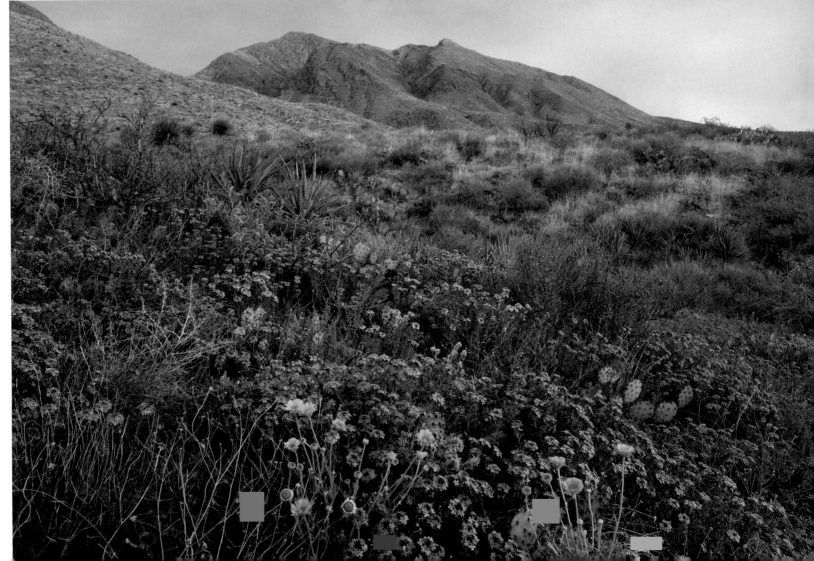

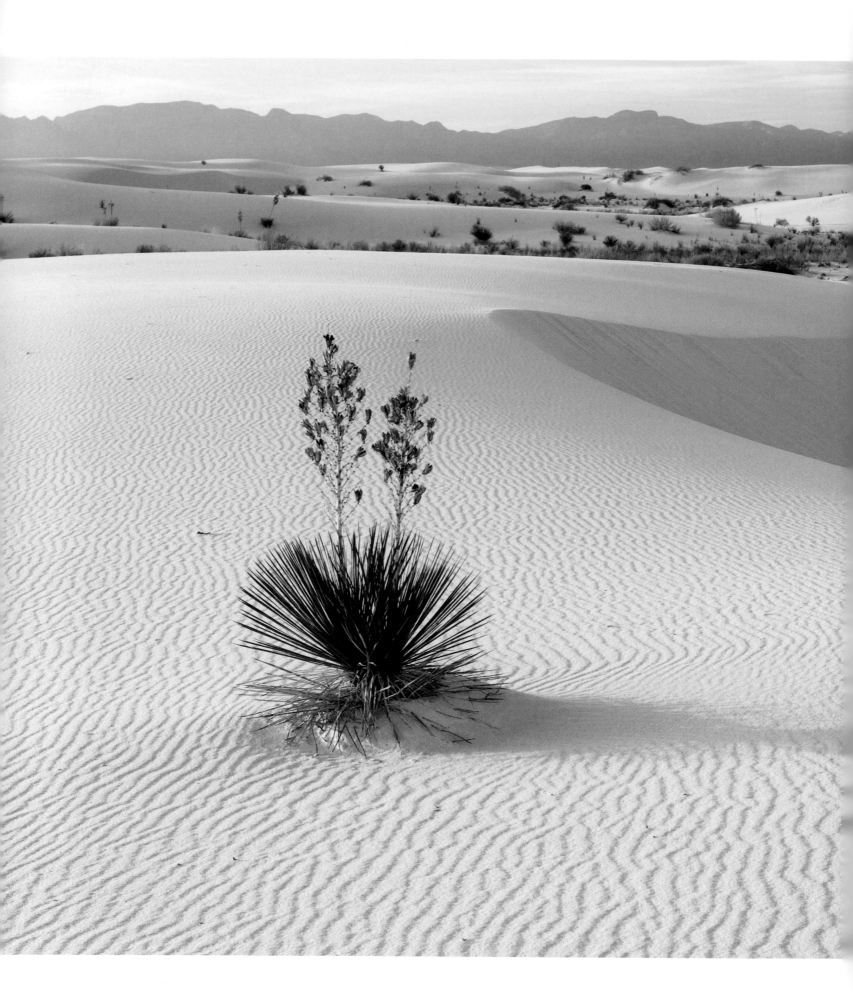

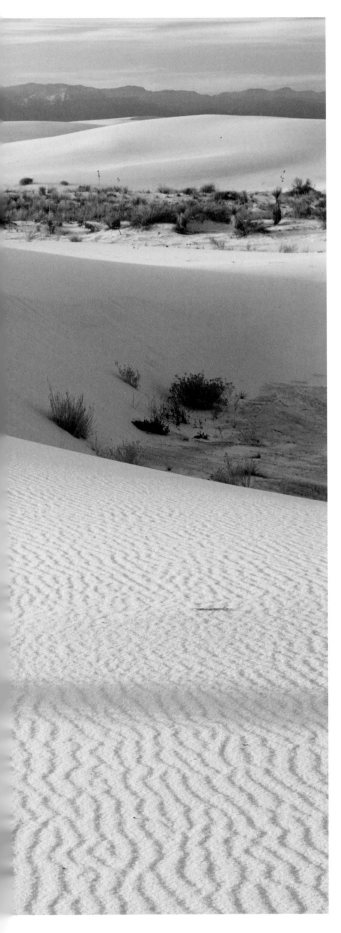

LEFT Located at the northern end of the Chihuahuan Desert, the White Sands National Monument is the largest gypsum dune field in the world. The dunes are very active, with some moving more than 9 metres (30 feet) in a year.

BELOW Masters of desert survival, Creosote Bushes are fully equipped for arid zone life. The even spacing between individual plants is an evolutionary adaptation that helps ensure each plant gets enough moisture from the surrounding soil to survive.

A characteristic species of more open areas, the Creosote Bush is able to survive on the scantiest and least forgiving of soils, thanks to a complex root system that extends both radially, just below ground surface, and downwards, enabling it to reach water reserves that are out of reach to some other plants. It also appears to be able to regulate its population density, so that each plant can obtain adequate moisture. In particularly well-favoured sites Creosote Bushes grow quite profusely in a seemingly random manner, but in drier locations where water is at a premium the bushes are clearly more regimented in terms of location, growing in a discernibly grid-like pattern with almost equal distances between each plant. This appears to be a natural response to the reduced availability of water, with each bush requiring a certain amount of open space around it from which it can extract moisture. Remarkably, seedlings that attempt to grow in the gaps between plants are killed off by a toxin released through the roots of the more established bushes around them.

Another characteristic species of the Chihuahuan Desert, particularly along the washes and watercourses, is the Mesquite *Prosopis* spp., a type of deciduous shrub or small tree which can reach heights of 7 metres (23 feet) or more and is therefore one of the largest plants found in the desert proper. A member of the pea family, its size and large number of leaves mean that it suffers from heavy transpiration rates, but this high level of water loss is counteracted by the fact that the Mesquite has some of the longest known roots of any plant. Mature specimens can have roots over 20 metres (66 feet) long and the plant can regenerate from points up to 15 centimetres (6 inches) below ground level, which helps it survive both flash floods and fires. However, it reproduces through the beans in its distinctive seedpods, which are an important source of nutrition for many species of desert mammal.

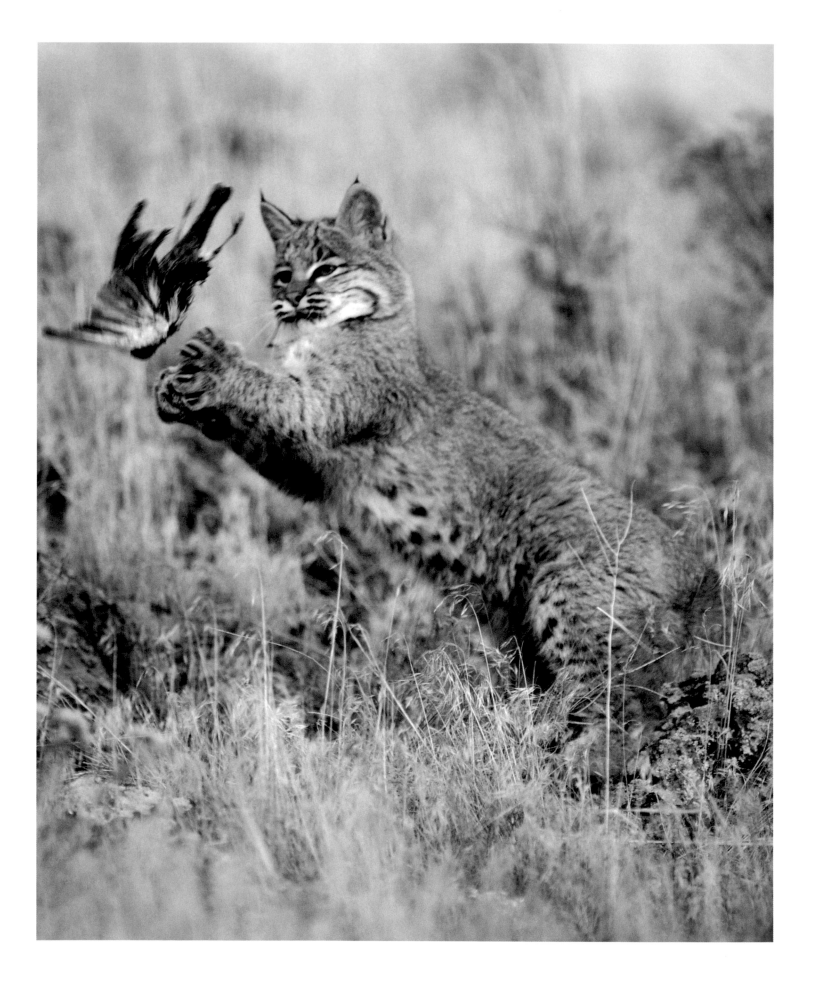

The Coyote *Canis latrans* is especially partial to Mesquite beans and in late summer these may form up to three-quarters or so of its diet in the desert. Coyotes are widely distributed across North America and Central America, extending from northern Canada as far south as Panama and occurring in every conceivable type of habitat, from Arctic tundra to downtown parking lots. Hugely opportunistic and very skilful hunters, they can live in packs, pairs or alone, hunting both by day and night and taking an enormous variety of food, from fruit and discarded hamburgers to carrion, small mammals, birds and reptiles, but with rodents usually forming the largest single dietary component.

The howling and distinctive "yipping" cries of coyotes are a regular sound after dusk in the desert and an atmospheric accompaniment to a night spent outside under canvas. They live in dens, which they either excavate themselves or adapt by enlarging an existing lair made by a Badger *Taxidea taxus*. Desert Coyotes are considerably smaller than those living in mountainous regions, for example, typically weighing half as much, and are usually paler in coloration, as befits their environment. Evidence suggests that the highly adaptable Coyote benefits when its larger relative, the Grey Wolf *Canis lupus*, is eradicated from an area, a factor which may explain the Coyote's general expansion in distribution during the twentieth century, a time when wolves were in retreat across much of their North American range as a result of human persecution.

The Mexican Grey Wolf *Canis lupus baileyi*, the smallest race of that species, once ranged across the Chihuahuan Desert, but had been virtually exterminated in the wild by the 1970s and was only saved from total extinction by a captive breeding programme. A reintroduction scheme in Arizona and New Mexico has seen the return of the species to some of its former haunts, but it remains highly endangered and an enduring source of controversy. Although polls indicate that the majority of local people supported the return of the wolf, the scheme did not meet with

OPPOSITE Bobcats are a type of lynx and are found across North America in a range of habitats, including semi-desert. Although relatively common, they are highly elusive and rarely seen. Their usual prey is rabbits, but they will also take insects, birds and small deer.

BELOW Research is revealing that Coyotes are more sociable than previously thought, with pair loyalty around which small family groups are maintained. However, Coyotes appear to hunt primarily on their own, unlike Wolves which almost always hunt collectively.

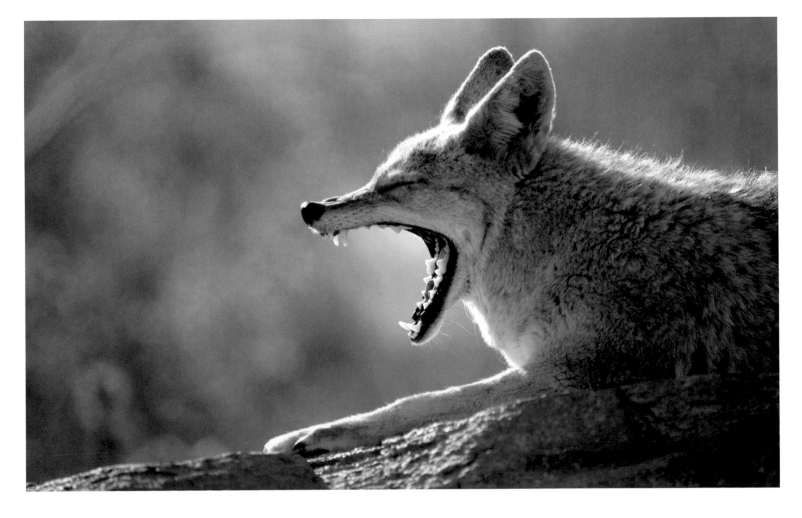

universal approval and several wolves have been killed illegally since the reintroduction. Potential predation on domestic livestock remains a source of concern and daily management issue for the US Fish and Wildlife Service.

Other desert-dwelling mammals in the region include the Collared Peccary *Pecari tajacu*, usually found in groups of anything between six and fifty individuals. This species of wild pig is also called "javelina", after the razor-sharp tusks used by the males to defend themselves against would-be predators and competition from their peers for the females in their harem. Peccaries are usually found in Mesquite scrub along watercourses and feed extensively on agaves and prickly pears, which give them most of the moisture they require. They are preyed on by humans, Coyotes, Bobcats *Lynx rufus*, Pumas *Puma concolor* and that most spectacular of all the mammals occurring in the Chihuahuan Desert, the Jaguar *Panthera onca*.

The most powerful cat, kilo for kilo, in the Americas, the Jaguar was once widely distributed across northern Mexico and the south-western United States but the resident US population was hunted to regional extinction in the early twentieth century. In recent decades, Jaguars appear to be gradually recolonizing from the south, although sightings remain few and most records are based on tracks, scat and images taken in remote camera traps. It is likely that most of the Jaguars recorded from Arizona and New Mexico are transient animals dispersing over the border from a small breeding population in Mexico's Sonora state. Although an encouraging sign, pressure on the Jaguar remains intense regionally – several animals have been killed in recent years in road accidents and by farmers concerned about their stock. Jaguars are not classic desert animals – their preferred habitat is thick forest and well-wooded wetlands, as they are excellent swimmers – but they are able to use the desert network of canyons and watercourses, as well as the ecologically rich "sky islands", to traverse the desert and thereby begin to restore their numbers at this northern frontier of their range.

Another flagship animal of the Chihuahuan Desert, the Desert Bighorn Sheep *Ovis canadensis nelsoni* is also recovering from near extinction. Once widely distributed across the American desert regions in scattered herds on mountains, rocky outcrops, bluffs and in foothills, the Bighorn was a prized target for trophy sportsmen and uncontrolled hunting drove many local populations to extinction or to below the point of viability. Compact and muscular, Bighorns are ideally suited to rocky terrain and move with ease over the most rugged of landscapes. The males are particularly impressive, never more so than during the annual rut, when the crash made by the colliding horns

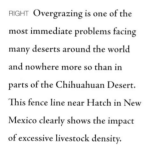

RIGHT **Overgrazing is one of the most immediate problems facing many deserts around the world and nowhere more so than in parts of the Chihuahuan Desert. This fence line near Hatch in New Mexico clearly shows the impact of excessive livestock density.**

ABOVE **Although Desert Bighorn Sheep have been successfully reintroduced to various parts of the Chihuahuan Desert, among other locations, they remain thinly spread and occupy only a fraction of their historical range.**

of two sparring males echoes around the mountains. Wary of people, bighorns often move away at the first sign of human presence, the most common view being of their distinctive white rumps as they scramble over the horizon out of sight. Reintroduction programmes are slowly returning this magnificent animal to parts of the desert, with the focus of much conservation attention being on the provision and maintenance of adequate sources of water – bighorn sheep need to drink at least every two or three days.

Water management is just one of many pressing conservation issues in the Chihuahuan Desert today. Overgrazing, which in the past has served to extend the boundaries of the desert into what was previously fertile and productive land, is a continuing problem, with ranching very much part of the land use pattern here. The overexploitation of certain desert plants, such as Mesquite, which is harvested for charcoal production, can have an undesirable effect on the fragile desert environment, as can the mining of minerals such as gypsum. However, for many conservationists the single biggest concern in recent years has been the construction by the United States government of a border fence along several sections of that country's frontier with Mexico in an attempt to stem illegal northward immigration. Over four metres (13 feet) high and composed of dense black mesh, the fence risks fragmenting ecosystems and compromising what are some of the most sensitive and biologically rich habitats in North America.

As it is constructed on land inside the United States itself, the fence also risks the isolation in no man's land of a series of nature preserves, located immediately next to the border and largely along the banks of the Rio Grande, and which has been carefully developed in recent decades to protect vulnerable species and habitats. Sections of fence can prevent on a daily basis the movement of wildlife through habitats that have been in continuous use by countless numbers of mammals, reptiles, amphibians and invertebrates for millennia, and may have an impact on the recolonization of the United States by the Jaguar, for example.

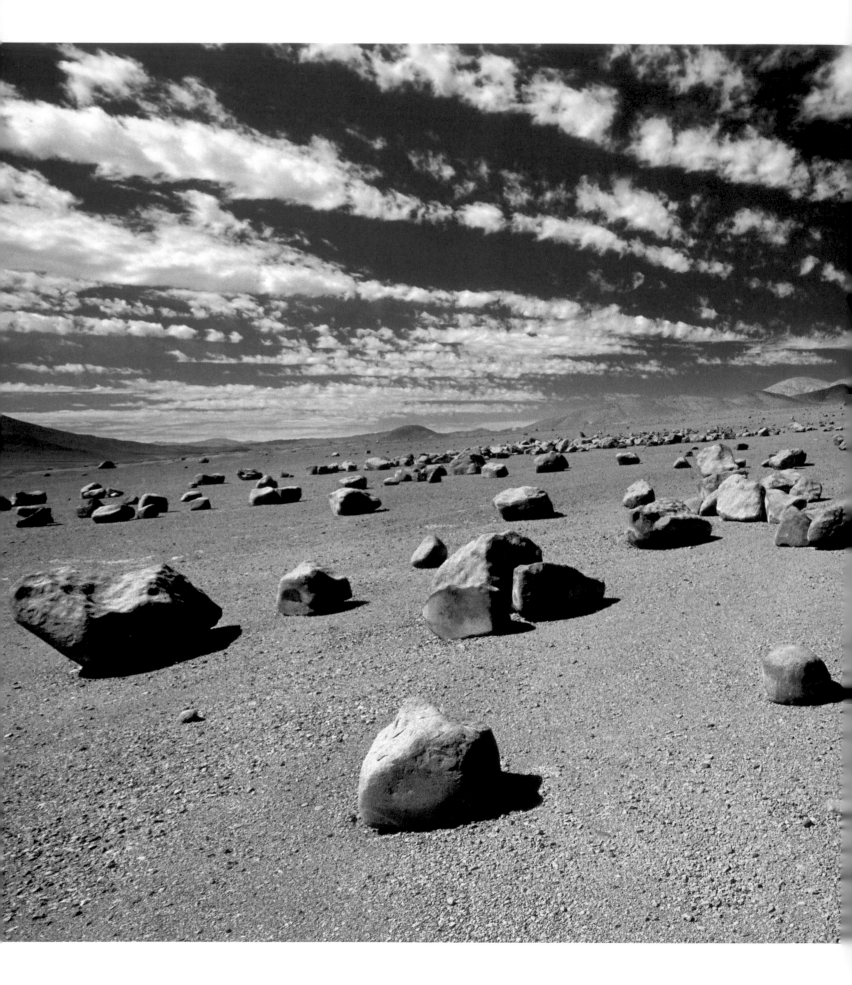

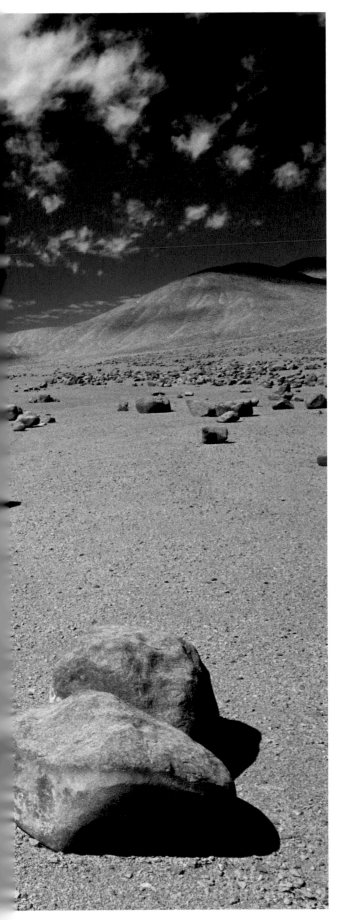

15: The Atacama, the Driest Place on Earth

The Atacama Desert is part of a wider complex of arid lands that occur along the western littoral of South America, specifically along the coastal strip of Peru and south to Chile, extending over 1,500 kilometres (930 miles) in total and to a width of 180 kilometres (112 miles) or so. The extreme aridity of region is the result of the offshore Humboldt Current, which draws cold water from the much cooler latitudes to the south. The cold water overrides the warm tropical ocean, causing a thermal inversion and a reduction in evaporation rates, which in turn means less rainfall. What this process does produce, however, is a high incidence of fog. This fog, known as *camanchaca*, brings life-giving moisture to the region, although it is not enough to sustain anything other than the most resilient forms of flora and fauna. Actual rainfall is rare to non-existent, and when it does arrive it often does so in the form of sudden, heavy yet short-lived downpours that do little to reduce the area's desiccated and decidedly lunar-looking character.

In the case of the Atacama proper, which lies slightly inland, in the lee of the Cordillera de la Costa mountain range and to the west of the *altiplano* or Andean foothills, this aridity is exacerbated by an acute rain shadow effect. Generally regarded as the driest place in the world, some parts of this extraordinary and dramatic landscape have received no measurable rainfall

LEFT **In some parts of the Atacama there has been no measurable rainfall in living memory, perhaps not for hundreds of years. The landscape is completely dry and barren, incapable of supporting even the most basic vegetation.**

RIGHT **Cold offshore currents produce regular mists and fogs. These give just enough moisture to sustain life in the arid and unforgiving Atacama coastal belt. The seas here teem with life, which attracts large numbers of birds and marine mammals.**

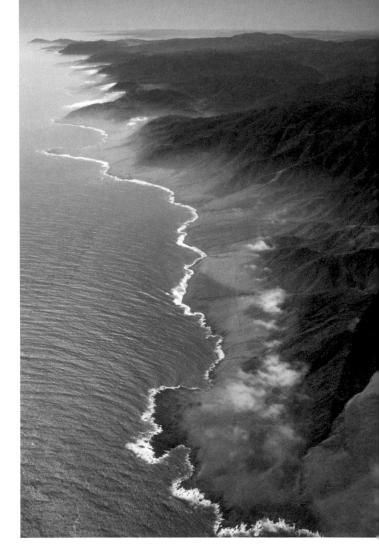

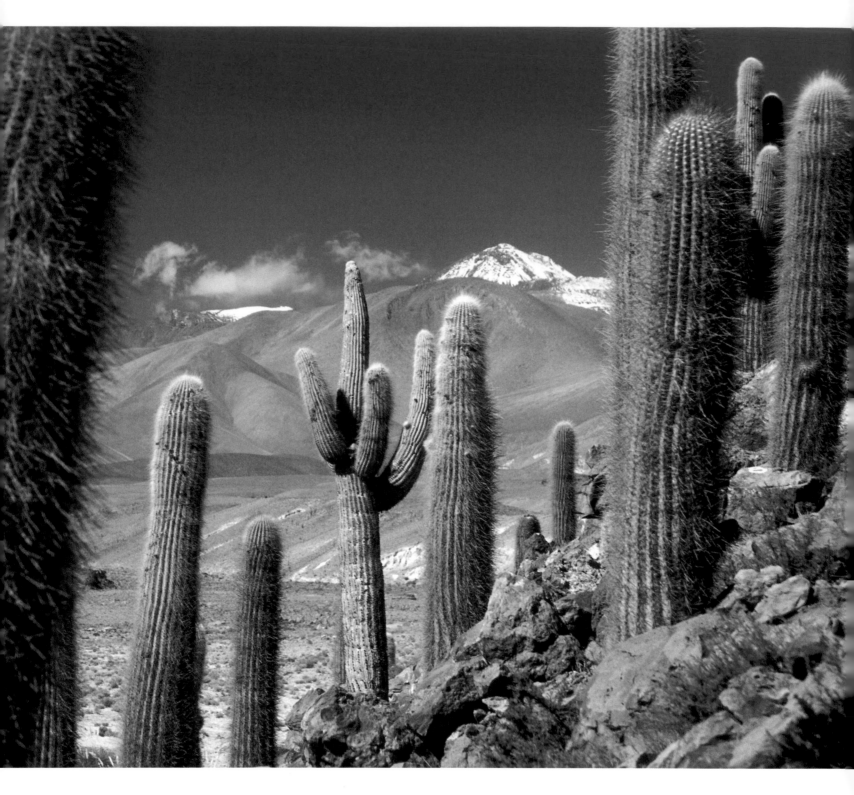

ABOVE **The Giant Cardon Cactus**
Echinopsis atacamensis is a
signature plant of the Atacama
– in some locations it is often the
only sizeable plant to be found.
When entering a grove of mature
specimens, the effect can be
quite cathedralesque.

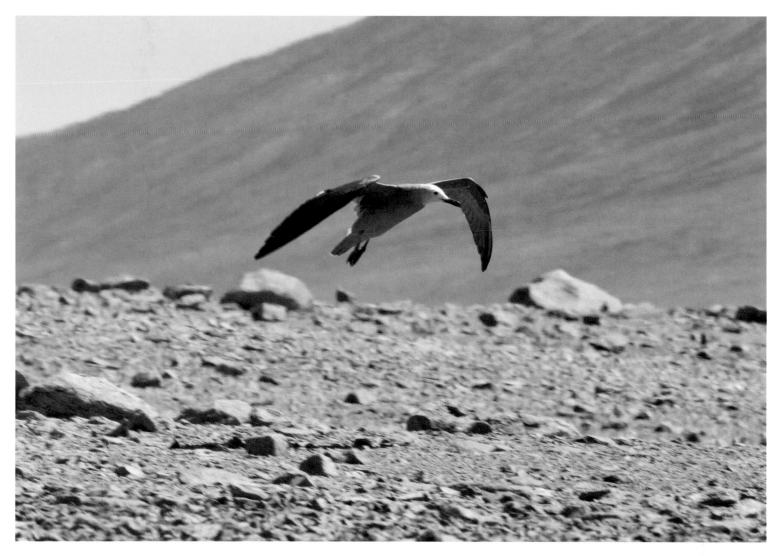

for many decades, possibly even centuries. Not surprisingly, these areas are virtually devoid of vegetation. Indeed, in the wider Atacama the most biodiverse habitats occur on the small bluffs or hills known as *lomas*, on which moisture from fog collects, as well as along the few river valleys and in places – usually around the fringes of the desert proper – where underground aquifers are close enough to the surface to sustain plantlife.

The nature of the Atacama landscape is dictated by the tumultuous volcanic activity that has shaped the region's topography over many millennia. This process continues to this day, with the desert set against a spectacular backdrop of snow-capped volcanoes, many of which are still active. Deeply incised canyons, gorges, erosional sands and gravels predominate, as well as vast areas of salt-encrusted pans. The few watercourses that struggle through this extreme landscape almost invariably succumb to evaporation or simply sink into the sand, salt and rock.

ABOVE **Exactly why Grey Gulls choose to nest in the heart of the Atacama Desert remains a mystery, but each November the birds move inland and form large breeding colonies. The females each lay between one and three eggs in a simple scrape on the ground.**

RIGHT **Parent birds take it in turns to attend to their chicks, taking "dayshifts" and "nightshifts". Grey Gulls are the slowest growing of all gull species, and do not fledge until they are almost six weeks. Much remains to be discovered about this enigmatic bird.**

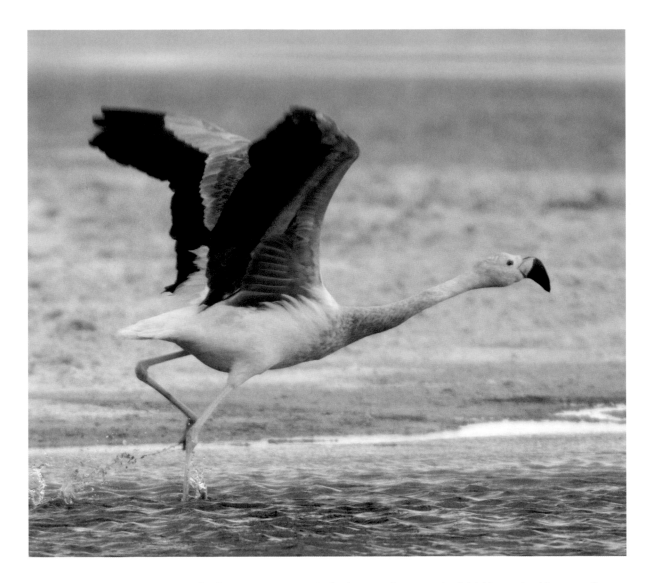

The Salar de Atacama is one of the best regional sites to observe flamingos, including the Andean Flamingo (shown here), which is the largest of the three flamingo species found in the Atacama. These extraordinary birds can live for up to 50 years.

Conditions are so extreme in the Atacama that vegetation is highly restricted in terms of diversity and density. A total of 550 or so vascular plants have been recorded from the area and the greatest number and variety of these are to be found in the "fog-zone communities" that occur on the *lomas*. Here shrubs and woody vegetation can grow, along with mosses, lichens and a few species of bromeliad. Elsewhere, especially in the more coastal areas, vegetation is much more modest. However, there is an interesting variety of cacti, with some 60 species considered endemic to the region, many of them belonging to the genus *Copiapoa*. A particularly widespread cactus is *Eulychnia iquiquensis*.

Mirroring the plant situation, Atacama wildlife is thinly distributed and some groups are virtually unrepresented – amphibians, for example. Yet some extraordinary natural history sights are to be found here. Among the most unlikely is the seasonal presence of the Grey Gull *Leucophaeus modestus*, which for much of the year is a coastal-dweller, occurring along the coastline of Chile, Peru and Ecuador. Every spring, however, the birds head inland, to their traditional nesting sites in the Atacama, as far as 70 kilometres (44 miles) inland. The heat is so intense here that one of the parent birds must remain with the chicks at all times to shield them from the sun. The other parent will make the long journey to the coast, where it will feed intensively, and then return, usually after darkness – it locates its mate via call recognition – to regurgitate the part-digested fish for the young. The next day the other parent bird will make the journey, on an alternating shift until the chicks fledge and then accompany their parents on the flight back to the coast.

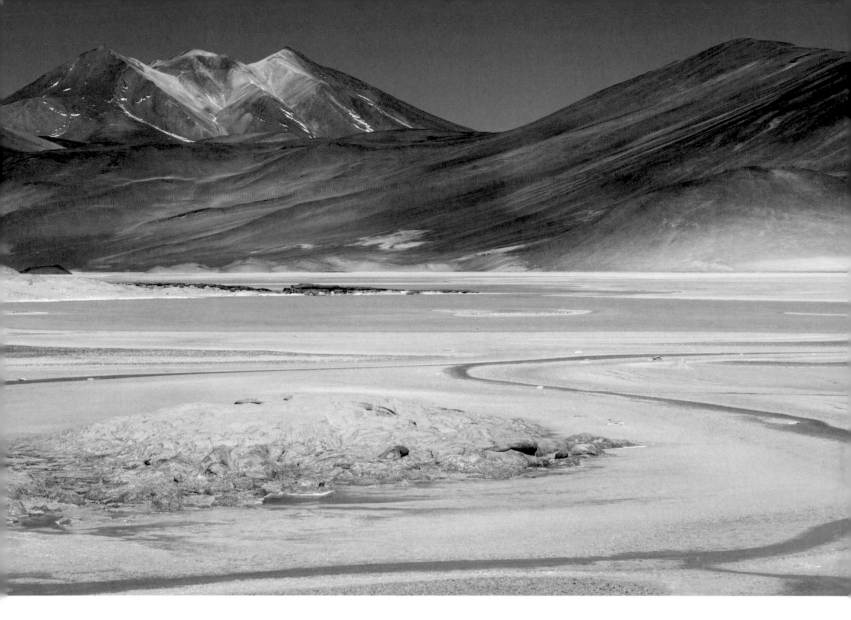

ABOVE **Parts of the Atacama seem totally devoid of vegetation, especially around the salt pans. What wildlife survives here needs to be highly specialized, and is therefore often unable to adapt to subtle changes in the environment.**

It is still not clear why the Grey Gulls nest where they do. It has been speculated that their presence in the desert predates a later uplift in the land mass and that the birds have simply not yet adapted to the topographical change. Meanwhile, much of the birdlife in the Atacama occurs around the salt pans that are such a characteristic of the desert. At the most productive of these, such as the Salar de Atacama, Salar de Tara and the lagoons of Miscanti and Miñiques, all within the Los Flamencos National Reserve, one can see impressive numbers of waterbirds, including three of the world's six species of flamingo, namely Andean *Phoenicoparrus andinus*, Chilean *Phoenicopterus chilensis* and Puna *Phoenicoparrus jamesi*. These dramatic birds are joined by birds such as Andean Avocet *Recurvirostra andina*, Andean Gull *Larus serranus*, Horned Coot *Fulica cornuta* and Silvery Grebe *Podiceps occipitalis*, as well as migratory waders en route from their North American breeding grounds to winter quarters even further south.

As far as the flamingos are concerned, the numbers of each species vary from year to year, but the overall trend appears to be downwards. Breeding success varies hugely, and evidence suggests that at certain sites the flamingos are losing out to increasingly intrusive forms of human activity. At Salar de Punta Negra, for example, a key nesting site for Andean Flamingos, the excessive plundering of the subterranean water aquifer for a huge copper mine nearby has led to the drying up of wetlands on which the flamingos depend. Various conservation actions have been attempted to reduce the impact on the birds, from the rescue of abandoned eggs and the raising of the chicks for release back in the wild to the recreation of wetlands through surface recharge, but it is clear that numbers are falling as a result of changing conditions and disturbance.

In 2009 thousands of Andean Flamingos abandoned their nests, with some 2,000 eggs failing to hatch as a result. No young birds were reared. It is not yet clear why the adults deserted, but an exceptionally hot summer may have caused salinity levels on the salt pans to rise, thereby killing off the micro-algae on which the birds feed. They were simply forced to go elsewhere. Further evidence of a dispersal to cooler and more productive areas came with the simultaneous discovery of an Andean Flamingo nest at a site 4,000 metres (13,120 feet) in altitude – the species normally nests at 2,000 metres (6,560 feet) or so.

Notable landbirds in the Atacama and associated arid regions include the tiny Chilean Woodstar *Eulidia yarrelli*, a species of hummingbird that occurs only in a handful of desert valleys in northern Chile and Peru. This highly localized bird reaches a total length of only 7.5 centimetres (3 inches) and has a total population of little more than 1,000. It appears to be in decline, mainly as a result of habitat destruction as its preferred scrub is removed to make way for agriculture.

Mammals in the Atacama are few and far between, and mainly restricted to small rodents. However, there are some interesting larger species here, including the Guanaco *Lama guanicoe*. The wild relative of the alpaca and llama, the Guanaco is a flexible and adaptable species capable of thriving in a wide range of habitats from desert grassland through to forest and in altitude from sea level to as high as 4,000 metres (13,120 feet) or more. It browses and grazes, and lives in both sedentary and migratory populations. In the Atacama it is generally restricted to areas offering consistent vegetation but will disperse to take advantage of ephemeral plant growth as and when that occurs.

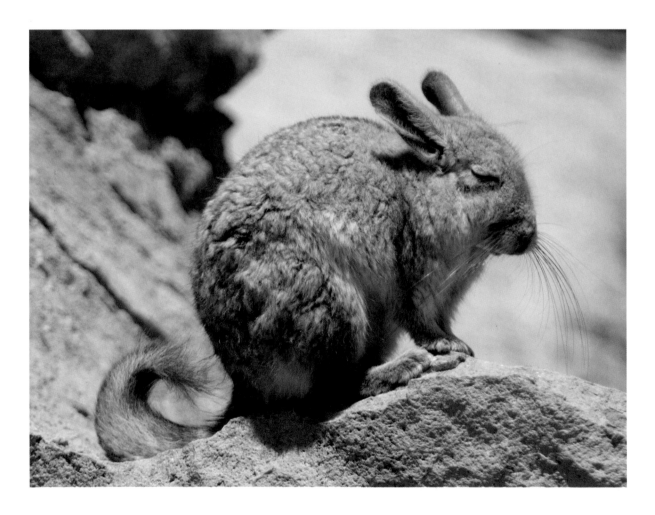

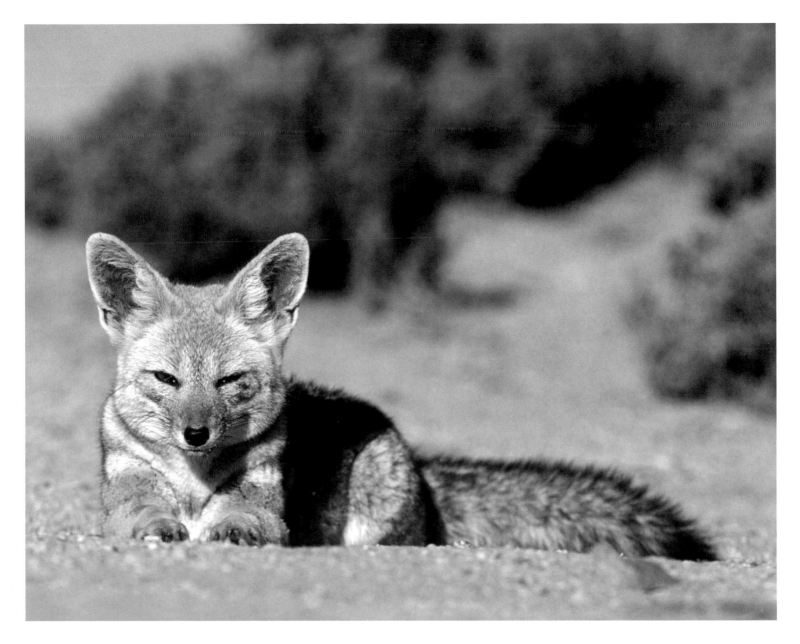

ABOVE **Widespread and common on both sides of the Andes, the Chilla or Grey Fox appears to be at home in a variety of habitats, from desert to thick scrub. Hunting by both day and night, it lives largely on rodents and is a frequently encountered predator.**

One of the most productive areas for wildlife in the Atacama region is the Pan de Azucar National Park. Established in 1985, the park covers only a little over 400 square kilometres (150 square miles) of dramatic coastal and inland desert but contains some of the highest levels of biodiversity in the region. Mammals that can be seen here include Guanaco, as well as Culpeo or Andean Fox *Pseudalopex culpaeus*, Chilla or South American Grey Fox *Pseudalopex griseus* and Mountain Viscacha *Lagidium viscacia*. Of particular interest along the shoreline is the Marine Otter *Lontra felina*, a little-known species which was hunted to virtual extinction during the twentieth century for its pelt and as a result of persecution by fishermen. Numbers are now slowly recovering but this remains a scarce and elusive animal. Considerably smaller than the better known Sea Otter *Enhydra lutris*, which is restricted to North America, the Marine Otter is also much less gregarious, usually moving around singly (over 70 per cent of sightings are of solitary animals) or, very occasionally, in groups of up to four. Much easier to see are South American Sea Lions *Otavia flavescens*, of which there is a large colony on the Pan de Azucar island offshore.

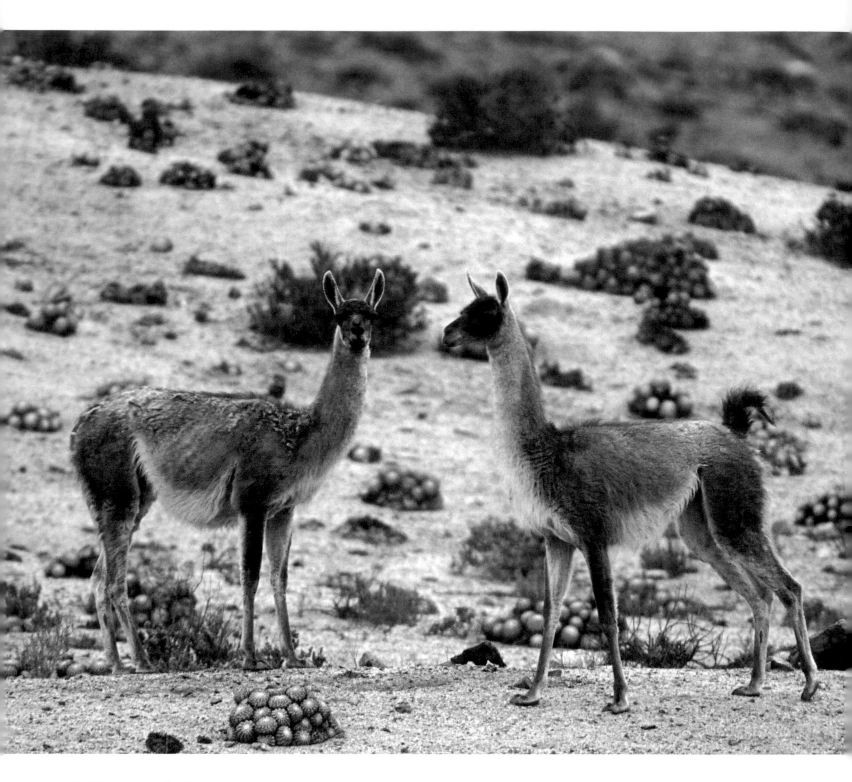

ABOVE **Guanacos can be found from sea level to as high as 4,500 metres (14,750 feet). While most populations appear to be largely sedentary, those living at higher elevations may undertake seasonal migrations to avoid harsh weather.**

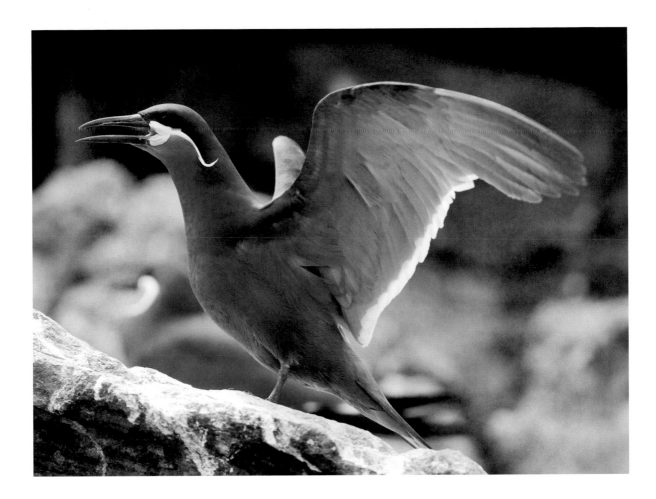

Birdlife in the park is especially rich, particularly on the islands. Here there is an important breeding colony of Humboldt Penguin *Spheniscus humboldti*, as well as many other species such as Peruvian Pelican *Pelicanus thagus*, Peruvian Booby *Sula variegata* and Inca Tern *Larosterna inca*. Such a concentration of seabirds is made possible by the presence of the food-rich Humboldt Current, which is probably the richest marine ecosystem in the world. However, every so often the current is disrupted by the phenomenon known as El Niño, when the upwelling that is responsible for the profusion of marine creatures on which the seabirds depend stalls or is even reversed. Fish stocks can subsequently plummet, and seabird populations crash accordingly.

Although much of the Atacama aridlands remain in good condition, largely unaffected by human activity, the mining of copper, sodium nitrate and other minerals – and associated road-building schemes – has had a serious environmental impact in some locations. Overgrazing by domestic livestock is a serious issue in the north of the Atacama in particular, affecting natural vegetation that is vulnerable at the best of times. The collection of rare plants, notably cacti and certain bulbs, is also a matter of conservation concern. Ecotourism offers some potential for sustainable income generation, but the Atacama and its sensitive habitats remain vulnerable to adverse exploitation.

ABOVE Undeniably one of the most glamorous of all seabirds, the Inca Tern occurs along the Atacama coast, breeding on coastal cliffs and islands. Unregulated commercial fishing could have a serious impact on tern numbers in this area.

AFRICA

Vast swathes of the African continent are covered by deserts, which include the world's largest – the mighty Sahara. This epic patchwork of sand and rock is expanding, eating up areas of the Sahel to its south, and is the unlikely home of creatures as diverse as crocodiles and elephants. It also harbours the last survivors of once sizeable populations of antelope and big cats. Towards Africa's southern tip lie the Kalahari, where thousands of herbivores follow age-old migration routes in search of water and fresh grass, and the Namib, where Africa's largest wild population of Black Rhinos roams free. Perhaps the continent's most unique arid land is Madagascar's Spiny Desert, where lemurs leap among thorn trees and some of the planet's rarest species find refuge.

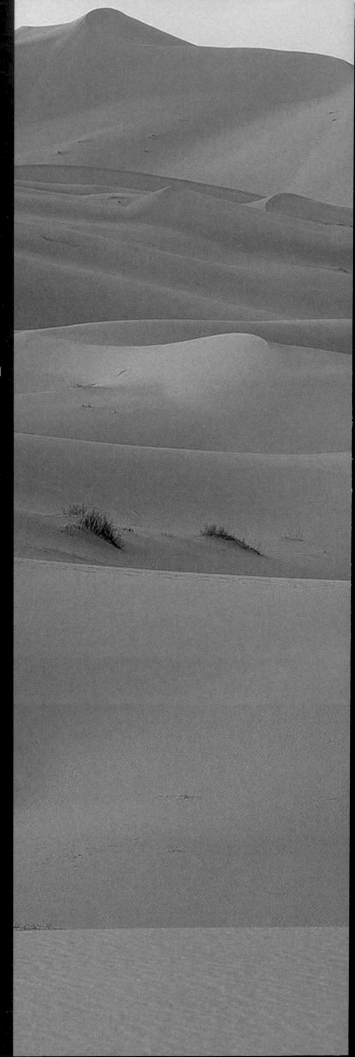

RIGHT The Sahara contains some of the most extensive sand dunes found anywhere on the planet, yet they are no obstacle for local people such as the Tuareg. For thousands of years their camel caravans have criss-crossed the desert, transporting commodities such as salt, gold, ivory and hides between ancient trading centres.

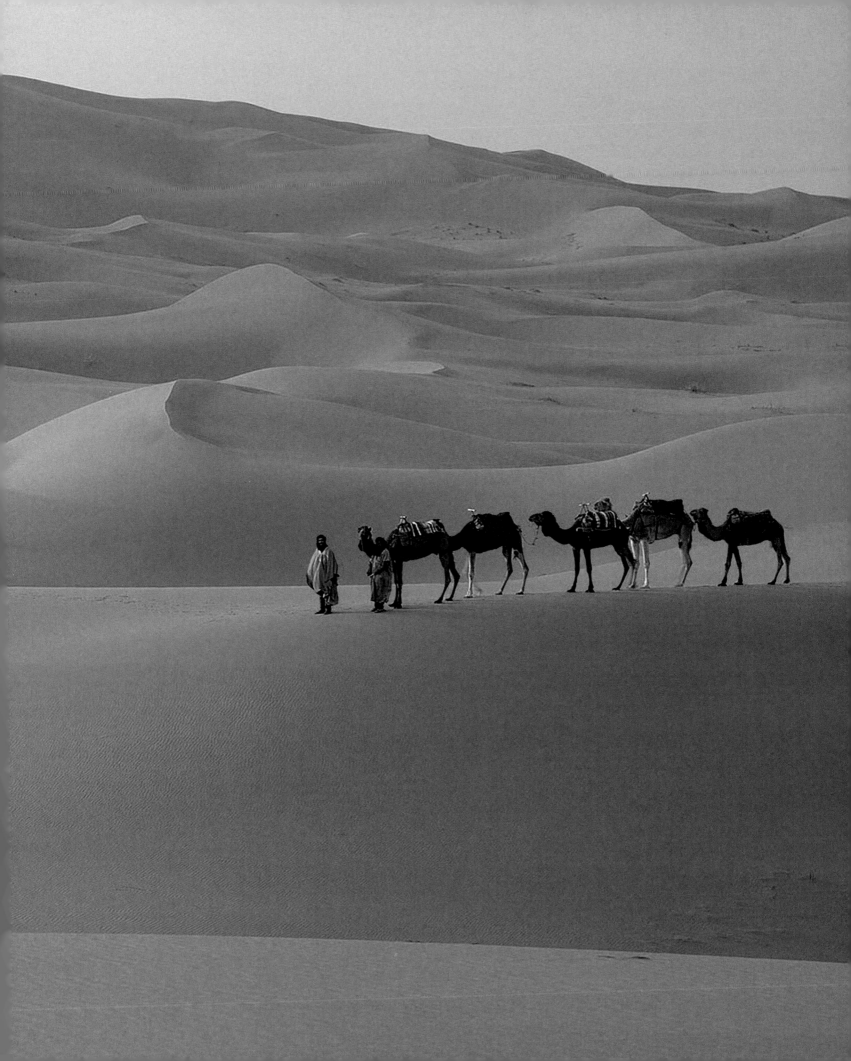

16: The Lost Wildlife of the Sahara

The Sahara needs little by way of introduction. The world's largest desert, it covers some 9 million square kilometres (3½ million square miles), over a quarter of Africa's land surface, stretching from the shores of the Atlantic in the west to those of the Red Sea, over 6,000 kilometres (3,700 miles) to the east. Approximately one-third of its area comprises sand seas, vast expanses of sand dune with very little vegetation. Yet the Sahara is nothing if not varied; stony and gravelly plains, rocky plateaux, salt pans and mountain massifs dissected by gorges and wadis all provide a surprising range of habitat niches. Two mighty rivers – the Nile and the Niger – cross parts of the desert, their freshwater providing a lifeline for both wildlife and humans alike. Spring-fed oases also punctuate the Sahara's seemingly barren wastes, supporting a range of wildlife that otherwise would not be able to survive in such an inhospitable environment. With summer temperatures rising to as much as 55°C (131°F) in the shade, the Sahara is the hottest of the world's large deserts and also exceedingly arid. Across much of the desert there is little in the way of perennial vegetation, and such plants as are able to survive are usually dependent on the erratic and minimal rainfall that occurs here, their accelerated life cycles designed to cope with the temporary nature of the opportunities for growth.

BELOW **Desert Monitors are the largest lizards in the Sahara. Although usually found where there is at least some vegetation for shelter and shade, they are also capable of crossing tracts of open sand. They chase down their prey with sudden bursts of speed.**

RIGHT **Sandstorms occur regularly in the Sahara and are caused by high winds whipping up loose particles from the surface of the ground. The leading edge of a sandstorm can reach heights in excess of 1.5 kilometres (1 mile).**

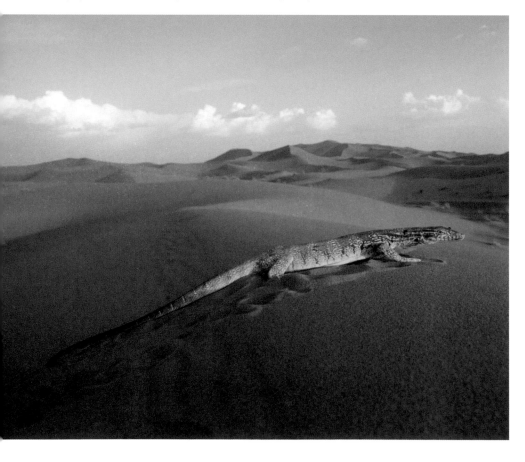

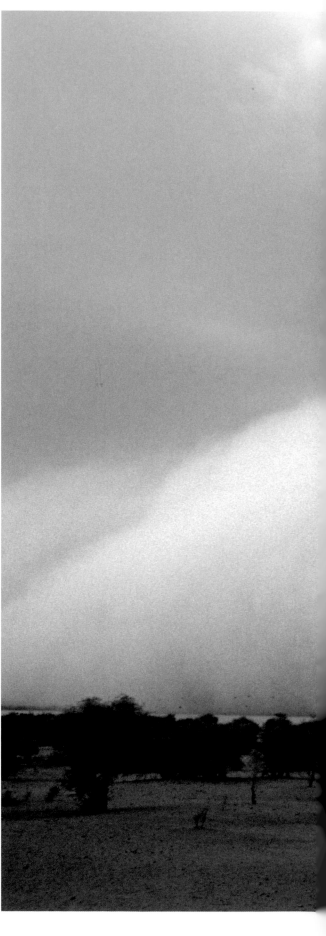

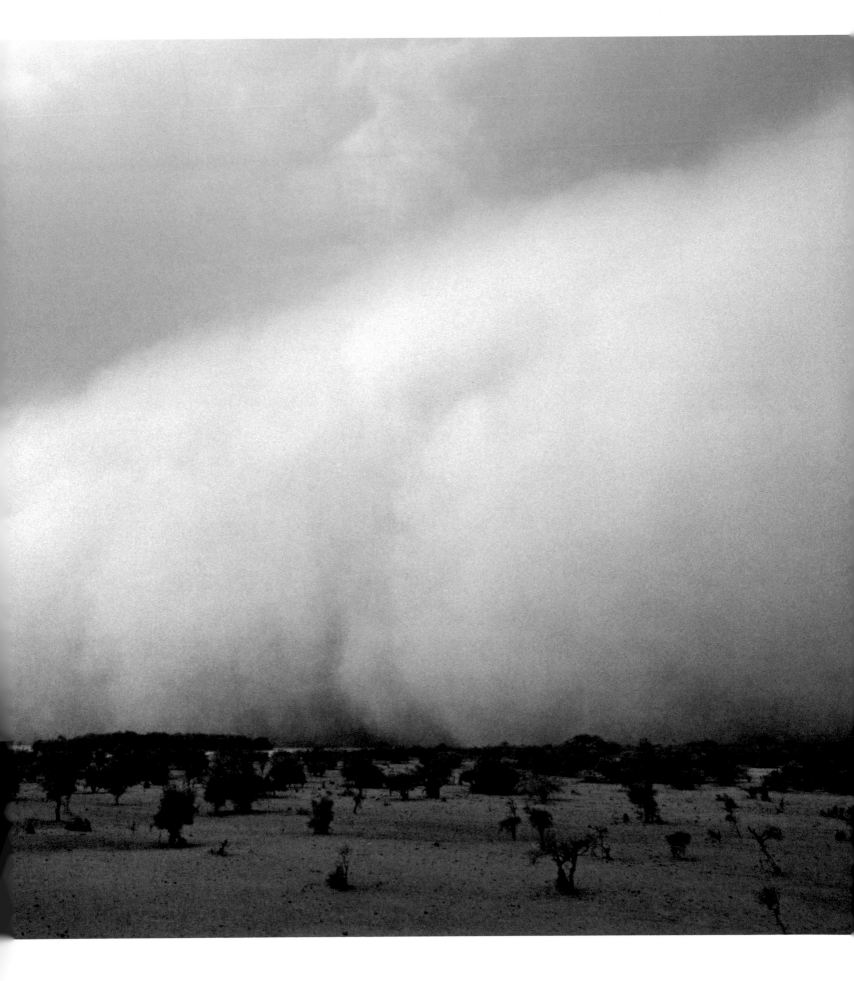

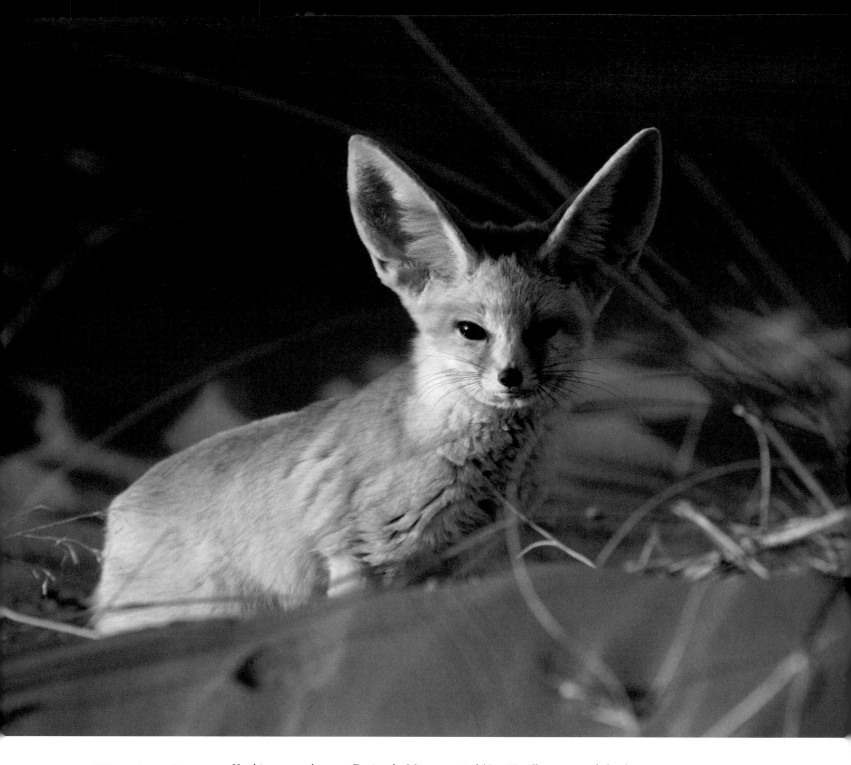

ABOVE **Widespread across the Sahara, the Fennec Fox** *Fennecus zerda* **demonstrates a host of classic adaptations for life in the desert. A sandy-brown coat helps with camouflage and heat reflection, while large ears radiate body heat.**

Yet this was not always so. During the Miocene period (6 to 25 million years ago) the climate in the Sahara was much wetter and much of the area was covered in lush forest and fertile grassland. Indeed, more benign conditions were found here as recently as 5,000 years ago, with evidence suggesting that savannah woodland was then a common and widespread habitat type in the region. At this time what are now often virtually lifeless landscapes would have been teeming with wildlife in scenes reminiscent of parts of modern East and Southern Africa. However, as a result of climate change, the Sahara gradually became more arid, the great herds of animals retreated southwards or died out altogether, and the Saharan landscapes that we see today began to take shape.

However, the Sahara and its habitats are anything but static. The region has become increasingly arid over the last few centuries, with the process of desertification exacerbated by growing human activity, particularly in the form of overgrazing by domestic livestock, the removal of precious tree cover for fuel and fodder, and the excessive exploitation of the few natural water

ABOVE **Finding tracks in the sand is one of the most important ways of determining the wildlife that inhabits a particular area. Each morning brings new evidence, with the characteristic traces of insects, such as this darkling beetle, among the most commonly found.**

sources, including aquifers. As a result, the Sahara Desert is expanding, particularly to the south. On the southern edge of the desert proper lies the Sahel, which is traditionally where the majority of the local human population has lived. *Sahel* is the Arabic word for "shore", and used to denote the littoral that lies between the desert proper and the more heavily vegetated savannah to the south. Traditionally the home of nomadic pastoralists, it is this transitional ecoregion, characterized by open acacia woodland and scrub, that is being particularly affected by habitat degradation and drought. Areas that were formerly productive agriculturally have turned into desert in a matter of decades, and that process is continuing. As a result, both the human and wildlife populations here are under increasingly intense pressure.

Although levels of diversity and rates of endemism are both generally low, the Sahara itself does boast a surprisingly interesting fauna and the Sahel even more so. Yet in recent decades the Saharan region has lost more higher vertebrate species (i.e. birds and mammals) than any other part of the Palaearctic. Those animals that do survive are remnants of what were once much

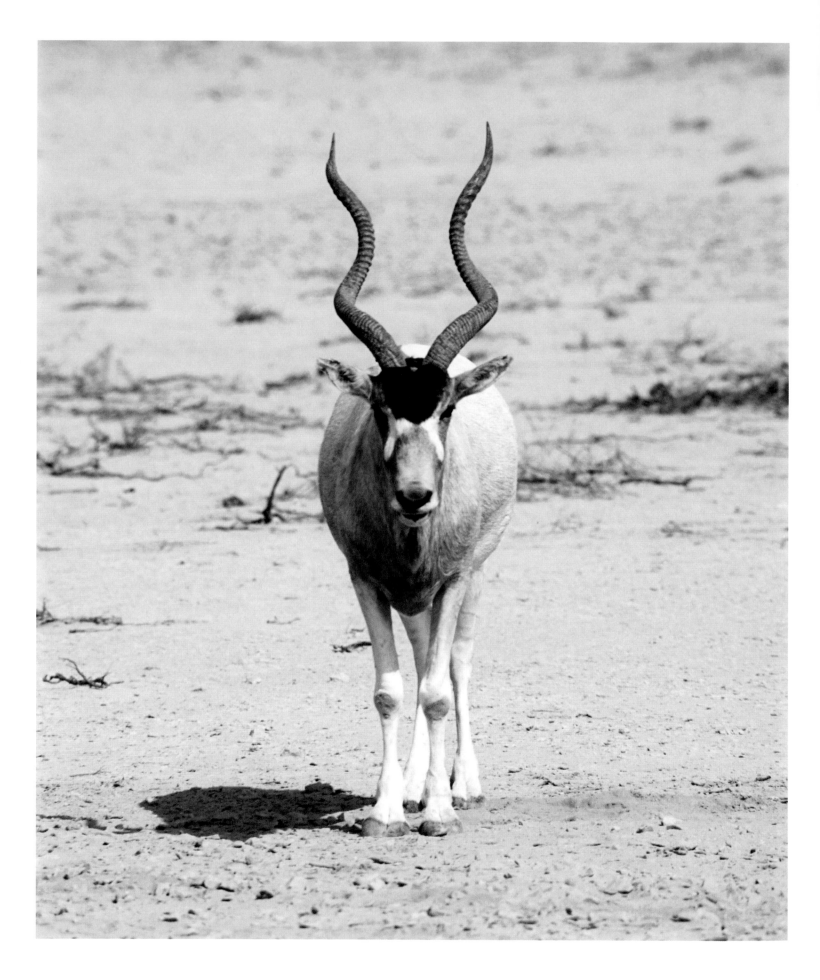

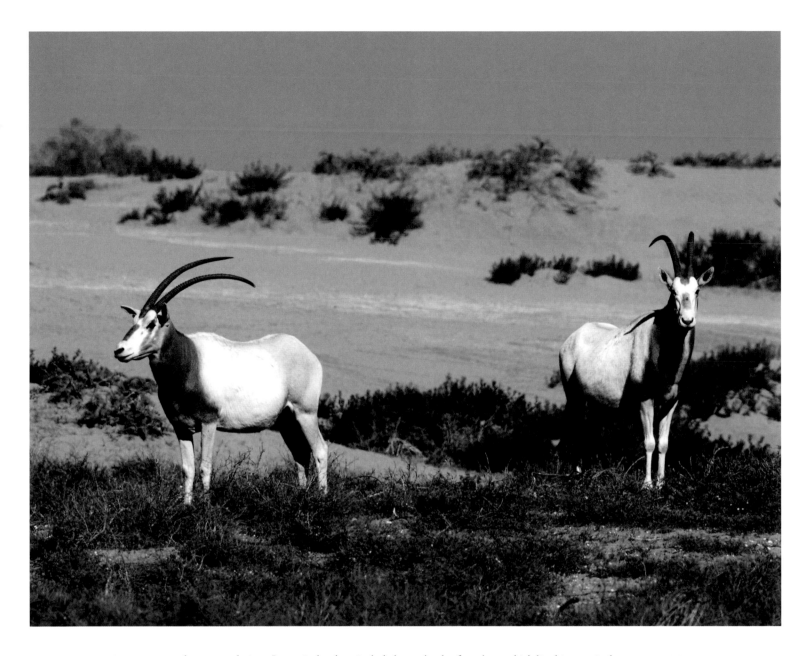

OPPOSITE Just a handful of Addax survive in the wild, teetering on the brink of extinction following decades of hunting and disturbance. Fortunately a substantial captive population means that reintroductions to the wild should be possible once suitable areas of habitat are secure and well protected.

larger populations. In particular these included great herds of antelope, which lived in seemingly uninhabitable parts of the desert and were able to go without drinking water for months on end. Supremely adapted to their natural environment, they were, however, incapable of surviving the onslaught of uncontrolled hunting, disturbance, overgrazing by domestic livestock and desertification. With much of their habitat destroyed and degraded, their numbers crashed and distributions contracted.

One species of antelope, the Bubal Hartebeest *Alcelaphus buselaphus*, once found in large numbers across much of North Africa, was totally wiped out, the last specimen dying in a Paris zoo in 1923. The Scimitar-horned Oryx *Oryx dammah*, arguably the most majestic of all the ungulates that once roamed across the Sahara, is now extinct in the wild. It is estimated that in 1900 there may have been as many as one million oryx, but the last wild specimens were recorded in the late 1980s in Chad, since when the species survives only in captivity. Meanwhile, the Addax *Addax nasomaculatus*, Dama Gazelle *Gazella dama*, Slender-horned Gazelle *Gazella leptoceros* and Cuvier's Gazelle *Gazella cuvieri* (the latter is endemic to the Sahelo-Saharan region) are all at risk, and the first two in immediate danger of extinction. Their populations are highly fragmented and difficult to protect, given the nature of the terrain and regional political uncertainties.

ABOVE The majestic Scimitar-horned Oryx was once widespread across the Sahara and accounts by nineteenth-century travellers talk of herds numbering hundreds of animals. Sadly by the late twentieth century this species had met the same fate as its Arabian cousin and been hunted to extinction in the wild.

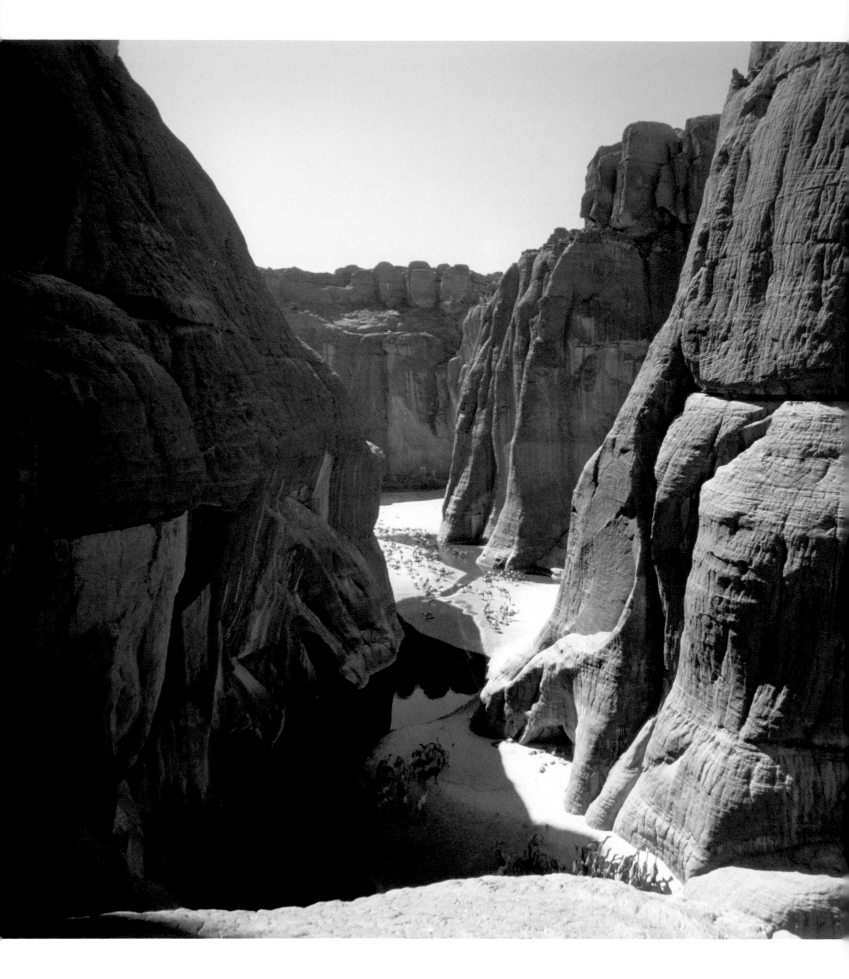

As the herds of antelope declined, so did numbers of the predators that depended upon them. Foremost among these was the Cheetah, once widely distributed across Saharan Africa but today teetering on the brink of extinction. The Saharan Cheetah population is regarded as a separate subspecies, *Acinonyx jubata hecki*, but very little is known about its ecology and requirements. Although there have been records and reports of Cheetahs in recent years from several countries, ranging from Algeria and Egypt south to Chad, Niger and west to Burkina Faso and Mali, actual sightings are few and far between. The surviving populations of this shy and elusive mammal are evidently small and widely scattered, with many likely to have fallen below the point of sustainability. Fewer than 200 individuals are estimated to survive, scattered at low density over vast areas. The continued depletion of their prey base and direct persecution from humans, in defence of livestock or simply for sport, make their conservation even more difficult to achieve.

Meanwhile, recent research has indicated the continued survival in Algeria's Ahaggar National Park of what may be one of the most viable Cheetah populations left in North and West Africa. Particularly critical to developing a conservation plan for this shy cat is an understanding of its prey base, which in the Ahaggar comprises mainly Dorcas Gazelle, as well as Barbary Sheep *Ammatragus lervia* and Cape Hare *Lepus capensis*. Yet Ahaggar Cheetahs also take feral donkeys and young camels, and are attracted to domestic sheep and goats. It is imperative, therefore, that strategies for minimizing conflict with local shepherds are a central element in any conservation plan for Cheetahs regionally.

LEFT Ancient rock drawings in Chad's Ennedi Gorge depict rhinoceros and giraffe, reminders of a time when the region was wetter and supported a savannah-type landscape.

BELOW Cheetahs live in small and widely scattered populations across the Sahara and little is known about their habits. Camera-trapping, as here in Algeria's Ahaggar National Park, is proving an invaluable way of assessing their numbers.

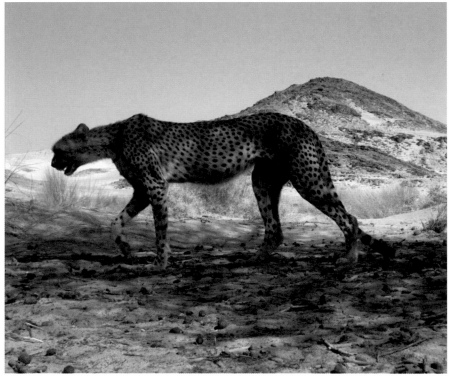

BELOW The few hundred elephants of Mali are the last vestige of a once much larger population that roamed the borders of the Sahara. They face an epic seasonal journey in search of adequate browse and water, usually moving in family herds of up to 30. Mature bulls, however, are more solitary and usually travel alone.

During the Sahara's historically wetter periods, herds of African Elephants were commonplace. Remarkably, a population of the world's largest land mammal still survives here, wandering the Sahel on a vast cyclical journey that takes them between an ever-dwindling series of reliable and undisturbed water sources in south-eastern Mali and neighbouring parts of Burkina Faso. Some 400 elephants live here, divided into a varying number of family groups and covering in excess of 1,000 kilometres (620 miles) per annum in their search for water and adequate browsing. These are highly marginal conditions for an animal which needs to drink upwards of 150 litres (33 gallons) of water every day and consume some 250 kilograms (550 pounds) of forage daily. Traditionally, the elephants have enjoyed a positive relationship with local people, who mainly comprise nomadic Tuareg and Fulani, and have been protected accordingly. However, in recent years this delicate relationship has come under some strain, as the extent of permanent agriculture in parts of the region has increased and prompted tension at waterholes between elephants and the owners of the greatly increased numbers of domestic livestock. The situation became particularly delicate during a severe drought in 2009, when desperate elephants were forced to try to drink from wells.

Finding elephants in the Sahara may be surprising, but among the most extraordinary wildlife discoveries in recent years in the Sahara was the discovery of isolated groups of Nile Crocodile *Crocodylus niloticus* surviving in various locations ranging from eastern Mauritania to the Ennedi Mountains in Chad. A relict from the time when the Sahara was much lusher and well-watered than it is today, these small communities of crocodiles – which became isolated from the main population, and indeed each other, as the Sahara environment gradually dried out – have somehow hung on in or near sources of permanent or semi-permanent water. Miraculously, they have evolved to withstand long periods of drought, during which there may be no water around them at all and equally nothing for them to eat, by retreating into caves, burrows or crevices and becoming dormant – a type of dry-season hibernation known as estivation. As a result of these limiting conditions, with little available food and correspondingly slow rates of growth, desert crocodiles are markedly smaller than their peers elsewhere in Africa, with mature individuals rarely exceeding 1.5 metres (5 feet) in length.

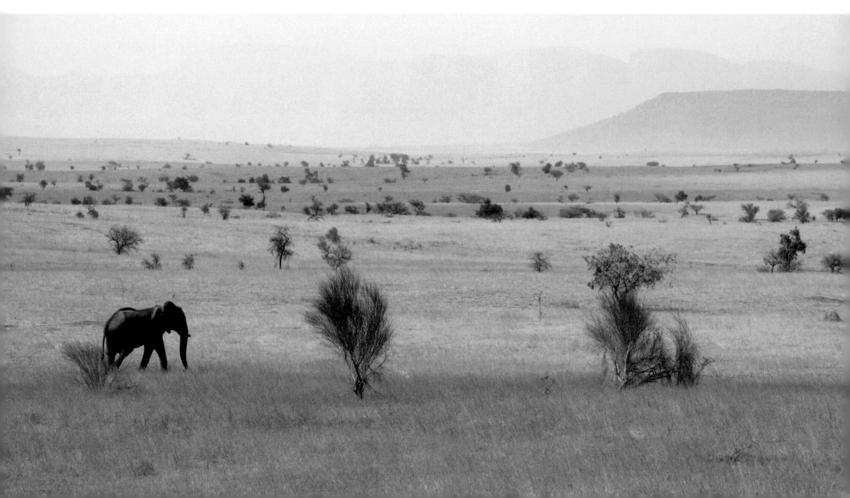

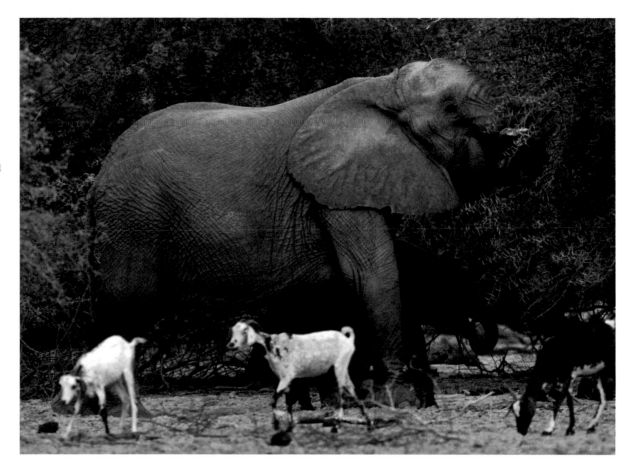

RIGHT Mali's elephants have historically been tolerated by the local human population, but conflicts are increasing. Domestic livestock and elephants compete for water and vegetation, and in times of drought problems arise. Many local nomads are becoming increasingly sedentary and so land use is intensifying.

The Sahara's crocodiles are highly vulnerable, with many of the widely scattered populations comprising only a handful of individuals and even just a singleton in some cases. It is hard to see how many of these populations can survive for much longer, a bleak forecast that until recently could be applied to much of the Sahara's wildlife. The overall situation remains difficult, but there are signs of hope. A network of national parks is in place across several of the countries that hold sovereignty over the Sahara, and the traditional lack of funding and variable political commitment is now being addressed, at least in part, by concerted action by international conservation organizations. In particular, reintroduction schemes are planned for some of the Sahara's most endangered species at locations where their security and protection can be guaranteed. Foremost among these is the planned return to the region of wild Scimitar-horned Oryx, a process already underway in protected areas within Tunisia such as Dghoumes National Park, where oryx drawn from captive populations have been released in recent years.

Similar initiatives are in hand for the Addax, but equally important are attempts to actually save the last few wild herds of this desert herbivore. Only in Niger and possibly Chad do viable populations of Addax survive outside captive situations, but they are not necessarily living within protected areas and, even if they were, many such designations exist only on paper. This is wild and hostile territory, its very remoteness the main reason why the Addax and other animals have survived here. Policing such areas is, however, understandably difficult, and poaching and the illegal harassment of wildlife are continuing problems, as are other activities such as the exploration and drilling for oil. Niger's Termit Massif is home to what is probably the last self-sustaining herd of wild Addax, while the country's 7.7-million-hectare (19-million-acre) Réserve Naturelle de l'Aïr et du Ténéré is another of the Sahara's most important wildlife refuges, with a good population of Dorcas Gazelle *Gazella dorcas* as well as predators such as Golden Jackal *Canis aureus* and Caracal *Felis caracal*. The future of this park, and of the wildlife within it, will depend on the establishment of adequate structures for protection and reserve management and on the development of sustainable tourism.

17: The Spiny Desert of Madagascar

Of the vast number of different habitat types found on Madagascar, the so-called Spiny Desert of the island's deep south-west is surely one of the most remarkable. Characterized by a vegetation dominated by succulents and in some respects reminiscent of the cactus fields of the American South-West, for example, this flat and low-lying area lies in a rain shadow and only receives average annual rainfall of between 300 and 500 millimetres (12 and 20 inches) per annum. This mostly falls during December and January, often in the form of violent thunderstorms, but is notoriously unreliable and some years may see hardly any precipitation here at all. The thin, porous soils have little water retention capacity, and so plant and animal life must therefore be capable of withstanding long periods of drought, as well as high temperatures in excess of 40°C (104°F). Such demanding conditions have produced a specialized flora and fauna, much of which is highly localized, endemic to the area, and under increasing pressure from a range of threats. The protection of these remarkable semi-desert habitats and their wildlife is therefore now a major conservation priority.

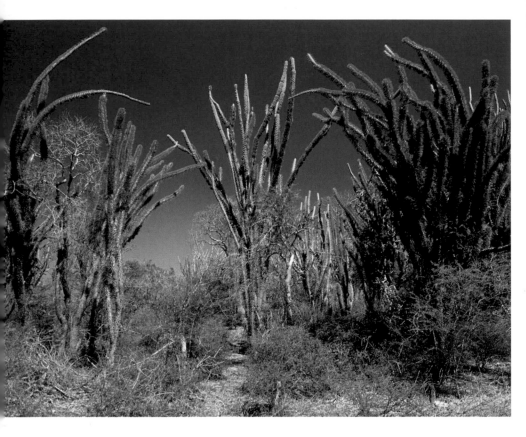

ABOVE **Octopus trees are characteristic of the Spiny Desert, their wavy limbs rising above an understorey of shrubs that help make this habitat one of the most important in all of Madagascar. It is, however, highly threatened and human pressures are mounting on the few surviving areas of pristine vegetation.**

RIGHT **These monumental trees, along the so-called Avenue des Baobabs near Morondava, are icons of Madagascar. Yet sadly they may well prove to be among the last of their type, as land use changes around them are preventing the germination of an adequate successor generation of young trees.**

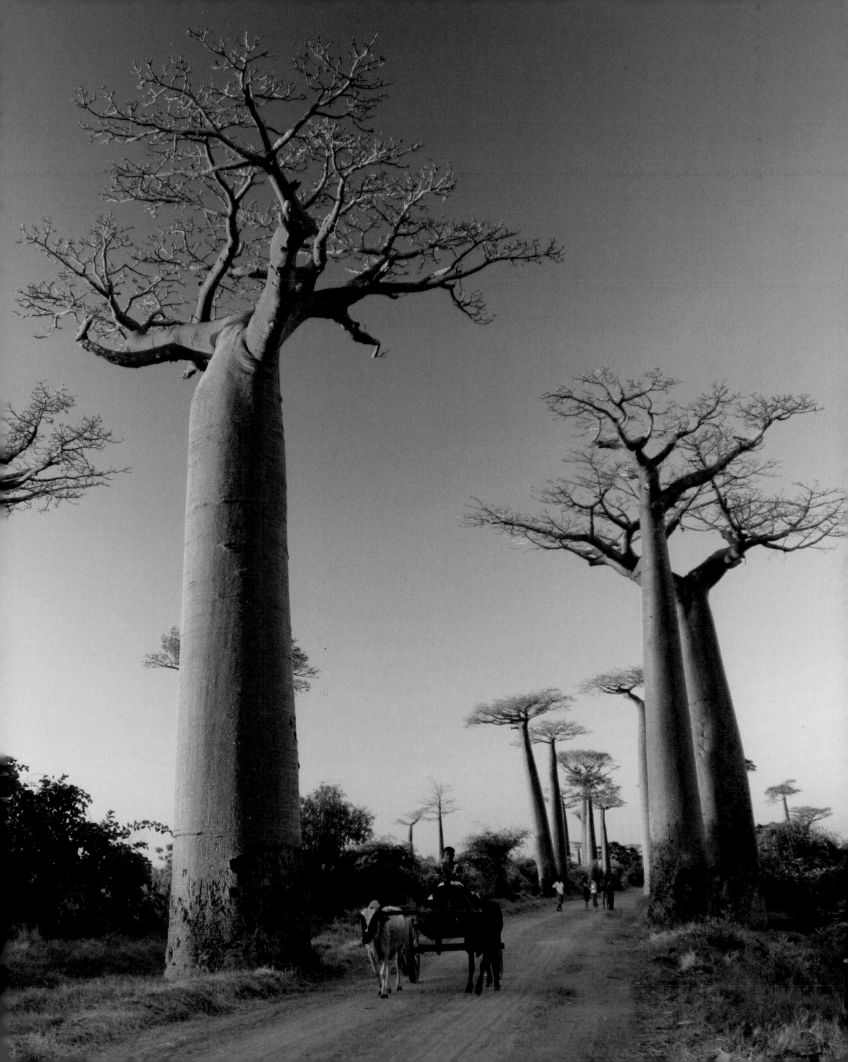

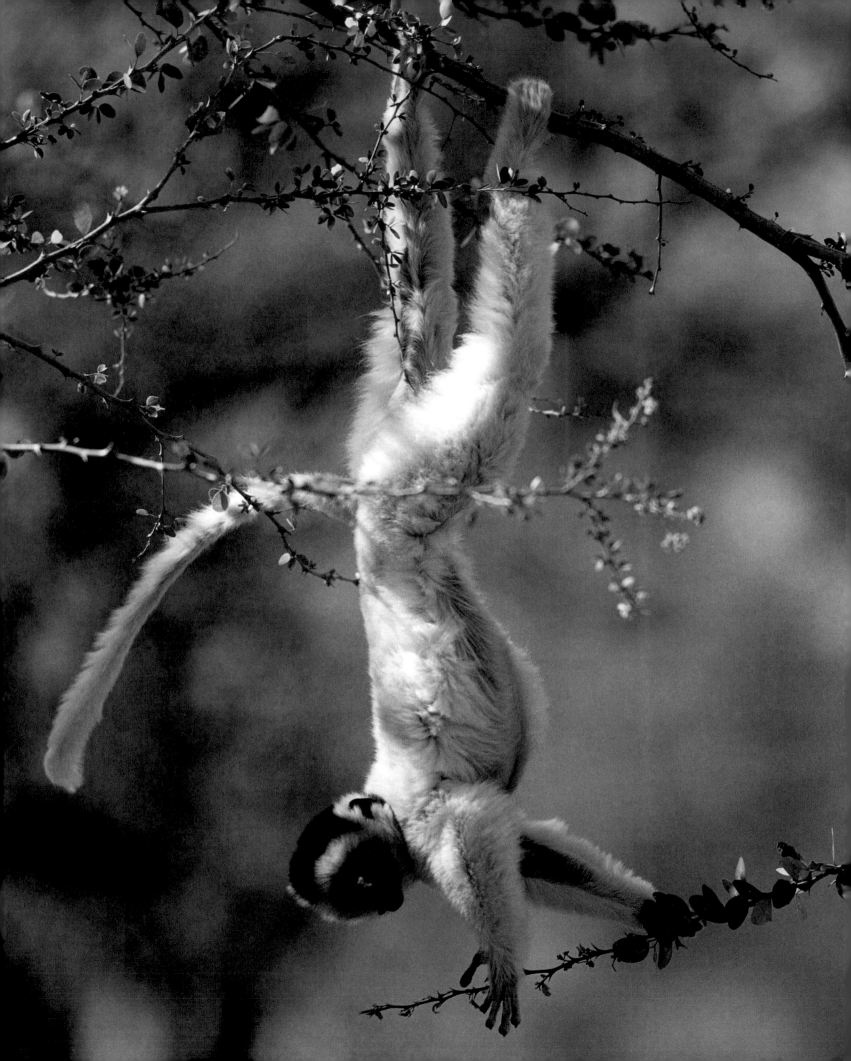

Although the precise composition of the vegetation of the Spiny Desert varies widely from one locality to another, it is composed generally of succulents, notably the thorny, cactus-like plants of the family Didiereaceae, all four genera (*Didierea*, *Alluaudia*, *Alluaudiopsis* and *Decaria*) and 11 species of which are endemic to Madagascar. Key species such the Octopus Tree *Didierea madagascariensis*, so-named for its plethora of tentacle-like branches, grow here alongside other arid zone species such as aloes and euphorbias, as well as baobabs. The result is a unique type of dry, deciduous woodland dominated by various thorny species, which gives the habitat its other name, the Spiny Forest. Many of the plant species here – some 95 per cent of which are endemic to this ecoregion, the highest figure for any of Madagascar's seven ecoregions – shed their leaves during the long dry season, thereby minimizing evaporation rates and helping ensure their survival through the driest and hottest parts of the year. Other survival techniques include enhanced water storage capacity in the pulpy tissue within large trunks and branches, as well as tubers, and extended root systems that help extract what little moisture there is in the soil. Other features such as small, needle-like leaves and waxy or hairy coatings are typical of plants that are adapted to life in arid zones.

The canopy of the forest is usually about 4 to 5 metres (13 to 16 feet) above ground level, but with some emergents reaching more than 10 metres (32 feet). The tallest species include the local specialities *Alluaudia ascendens* and *A. procera*, both of which can exceed 15 metres (49 feet) in height, as well as the remarkable baobabs, *Adansonia* sp., arguably the most iconic plants of the Spiny Desert. There are eight species in the *Adansonia* genus, one each in mainland Africa and Australia, with the remaining six being native to Madagascar. The largest of these is the statuesque *Adansonia grandidieri*, which can reach a height of up to 25 metres (82 feet) and forms impressive arcades, its pillar-like trunks giving an effect more reminiscent of a temple than a forest. Although parts of the Spiny Forest are still characterized by these giant trees, there is a growing problem with their succession. With increasing parts of the forest now under cultivation or having degenerated into degraded scrub, it has become difficult, if not impossible, for baobab seeds to successfully germinate. As a result, there are very few young trees coming through to replace their magnificent forebears and the next few decades will see a decline in the presence of baobabs in the Spiny Forest landscape as the older trees die and are not replaced.

In terms of mammals, Madagascar is renowned for its lemurs, a unique group of primates that are endemic to the island. During their long history of isolation, lemurs have developed an impressive variety of adaptations, their evolution reflecting the diversity of ecological opportunities available on Madagascar. So while the thorn-covered vegetation of the Spiny Desert may seem an unpromising environment for tree-climbing animals, certain species of lemur can be seen readily here and are able to cope well with the conditions. The White-footed Sportive Lemur *Lepilemur leucopus* appears to be endemic to the Spiny Desert, but the two most regularly seen lemur species in this area are Verreaux's Sifaka *Propithecus verreauxi* and Ring-tailed Lemur *Lemur catta*. Both are essentially diurnal, and often to be seen scrambling and jumping about in thickets of seemingly razor-sharp foliage, their soft, velvety hands coping with the barbs and spines without any apparent difficulty. They are equally impressive when on the ground. Indeed, Ring-tails are the most terrestrial of all lemurs, spending much of their time at ground level foraging for food and capable of living in areas that are largely devoid of trees. Sifakas are primarily arboreal, but when they do descend from the trees they have a distinct and engaging form of locomotion – to cover open ground they leap sideways in a series of extended jumps, holding their arms outstretched as a way of keeping their balance.

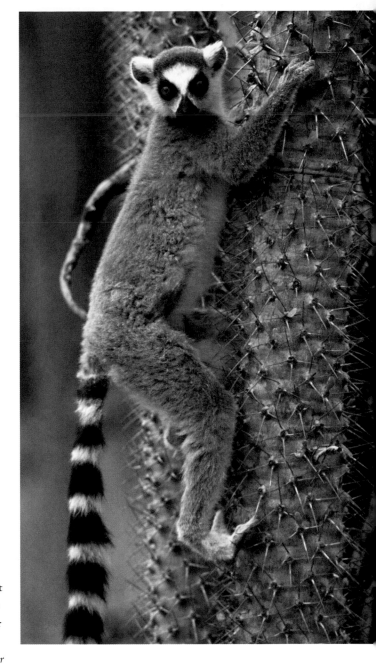

OPPOSITE **Sifakas usually rest during the hottest part of the day, foraging for food in the early morning and late afternoon. They feed primarily on leaves, moving acrobatically through the vegetation and using their long tail as a balance when leaping from tree to tree or hanging upside down.**

ABOVE **Highly dextrous and seemingly impervious to the vicious thorns that are characteristic of Spiny Desert trees and plants, Ring-tailed Lemurs live in a range of different habitats from thick forest to tracts of open rock. This versatility has doubtless helped them survive as Madagascar's landscapes have changed around them.**

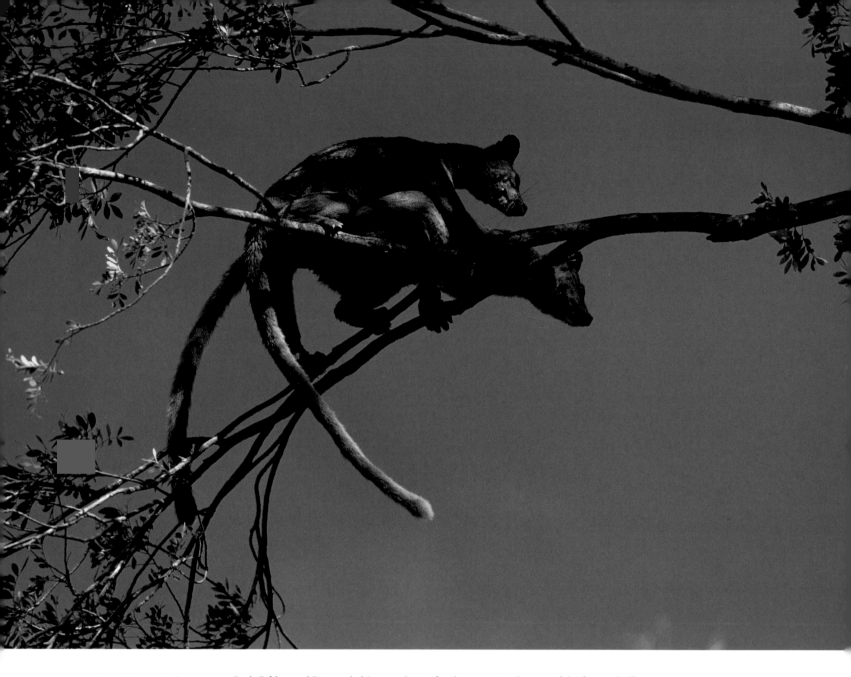

ABOVE **A rare photograph of Fossas coupling in a "mating tree". A female will mate in turn with a whole group of male admirers in what can be a lively and noisy encounter lasting several days. This usually takes place between September and November, with a female giving birth to two to four young three months later.**

Both Sifakas and Ring-tailed Lemurs live in family groups; in the case of the former, half a dozen animals is usually the norm, but the latter can be seen in troops of up to 20 or so. The societies of both species are female-dominated, with males generally subservient during activities such as foraging, although they appear to carry responsibility for defending the group against predators. Foremost among these is the Fossa *Cryptoprocta ferox*, a civet-like creature and the main predator of lemurs. Endemic to Madagascar, the Fossa is the island's largest carnivore and, with a tail that is almost as long as the rest of the body, can reach a total length of up to 2 metres (6½ feet). It looks like a cross between a cat and a dog, and is equally at home on the ground or in trees, up which it climbs readily – and with some speed – in pursuit of lemurs. Although widely distributed, Fossas are nowhere common and among the most elusive and difficult to see of the island's mammals. One of the best opportunities for a good view is a chance encounter upon one of their "mating trees", where the Fossa's extraordinary coupling ritual can, with luck, be observed. A single female Fossa will position herself high in the tree canopy, attracting up to five or six male animals below. She will mate with some or all of those gathered, each of which will climb the tree to reach her and will then mate with her in sessions lasting up to two or more hours. A female may occupy one of the mating trees for as long as three or four days and will then move on, sometimes to be replaced by another female, whereupon the whole process starts anew.

BELOW **Fossas are carnivorous and prey on wide variety of mammals, birds and reptiles. In forested areas lemurs are estimated to account for up to 50 per cent of their diet and are hunted by Fossas both on the ground and in trees, with the predator moving swiftly and securely through the canopy in pursuit.**

The Spiny Desert is also home to the Lesser Hedgehog Tenrec *Echinops telfairi*. Tenrecs are insectivorous mammals, related to moles and shrews, and essentially nocturnal. Almost 30 species have been recorded from across Madagascar. Some of these – including the two "hedgehog" species – have spines rather than fur, and curl up into a ball when threatened. The Lesser Hedgehog Tenrec is restricted to the Spiny Desert region, where it is usually found foraging among the leaf litter on the ground. Somewhat surprisingly, however, it is also an accomplished climber and will scale quite large trees in search of insects. During the dry season it estivates, becoming dormant and emerging from its den only when conditions are suitable and it can be confident of obtaining an adequate food supply. Although still relatively common and widely distributed across south-western Madagascar, this species – like all tenrecs – is prized as a source of food by local people and is under pressure from excessive hunting.

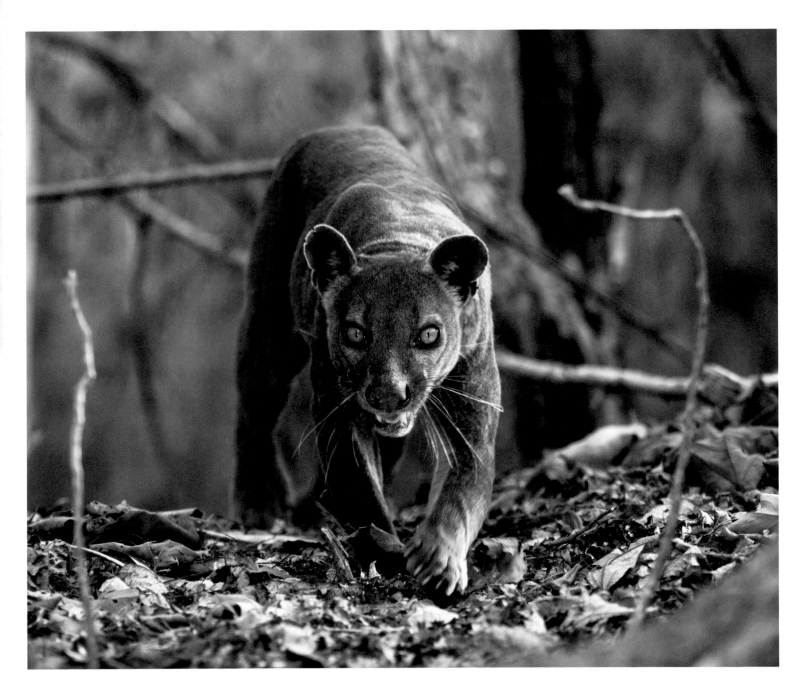

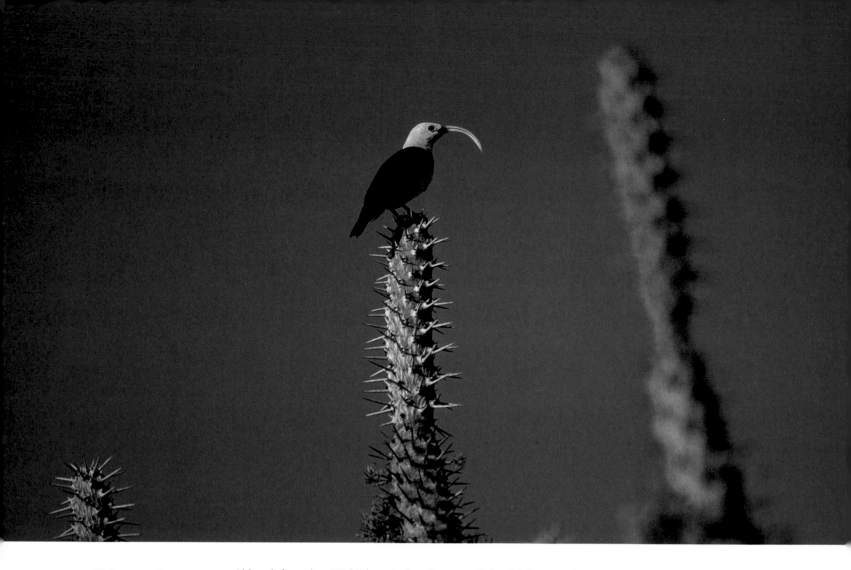

Although fewer than 300 bird species have been recorded on Madagascar, the vast majority of resident birds are endemic. Indeed, whole families of species are found only on the island, which, not surprisingly, is regarded as one of the world's birding hotspots. Its appeal to the ornithological fraternity is made all the more compelling by the fact that many of the species are extremely rare and/or highly localized. These include a number of Spiny Desert specialities, often restricted to small areas of suitable habitat and so very vulnerable to disturbance and changes in their environment. The dominant substrate of loose sand means that tracks are an important indicator of what wildlife is using a particular area. This is particularly so for ground-dwelling birds, and local bird guides rely extensively on their ability to find and identify the right tracks in order to locate two of the blue riband species here, Long-tailed Ground Roller *Uratelornis chimera* and Subdesert Mesite *Monias benschi*. Both these birds are found only in a narrow coastal strip. Other notable Spiny Desert species, and rather more widely distributed, include three species of coua *Coua* sp., Lafresnaye's Vanga *Xenopirortris xenopirostris*, Sickle-bill Vanga *Falculea palliata* and Madagascar Plover *Charadrius thoracicus*.

Reptiles in the Spiny Desert notably include Dumeril's Ground Boa *Acrantophis dumerili*, although this species also occurs in other habitats, and Radiated Tortoise *Geochelone radiata*. The latter species, one of the most attractive of all chelonians, is endemic to the Spiny Desert and has declined markedly in recent years. Although habitat destruction is a contributory factor, collection to satisfy the local demand for meat and also for the illegal pet trade overseas has been a major cause in the decrease in tortoise numbers and is likely to have been responsible for several local extinctions. As a result of these pressures, the Radiated Tortoise's range has contracted by at least 25 per cent in little over a decade and even areas which once held strong populations have seen substantial falls in numbers. Historically, animals such as tortoises and lemurs suffered

RIGHT The Spiny Desert is home to many notable bird species, but few have as restricted a range as the Subdesert Mesite. This ground-dwelling bird is known from only a few locations, where it forages for food among soil and leaf litter and builds its platform nest in thick scrub up to 2 metres (6½ feet) above ground level.

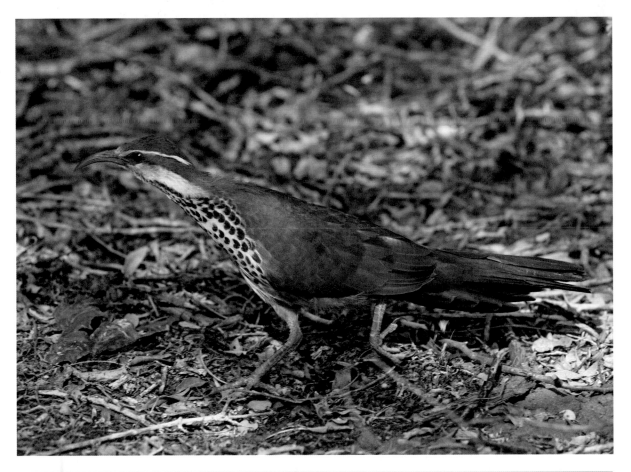

RIGHT The five species of ground roller are endemic to Madagascar and look like crosses between roadrunners, pittas and rollers. The engaging Long-tailed Ground Roller is highly territorial and nests in sandy banks, excavating a tunnel with a chamber at the end in which the female will lay her eggs.

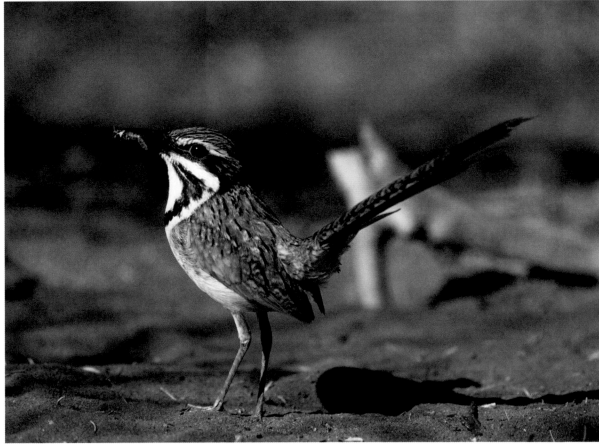

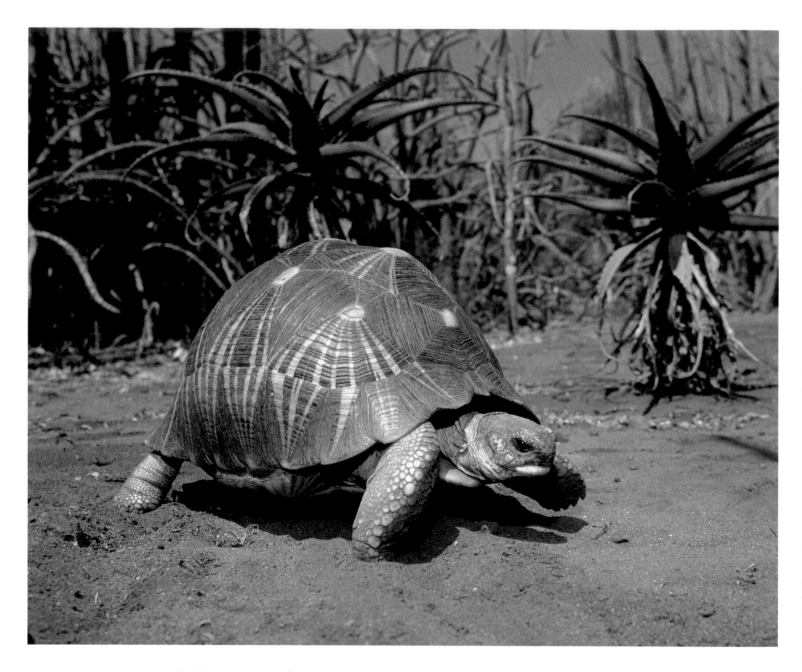

ABOVE **The illegal pet trade has helped put the Radiated Tortoise on the Critically Endangered list. Many areas have been stripped of all their tortoises, with armed bands of poachers moving in on the few surviving populations. Without action to stop them, this species could become extinct in the wild within a decade.**

little direct persecution from the local human population, thanks largely to traditional beliefs that harming or killing them is taboo ("fady") or brings bad luck. However, in recent years these beliefs have shown signs of breaking down, and the taking of local wildlife for the cooking pot is an understandable response to what is, by any standards, a very difficult environment in which to scratch a living. Equally, the financial incentives offered by unscrupulous collectors of wildlife are hard for some local people to resist. Nor does this threat extend only to animals. During the 1980s, for example, species of Didiereaceae were highly prized by specialist plant collectors, mainly in Europe, North America and Japan, and many thousands of specimens were being taken from the wild. The volume of this illegal trade was such that several species were at risk of extinction and the entire family was placed on Appendix II of CITES. Meanwhile, human pressure on the Spiny Desert continues to intensify. The felling of trees for charcoal production is a major source of forest fragmentation, and agricultural expansion – mainly to plant maize and provide new areas of pasture for cattle – is having a serious effect on the quality and extent of wildlife habitat. Of paramount concern is the fact that, despite the existence of some national parks, the vast majority of the Spiny Desert enjoys little by way of statutory or practical protection.

OPPOSITE **Despite its name, Dumeril's Ground Boa is as at home up in trees as on the ground, and will take birds as well as small mammals. It is mainly nocturnal, resting up during the day in leaf litter on the ground, in burrows or in holes in trees. Like all pythons, it constricts its prey before swallowing it whole.**

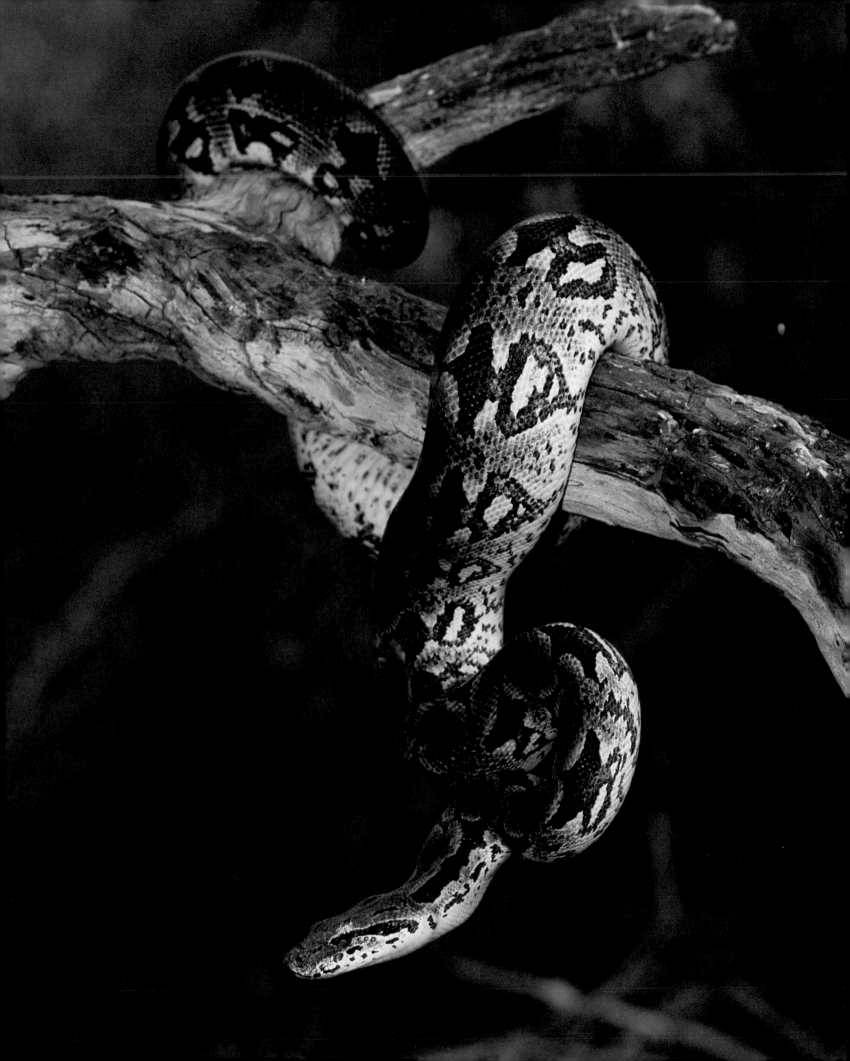

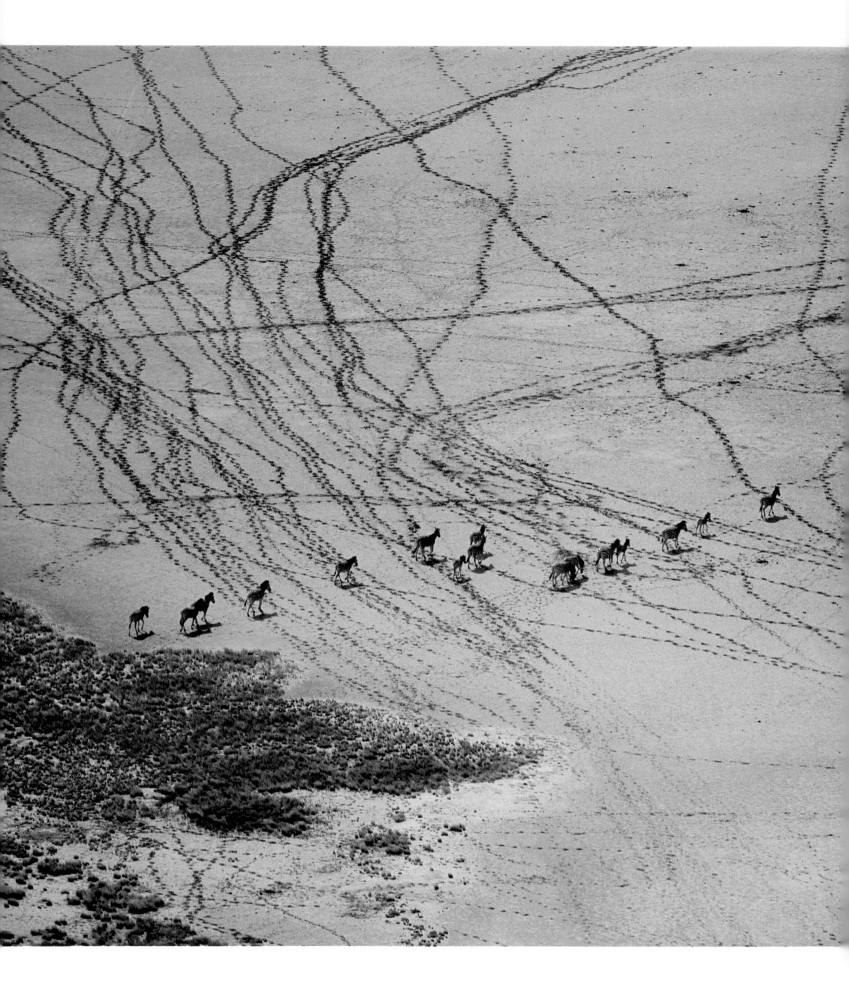

18: The Great Herds of the Kalahari

The Kalahari is not so much a desert as a vast area of arid savannah or lowveld, sitting atop what is probably the single largest expanse of sand in the world. Occupying some 70 per cent of Botswana, the Kalahari's average – and very variable – annual rainfall of 250–650 millimetres (10–25 inches) is greater than the strict definition of "true desert" allows. However, much of the landscape here has a distinctly desert-like character, typically comprising scattered thorn scrub and extensive grassy plains, which during the dry season become bone dry and little more than tracts of dust. There are also areas of sand dune and patches of forest, the latter mainly on the northern and eastern extremities of the Kalahari itself, as well as the most extensive complex of salt pans in the world, the Makgadikgadi Pans. The climate is harsh, with summer temperatures exceeding 40°C (104°F) and dropping as low as -10°C (14°F) in winter.

Characterized by a variety of acacias and thorntrees *Acacia* spp., alongside species such as Terminaria *Terminaria prunoides*, Kalahari Appleleaf *Lonchocarpus nelsii* and Shepherd's Tree *Boscia albitrunca*, and with grasses such as the ubiquitous Bushman's Grass *Stipagrostris uniplumis* dominating open areas, the Kalahari lowveld supports a greater variety of larger mammals than almost any other habitat in the world. At certain times of year it is thronged by great herds of ungulates, on a scale now unknown elsewhere in southern Africa and which has at times rivalled the more famous spectacles of the East African plains. Attracted by the sweet grazing that immediately follows the first seasonal rains, which usually arrive in late November, many thousands of Springbok *Antidorcas marsupilis*, Gemsbok *Oryx gazella*, Plains Zebra *Equus burchelli* and Blue Wildebeest *Connachaetes taurinus* move across the landscape, along with smaller numbers of Eland *Taurotragus oryx*, Red Hartebeest *Alcelaphus buselaphus* and Giraffe *Giraffa camelopardalis*.

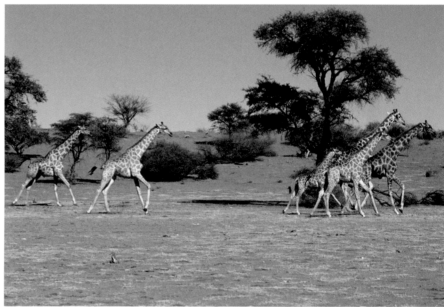

LEFT The fringes of the Makgadikgadi Pans can be thronged with animals at certain times of year. Zebra, wildebeest and other antelope move through in large numbers in search of water and fresh grazing.

ABOVE **Giraffes seem an unlikely** member of the desert fauna but can live in arid country so long as there is adequate browse – they thrive on acacia, taking up to 120 kilograms (550 pounds) of leaves each day.

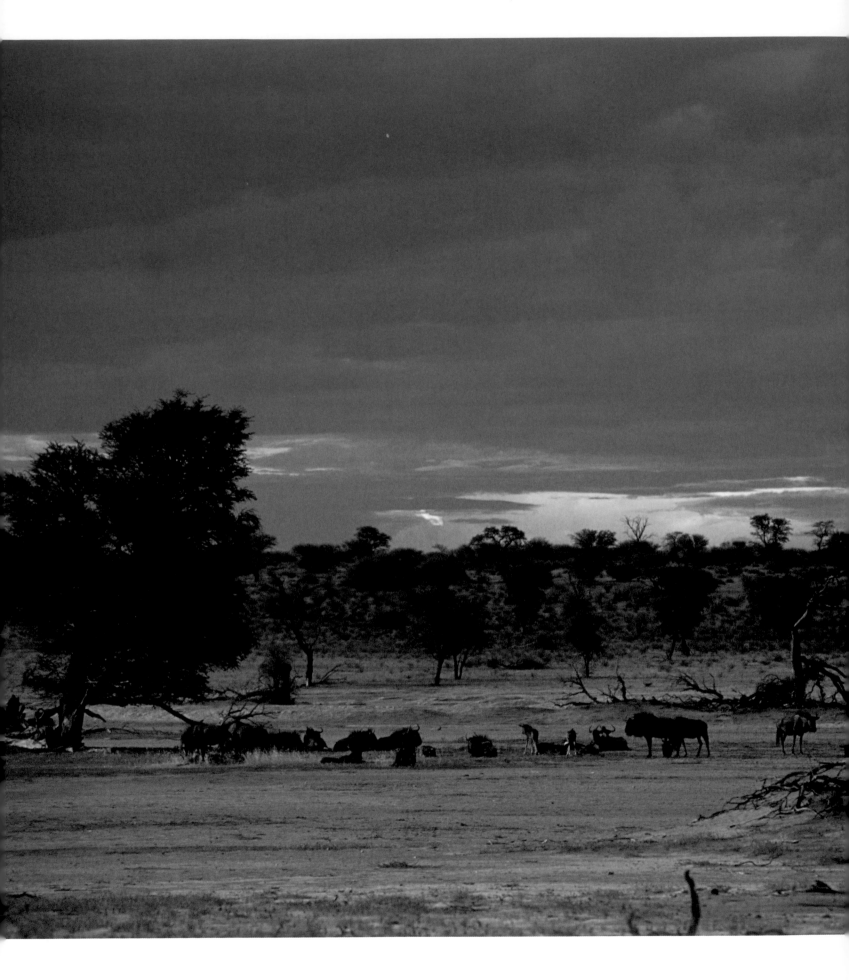

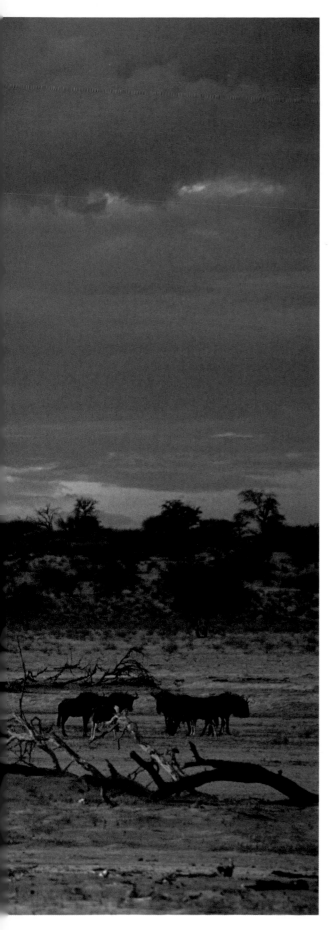

During the dry season almost all the animals congregate along the few remaining rivers and in the ephemeral watercourses, where underground water reserves help sustain vegetation all year round. Upon the arrival of rain the herds become highly nomadic, moving in response to the often localized rainfall patterns and appearance of new growth across different areas of the lowveld. The thousands of herbivores, which time their breeding cycles with this period of plenty, in turn attract good numbers of each of Africa's big cats – Lion *Panthera leo*, Leopard *Panthera pardus* and Cheetah *Acinonyx jubatus*, as well as packs of one of the continent's most endangered predators, African Wild Dog *Lycaon pictus*.

Important sections of the Kalahari are protected by national park and game reserve designations. The largest of these is the Central Kalahari Game Reserve, which covers 52,000 square kilometres (20,080 square miles) and was created in 1961. Remote, stark and at times overwhelming, the CKGR supports important populations of the main ungulates (particularly Springbok and Gemsbok) and attendant big cats, all at generally low densities, alongside a host of classic smaller Kalahari mammals such as Bat-eared Fox *Otocyon megalotis*, Springhare *Pedetes capensis* and Meerkat *Suricata suricatta*. The CKGR was established primarily to protect the ancestral homeland of the Bushmen, also known as the Basarwa or San people. Approximately 65 per cent of Bushmen (whose total population is probably rather fewer than 100,000) live in Botswana and although traditionally they are hunter-gatherers, the majority now live in settlements. Their right of residence in the CKGR, and access to hunting grounds there used by them for millennia, have in recent years been denied them by the government of Botswana, actions which the Bushmen successfully challenged in the courts.

LEFT The requirement of Wildebeest for short grass means that they face one of the biggest journeys of all herbivores, forming large herds as they move around in search of new pasture.

BELOW Female Wildebeest give birth annually to a single calf, which can stand and move with the herd within 30 minutes of birth. Even so, this is a fraught time with predators ever watchful for a chance to take a newborn.

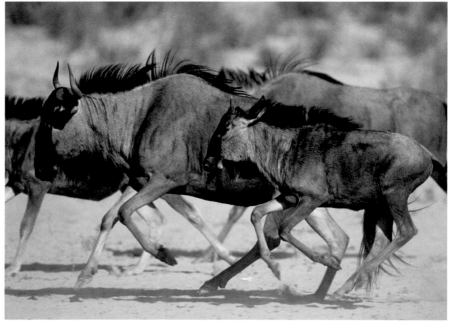

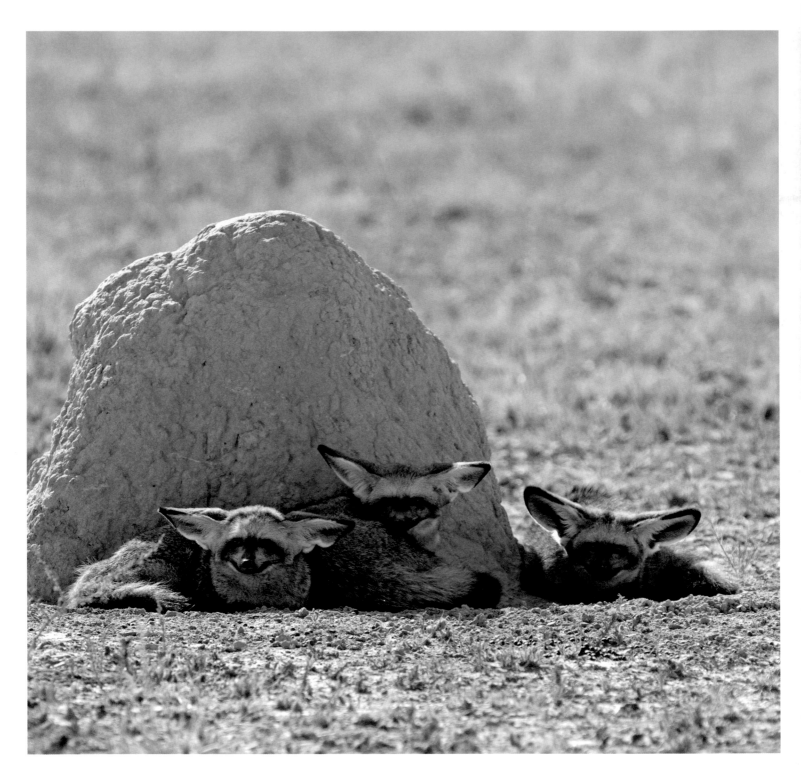

ABOVE Bat-eared foxes live in family groups and are often seen outside the entrance to their den. They are mainly insectivorous, with a penchant for termites, although like most foxes they are omnivorous and will readily take fruit, rodents, small birds and much else that comes their way.

OPPOSITE A seemingly unlikely sight as it crosses a salt pan, this Flap-necked Chameleon *Chamaeleo dilepis* is probably searching for new feeding grounds or possibly a mate. Progress across open ground is slow and fraught with danger as predators are on the lookout for easy pickings.

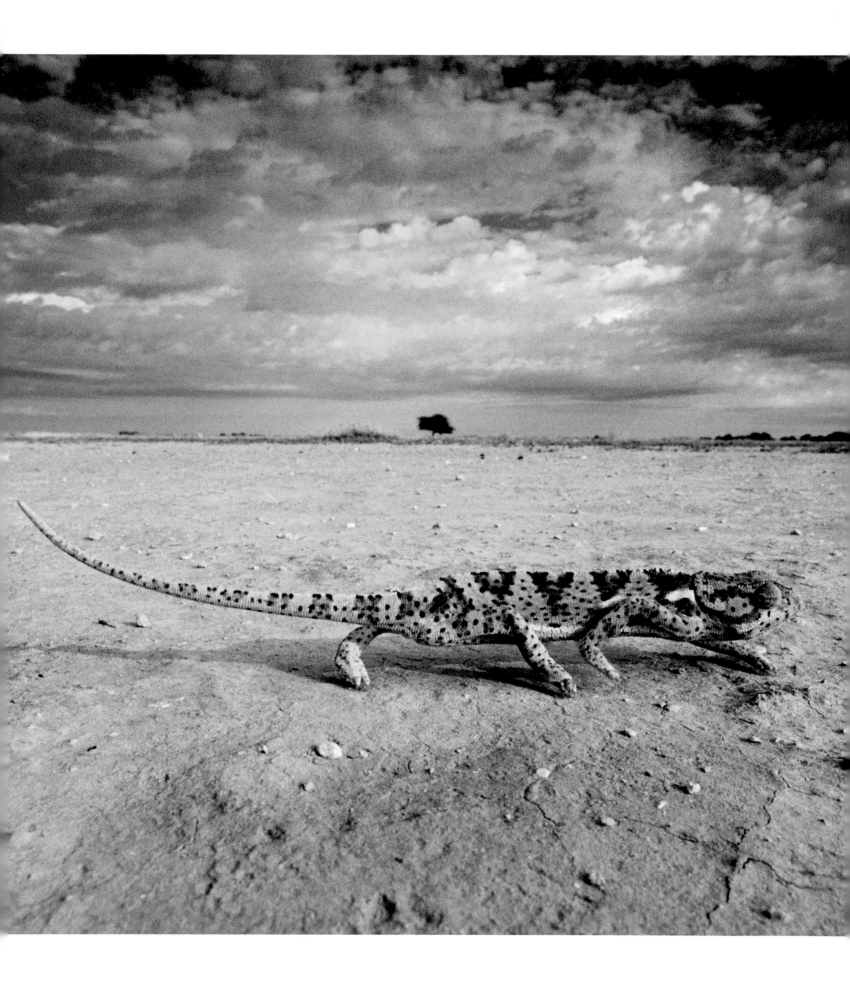

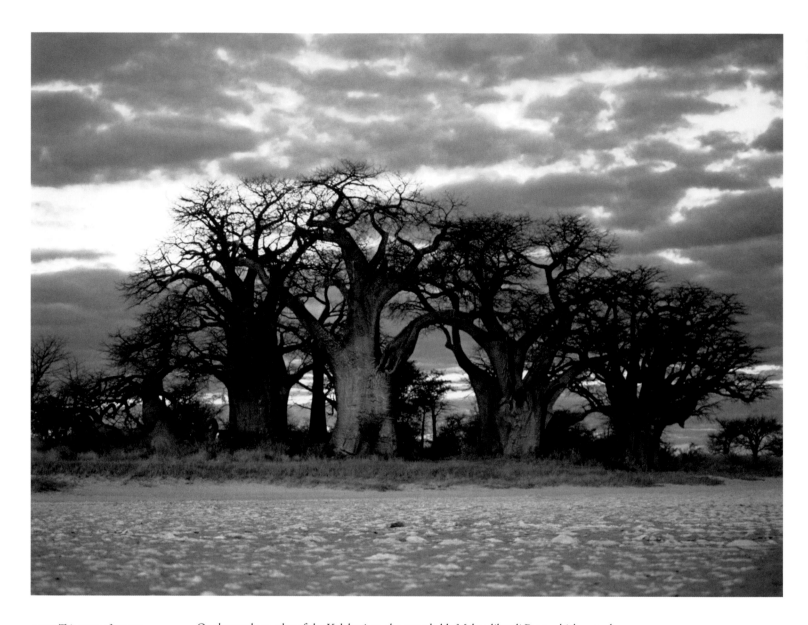

ABOVE **This group of veteran baobabs at Nxai Pan is known as Baines's Baobabs and was immortalized in paintings by Thomas Baines, who visited the site in 1862. He had originally been a member of David Livingstone's expedition to the Zambezi, but was mistakenly accused of theft and forced to leave the party.**

On the northern edge of the Kalahari are the remarkable Makgadikgadi Pans, which extend over 12,000 square kilometres (4,600 square miles) and were originally part of a prehistoric super-lake that covered much of what is now northern Botswana. For several months of the year the pans are a virtually lifeless crust of saline silt and dust, bleached by sun, scoured by wind and whipped up into swirling "dust devils", but from mid-November onwards the rains arrive and the landscape is transformed. The pans fill with water, becoming vast lakes, and in most years they retain their water until the following April or May. Huge herds of herbivores start moving towards the pan area shortly before the arrival of the rains, in anticipation of the rich grassland that rapidly develops.

There are many pans in the Makgadikgadi, but the two largest are Ntwetwe and Sowa. The latter is especially notable for the thousands of flamingos that flock to the eastern side of the pan when it fills with water after the rains. Both Greater *Phoenicopterus ruber* and Lesser Flamingos *Phoenicopterus minor* breed here when conditions are suitable, with up to 100,000 birds present in good years, making this one of the largest colonies in Africa. The young flamingos face a series of hazards, however: extreme heat, which out on the pans can reach 80°C (176°F) in the sun (there is no shade); predators such as hyenas and jackals, which periodically raid the colonies; and in some years, the water recedes before the young birds have fledged, requiring their parents to walk them to the wetter northern side of the pan, a dangerous and arduous journey.

In the south-western section of Sowa Pan is Kubu Island, an outcrop of igneous rock and one of the most compelling places in the Makgadikgadi. With its huge baobabs and abundant evidence of the area's Stone Age inhabitants – their discarded tools and arrowheads are easy to find here along the island's shoreline – Kubu has a very distinctive and special atmosphere. West of Sowa is Ntwetwe Pan, the largest pan in the Makgadikgadi complex, and part of which falls within the Makgadikgadi Pans National Park. The western boundary of the park is formed by the Boteti River, which connects the pans with the Okavango Delta 200 kilometres (124 miles) to the north. Thick riverine forest lines its banks, and it is along the river that many animals congregate during the dry season pending the arrival of the rains and their dispersal over the grazing grounds around the pans. However, in 1993 the Boteti ceased to flow, resulting in the death of thousands of wild animals and the displacement of many others. Miraculously, the river started flowing again in November 2008, a welcome event marked by the return of such key indicator species such as African Fish Eagle *Haliaeetus vocifer* and the anticipation that inhabitants such as Hippopotamus *Hippopotamus amphibius* and Nile Crocodile *Crocodylus niloticus* would be able to recolonize the whole river from the landlocked waterholes to which they had become confined.

Immediately north of Makgadikgadi Pans NP is Nxai Pan, also a national park and the venue for some of the most impressive wildlife-watching in southern Africa during the austral summer. Hundreds of thousands of animals move into the area at that time to feed on the lush vegetation and give birth to their young. The range of antelope includes all the expected participants plus more localized species such as Impala *Aepyceros melampus* and Greater Kudu *Tragelaphus strepsiceros*, and Nxai can be an excellent place to watch predators. Spotted Hyenas *Crocuta crocuta* are common, and there is also an important population of the scarce and highly elusive Brown Hyena *Hyaena brunnea*. Lions are regularly seen, and along with those that live in Namibia (see page 218), can be quite distinctive. The males are as much as twenty per cent lighter in weight than their counterparts on the savannah of East Africa, for example, and are generally distinguished by their darker manes. Like many other desert-dwelling creatures, they depend on their prey for obtaining moisture, often first tearing open the stomach of a prey victim to drink up its juices before they tackle the meat.

BELOW A Wild Dog at its den. One of the most mercurial of all Africa's mammals, Wild Dogs were once killed on sight by ranchers and even by game wardens, who resented their harrying of ungulates. The species is now much declined and struggling to survive in many countries, although Botswana retains a healthy population.

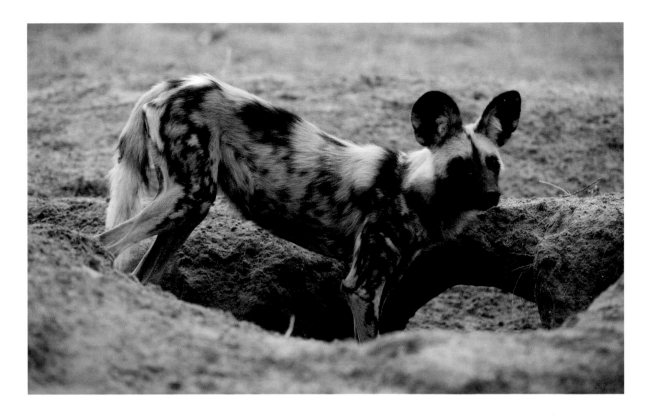

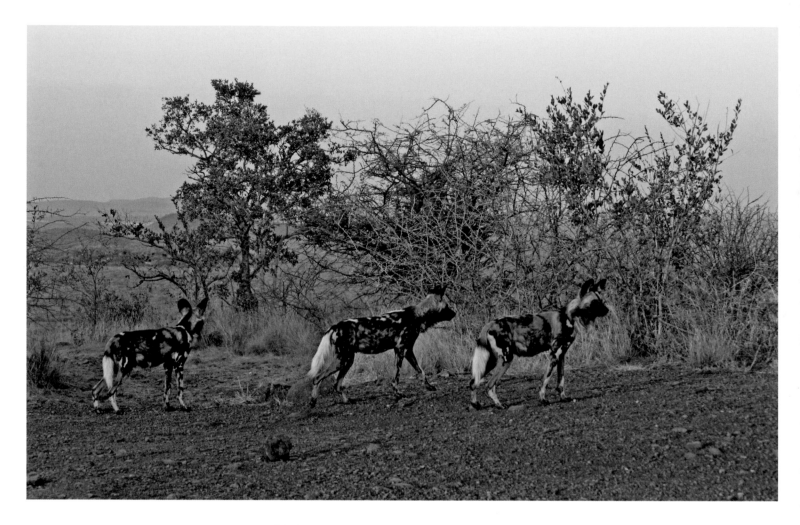

ABOVE Sometimes called "painted wolves" on account of their colourful piebald coats, Wild Dogs hunt in packs and work cooperatively to select their prey and then carry out a chase to bring it down. They are unusual among predators in successfully making a kill in the majority of their hunts, with prey unlikely to escape.

Botswana is one of the last strongholds of the African Wild Dog *Lycaon pictus*. Once found widely across much of sub-Saharan Africa, the Wild Dog is now extinct in many countries and its numbers are greatly reduced elsewhere. Although diseases such as canine distemper are known to have caused the local extirpation of some populations, direct persecution by humans – particularly by livestock farmers fearing for their animals – is the main reason for their decline. There are now estimated to be fewer than 4,000 Wild Dogs left in the world, with under ten populations containing more than 100 individuals. The Kalahari, and the Okavango Delta to its north, still have reasonable numbers of dogs, but they are nowhere a certainty and for much of the year are very difficult to pin down. Whimsical and highly peripatetic, they operate over huge territories – sometimes in excess of 400 square kilometres (150 square miles) – and can only be seen reliably in any one place for a few weeks each year, when they remain around a denning site for the birth of their pups. The adult animals will go off to hunt every few hours, returning with food for their young until the latter are old enough to go on the move with the rest of the pack.

Occasionally a pack of Wild Dogs will turn up around one of the pans and start hunting, causing instant panic among the herds of ungulates. A pack usually comprises ten or so dogs, although in the past – when the species was more numerous – packs of up to 40 were recorded. Watching these remarkable animals on a hunt is one of the great wildlife experiences, but not for the faint-hearted. The dogs rely on a combination of pace, stamina and cooperation to run down their prey and can keep moving at speeds of up to 50 kilometres (31 miles) per hour for as much as 5 kilometres (3 miles), constantly staying in contact with each other via their characteristic and bird-like "chirping" calls. When they get within biting range of their prey they will start nipping at it before pulling it down and often killing it by disembowelment. While often a gruesome sight, the skill and flair of this consummate predator is rightly a source of respect and admiration.

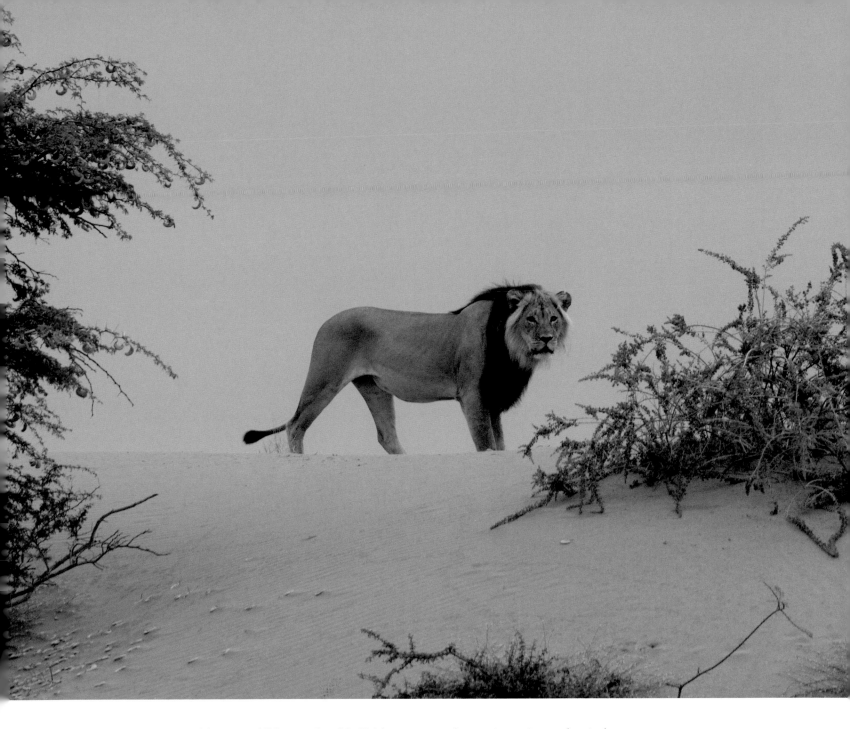

ABOVE As herds of grazing animals move into areas offering fresh grazing and water, so predators such as lions gather. Although opinions vary on whether or not they constitute a distinct subspecies, Kalahari lions differ from their East African cousins in having darker-coloured manes and usually being smaller.

The great wildlife spectacles of the Kalahari are among the most impressive anywhere in the world, and are set against some of the finest landscapes. Yet the Kalahari is facing a wide range of increasingly complex and politicized conservation issues, with regard both to its traditional human inhabitants, the San people, and the wildlife on which they depend and which tourists from overseas come to see and photograph. For example, the discovery of diamonds in the Central Kalahari Game Reserve in the 1980s prompted the Botswana government to attempt the relocation of the local San inhabitants to land outside the reserve. This was largely against the San people's will, and was accompanied by a ban on their hunting in their ancestral areas – ostensibly on the grounds of wildlife conservation. Forcible evictions, and the destruction of San villages and waterholes, eventually saw the complete removal of the San from the CKGR by 2002. A Botswana court ruling subsequently declared the government's actions unlawful and unconstitutional, following which small numbers of the San have been allowed back. However, many still remain in camps outside the reserve boundaries and, as of early 2011, the authorities are continuing to refuse to cooperate with their return.

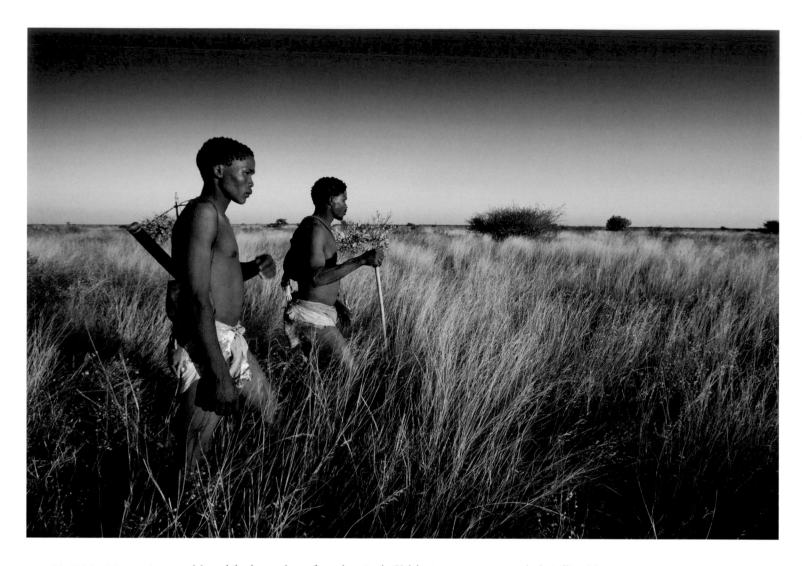

ABOVE The Kalahari's San people have seen dramatic changes in their traditional environment in recent decades. Access to ancestral hunting grounds has become restricted and there has been increasing pressure from regional governments for them to surrender their nomadic hunter-gatherer lifestyle.

Meanwhile, the numbers of ungulates in the Kalahari system are constantly dwindling. The massive migrations of the early- and mid-twentieth century are almost certainly gone forever and those that still take place have become increasingly fragmented and compromised. Much of this is the result of the erection of extensive game-proof, disease-control fences ("veterinary cordons") across important sections of the Kalahari as a means of protecting the cattle that underpin Botswana's lucrative beef industry. These serve to divorce wild animals from their preferred grazing areas and essential water sources, and there is no doubt that the numbers of zebra and wildebeest have declined accordingly, and their distribution has been affected as a result. At the same time, human encroachment on those resources to which the wild animals still have access is increasing constantly, a pattern of conflict between man, livestock and wildlife that is replicated across much of Africa. However, a potential way forward is offered by initiatives such as the Kgalagadi Transfrontier Park, declared in 2000 and spanning a large swathe of the southern Kalahari on both sides of the Botswana/South Africa border. The park combines what were previously two separately managed national parks into one unit, reflecting more accurately the character of the local ecosystem and helping to make possible once again the large-scale migratory movements of wild animals in that area.

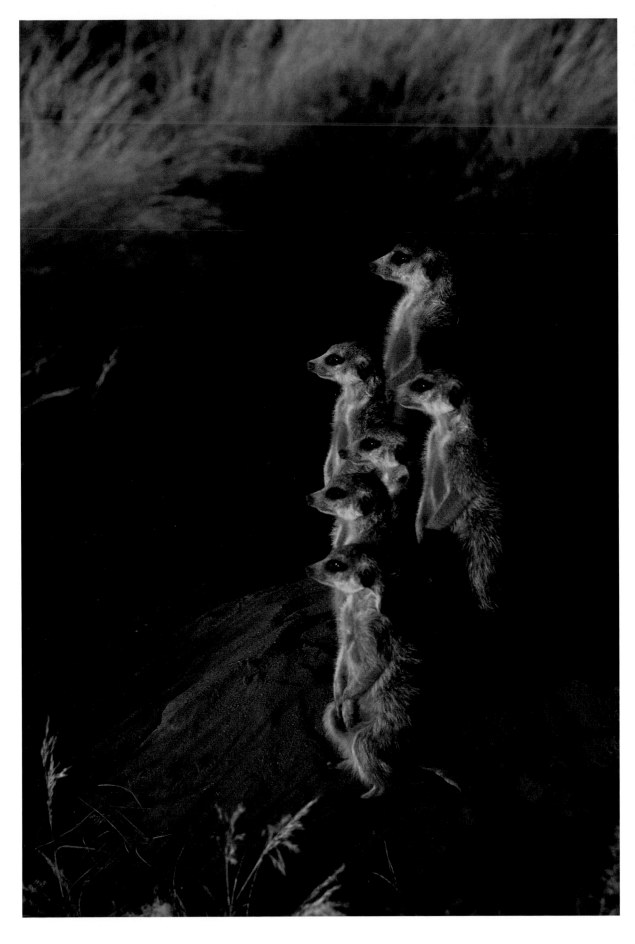

LEFT Thanks to a spate of popular television programmes, Meerkats are among the Kalahari's most famous ambassadors. Their engaging habits and highly sociable nature – they live in groups of up to 50, led by a dominant pair – make for entertaining viewing, especially the sentry system that helps protect the group.

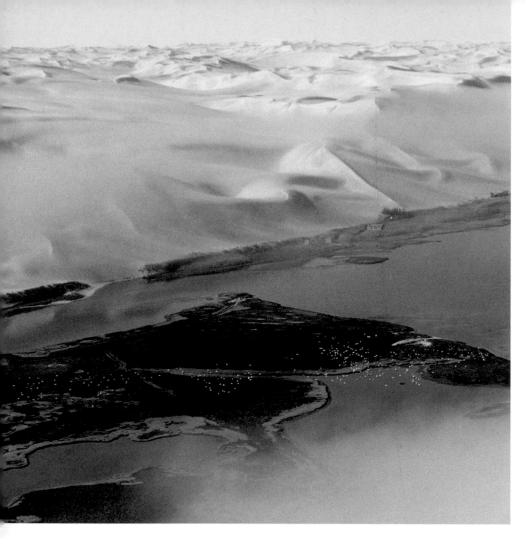

19: The Desert Elephants and Rhinos of Namibia

Namibia can claim some of the most spectacular landscapes in the world. Six times the size of Britain and twice as big as California, but with a population of fewer than two million people, this is a remarkable place of seemingly endless tracts of sand, deep canyons, vast gravel plains and volcanic outcrops. Rainfall levels are generally very low, and temperatures high throughout much of the year. This is desert country *par excellence* and hugely varied, from the stark shores of the Skeleton Coast to the dramatic lunar landscapes of Damaraland and the soaring sand dunes of the Namib-Naukluft National Park. Whereas in the last few decades a combination of overhunting, disturbance and agricultural encroachment have denuded many of the world's deserts of much of their wildlife, especially the larger mammals, Namibia retains as rich a selection of desert-dwelling animals and birds as anywhere. These include unique populations of iconic animals such as African Elephant *Loxidonta africana*, Black Rhinoceros *Diceros bicornis* and African Lion *Panthera leo*.

ABOVE The extreme aridity of the Namibian coast is alleviated by the regular fogs that affect the area and which provide a lifeline for desert wildlife.

RIGHT Scientists have long debated whether the desert elephants of Namibia constitute a subspecies of the nominate African Elephant.

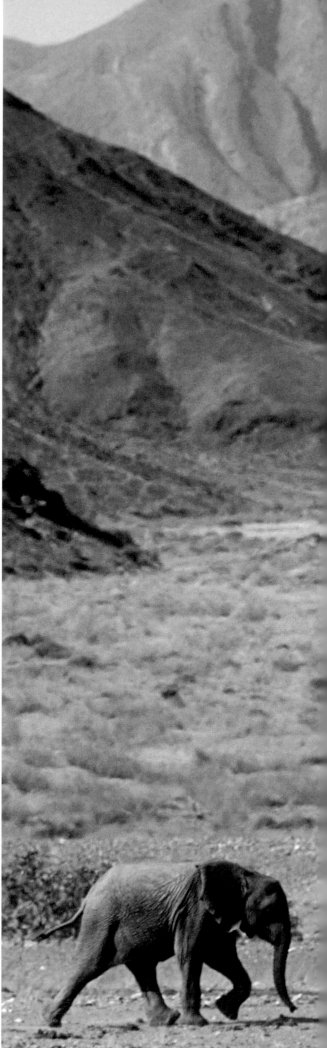

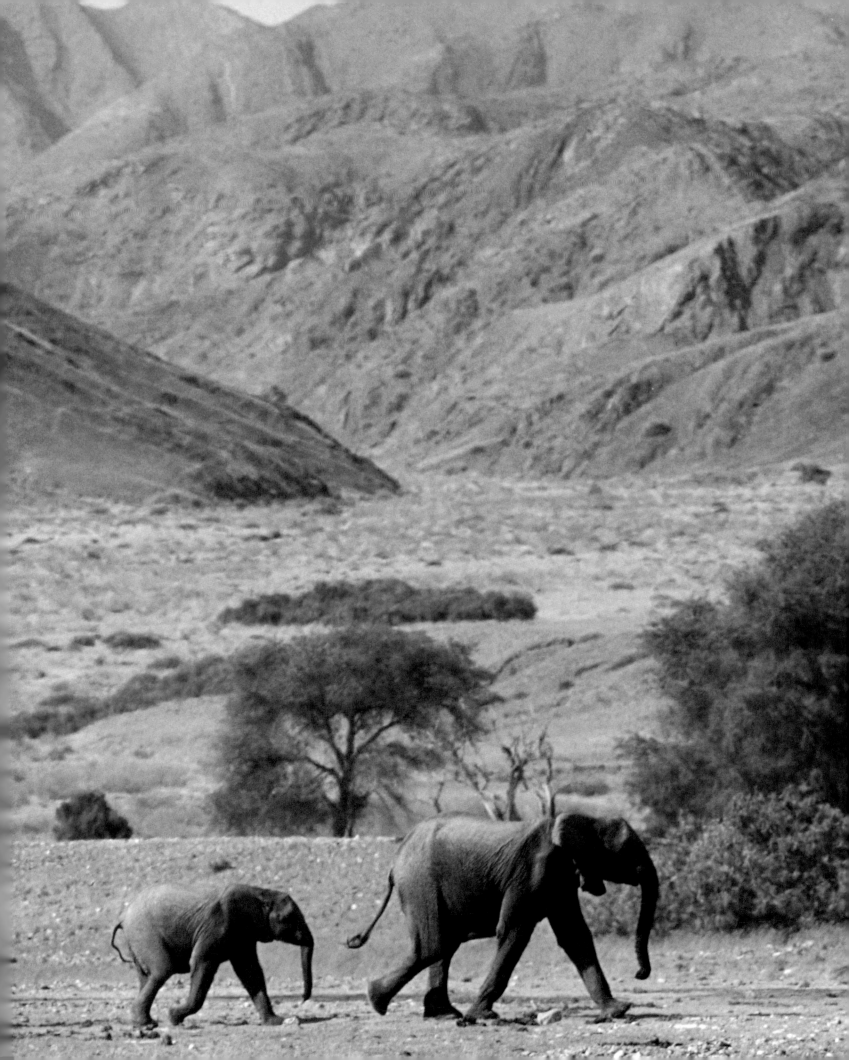

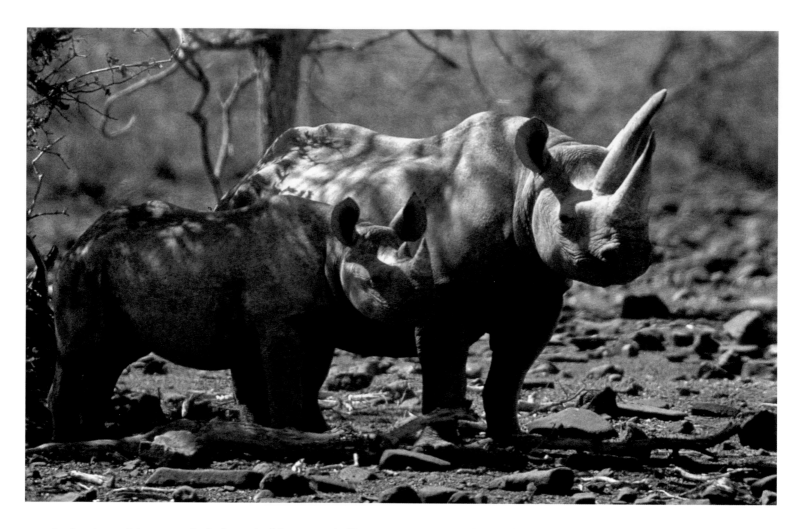

Poaching decimated rhino populations in the late twentieth century. The Black Rhino became extinct in several countries and was reduced to isolated small groups and individuals elsewhere, only secure if guarded around-the-clock by armed wildlife rangers. Only in Namibia did a sustainable free-ranging population survive.

In the far north of the country, the Kunene region – covering the area also known as Damaraland and the Kaokoveld – is home to one of the most unusual populations of African Elephant. Living in terrain far removed in character from the vast majority of their brethren elsewhere on the continent (although see those of Mali, pages 194–195), these elephants are an incongruous sight when they are encountered plodding across gravel plains and even over sand dunes. So marginal is this environment for elephants that it is not totally understood why they are here; they may represent a relict population from a time when this region received greater levels of rainfall and represented far more typical elephant habitat. Whatever their history, these elephants are remarkable in their ability to survive in such arid conditions. They do so via an encyclopaedic knowledge of the location of the area's waterholes, ephemeral rivers and prime locations for grazing and browsing, essential knowledge that is passed on from one generation of elephants to the next and which takes them on journeys of hundreds of kilometres every year. Elephants need to drink and eat prodigiously every day, and so the margin of error on their travels is minimal – if they get it wrong, and a waterhole is dry or the vegetation inadequate, the result can be the death of the younger and weaker members of the group.

Severe poaching during the 1980s reduced the local elephant population to fewer than 100 individuals, scattered over a wide area in small groups. Today numbers have built up again to an estimated 700 and are increasing steadily. However, as the number of elephants grows, and human activity in parts of the elephants' range also increases, primarily in the form of an expansion in farming by local people, so conflicts have inevitably arisen. The elephants sometimes raid crops and damage farm infrastructure, and are in turn harassed, chased away and even shot at by landowners and farmworkers. The situation further intensifies as a result; humans have been attacked and killed by elephants, and "problem" animals are then shot – a depressing spiral of events.

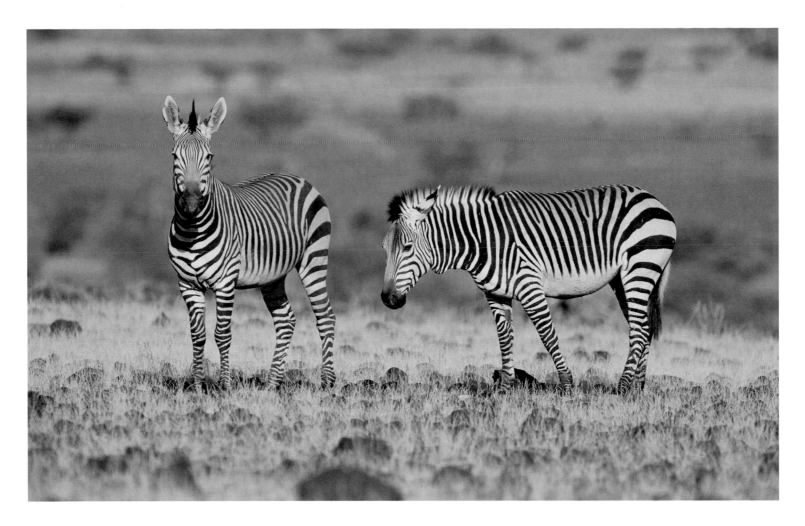

Hartmann's Mountain Zebras live in smaller groups than their relative, the Plains Zebra, and also associate less frequently with other ungulates than that species. During the driest times of year they move to higher ground, often moving along networks of well-worn paths to springs, where they usually drink at least once daily.

Meanwhile, the Kunene region is also home to the largest remaining population of free-ranging Black Rhinoceros in the world. Hammered by poaching for horn in the 1970s and 1980s, Black Rhino numbers in the wild across Africa collapsed from an estimated 70,000 in the late 1960s to fewer than 2,500 in 1995. Only in Namibia did a reasonable number of Black Rhinos survive in the wild, many of them in the largely inaccessible landscapes of Damaraland. This desert subspecies is specially adapted to life in arid conditions, coping well with the barren and stony terrain. The rhinos are surprisingly adept at scaling rocky slopes in search of food and, equally important, shade. They can survive without water for up to four days, and are flexible on diet, living on different plant species at various times of year, depending on what is available. Particular favourites are species of *Euphorbia*, some of which are highly toxic to most other animals (including humans), but which the rhinos tackle with relish. They have been known to browse on an especially appealing plant for several days, only moving on when there is nothing left to eat on it. Large euphorbias are also useful for rhinos as shade, as they will tuck themselves in underneath the bush and often fall asleep; for such a large beast they can be surprisingly difficult to see when settled down like this.

Like many desert animals, the rhinos are forced to wander far and wide in order to obtain adequate sustenance from the meagre vegetation on offer. A rhino's home range therefore normally covers 500–600 square kilometres (100–230 square miles), but individuals can roam over an area as vast as 2,500 square kilometres (1,000 square miles) in search of sustenance. This makes locating these surprisingly mobile creatures rather difficult, and research teams rely heavily on radio-tracking collared animals to monitor their whereabouts. Rhinos are predominantly solitary creatures, usually coming together only for mating in what can be a rumbustious and often cantankerous affair. Females give birth to a single calf, which will remain with its mother for up to two and a half years.

The difficult terrain and remoteness of Damaraland and the Kaokoveld have helped protect these unique rhinos. Under careful protection their numbers are increasing and as many as 150 are now estimated to roam the gravel plains and basalt hills. Tracking teams of rangers, often including former poachers who are experienced in rhino habits, keep detailed records of sightings, with many of the rhinos individually known to the team that protects them. Much of the fieldwork involves monitoring the various types of evidence of rhino presence, including the location of territorial middens, where individual animals spray urine and kick dung as a means of announcing their presence to other rhinos. These middens can be easy to spot, advertised primarily by the conspicuous splashes of rhino urine, which is bleached white by the sap of the euphorbias on which the rhinos feed.

The same habitats frequented by the elephants and rhinos are also home to a range of other classic African mammals for which this seems an equally unlikely environment. Among these are Giraffe *Girafa camelopardalis* and Zebra (the Hartmann's Mountain Zebra *Equus zebra hartmannae*). Although densities of these species are not high, they are well distributed across much of the region. The zebras live in small groups of up to 10 or so animals, typically comprising one adult stallion with a harem of mares and their dependent foals, with non-breeding or immature males usually forming bachelor herds. Mountain zebras are skilful climbers, easily scaling rock-strewn slopes, and interestingly the distinctive pattern of their hide serves as effective a camouflage in the lunar landscape of Namibia as it does for their savannah-dwelling relatives in East Africa. Meanwhile, zebra predators locally include an interesting population of desert-dwelling African Lions *Panthera leo*. In recent years these have increased in numbers quite markedly and started expanding into areas in which lions have not been seen for many years, even decades.

RIGHT By sidewinding, Peringuey's Adder *Bitis peringueyi* is able to move across hot sand with minimal body contact, leaving characteristic J-shaped tracks.

BELOW The role of Black-backed Jackals *Canis mesomelas* as wily and opportunistic attendants at a carcass is well known. Although always ready to snatch a morsel from in front of much larger predators such as lions, they are not simply scavengers.

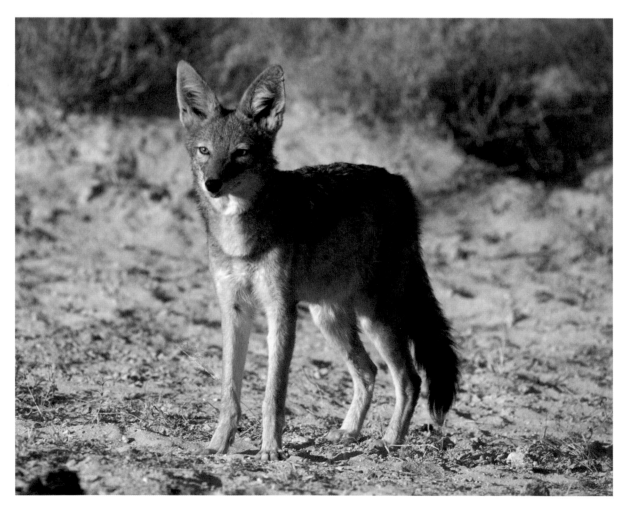

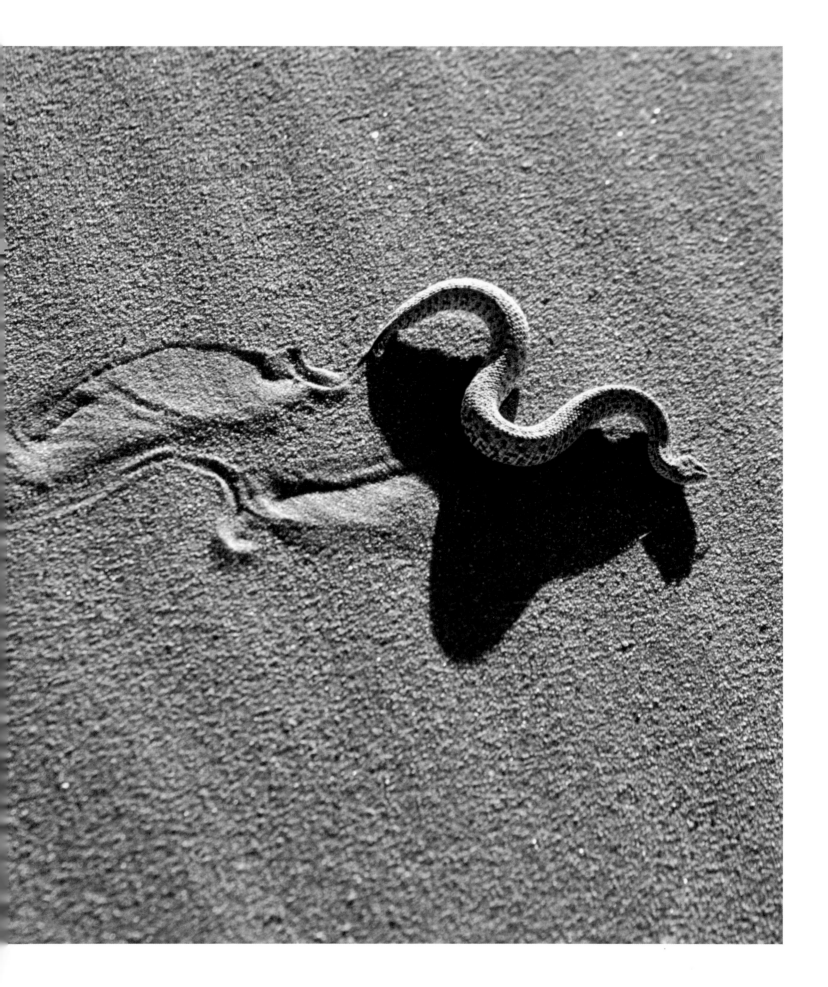

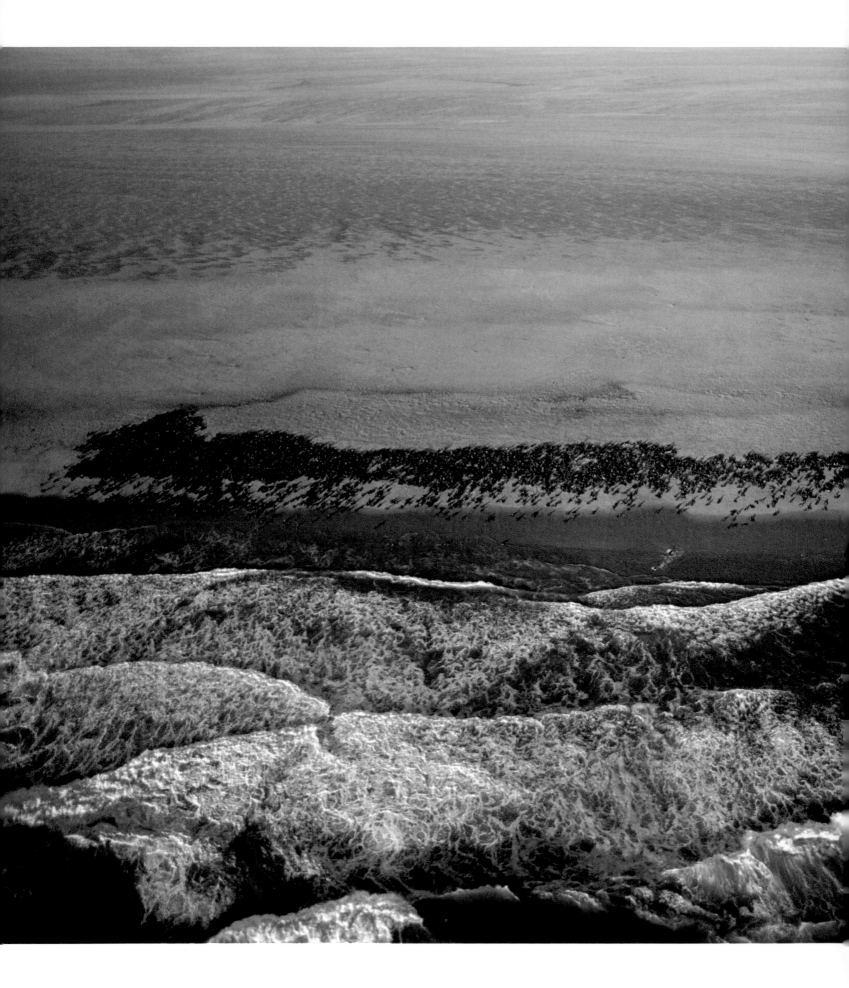

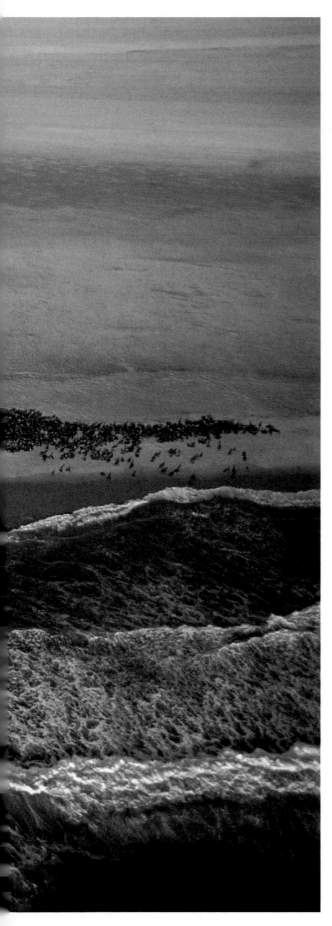

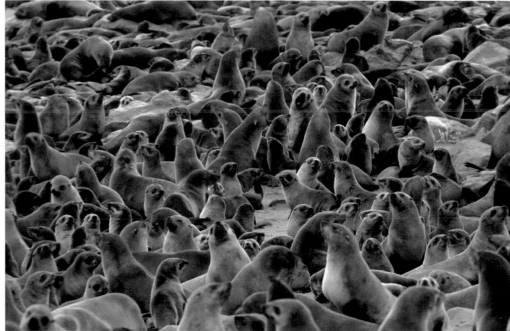

Although they live mainly around springs and dry riverbeds, where much of their prey congregates, lions have even been seen wandering along the beaches of the Skeleton Coast. This wild and remote stretch of coastline, periodically studded by the dramatic wrecks of washed-up ships and tankers and the skeletons of beached whales, is home to many species of seabird and the world's largest colony of southern Africa's only seal, the Cape Fur Seal *Arctocephalus pusillus*. Approximately 200,000 seals congregate at Cape Cross from October onwards, with the mature bulls first to arrive. Each stakes out a territory on the beach and attempts to defend it against rival males in what are often fiercely fought tussles, with the more successful individuals eventually establishing control over a stretch of sand. These so-called "beach-masters" are then well placed for the arrival of the cow seals in the following days and weeks. The cows come ashore to give birth and are receptive to being mated again within a week of their single calf being born. More violent battles then ensue, as the bull sea lions attempt to service as many cows as pass through – or are encouraged to enter – their area of control. Particularly successful males have been estimated at mating with up to 60 females during a single season. Calves, meanwhile, remain dependent on their mothers for up to a year.

LEFT **It is impossible to miss the Skeleton Coast's fur seal colonies. The stench and noise of the seals, particularly in the mating season when the males are especially vocal, hits the senses even before the animals are in sight. Hyenas and jackals hang about the colony's edges, picking up afterbirths and sickly pups.**

ABOVE **Tightly packed on the beach, the seals live at very high densities, with much jostling for position and territorial bickering. The situation becomes particularly chaotic when males are seeking to mate, as they will launch into the crowded colony and aggressively chase females, often crushing younger seals in the process.**

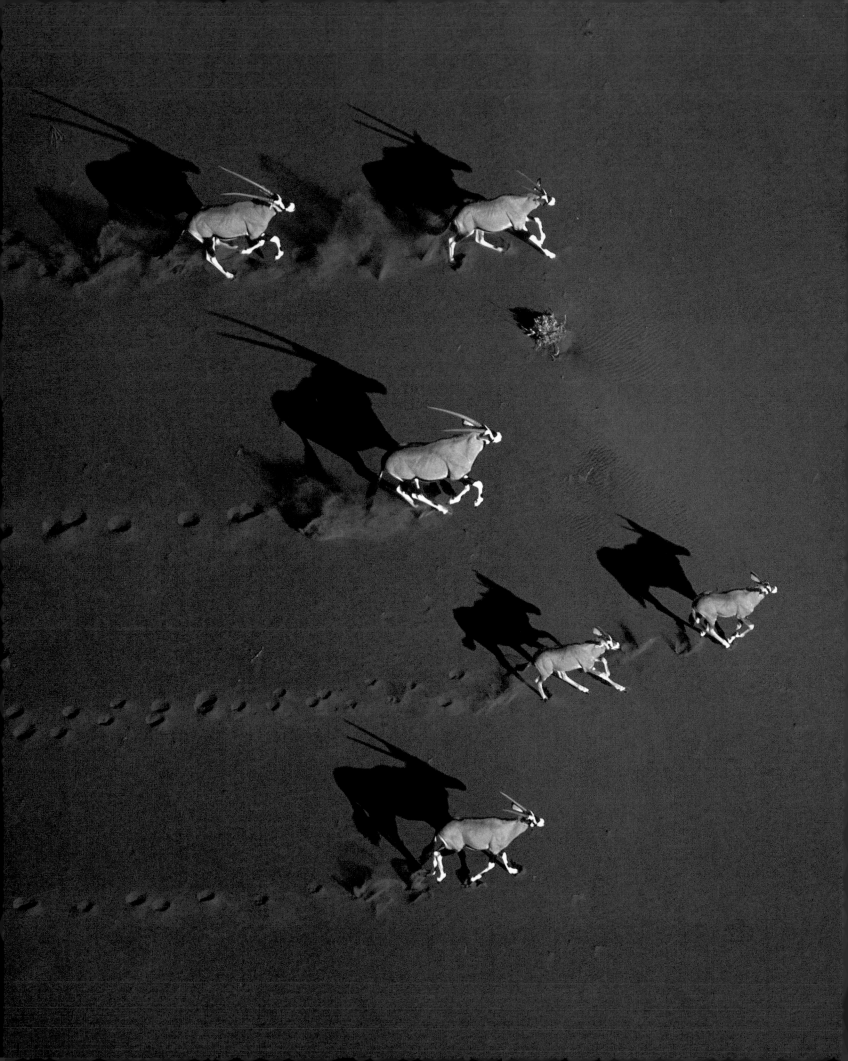

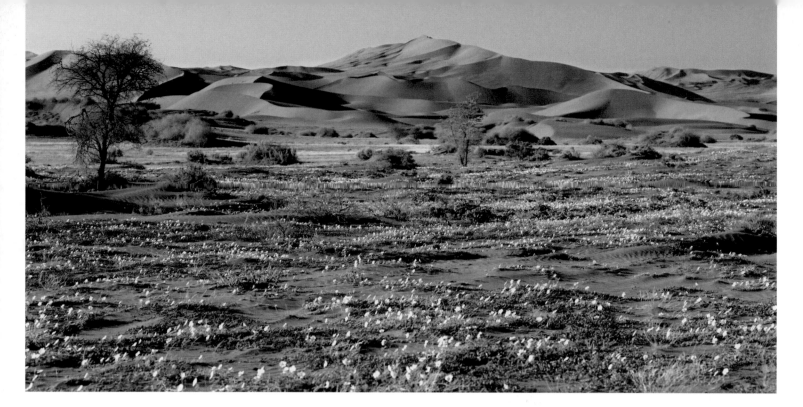

Few large mammals relish life on the open dunes, but the Gemsbok is in its element there. They are largely nomadic and whilst groups of up to 200 have been recorded, the average herd size is more like 14. Like other species of oryx, Gemsbok hardly ever need to drink, deriving adequate moisture from their food.

Further south, the Namib-Naukluft National Park and adjacent NamibRand Nature Reserve cover over 50,000 square kilometres (19,300 square miles) of the Namib Desert and the Naukluft Mountains. Wildlife in this area includes good numbers of the iconic Gemsbok *Oryx gazella*, an antelope species that is particularly adapted to living in landscapes that other large mammals avoid. Equally at home galloping across gravel plains or up sand dunes, gemsbok will range widely in search of suitable vegetation on which to graze or browse, even venturing into mountainous areas in search of water. They also dig readily for water-retaining roots and tubers, and are particularly partial to fruits such as wild melons. Despite the obvious defensive potential of their rapier-like horns, gemsbok rarely turn to face predators such as lions, preferring instead to rely on their impressive speed as a means of escape.

The northern section of the Namib-Naukluft is famous as a site for the remarkable *Weltwitschia mirabilis*, endemic to the Namib Desert and one of the world's most bizarre plants. Some specimens are estimated to be at least 1,500 years old. Weltwitschia plants have a short woody trunk fed by a long taproot, and two (very occasionally three) strap-shaped leaves that grow continuously and can reach up to 4 metres (13 feet) in length. Although these leaves are never shed, they fray and shred over time, the desiccated strips often tangled or strewn across the parched ground. Nonetheless, they fulfil a vital role for the plant, which is able to harvest valuable moisture from morning dew via structures on the surface of the leaves.

ABOVE **After a bout of rainfall, the Namib Desert can burst into flower, with blooms appearing almost overnight. Many plants have an accelerated life cycle to take advantage of what are often very short-lived times of plenty, and herds of herbivores will quickly move into such areas to graze on the lush new vegetation.**

LEFT **Although not one of the botanical world's most beautiful representatives, Weltwitschia is certainly among the most curious. Restricted to Namibia and a small part of Angola, these ancient plants are pollinated by insects attracted by the nectar produced by the plant's small brown cones or strobili.**

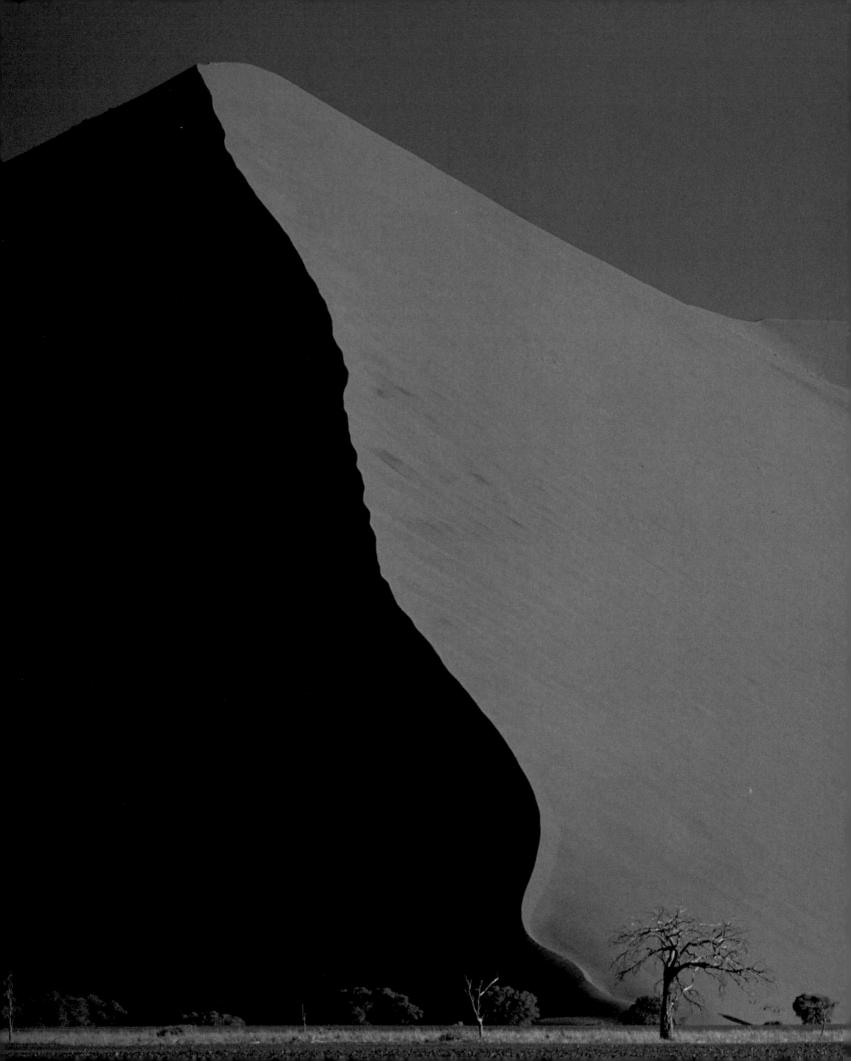

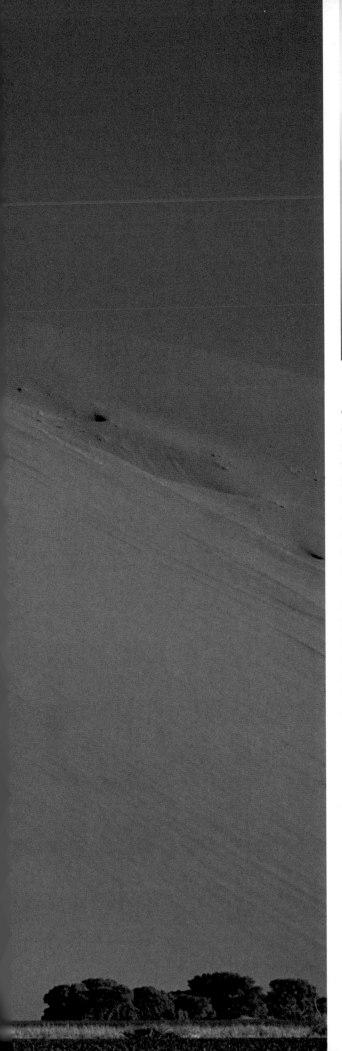

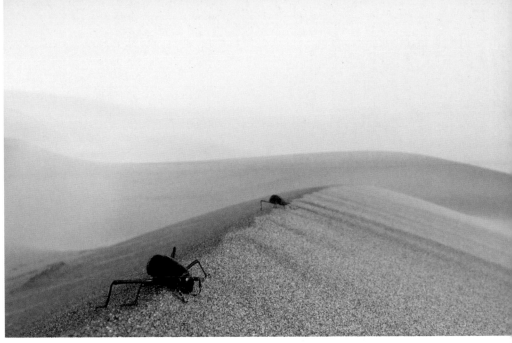

Although the Naukluft Mountains receive relatively generous rainfall in some years, much of the rest of the area is highly arid, with some coastal locations receiving only 5 millimetres ($^1/_5$ inch) of rain each year. The only reliable source of moisture in such areas is the fog that regularly blankets the desert during the night and early morning. Generated when hot air from the land interacts with the chilly marine conditions of the cold offshore Benguela Current, this fog can extend up to 100 kilometres (62 miles) inland. Many of the creatures living in the coastal fog belt have developed special adaptations to enable them to harvest the precipitated fog. When a sea breeze blows over, the Namib Desert Beetle *Onymacris unguicularis*, for example, turns into the wind and angles its body at 45 degrees. Water droplets slowly condense on its back and then trickle down towards its mouth parts, encouraged by the beetle performing a series of gyrations to help them on their way.

Undoubtedly the most famous – and much-photographed – section of the Namib-Naukluft is the area around Sesriem and Sossusvlei, where vast orange-coloured dunes soar up on the horizon, their ridges often whipped by the wind into elegant curves and razor-sharp edges. Scrambling to the top of the dunes is not for the faint-hearted; the highest are over 300 metres (985 feet) high and, although they give spectacular views, the ridges at the top can be as little as 20 centimetres (8 inches) wide. It is also in this area that two rivers – the Tsauchab and the Tsondab – end their futile attempt to get to the ocean from their headwaters to the east; they are simply swallowed up by the vast tracts of sand, ending their days in white pans supporting clusters of trees set in the heart of the dunes like a memorial.

LEFT The sand dunes at Sossusvlei are the highest in the world and Dune 45, shown here, is probably the most photographed. The dunes surround a salt pan, almost always dry but which occasionally fills with water after heavy rain. Despite the general lack of vegetation, the open dunes support a variety of insects and reptiles.

ABOVE The Namib Desert Beetle has evolved to take advantage of the desert fog. The beetle will lean into the wind and present its raised back, which has a bumpy surface. Droplets of water gather on the raised ridges and then trickle down the intervening groves towards the beetle's mouth, where it can then drink.

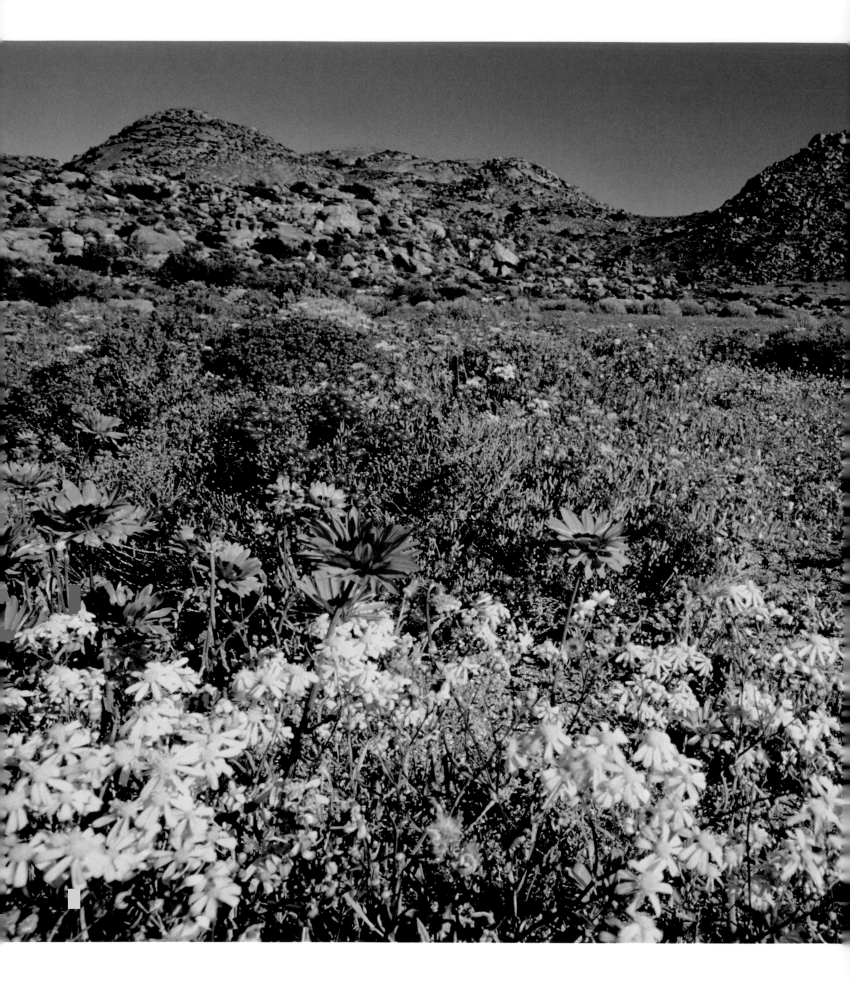

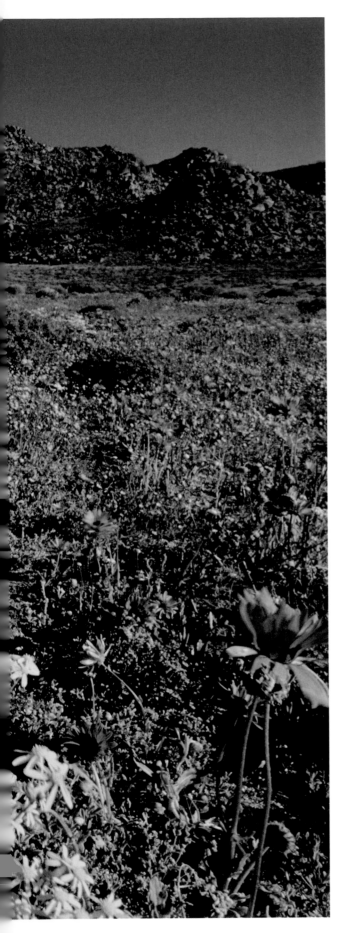

20: The Desert Blooms of Namaqualand

Tucked into the north-west corner of South Africa's Cape Province, Namaqualand is overwhelmingly arid and, for much of the year, seemingly barren. Yet every August and September this area erupts into one of the greatest displays of wildflowers seen anywhere on the planet, when the apparently lifeless semi-desert landscape becomes carpeted in a blaze of brightly coloured flowers. Millions of plants flower simultaneously, stretching towards the horizon in swathes of yellows, oranges, purples and pinks. This spectacular if brief display is not the region's only botanical offering; almost 40 per cent of the world's succulent plant species are found in South Africa, most of them in this region. Overall, Namaqualand's wealth of flora is so important that, along with the Southern Karoo, a semi-desert shrubland that extends over much of the central and western Cape, it is considered to be one of the world's biodiversity "hotspots".

Collectively named the Succulent Karoo and covering some 102,000 square kilometres (39,380 square miles), these two closely related areas are among the very few arid ecosystems to earn hotspot status and are home to over 6,000 vascular plant species, 40 per cent of which are endemic. Not surprisingly, the range of plants is hugely diverse, but they share one key feature – the ability to withstand long periods of drought. Some species, most notably the succulents, do this through maximizing water storage in their roots, stems and leaves. Others, such as the seasonal bulbs and annuals that bring the desert alive with colour every spring, have the ability to lie dormant for much of the year before bursting into life when conditions become suitable. Their life cycle is necessarily rapid – they can germinate, grow, flower and set seed all within a period of eight weeks or so. The seeds then lie dormant in the soil until the next season's rains.

LEFT Even to old hands who have witnessed many seasons in Namaqualand, the annual flowering of the desert cannot fail to inspire. The sheer density and radiance of colour can be quite bewildering, especially given the stark and apparently sterile appearance of the landscape just a few weeks before.

BELOW A dirt road leads through flowering daisies in the Goegap Nature Reserve. The precise extent and quality of the dramatic "show" varies from year to year, and how long it lasts is equally dependent on the weather.

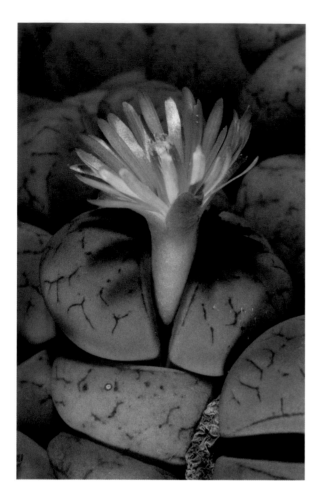

ABOVE **Desert miracles seem commonplace in Namaqualand. If the sudden flowering of hitherto arid tracts were not enough, the blooming of bizarre *Lithops* stone plants is even more curious. The sealed "leaves" have invisible windows that let light in, rather like an eyeball does, but no moisture is allowed to escape.**

Namaqualand is an example of a winter rainfall desert, its climate heavily influenced by the cold Atlantic Ocean currents offshore and with almost all of its precipitation falling in the months of June and July. Even so, annual rainfall totals are low, rarely exceeding 200 millimetres (8 inches) per annum and in some places barely reaching half this amount. There are several distinct landscape and habitat types in Namaqualand; these range from the very arid Richtersveld in the north, a mountainous area that is especially noted for succulents and is now part of an ambitious transfrontier national park shared with neighbouring Namibia, through the uplands and "Klipkoppe" of central Namaqualand, the location for most dramatic springtime displays of annuals and bulbous plants, to the Knersvlakte with its quartz pebble fields and enigmatic dwarf succulents (notably the so-called "stone plants") and finally to the coastal plain, where slightly wetter conditions sustain a more shrub-like vegetation.

The Namaqualand landscape is therefore essentially one of stark, stony plains and rolling hills, with very few tall shrubs and trees, fiercely hot in summer and further desiccated by the strong winds that often sweep across the region. Thinly populated in human terms and decidedly remote in atmosphere, this apparently unpromising environment makes the dramatic springtime transformation even more remarkable. At this season waves of wildflowers carpet the landscape, the most celebrated probably being the Namaqualand daisies *Dimorphotheca* spp., yellow-, orange- and white-flowered annuals that are popularly known as "the stars of the veld" and also as Osteospermums, although the latter term is now used for perennial species only. Also prominent are Kingfisher Daisy *Felicia bergerana* and several species of *Gazania* (notably *G. krebsiana*), as well as the golden spikes of Yellow Bulbinella *Bulbinella floribunda* contrasting with the azure swathes of Sunflax *Heliophila coronopifolia* and the pinks and reds of *Pelargonium* spp., although the precise mix of species varies between location and with each year. The best displays follow a relatively even fall of rain over several days, rather than one or two cataclysmic downpours, but local observers will never lose an opportunity to explain to visitors how no two years are ever the same.

Namaqualand's huge range of succulents includes species of *Crassula*, *Conophytum* and *Drosanthemum*, among others, but the region is especially notable for its dwarf and contracted leaf succulents, including the bizarre "stone plants", *Lithops* spp. These extraordinary plants closely resemble pebbles, a form of mimicry which it is assumed is designed to help avoid their being eaten by grazing animals. Their compact form is created by the virtual fusion of their pair of leaves, with the flower stem emerging from the central fissure between the two. Almost the entire plant is designed to conserve water.

Among the larger plants notable species include the distinctive Quiver Tree or Kokerboom *Aloe dichotma* and Bastard Quiver Tree *A. pillansii*, as well as the Butter Tree or Botterboom *Tylecodon paniculatus*, a stem succulent with glossy leaves in winter and reddish-orange tubular-shaped flowers in summer. The reference to butter in its name comes from its distinctive peeling, yellow bark. Particularly intriguing is the Halfmens ("semi-human") or Elephant's Trunk *Pachypodium namaquanum*, an endemic stem succulent found in the Richtersveld and which can grow up to 4 metres (13 feet) tall. Clusters of Halfmens stems tend to face toward the north, giving the appearance of groups of people gazing northwards. The impression is enhanced by the fact that each stem carries a crown of leaves, giving more than a passing resemblance to hairy human heads. The scientific explanation for their unusual orientation is that the plants, which usually grow on shaded sloping terrain, lean northwards in order to ensure that their leaves and developing flowerheads, produced during the cool, foggy winter months, are maximally exposed to the sun's warming rays.

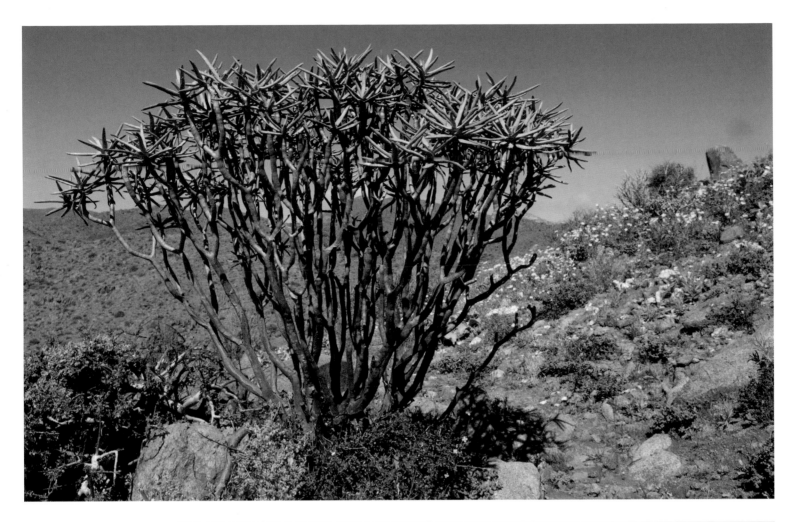

ABOVE **Quiver Trees (Kokerboom)** were so named in 1685 by Simon de Stel, the governor of the Cape, because their bark and branches were used by indigenous people to make quivers for their arrows. Nectar-rich yellow flowers bloom in June and July and attract large numbers of bees and birds, as well as baboons.

RIGHT The curious **Halfmens** is particularly revered by the Nama people as the embodiment of their ancestors, half human, half plant, mourning for their ancient Namibian home. The bottle-shaped trunk helps with water storage and is reflected in the generic name *Pachypodium*, from the Greek words for "thick foot".

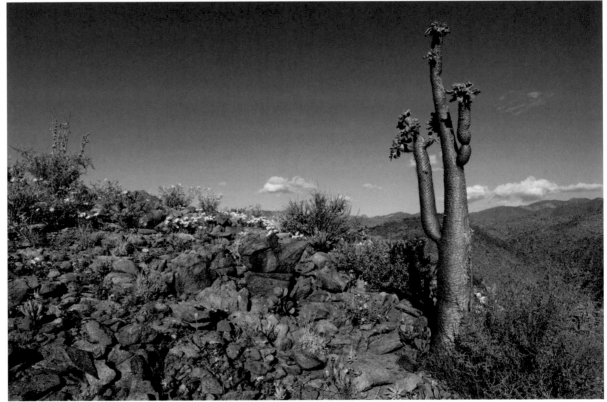

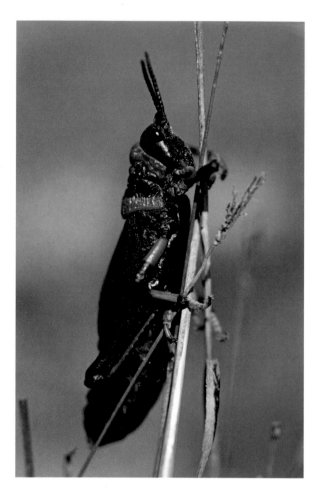

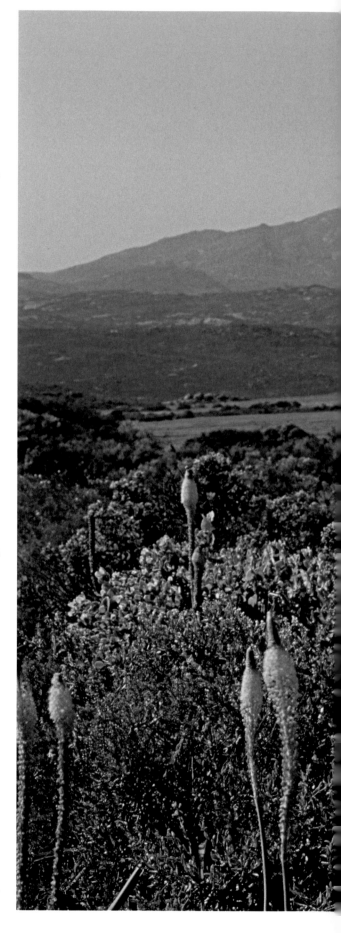

LEFT The rush of new vegetation following the rains is a boon for invertebrates, such as this grasshopper *Zonocerus elegans*. Many species of insect emerge for just a short period in spring and early summer, with bees and wasps fulfilling their vital role as pollinators. Certain species of fly pollinate over 20 different species of iris and pelargonium, for example.

RIGHT Skilpad Flower Reserve can claim some of the most dramatic spring flower displays anywhere, with vibrant swathes of colour enlivening the landscape and almost resembling molten lava in their intensity. The fine display of *Bulbinella* sp. blooms in the foreground is typical of the season.

One of the most reliable sites for a dazzling display of spring flowers is the former Skilpad Wildflower Reserve, now part of the Namaqua National Park, which was declared in 1999. The park covers over 700 square kilometres (270 square miles) and some of the best flowering displays occur on what are former wheat fields. The huge variety of blooms attract millions of insects, some of which are the sole pollinators of particular plant species and have evolved precisely to fulfil this function. The perpetuation of such delicate ecological choreography calls for very particular refinements. Among these are the long-tongued flies of the genus *Philoliche*, which have developed mouthparts up to 50 millimetres (2 inches) long that enable them to penetrate the tubular flowers of certain species of Geraniaceae and Iridaceae. Monkey beetles (Rutelinae) are also an important group, largely endemic to southern Africa and important pollinators of daisies.

Birdlife in the Succulent Karoo totals over 220 species, one of which – Barlow's Lark *Certhilauda barlowi* – appears to be endemic to the ecoregion and was only relatively recently split from another species (Dune Lark *Certhilauda erythrochlamys*). Two species of bustard, Karoo *Eupodotis vigorsii*) and Ludwig's *Neotis ludwigii*, have important local populations, as does the handsome and generally scarce Black Harrier *Circus maurus*, which can with luck be seen flapping lazily over the plains.

Although almost 80 species of mammal have been recorded in the region, this is not a part of South Africa in which classic big game viewing should be anticipated. Although species such as Black Rhinoceros *Diceros bicornis* were once present, they were hunted to local extinction long ago and the largest mammals likely to be spotted today are grazers such as Bontebok *Damaliscus pygargus* and Springbok *Antidorcas marsupialis*. Smaller mammals include two notable endemics, De Winton's Golden Mole *Cryptochloris wintoni* and Namaqua Dune Mole Rat *Bathyergus janetta*, neither of which is likely to be seen by the casual visitor.

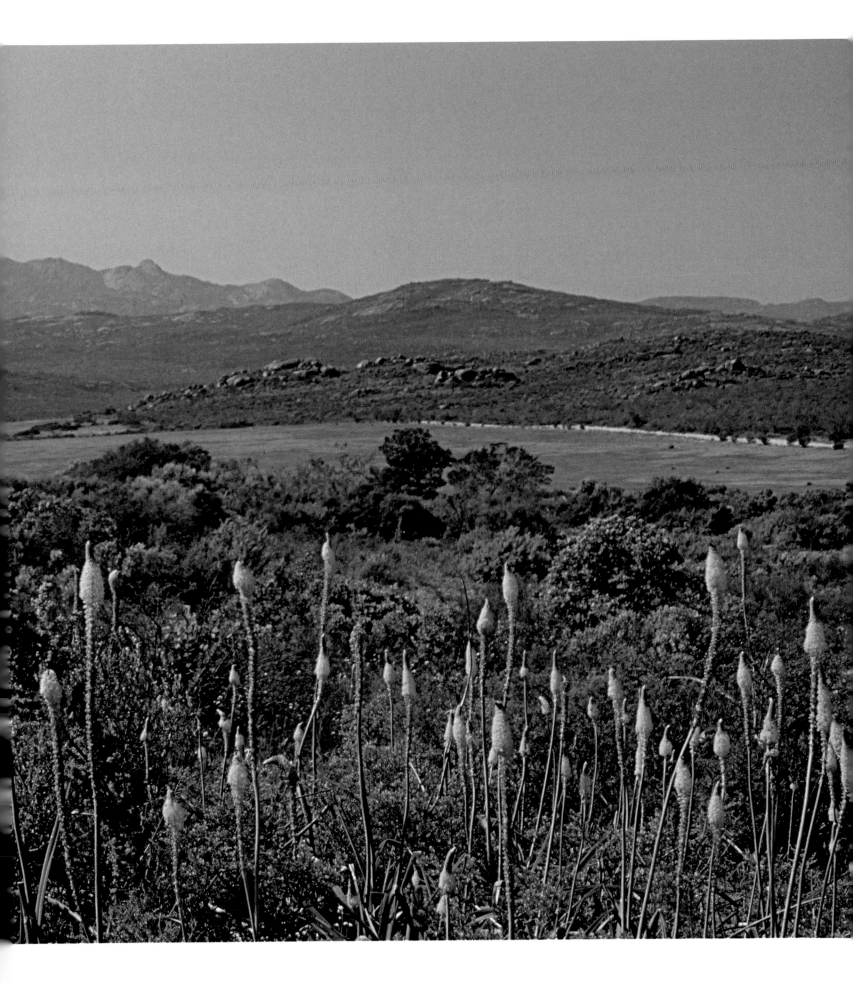

Rocky outcrops or kopjes are often home to Rock Hyrax *Procavia capensis*. More usually known in South Africa as dassies, these guinea pig-like animals live in herds of up to 60 animals, usually dispersed into associated smaller family groups, each with its own territory. Dominant males usually position themselves on a prominent lookout, keeping watch over their charges and giving a shrill alarm call when they perceive a potential threat. Hyrax are well equipped for life in arid, rocky terrain; a slow metabolism enables them to survive on meagre grasses that are low in nutritional value, and also explains why during the first half of the morning they are often seen huddled together in groups, sunbathing – like reptiles, they need to warm up before they can start their day.

Hyrax feet have rubbery pads containing glands that exude sweat when the animal is running, which helps with traction, and they are also able to retract part of the underside of each foot, thereby obtaining additional grip. However, they are relatively inactive animals, and usually just sit about or graze quietly on grassy ledges and slopes. Only when a predator appears will they burst into action and flee to safety, disappearing either underground or between rocks. Hyrax do not dig their own burrows, instead using natural crevices and cavities or those made by other animals. While snakes, jackals and hyenas will all take Hyraxes, their greatest predator is Verreaux's Eagle *Aquila verreauxii*, which feeds exclusively on them.

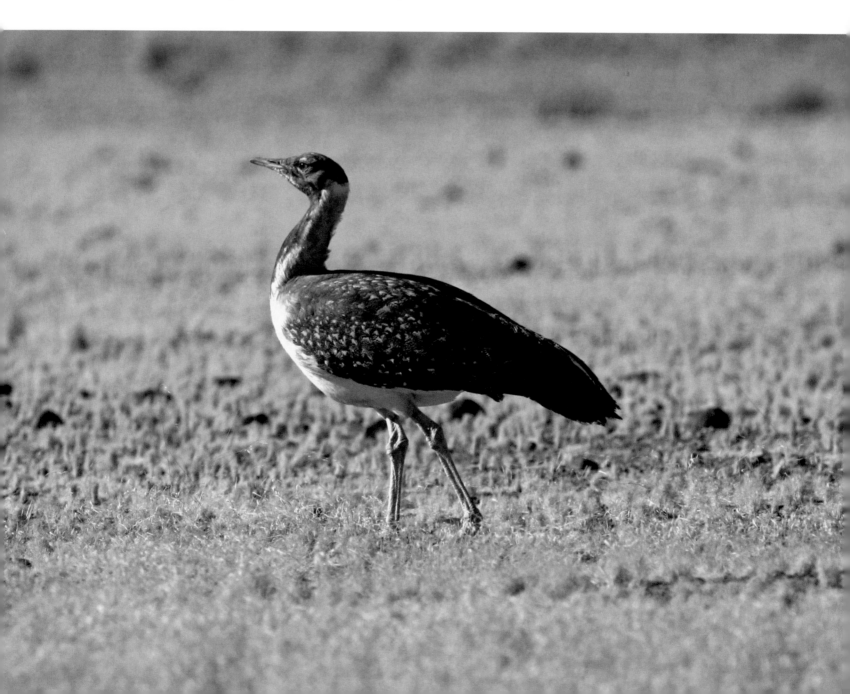

Kopjes are also the preferred habitat of one of the most engaging of all African antelopes, the Klipspringer *Oreotragus oreotragus*. Found in suitable habitat across most of eastern and southern Africa, this highly specialized animal moves with ease over terrain that would defeat most other mammals. It has several adaptations that enable it to cope with life on what can be virtually sheer rockfaces and the narrowest of ledges. Its arched back enables it to stand with all four feet on the ground in a very confined space, for example. Powerful hindquarters enable it to launch itself across gullies, and its surefootedness is assisted by hooves that are peg-shaped, giving it the required purchase; they also have a central rubbery pad that helps grip the rock. When a Klipspringer lands after a jump, it does so on all four feet and when walking it has a rather stilted, "on tip-toe" style of gait.

Klipspringers usually live in a closely bonded pair and are almost invariably seen together. They are highly territorial, marking their domain regularly with the orbital scent glands located near their eyes and usually staying within the same small area for their entire adult lives, if left unmolested. Always alert to danger, the first sign of their presence is often their distinctive whistling, frequently uttered by both sexes simultaneously and even in duet.

Namaqualand is an important location for reptiles. Over 90 species have been recorded here, with at least 15 being endemic, mostly lizards and geckos. Highlights include Armadillo Girdled Lizard *Cordylus cataphractus*, an armour-plated creature which, when threatened, rolls itself into a tightly coiled and seemingly impregnable bracelet. Tortoises are well represented here, with the several species recorded including two endemics – the Namaqualand Speckled Padloper *Homopus signatus*, the world's smallest tortoise with males seldom exceeding 7 centimetres (3 inches) in length and 70 grams ($2^{2}/_{5}$ ounces) in weight, and Namaqualand Tent Tortoise *Psammobates*

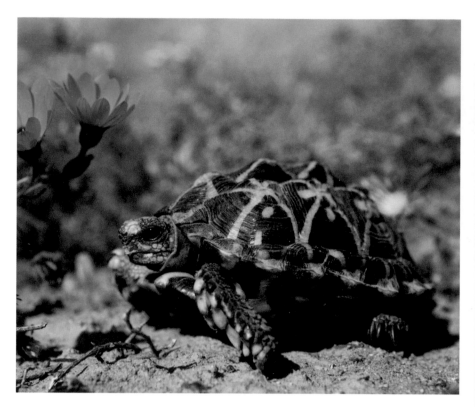

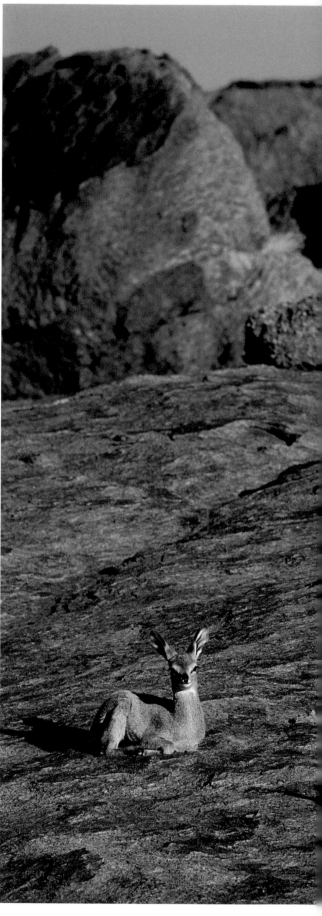

tentorius trimeni. Both exist largely on succulents, and the tent tortoise is able to take the fullest advantage of wet weather by extending its hind limbs and raising the rear end of its shell, so that rainfall collects on it and is channelled along the grooves towards its forelegs, from which it can drink.

Despite the ecological importance of Namaqualand and the Succulent Karoo, only a small fraction of this hugely important area is protected. Much of the land is seriously overgrazed by sheep and goats, an attritional pressure that is having a severe impact on the flora and causing landscape degradation and soil erosion in some areas. With little or no opportunity to recover from intensive grazing, some species of plant are declining and the spectacular springtime displays are becoming less diverse and smaller in extent. There are also problems arising from the illegal harvesting of plants for horticulture and private collections, the widespread use of pesticides on farmland, and the impact of mining (particularly for diamonds), the main industrial activity in the area. Unmanaged tourism can also be an issue away from protected sites – uncontrolled off-road driving can spell disaster for delicate plantlife, for example, and cause damage that can take decades to repair.

ABOVE The Namaqualand Tent Tortoise is vulnerable to natural predators such as baboons, as well as to bush fires, agricultural expansion and illegal collection for the pet trade. Its English name comes from the tent-like projections on its shell.

RIGHT Two Klipspringers in classic habitat. They can move swiftly over seemingly impossible rocky terrain and are notable for their very dense and coarse coat, which is composed of hollow hairs and makes a distinct rustling sound when shaken or touched. Only male Klipspringers have horns.

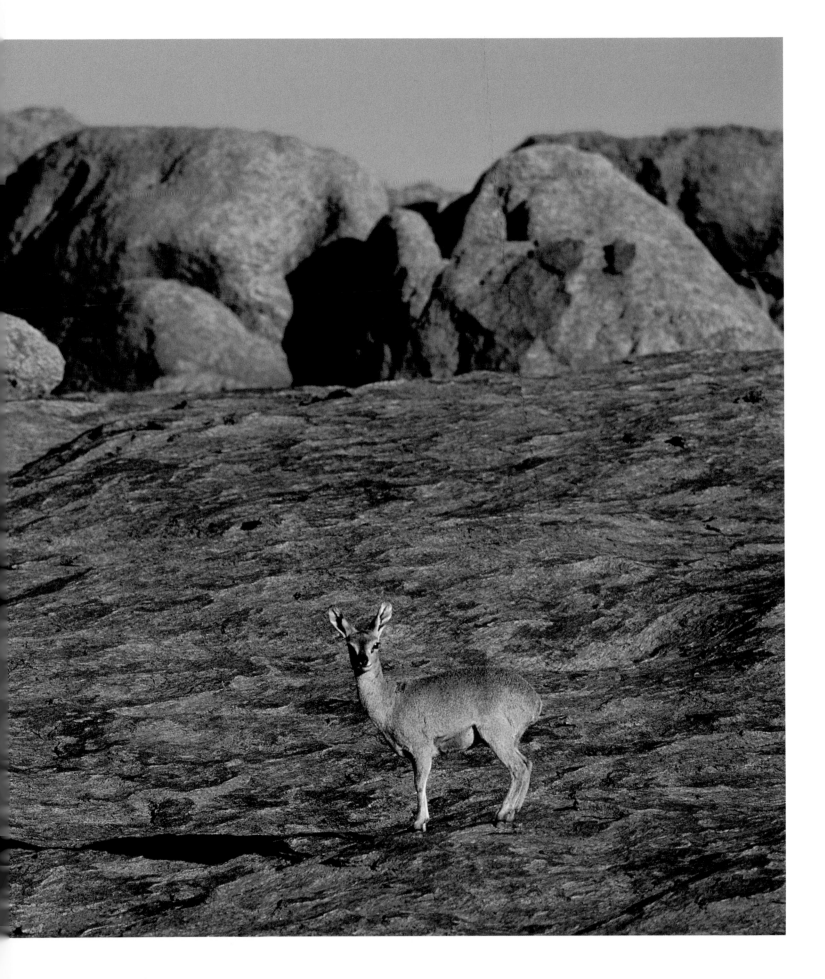

THE FUTURE OF DESERTS AND THEIR WILDLIFE

The twentieth century was kind neither to deserts nor to their wildlife. In 1900 the world's arid regions still mostly ranked among the great wilderness areas, but by the 1950s almost all had been opened up to various forms of human exploitation. The proliferation of motorized transportation and other technology, together with the rapidly rising demand for scarce natural resources, helped ensure that even the most remote regions became accessible. For example, drilling for oil soon changed the face of Arabia forever, and the peninsula's once rich wildlife went into rapid retreat. Tracts of pristine desert were despoiled and compromised by the installation of the hardware required for the region's burgeoning oil industry, and the rapid rise in living standards and disposable income saw an end to the old and generally sustainable way of life that Arabia's human population had traditionally followed. In its place came a modern and increasingly ostentatious mode of living characterized by a massive increase in the consumption of resources and a desire to create a more urban society free of what were perceived to be the poverty and hardship of the desert. From being the focal point of human existence, the desert became increasingly irrelevant, more of an inconvenience.

This, then, lies at the heart of the pressures facing modern deserts. They have become undervalued, problem landscapes – especially in countries where wealth has brought modernization and an end to the "old" ways. In such situations they are increasingly regarded as wastelands, arid and unproductive, fit only for improvement through carpet irrigation or for exploitation of the minerals that may lie beneath their sand and rock. Such wildlife as remains is vulnerable to similar desecration, with sensitive habitats degraded and destroyed, and the animals, birds, plants and other creatures that rely on them placed under such intense pressure that even the toughest struggle to hold their own and the more vulnerable disappear completely. The balance between man and the desert environment, always a delicate one, became increasingly skewed and the sensitive character of many dryland habitats was compromised or destroyed entirely. In many places this process still continues.

Human population pressure is perhaps the single biggest issue facing the planet today, and nowhere more so than in deserts. More people than ever before are dependent for their livelihood on the world's arid lands, and their exploitation of the scant resources is running well above sustainable levels. Overgrazing is a particular problem, with excessive numbers of domestic livestock stripping away native vegetation and contributing directly to desertification. In any case, the presence of large numbers of livestock in desert areas raises a host of problems, ranging from interbreeding with endangered wild species (e.g. the Wild Bactrian Camel in Mongolia/Tibet, which is threatened genetically by cross-breeding with free-ranging domestic camels) to outcompeting indigenous herbivores such as gazelles, which are forced to move to other, often more marginal, grazing lands.

RIGHT The exploitation of desert resources continues to bring dramatic change to previously remote landscapes. Oil and gas production have transformed large areas of desert in the Middle East in particular, as here in Saudi Arabia, seemingly overnight.

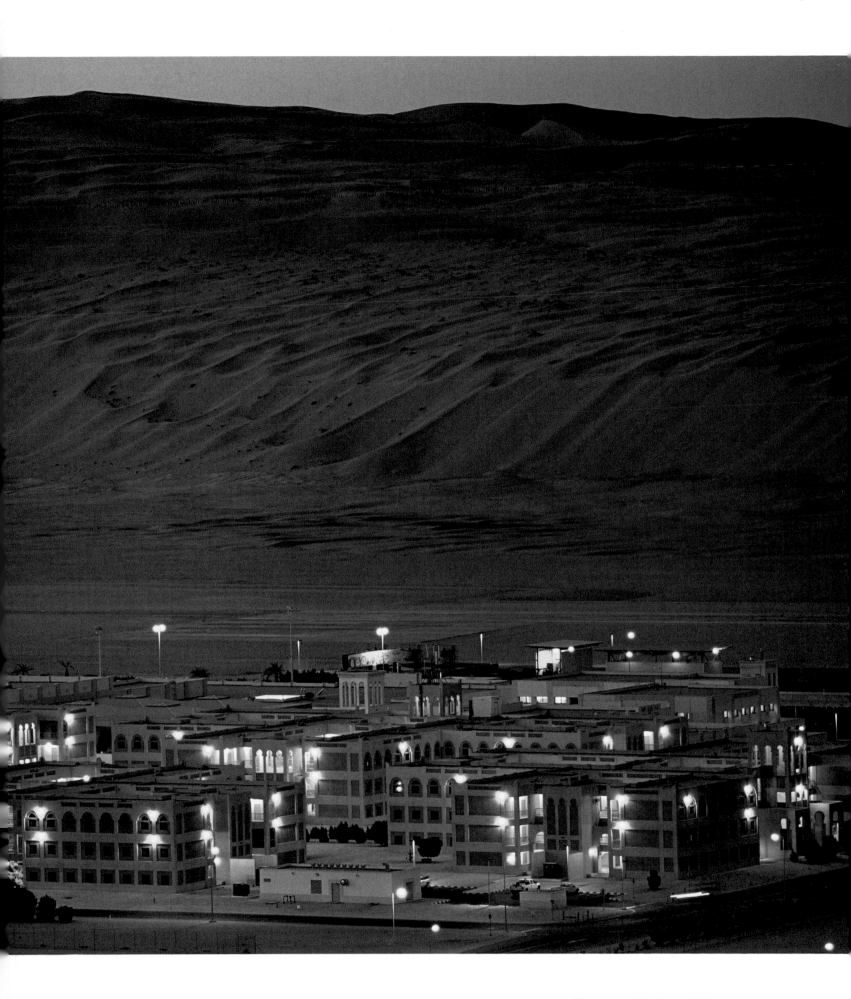

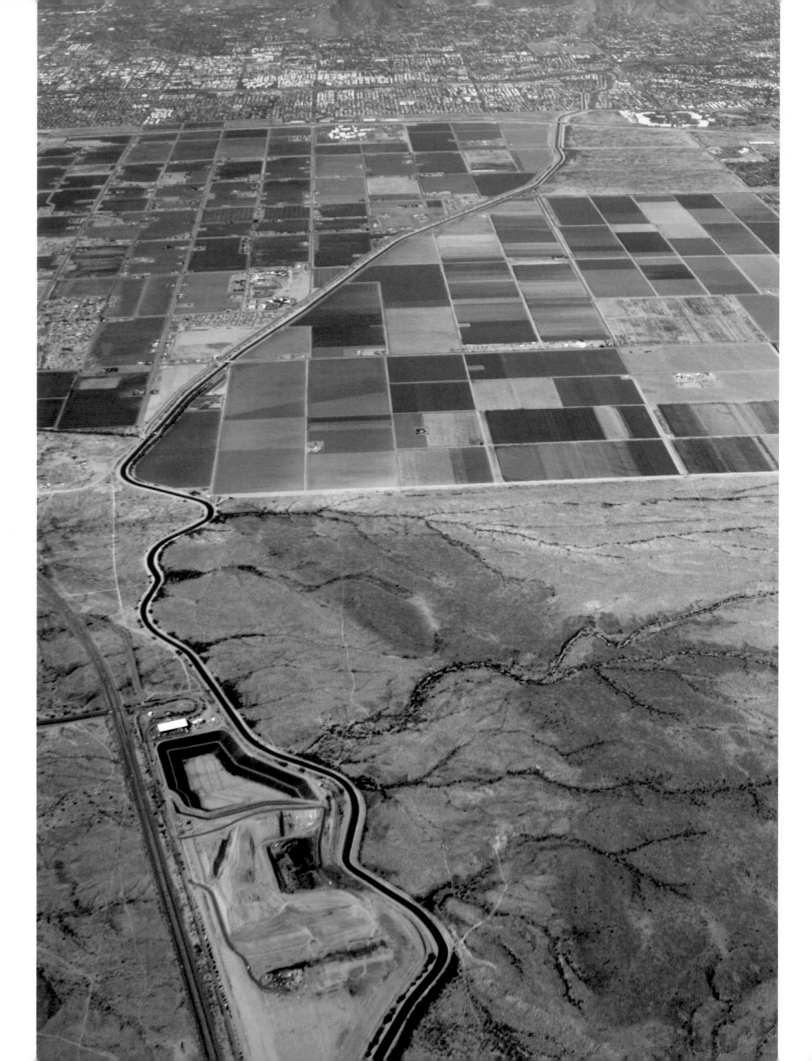

Expanding urban centres such as Phoenix, Arizona place particular pressure on deserts. Already scarce water resources are diverted for domestic, recreational and agricultural use, and areas of desert on the urban fringe often become fragmented and their wildlife populations fragmented.

The human demand for firewood is also a major contributory factor to environmental deterioration within deserts. In parts of the Sahel, for example, large areas have been effectively cleared of their trees and larger shrubs by local people for whom wood is often the only affordable or readily accessible means of fuel for cooking. Once exposed, the soils there become fragile and soon deteriorate and erode. Seeds cannot germinate in such impoverished and unstable conditions, and so it is impossible for the vegetation to regenerate. Local people are therefore faced with relocation to new areas that still retain adequate resources to support them but which they will in turn deplete.

Deserts have long been affected by human land use patterns, but this process has accelerated and intensified in line with man's increasing ability to bring about medium- to long-term change through processes such as artificial irrigation. The "reclaiming" or "greening" of the desert – still regarded in many quarters as a highly laudable and necessary development – has had a negative effect on desert habitats in many countries, especially those within the oil-rich countries of the Arabian Gulf. The resulting agricultural land can indeed produce high crop yields but the investment costs are huge and the environmental implications little understood and often ignored. Meanwhile the greening of deserts is, in many parts of the world, associated with increasing urbanization and the spread of urban centres into desert areas. The expansion of cities such as Phoenix in Arizona, USA, is a classic example of where a burgeoning city has impinged directly on the desert and its habitats. The range of threats is wide, from loss of desert habitat to housing plots through the depletion of underground aquifers for irrigation of gardens and parks to the cutting of roads through sensitive habitats and the illegal removal of natural features such as mature Saguaro cacti for landscaping.

RIGHT Once common across the deserts of North Africa, Arabia and Central Asia, thanks to overhunting the Houbara Bustard is now locally extinct in many of its former haunts. Captive breeding programmes are helping to reintroduce the birds to the wild.

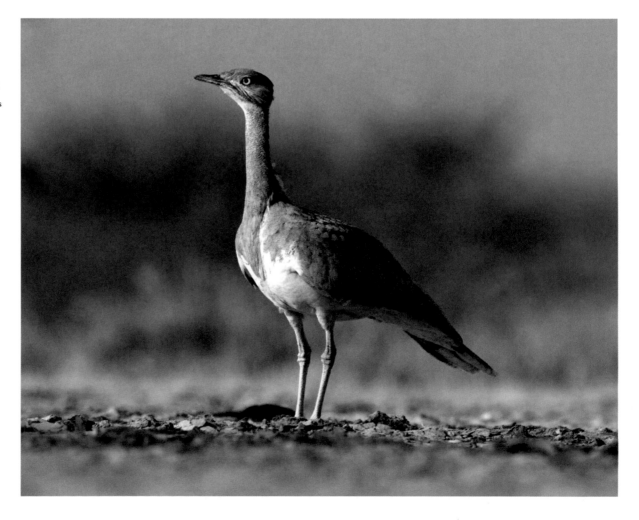

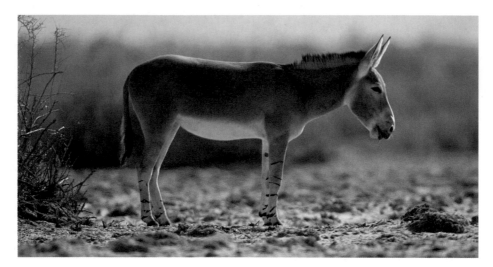

LEFT Probably the world's rarest wild equid, the Somali Wild Ass *Equus africanus somaliensis* is fast moving towards extinction; only a few hundred survive across the deserts of Ethiopia and Somalia. Vulnerable to hunters, they also have to compete with domestic livestock for grazing and water.

All these factors have a negative impact on desert wildlife. This is to say nothing of the effects on the desert's traditional human inhabitants, many of whom are nomadic pastoralists living on the very brink of viability. With nomadic peoples worldwide under a host of pressures, not least politically motivated efforts by some governments to "settle" them in approved areas, the plight of desert peoples has taken on an increasingly political dimension. Man's ancient traditional relationship with the desert environment seems ever more lost against the contemporary backdrop of fiercely contested debates over water resources, hunting laws and the right to even occupy a tract of desert.

However, there are signs of hope that our attitude to deserts, their people and wildlife may be changing. Leading conservation organizations have finally woken up to the fact that these are rich and unique ecosystems, as worthy of protection as the most biodiverse rainforest. Yet international attention is only one part of the equation; unless local people themselves, many already estranged from an environment that was home to their parents and/or grandparents, are reconnected with the desert and begin to view it as something worth preserving and enhancing, then frontline conservation efforts will not succeed. Hearteningly, they are now doing so in desert countries as varied as Jordan, Namibia and Mongolia, a process which we can hope is only just beginning. A renewed appreciation of desert wildlife is the hallmark of the nascent conservation organizations in these countries; one need only look at the use of the Arabian Oryx as an icon in that particular region to understand the potential strength of the desert wildlife "brand".

Although increasing population pressure is going to make it ever harder to secure sustainable solutions, it is imperative that people living in arid and semi-arid environments are helped to develop sustainable methods of managing their environment. These can include a range of options, including the use of modern technologies to relieve direct pressure on natural resources. In some desert locations small-scale solar panels – cheap to produce, install and maintain – are proving a popular method of providing energy for remote desert peoples, who are then able to reduce their "take" of the local vegetation. In many countries, sustainable forms of tourism in desert areas are already providing alternative livelihoods for local people whose traditional ways of life may have become impossible to follow. There are other potential opportunities too – for example, the potential use of desert plants by the pharmaceutical industry is an area barely yet understood or explored by modern science.

The next two decades will most likely mark a watershed in the nature of man's relationship with the deserts of the world. We have the knowledge and technology to halt our plunder of the deserts and their resources, but it is not yet clear that we have the will to do so. Captive breeding programmes are successfully saving many of the flagship desert animals, but unless more effort is made to safeguard the remaining wild habitat, the majority of them will be destined to spend their lives in captivity. Looking after wild arid areas – and keeping them truly wild – will be a major challenge for those responsible for the stewardship of a landscape that covers almost one-third of the world's land area.

OPPOSITE An Aloe Tree in the Ai-Ais/Richtersveld Transfrontier Park, an international peace park that straddles the political border between Namibia and South Africa. Such initiatives are likely to play an increasingly important role in desert conservation.

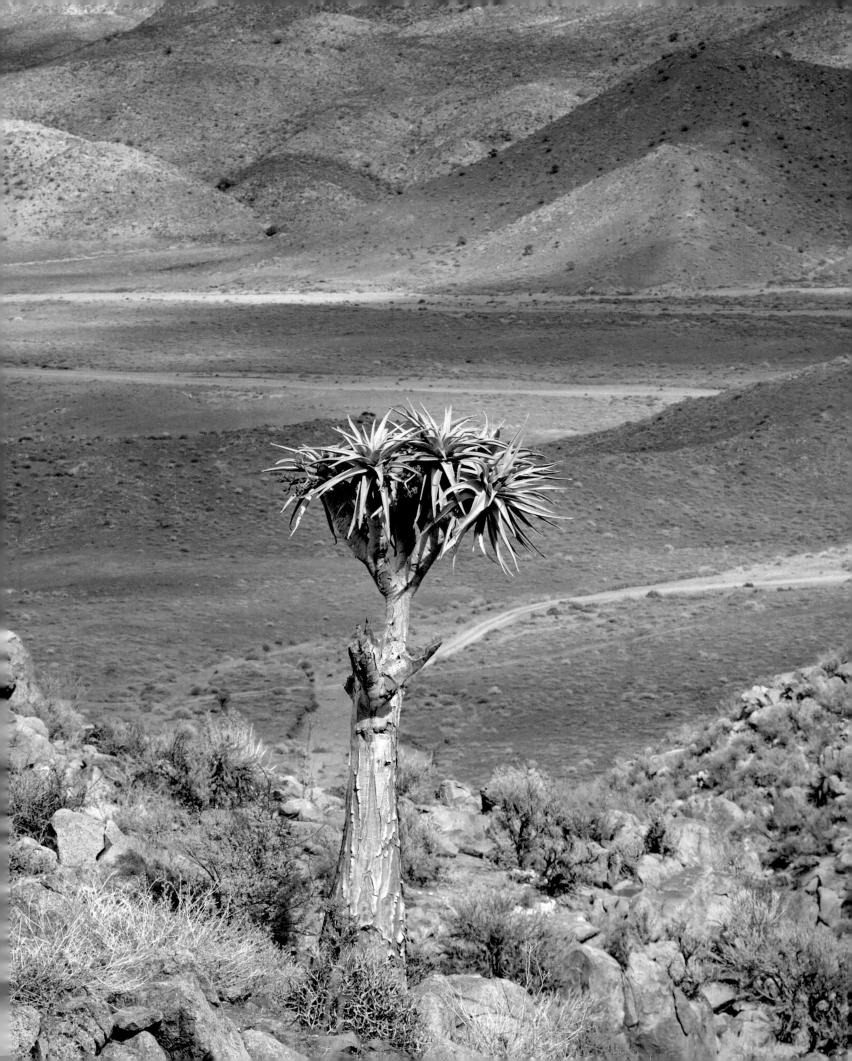

GLOSSARY

Alluvial fan – Fan-shaped, gently sloping mass of alluvium deposited by a stream where it issues on to a plain.

Amphibian – Class of animal, including frogs, toads, newts and salamanders, that spends part of its life on land and part in water.

Biodiversity – Short for biological diversity, refers to the wealth of a particular region or habitat in terms of the number of species to be found there.

Chelonian – The shield reptiles, a group comprising tortoises, turtles and terrapins.

CITES – Convention on International Trade in Endangered Species of Wild Fauna and Flora (www.cites.org). Its aim is to ensure that international trade in specimens of wild animals and plants does not threaten their survival. Roughly 5,000 species of animal and 28,000 species of plant are protected by CITES against overexploitation through international trade.

Ecosystem – Network of interacting elements, both living and non-living, that work together to make a balanced system.

Ecotourism – Sustainable travel that has minimal impact on the host environment and is designed to help build cultural and environmental awareness. Where possible provides a positive experience for both visitor and host.

Endemic – Species that is restricted to a specific geographical area or habitat.

Feral – Having escaped from domestication and returned to the wild state.

Gondwanaland – Hypothetical supercontinent of the southern hemisphere which, according to the theory of plate tectonics, broke up into India, Australia, Antarctica, Africa and South America.

Herbivore – Animal that feeds solely on plants.

Hybridization – The mixing of different species of animals or plants.

Indigenous – Native (or local) to a particular geographical area or habitat.

Invertebrate – Animal without a backbone.

Karoo – Semi-arid plateau in southern Africa.

Marsupial – Mammal of the order *Marsupialia*, including kangaroos and wombats, in which the young are born prematurely and not completely undeveloped and are reared through infancy in a pouch on the mother's belly.

Monsoon – Seasonal, heavy rains carried by high winds from the Indian Ocean, mainly over south Asia. The typical monsoon period is from mid-July to the end of September.

Passerine – Birds belonging to the *Passeriformes* group, which are characterized by their perching habit.

Pelage – The hair, fur or wool coat of an animal, as distinct from the bare skin.

Rain shadow – Dry area on the lee side of a mountain or ridge. As warm, moist air is drawn by the prevailing winds over high ground it condenses and falls as rain. The dry air then moves forwards, leaving a "rain shadow" on the lee side.

Raptor – Bird of prey, such an eagle, falcon, hawk or owl. The word comes from a Latin root, meaning "to seize and carry away".

Relict – Organism or species that has survived an earlier period in an environment that has undergone considerable change.

Riparian (Riverine) forest – Forest that grows along the banks of rivers and other watercourses.

Salinization – Process in which salts build up at or near the surface of the soil, to a level that is harmful to crops. It occurs naturally in deserts but can be exacerbated by incorrect use of irrigation.

Steppe – Vast, semi-arid, grass-covered, treeless plain.

Ungulate – Animal with hooves.

RESOURCES

Travelling to and through the world's arid lands can be an arduous and expensive business but it invariably proves to be a worthwhile experience. All of the deserts covered in this book can be visited, some more easily than others, with the more remote of them truly representing the world's last frontiers. A great variety of tour operators and travel companies, both specialist and otherwise, offer guided visits to desert regions across the continents. It is worth looking carefully at particular itineraries to assess how long you will actually be staying in the desert, and in what sort of conditions. The more interesting locations tend to be the more remote, often taking several days to reach, and where accommodation options may be severely limited. Pre-trip research is invaluable in deciding where you should go, especially if you have particular interests – be sure to scrutinize the trip dossiers and tour reports. As with anywhere, watching wildlife in the desert can be very hit-and-miss; many desert creatures are notoriously elusive and it may take several days to locate target species – if they are found at all.

Deserts are highly fragile environments and it is important that when considering joining an organised tour you look into the precise mechanics of how the tour works. Ecotourism and wildlife-interest travel can make a real difference to desert locations and the people who live there, but only if the required infrastructure is sustainable and carefully assessed in terms of impact. Some deserts can also be visited independently, although in such cases it is always worth employing the services of a local guide. This not only helps to reinforce the economic value of the desert and its wildlife on a direct level to those that matter most, but should also help ensure that you get to see more and develop a greater understanding of where you are and what you are looking at.

On a broader level, the following websites provide valuable background, both general and specific, on deserts, their habitats, wildlife and conservation.

The United Nations Environment Programme's World Conservation Monitoring Centre website contains useful information on a vast range of subjects, from climate change through biodiversity to accounts of individual species and conservation legislation. The sections on different types of desert habitat are especially interesting – www.unep-wcmc.org.

Some of the deserts in this book are listed as World Heritage Sites, and more information about them, and about what WHS status means, is available at **http://whc.unesco.org.**

There are now more organisations dedicated to the protection and conservation of wildlife and habitats than at any point in human history, and many of them are involved with deserts in some way. The biggest players include the following:

Birdlife International **www.birdlife.org**

Fauna & Flora International **www.fauna-flora.org**

The Nature Conservancy **www.nature.org**

The Wildlife Conservation Society **www.wcs.org**

The World Conservation Union **www.iucn.org**

The World Wide Fund for Nature **www.panda.org**

Organizations focused more on the state of the environment *per se*, which inevitably includes campaigns and projects related to deserts and desertification, include:

Friends of the Earth **www.foe.org**

Greenpeace **www.greenpeace.org./international**

People & the Planet **www.peopleandplanet.net**

Excellent information on the arid lands that rank among the world's top locations in terms of biodiversity can be found at **www.biodiversityhotpots.org**

The Earthwatch Institute supports and funds scientific research into a range of habitats, including deserts: **www.earthwatch.org**

Organizations or websites with a specific emphasis on deserts or on sites included in this book include **www.saharaconservation.org** and **www.conservationfund.org**

INDEX

Page numbers in *italic* refer to illustrations.

ACKNOWLEDGEMENTS

PICTURE CREDITS

The publishers would like to thank the following sources for their kind permission to reproduce the pictures in this book.

Key, t: top, b: bottom, l: left, r: right, c: centre

Africa Image Library: /Ariadne Van Zandbergen: 238

Alamy Images: 73, /Danita Delimont: 214, /Don Fuchs: 78, /Christian Heeb: 158–9, /Ted Mead: 82–83, /John Warburton-Lee: 6–7

Carlton Ward Photography: 186–7, 195

Christian Walzer: 123 b

Corbis: 244, /Theo Allofs: 67 t, /Caren Firouz: 123 t, /Patricia Fogden: 234–5, /Martin Harvey: 232, /Frans Lanting: 230–1, 231, /Steve Parish: 74–75, /Kevin Schafer: 198, /Scott Smith: 28, 151, /Scott T Smith: 154, /Frédéric Soltan: 61, /George Steinmetz: 115, 140–1, /Jake Wall: 194

David Murdoch: 14, 101, 102

FLPA: /Bill Baston: 90, 127, /Fred Bavendam: 70, /Neil Bowman: 55 b, 57, 69, 80, 81, /Jim Brandenburg: 218, 4–5, /Robin Chittenden: 89 bl, 113 t, /William S. Clark: 93 b, /Carr Clifton: 147, 256, 138–9, 156–7, /Wendy Dennis: 229, /Richard Du Toit: 226, 206–7, 238–9, /Gerry Ellis: 133, 172, /Yossi Eshbol: 26 t, 89 br, 122, /Guenter Fischer: 10–11, /Tim Fitzharris: 156 b, 164, 167 t, 167 b, 164–5, /Michael & Patricia Fogden: 62, 224–5, /Michael Gore: 236, /David Hosking: 26 b, 52, 94, 97, 163, 222, /ImageBroker: 110 b, /Gerard Lacz: 237, /Frans Lanting: 211, /S & D & K Maslowski: 156 t, /Chris Mattison: 15 t, /Wil Meinderts: 146–7, /Larry Minden: 149 t, /Mark Moffett: 149 b, /Michael Quinton: 170, /Mandal Ranjit: 55 t, /Cyril Ruoso: 58–59, /Olaf Schubert: 30–31, 34–35, /Malcolm Schuyl: 144 l, 145, 171, 210, /Jurgen & Christine Sohns: 1, 140, /Ariadne Van Zandbergen: 213, 233 t, 233 b, /John Watkins: 56, 135 b, /Larry West: 159 c, /Winfried Wisniewski: 83, /Martin B Withers: 203 t, 152–3, /Konrad Wothe: 34, 204, 168–9, /Shin Yoshino: 52–3, /ZSSD/Minden Pictures: 148

Farid Belbachir: /ZSL/OPNA: 193

Gerald Cubitt: 37, 50, 93 t

Gerhard Huedepohl: 174, 175, 176, 177 t, 177 b, 178, 179, 180, 181, 182

Getty Images: /Jose Luis Roca: 128, /Kevin Schafer: 183

Luke Hunter: 118, 121, /I.R.Iran DoE/CACP/WCS: 116–7

Mahmud Sheish Abdallah: 100, 101, 105 t, 105 b

Nature Picture Library: 242, /James Aldred: 23 t, /Doug Allan: 192, /Bartussek: 77, /Nigel Bean: 27, /Juan Manuel Borrero: 126–7, 131, /John Cancalosi : 68 r, 71, /Bernard Castelein: 51, 54, 58, 60, 18–19, /George Chan: 12, 31, 32–33, 36–37, /Christophe Courteau: 216, /Pat De La Harpe: 92, /Delpho: 225, /Delpho/ARCO: 110 t, /Gertrud & Helmut Denzau: 22, 25, 46–47, /John Downer: 39 tr, /Eric Dragesco: 42–43, 47, /Richard Du Toit: 109, /Jack Dykinga: 15 b, 169, 142–3, /Hanne & Jens Eriksen: 91, 107, 108, /Jurgen Freund: 66, /Nick Garbutt : 196, 201, 205, /Dr Axel Gebauer: 32, /Chris Gomersall: 227 b, /Graham Hatherley: 3, 188, /Tony Heald: 234, /Jouan & Rius: 215, /Simon King: 217, /Nigel Marven: 20–21, /Konstantin Mikhailov: 42, /Steven David Miller: 67 b, /David Noton: 64–65, /Pete Oxford : 40–41, 96, 200, /Mark Payne-Gill: 106–7, /Mike Potts: 190, /Inaki Relanzon: 196–7, /Jose B Ruiz: 129, 132, 134, 228–9, /David Shale: 112, /Shattil & Rozinski: 150, /Marguerite Smits Van Oyen: 13, /Lynn M Stone: 155, /Tony Heald: 218–9, /Robert Valentic: 68 l, /Jason Venus: 186, /Gerrit Vyn: 153, /Dave Watts: 72, 76, 161, /Staffan Widstrand: 8–9, /Xi Zhinong: 39 br

Petra Kaczensky: 49

Photolibrary.com: 114, 119, 184–5, /Maurizio Bachis: 88, /Eyal Bartov: 89 t, 103, /Rafi Ben-Shahar: 212, /Werner Bollmann: 221, /Daniel J Cox: 199, /Nigel Dennis: 209, /Don Fuchs: 2, /Geostock Geostock: 189, /Gerald Hinde: 208–9, /Gerald Hoberman : 207, /J-L. Klein & M-L. Hubert: 162, /JTB Photo: 29, /Konstantin Mikhailov : 41, /Morales Morales: 222–3, /Bruno Morandi: 98–99, /Obert Obert: 44–45, /Nigel Pavitt: 227 t, /Sylvestre Popinet & Christel Freidel: 23 b, /Valentin Rodriguez: 130, /David Tipling: 111

Photoshot: 95, 142, 140–1 r, /Frank Cara: 144 r, /Steve Knell: 124–5, /NHPA: 137 r, 245, 160–1, /NHPA/Daryl Balfour: 220, /NHPA,/Jordi Bas Casas: 135 t, /NHPA/Nick Garbutt: 202, 203 b, /NHPA/Martin Harvey: 79, 191, /NHPA/John Hatt: 113 b, /NPHA/Daniel Heuclin: 25 , /NHPA /Dhritiman Mukherjee: 243, /NHPA/T Kitchen & V Hurst: 38, /NHPA/ World Pictures: 86–87, /NHPA/Kevin Schafer: 159 r, /NHPA/Roger Tidman: 104, /Woodfall: 166, 173, /Martin Zwick: 84–85

Ryan Pyle: 120

Teresa Farino: /Iberian Wildlife: 136

Every effort has been made to acknowledge correctly and contact the source and/or copyright holder of each picture and Carlton Books Limited apologises for any unintentional errors or omissions, which will be corrected in future editions of this book.